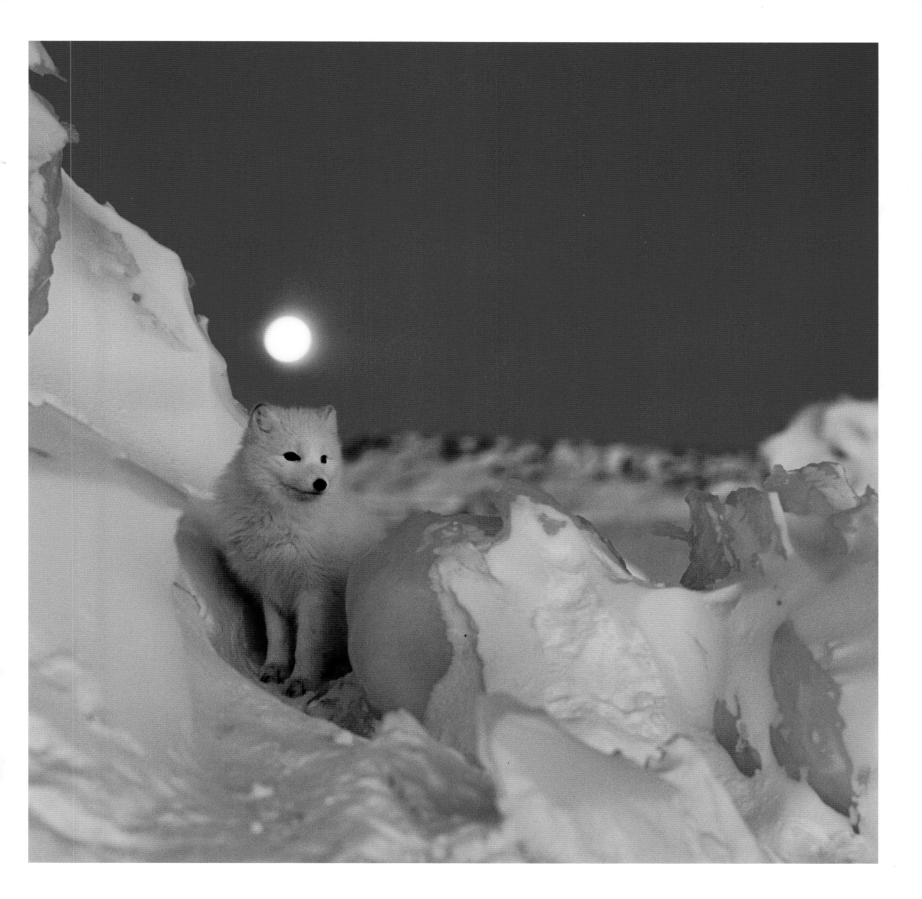

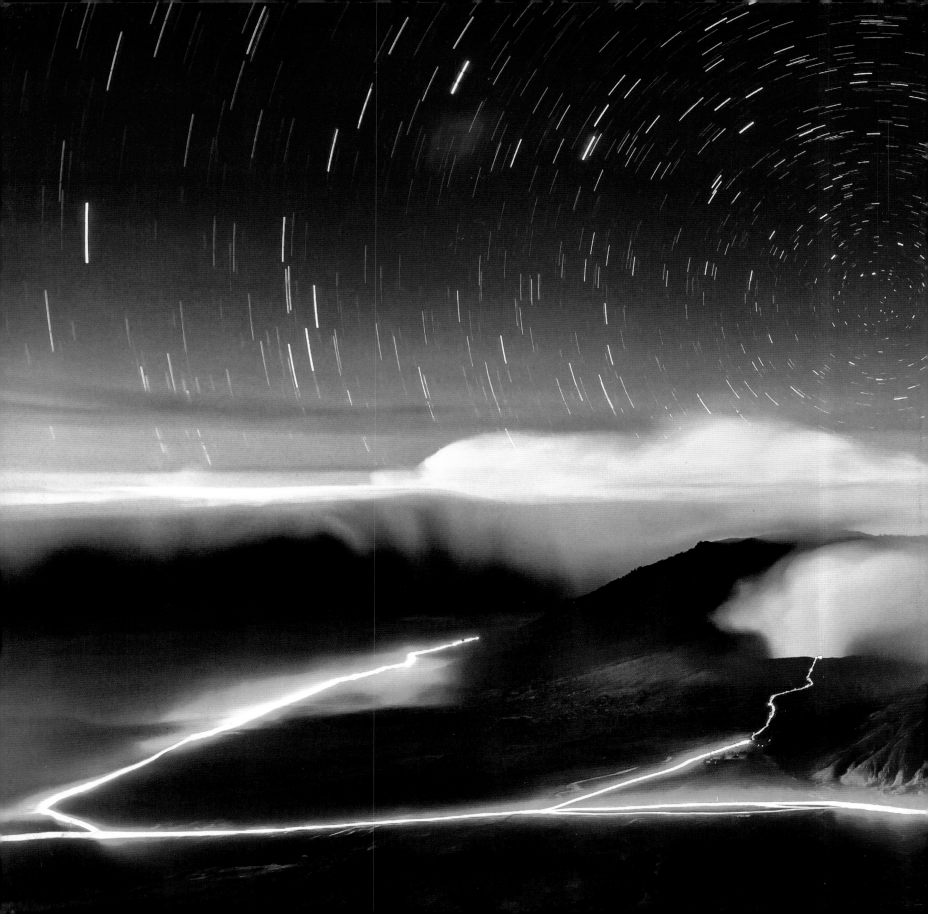

NIGHT
MAGICAL PHOTOGRAPHS OF LIFE AFTER DARK
VISION

SUSAN TYLER HITCHCOCK

FOREWORD BY
DIANE COOK AND LEN JENSHEL

NATIONAL GEOGRAPHIC
WASHINGTON, D.C.

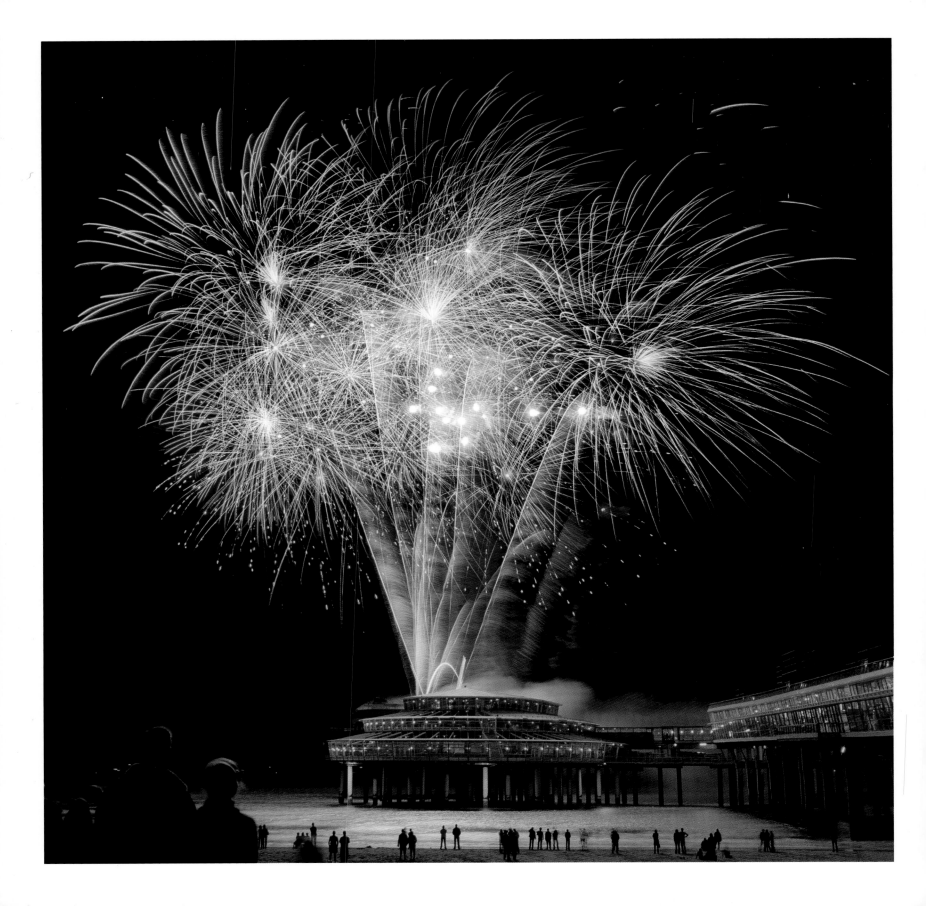

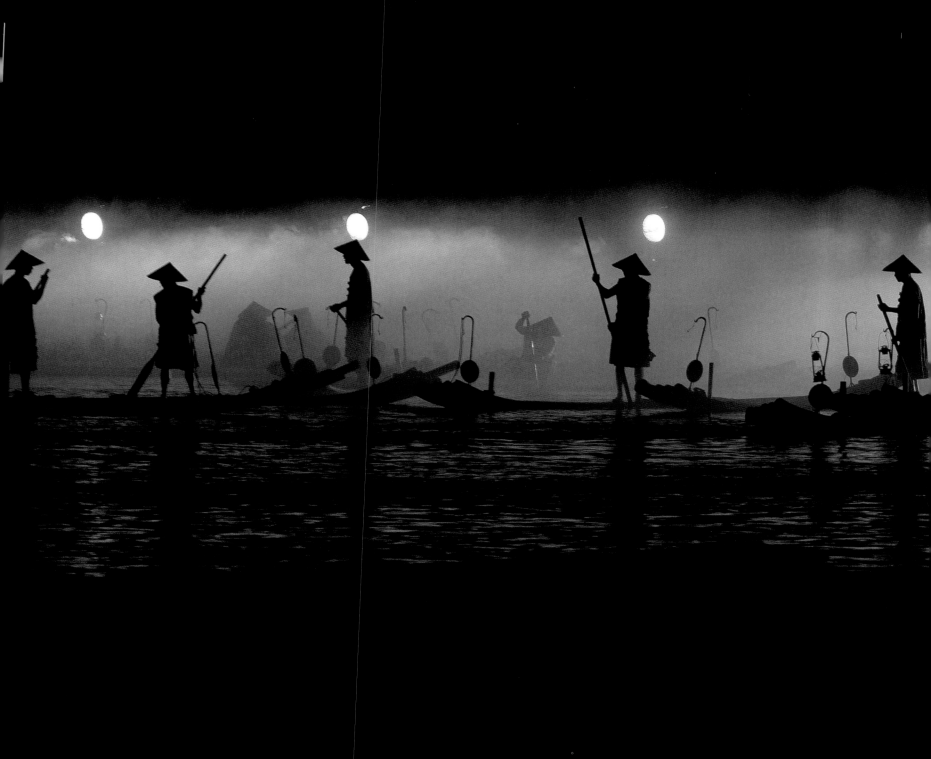

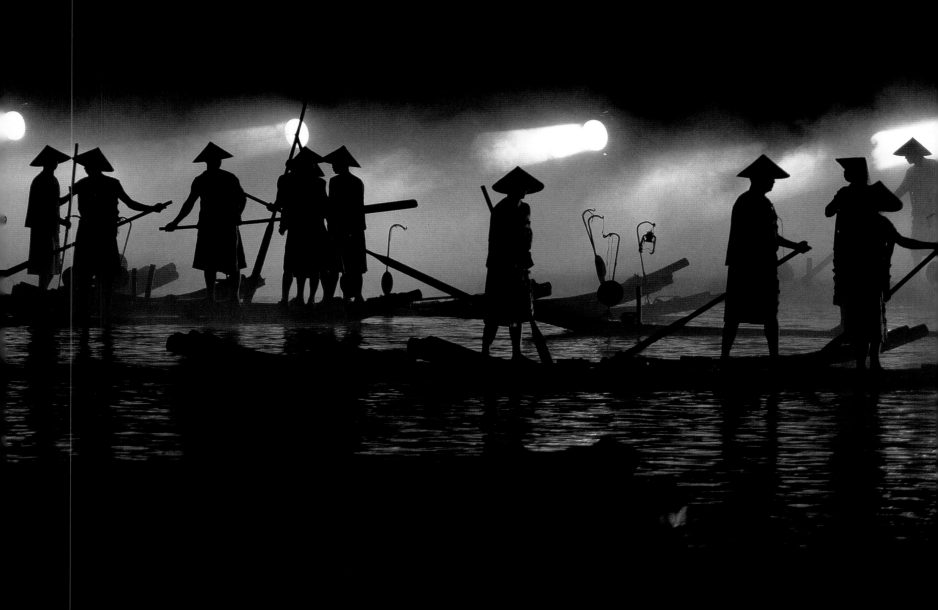

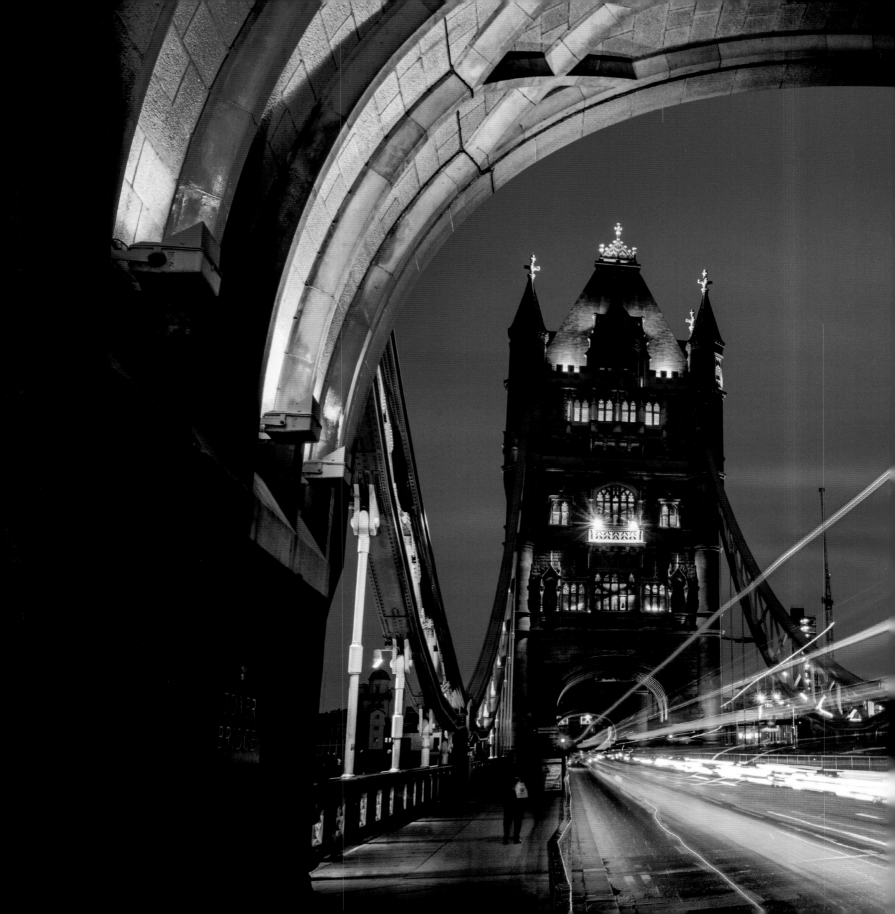

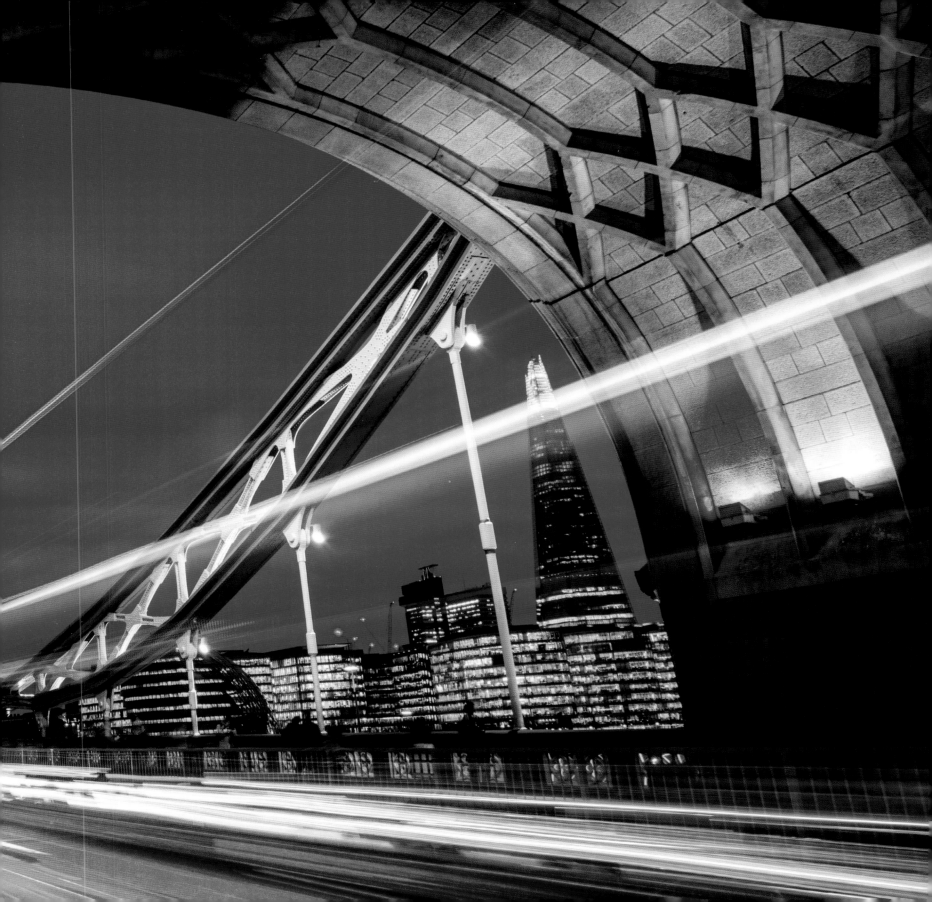

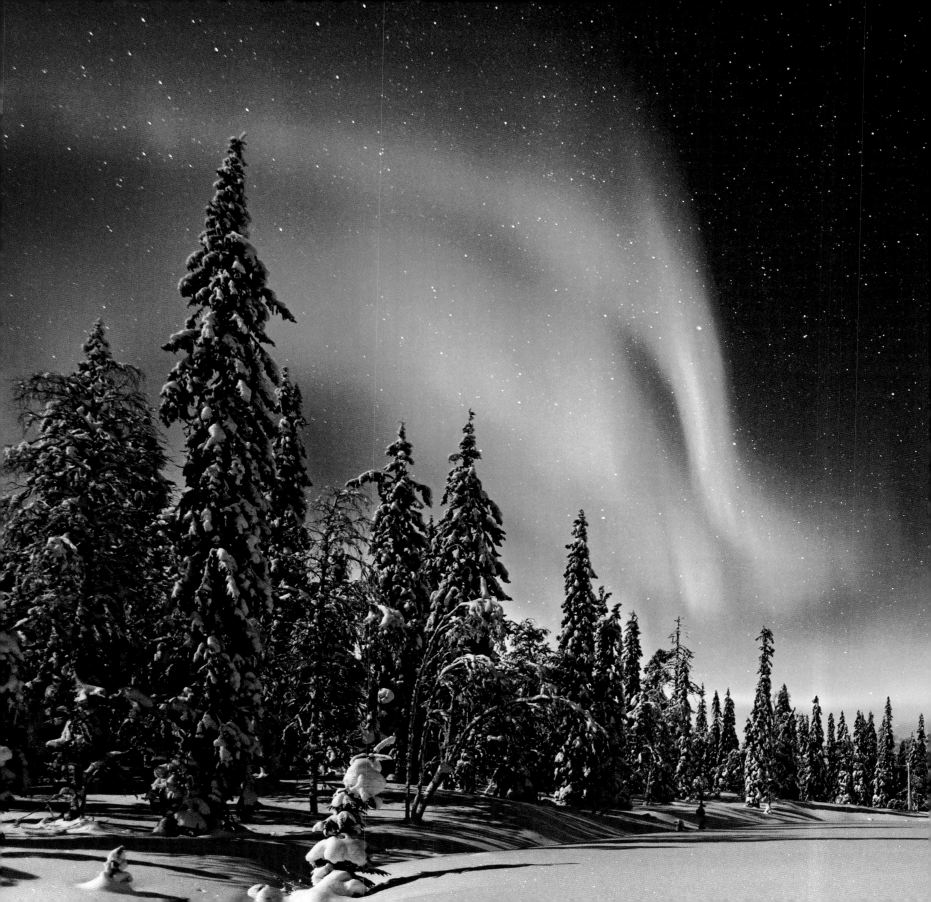

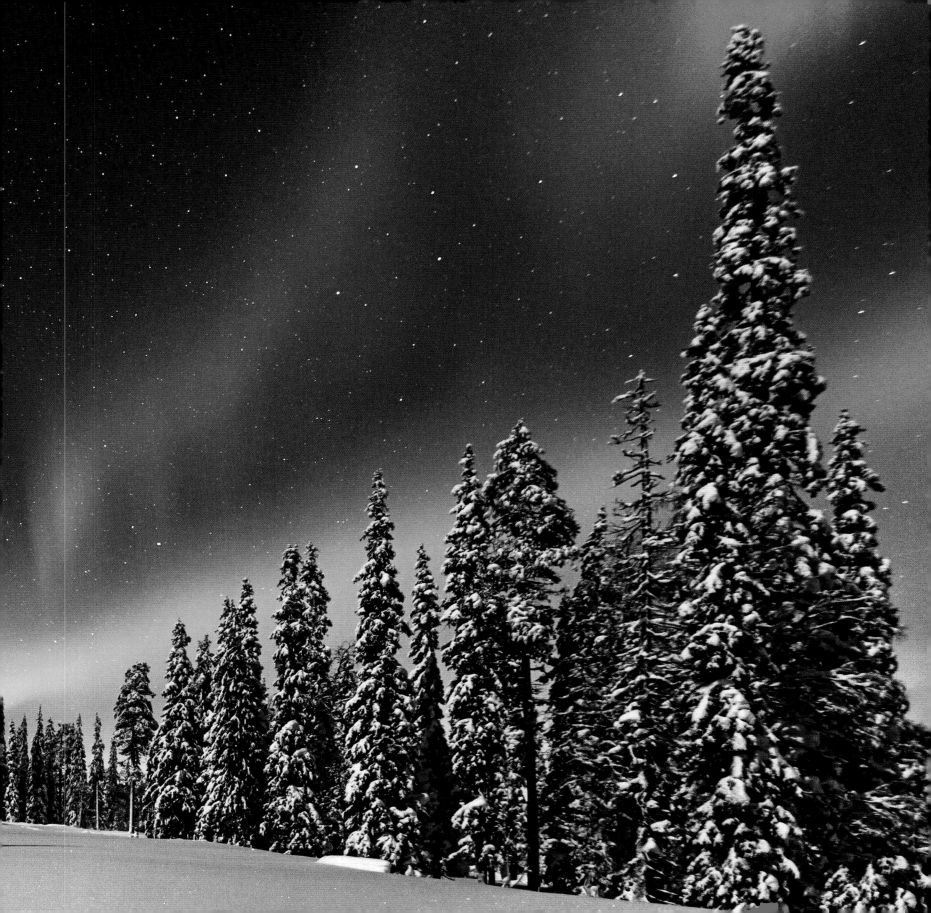

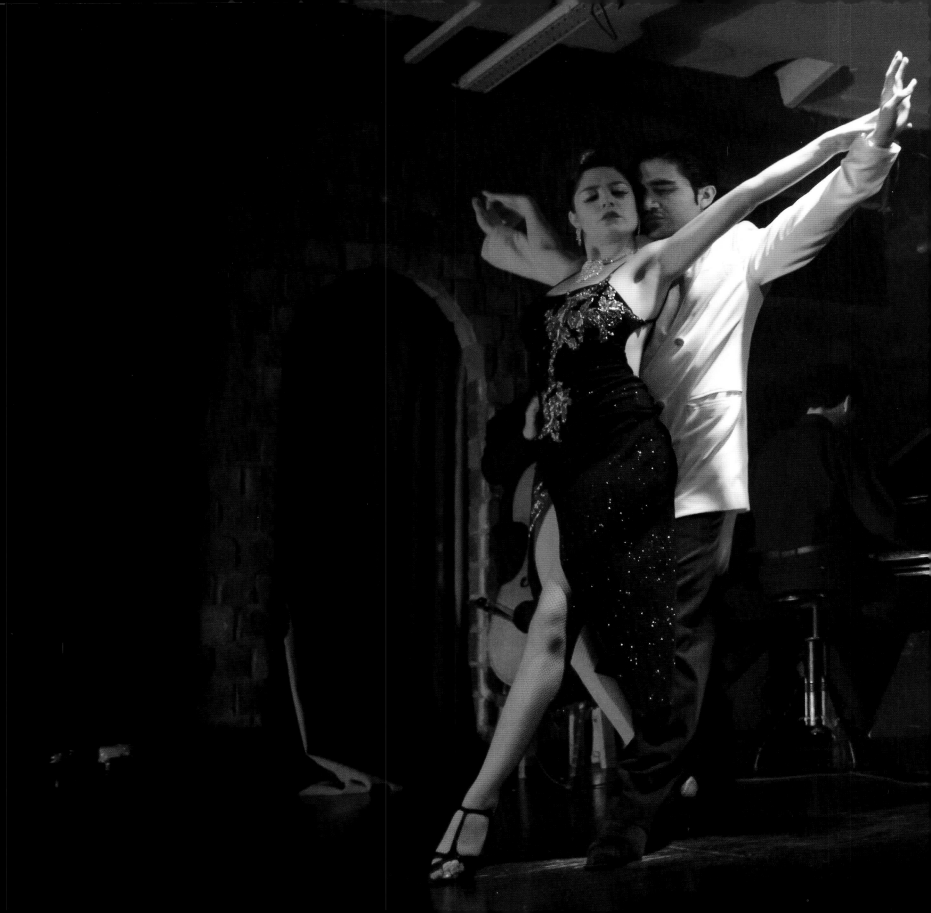

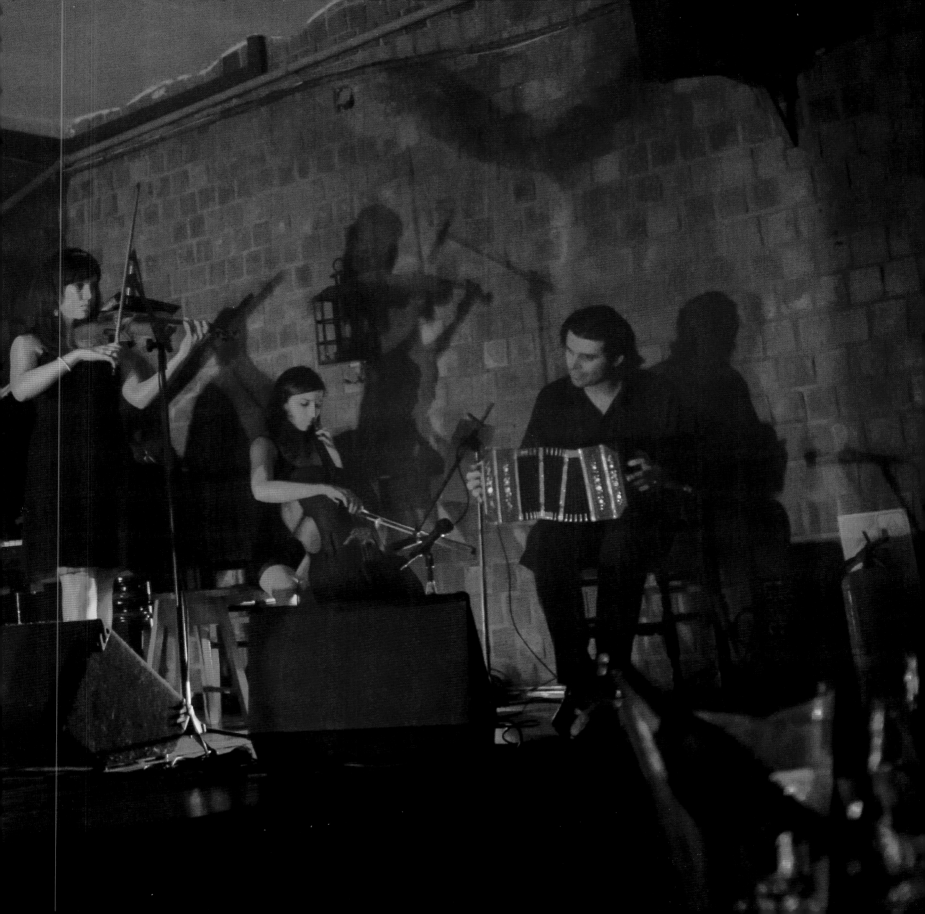

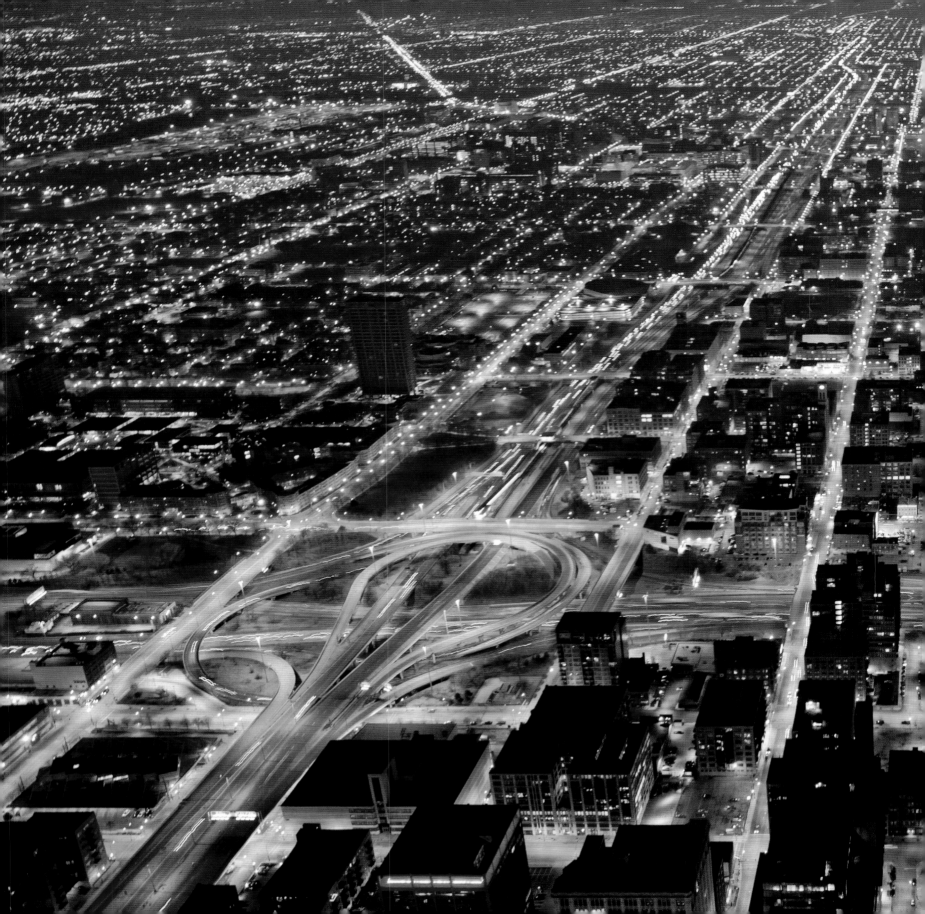

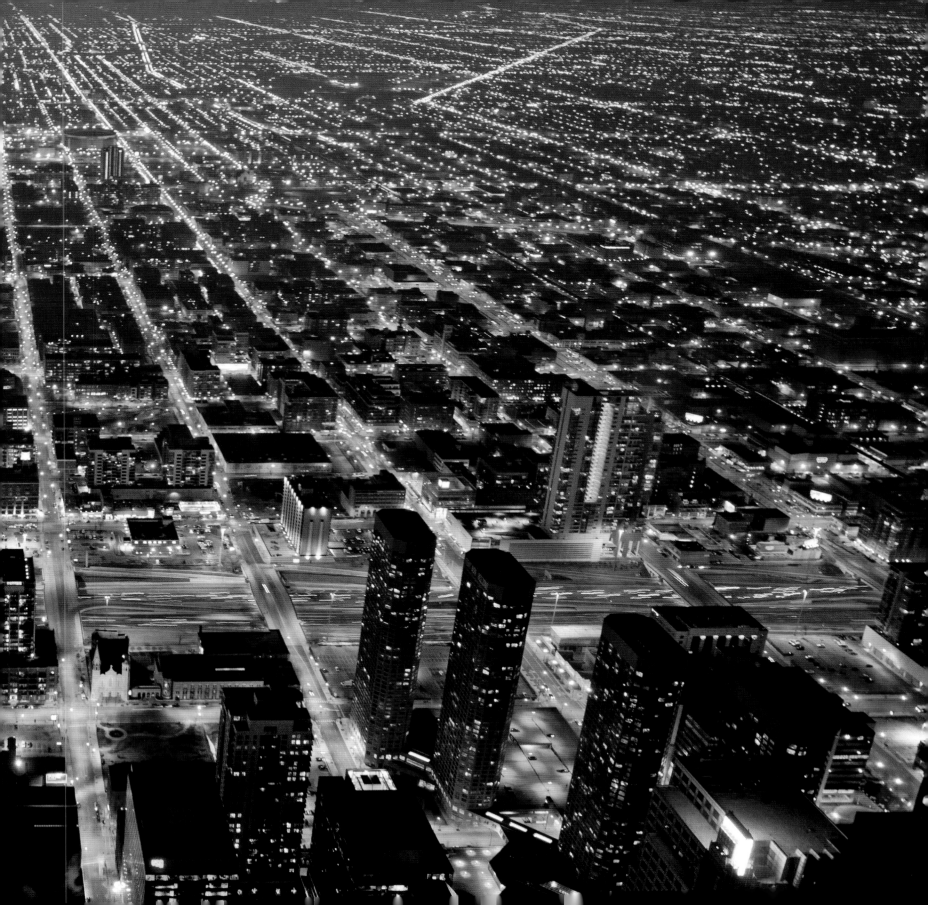

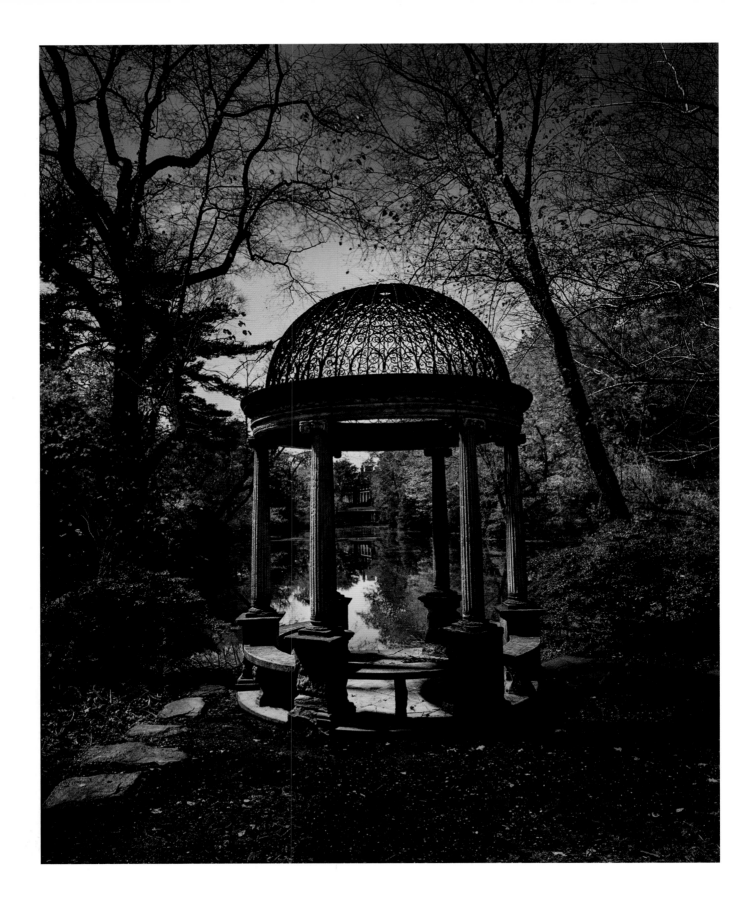

The night is strange and mysterious, beautiful and romantic, sinister and frightening—and what transpires after dark has lured artists for centuries. Like moths to a flame, we are drawn to the magic of those nocturnal hours.

When we first began photographing landscapes after dark, we were amazed that an image could capture the night with such surprising clarity. That unforeseen result was reminiscent of seeing a picture—at first a ghostly shape in a tray of developer—miraculously materialize on photographic paper.

What *really* happens for photographers working at night is an incredible leap of faith—because what you see is *not* what you get. You are collaborating with intuition, instinct, luck, and patience.

Why the world looks so different at night has to do with the way our eyes see. Our retinas are layered with photoreceptive cells called rods and cones. Rods, which detect the intensity of light, are able to sense low levels of illumination. An owl has great night vision, because its eyes contain an abundance of rods. Cones, which our eyes use to perceive color, require a certain threshold of light in order to function. Moonlight is generally not bright enough for the human eye to detect color. In low-level light, we see only shades of black, white, gray, and silver. But in a photograph—since both film and pixels do what the retina cannot—we can "see" and record color.

OPPOSITE: **OLD WESTBURY, NEW YORK** | A gazebo in the Old Westbury Gardens
sits in the still of the night. | *Diane Cook & Len Jenshel*

In 2001 we began a project called "Gardens By Night." Because most of our images were made with only the illumination of the moon, our film exposures took well over an hour. Our aim was to document how surreal gardens appeared at night—and to understand how different cultures appreciate their nocturnal beauty. The idea struck a chord with the romantic poets within us but begged a few questions: How can darkness be so frightening to some and yet so alluring to others? And how do we coax the night to reveal its secrets to us?

As if these matters of working in a garden at night were not daunting enough, there were a host of physical challenges to contend with. There's the wind (although sometimes movement can reward you with a fortuitous gift). Then there's the dreaded dew point: As temperatures drop and humidity rises into the wee hours of the night, camera lenses can often become fogged with condensation. Other challenges include batteries dying in the middle of a multi-hour exposure, hungry mosquitoes, and perhaps most important, maintaining the ability to be resourceful and creative while totally sleep deprived.

So with myriad technical nightmares to deal with, why do we do what we do? The simple answer is that it matters little how many obstacles there are to overcome—our rewards are images filled with wonder. In this revealing book, the diverse ways different photographers deal with darkness is fascinating. These pages show countless sensibilities and captivating interpretations of life after dark. And whether you prefer moonlight, artificial ambient light, or strobe lighting, these images will surprise, startle, and most of all, inspire.

OPPOSITE: **KYOTO, JAPAN** | Spires of bamboo flank a path curving up to Kodai-ji temple. | *Diane Cook & Len Jenshel*

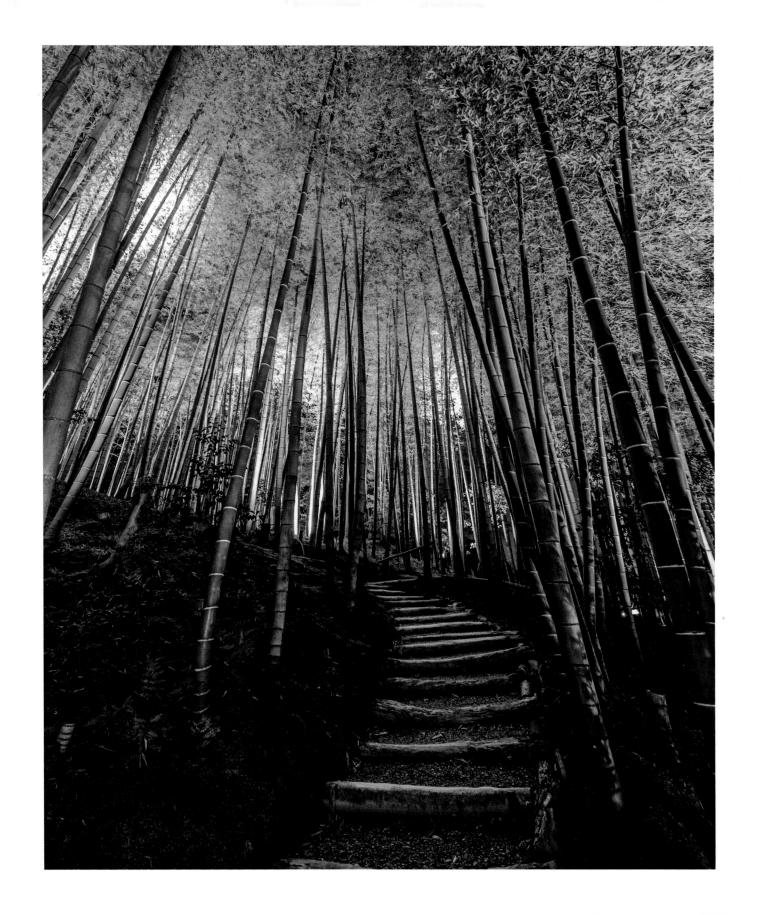

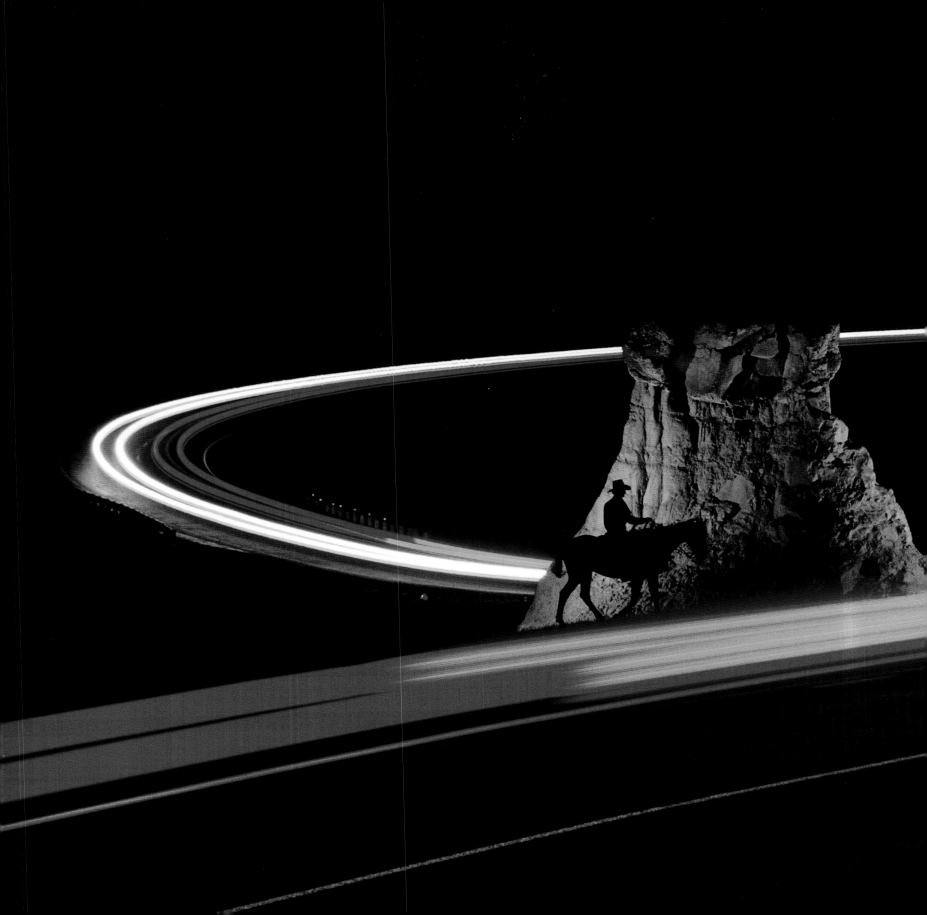

ENERGY

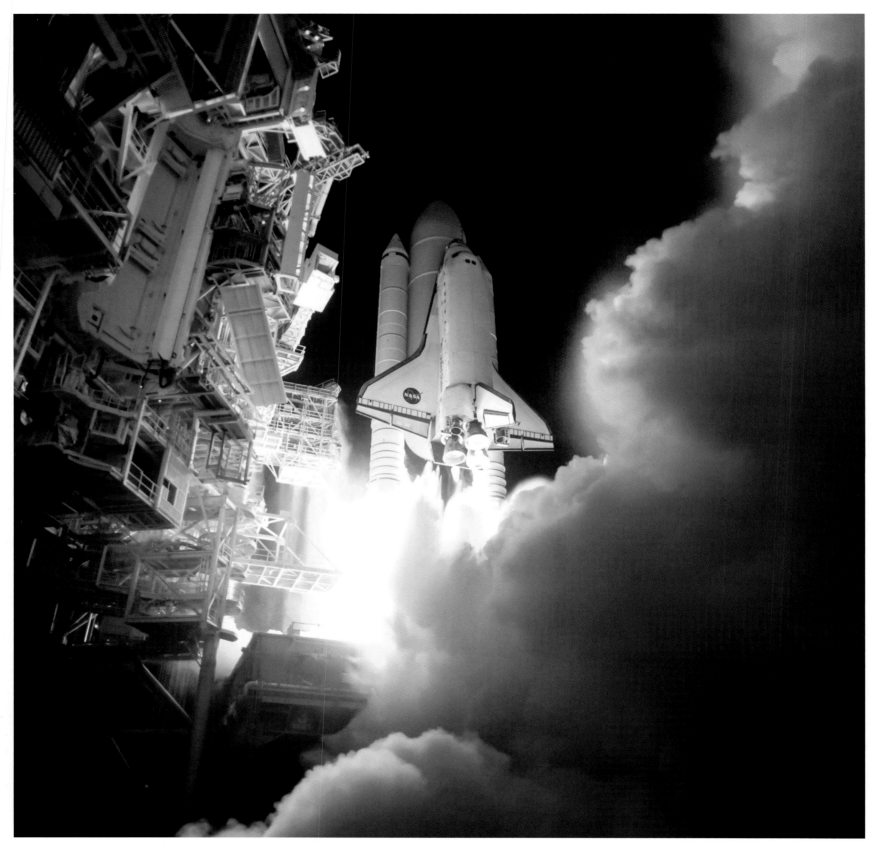

The pulse of life throbs loudest at night. Our senses run deep. Without the distractions of daylight and all it illuminates, you can cut through to the core of life. The heart of the Earth, with its red-hot molten rock, may appear charred and lackluster by day. But set against the black of night, it seethes with a brilliant intensity that is frightening, fascinating, and irrepressible.

And so in our lives, when it feels as if no one is looking, that's when the action begins: a sultry tango after hours, a griddle's sizzle to tide us over till morning, the noise and ferocity of carnival madness climaxing just before dawn. The darkest depths reveal our innermost selves.

At the same time, night invites us to look out ever farther. Billions of galaxies spin their courses, mindless of our earthly existence; we carry on by day, equally mindless. It's only in the deep black of night that the dense and endless blanket of stars, horizon to horizon, declares its overwhelming, energetic presence and humbles us into realizing how faint our planet must be.

That's when we hear the heart best. That's when we feel how the drumbeat of the universe resonates through every human body.

OPPOSITE: **JOHN F. KENNEDY SPACE CENTER, FLORIDA** | A tower of fire from the launch of the space shuttle *Discovery* lights up an exhaust cloud. | *Tony Gray & Tom Farrar*

PREVIOUS PAGES: **BADLANDS, NORTH DAKOTA** | Cars stream past a cowboy on horseback in this long exposure. | *Annie Griffiths*

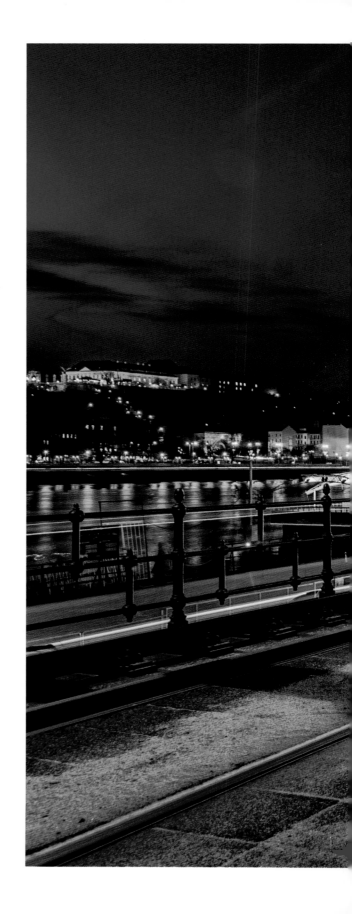

BUDAPEST, HUNGARY | More than 30,000 blinking LEDs light a city tram to create a festive atmosphere during the cold winter season. | *Viktor Varga*

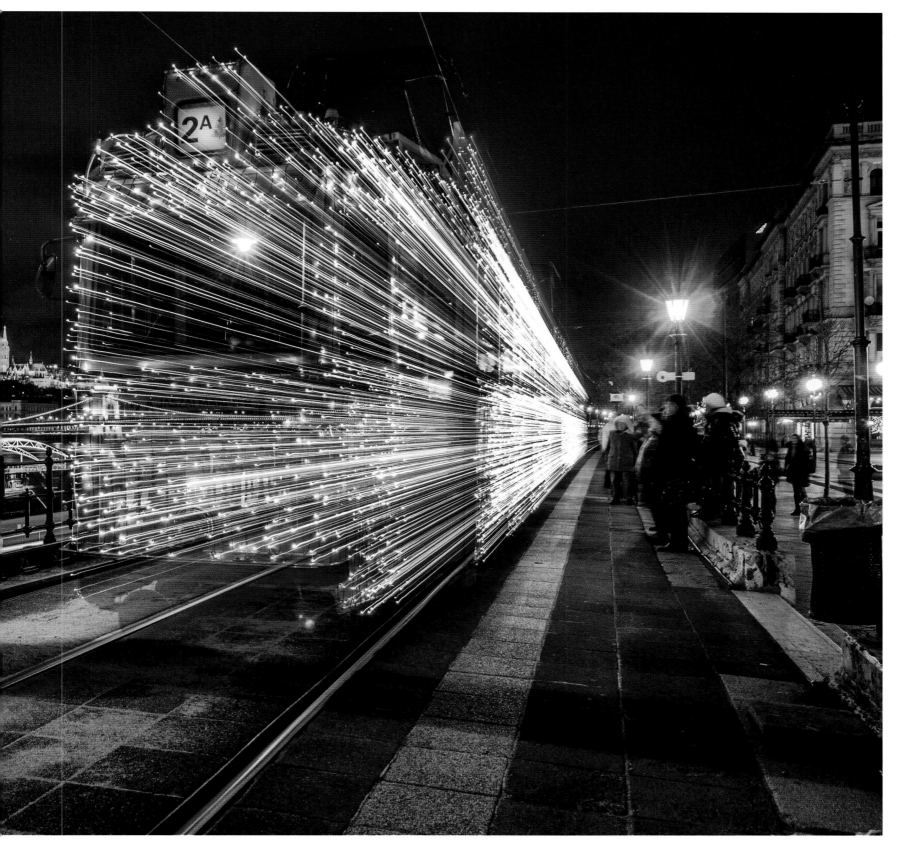

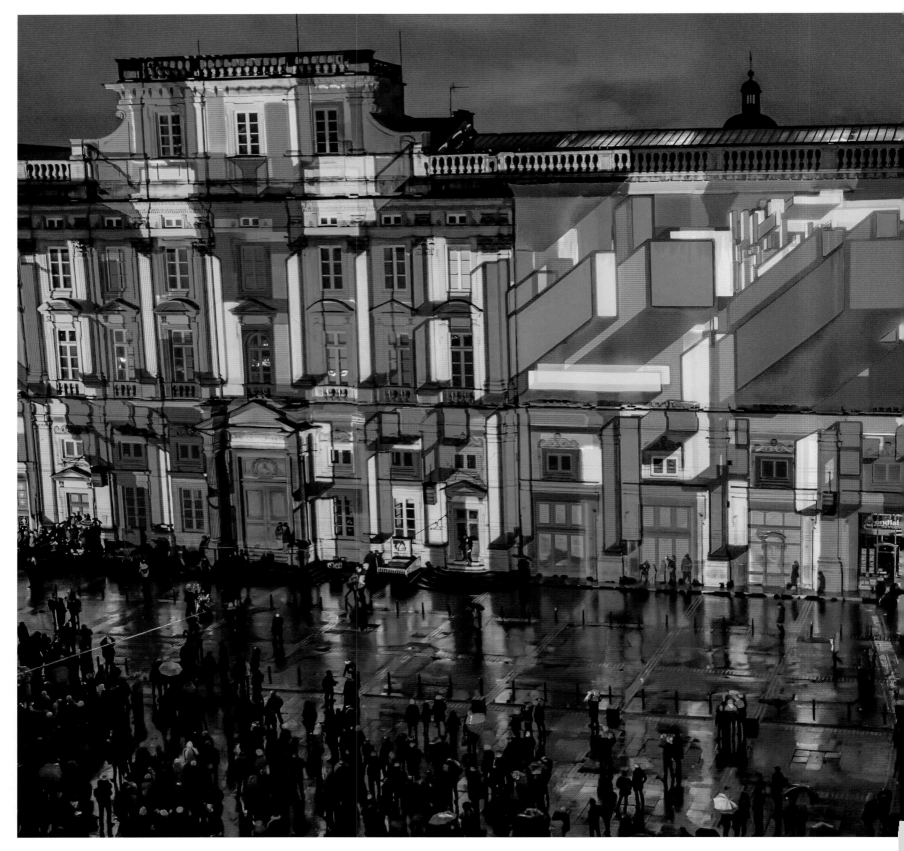

LEFT: **LYON, FRANCE** | Multicolored lights shine on the front of the Museum of Fine Arts during the Fête des Lumières. | *Jacques Pierre*

FOLLOWING PAGES: **RIO DE JANEIRO, BRAZIL** | Samba dancers perform during the final night of Carnival. | *Yasuyoshi Chiba*

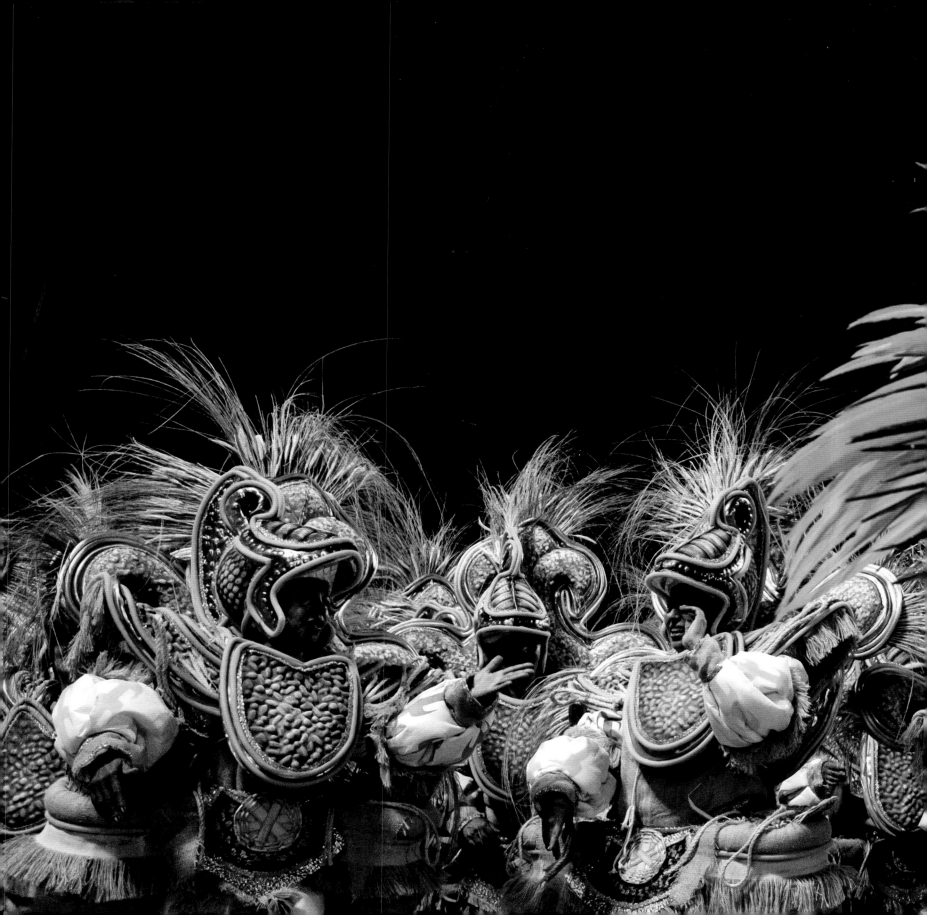

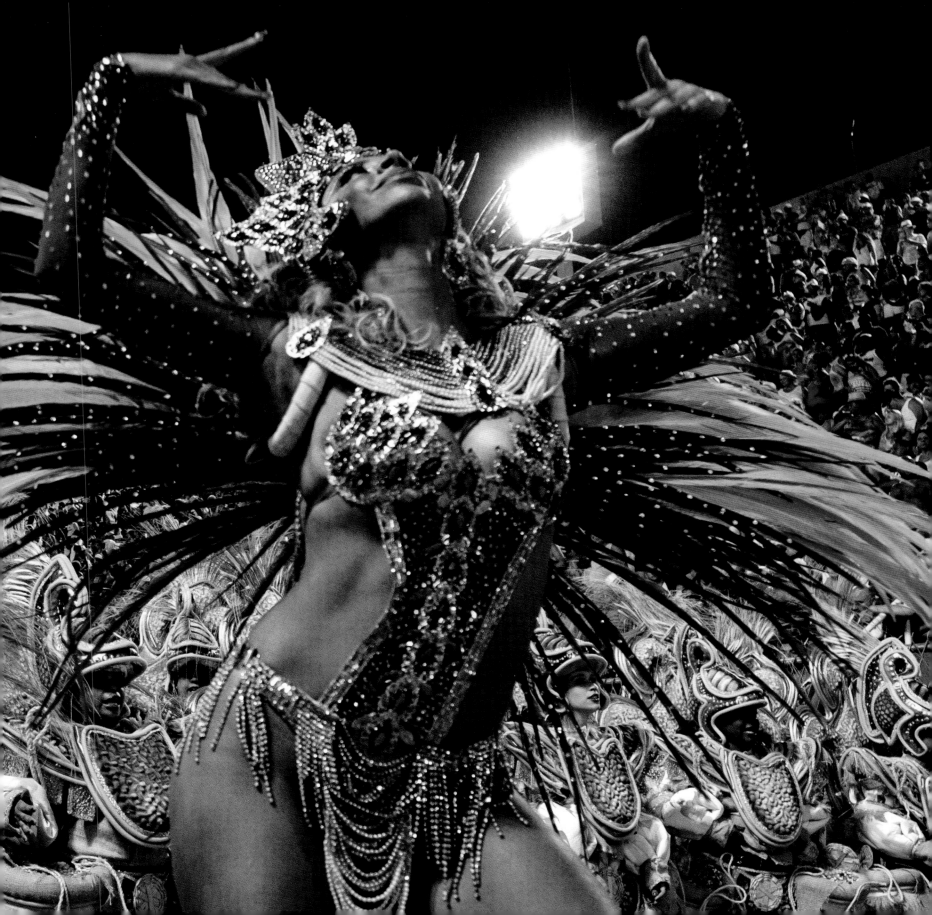

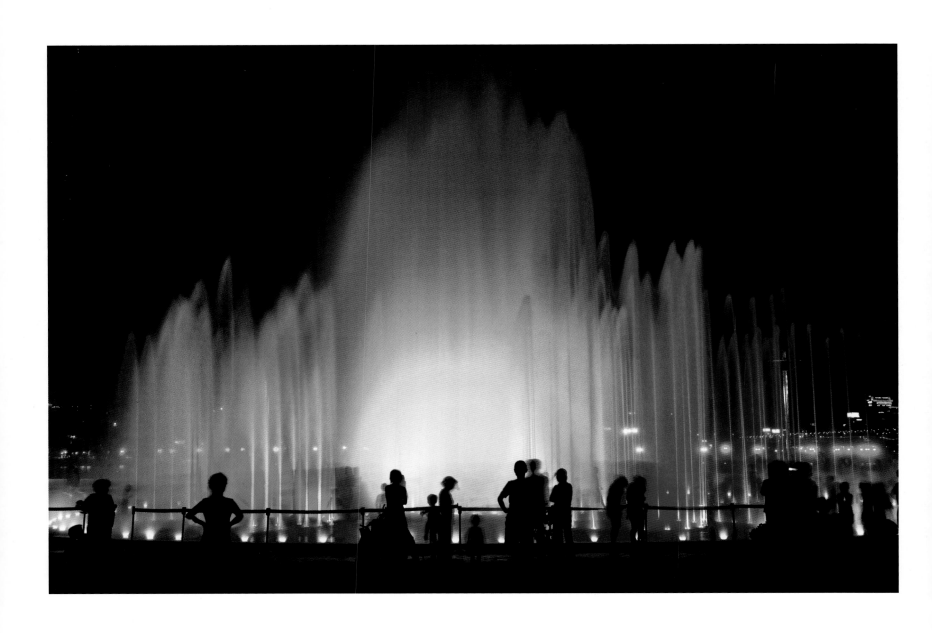

SEOUL, SOUTH KOREA | A fountain comes alive
with color in Ttukseom Hangang Park. | *Sungjin Kim*

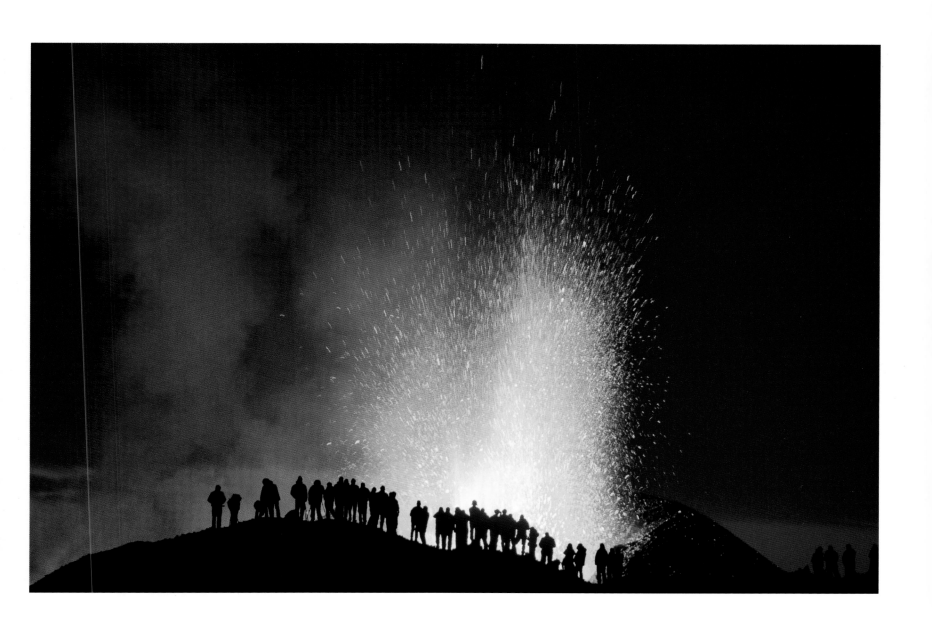

EYJAFJALLAJÖKULL, ICELAND | Tourists watch lava erupt
from Eyjafjallajökull volcano. | *Sigurdur Hrafn Stefnisson*

RIGHT: GUILDFORD, SURREY, ENGLAND | A southern flying squirrel
takes off into the night. | *Kim Taylor*

FOLLOWING PAGES: SAKHIR AIR BASE, BAHRAIN | During an air show,
jets create arcs of light. | *Ajay Kumar Singh*

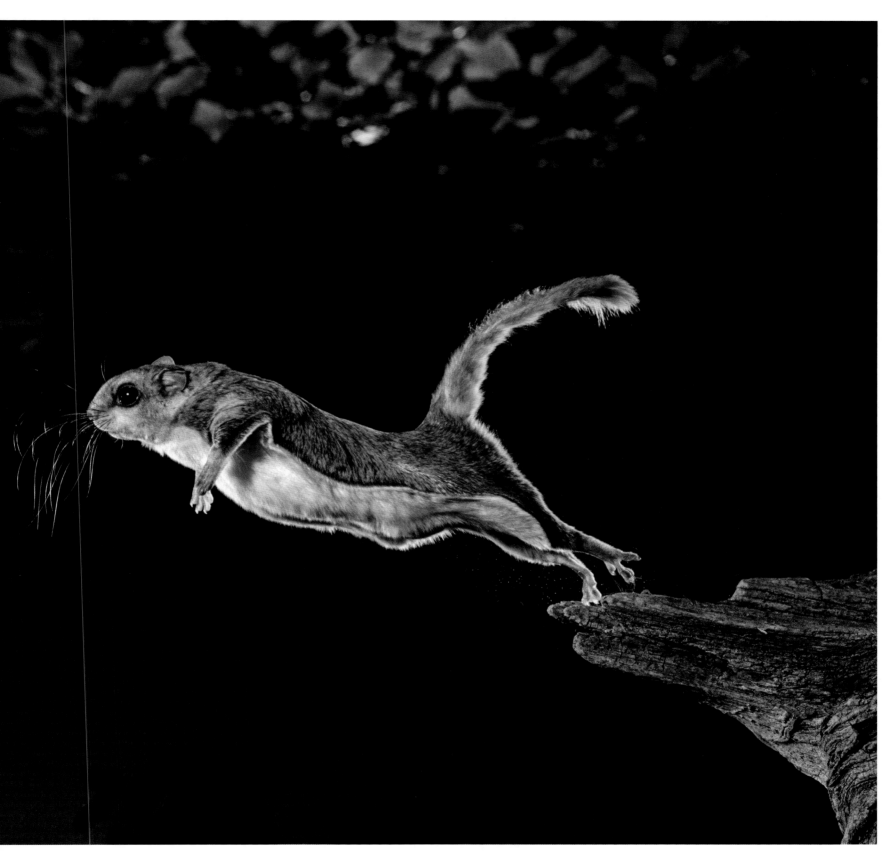

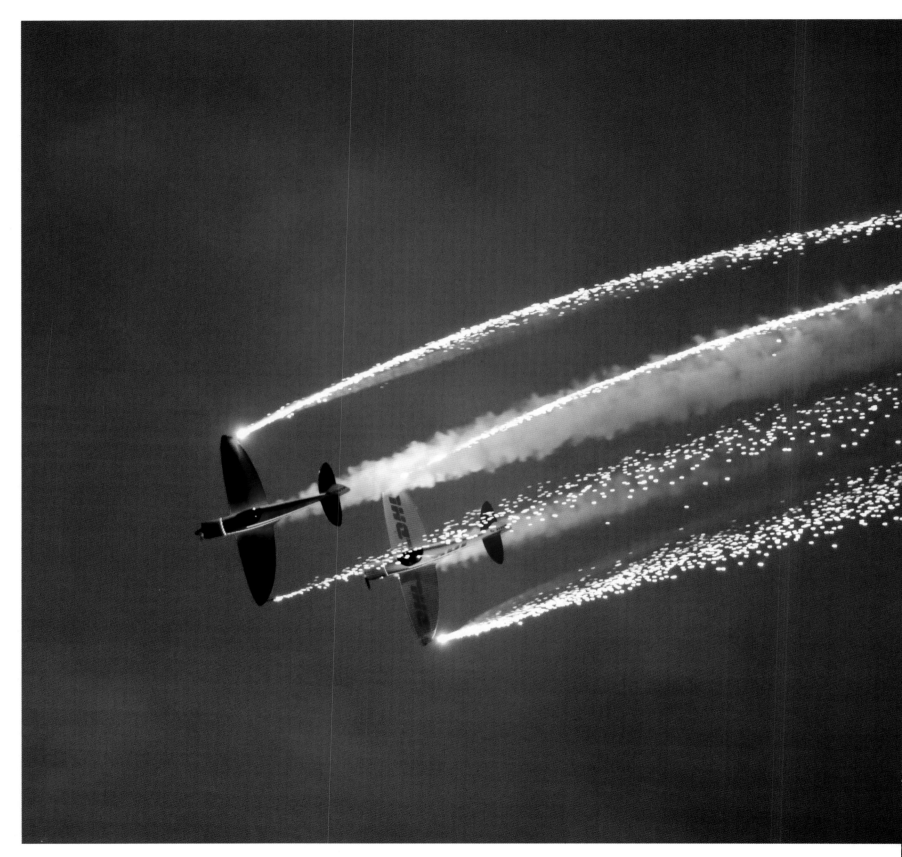

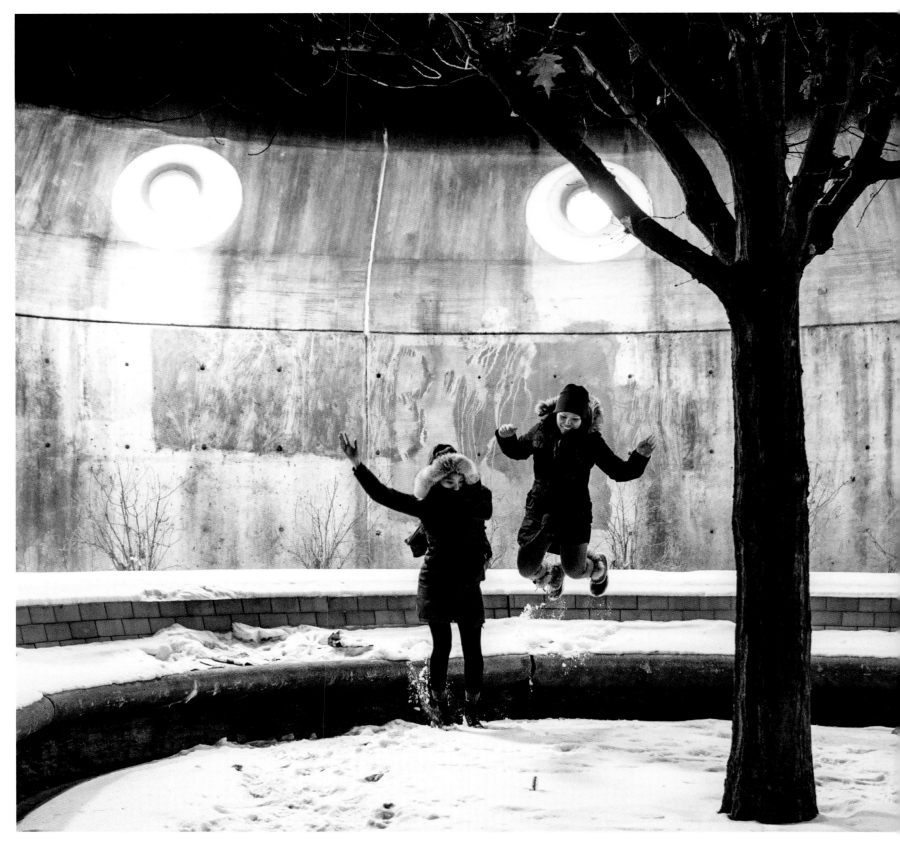

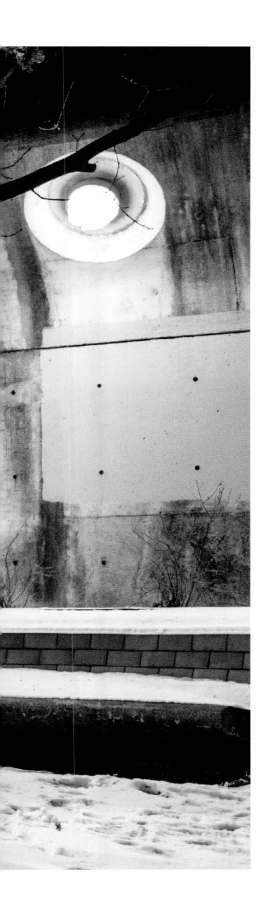

ONTARIO, CANADA | Friends jump in the fresh snow. | *Rosanna U*

"THE NIGHT IS MORE ALIVE AND MORE RICHLY COLORED THAN THE DAY.

—VINCENT VAN GOGH

OPPOSITE: BIRMINGHAM, ALABAMA | An art installation by Bill FitzGibbons
in the 18th Street Railroad Viaduct encourages night exploration. | *Susan Seubert*

38

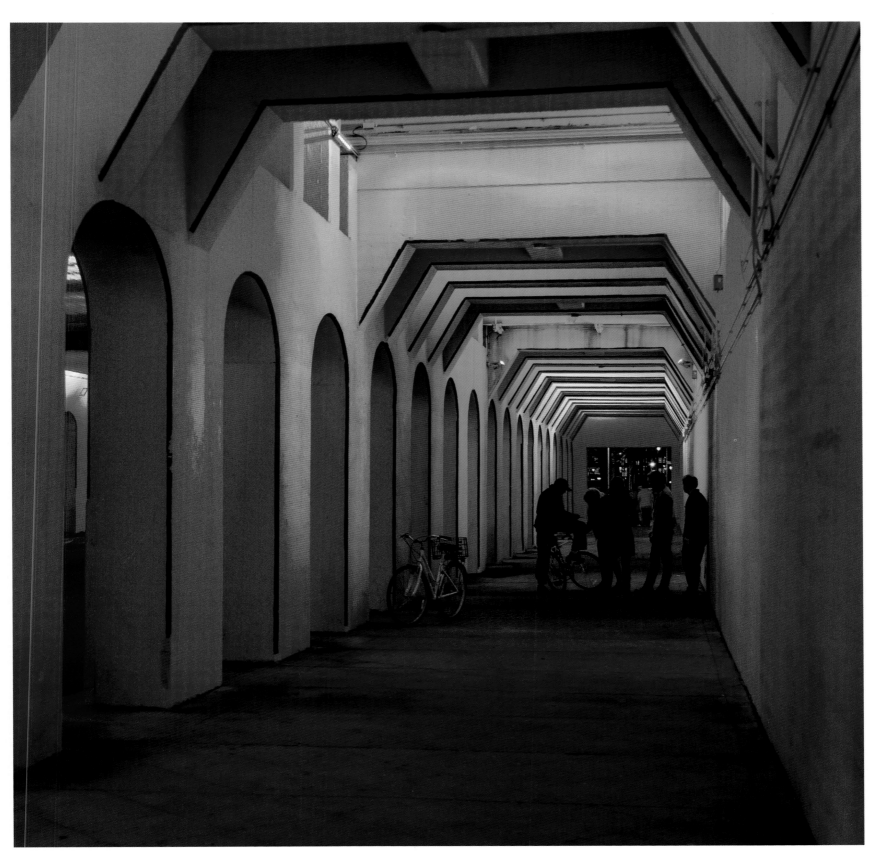

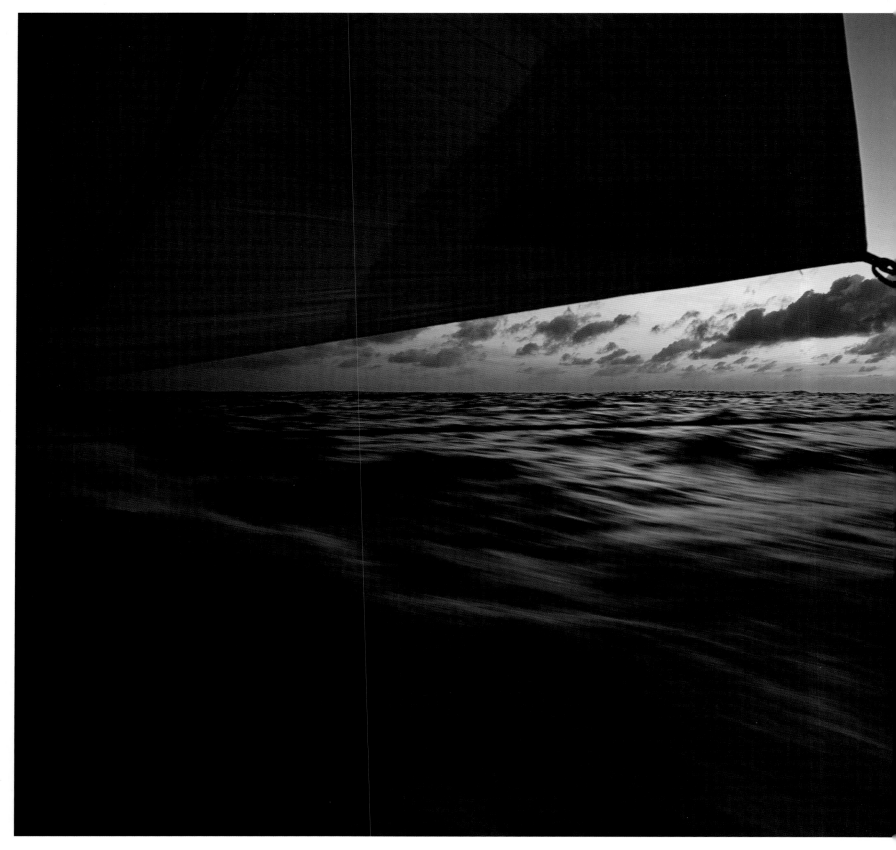

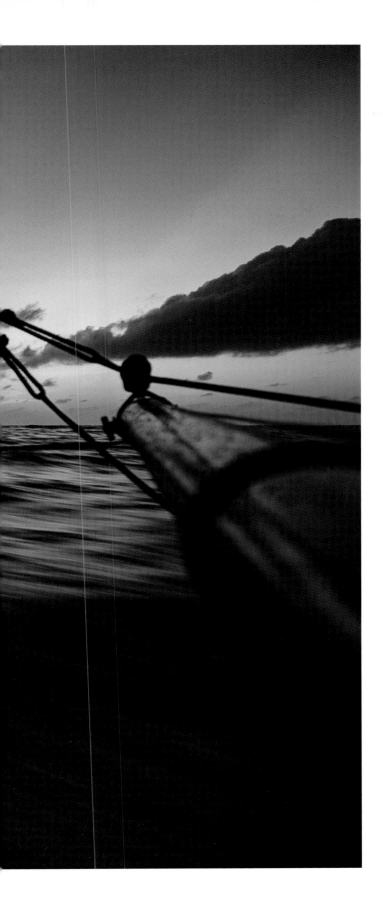

LEFT: **ATLANTIC OCEAN** | Evening falls across the sky as Team Alvimedica leaves Cape Verde during the nine-month-long Volvo Ocean Race. | *Amory Ross*

FOLLOWING PAGES: **OSAKA, JAPAN** | Hands reach for falling confetti, marking the end of a concert. | *Ian Collins*

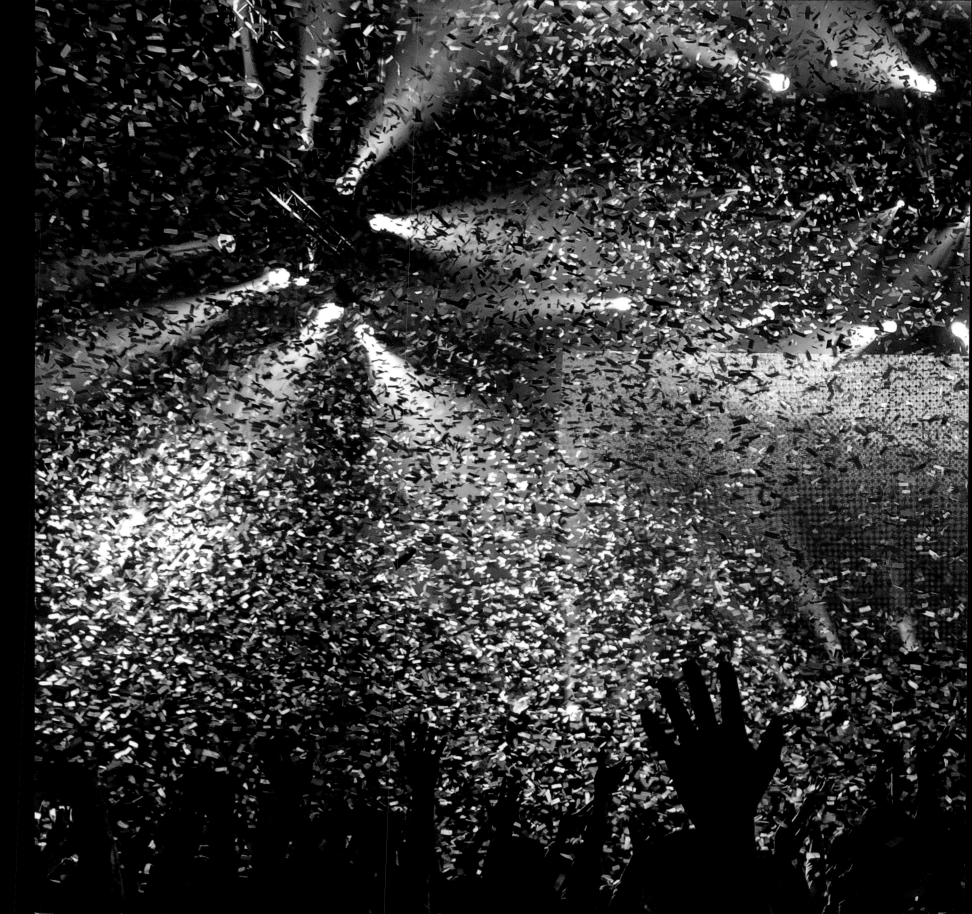

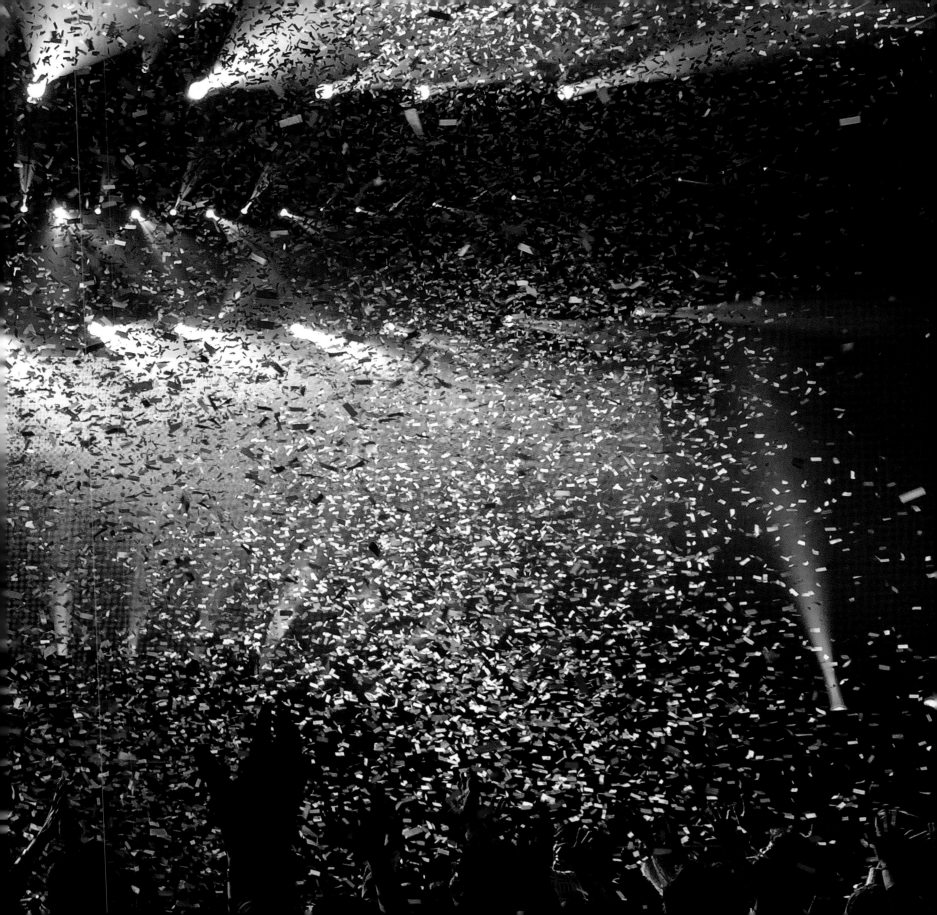

RIGHT: **NEWBURYPORT, MASSACHUSETTS** | Guinness, a chocolate Lab, takes to the air in a snowy field. | *Kaylee Greer*

PAGE 46: **BANGKOK, THAILAND** | From the air, the Wongwian Yai roundabout forms a geometric pattern. | *Thanapol Marattana*

PAGE 47: **PARIS, FRANCE** | When seen from below, the girders of the Eiffel Tower yield an intricate skeleton. | *Achim Thomae*

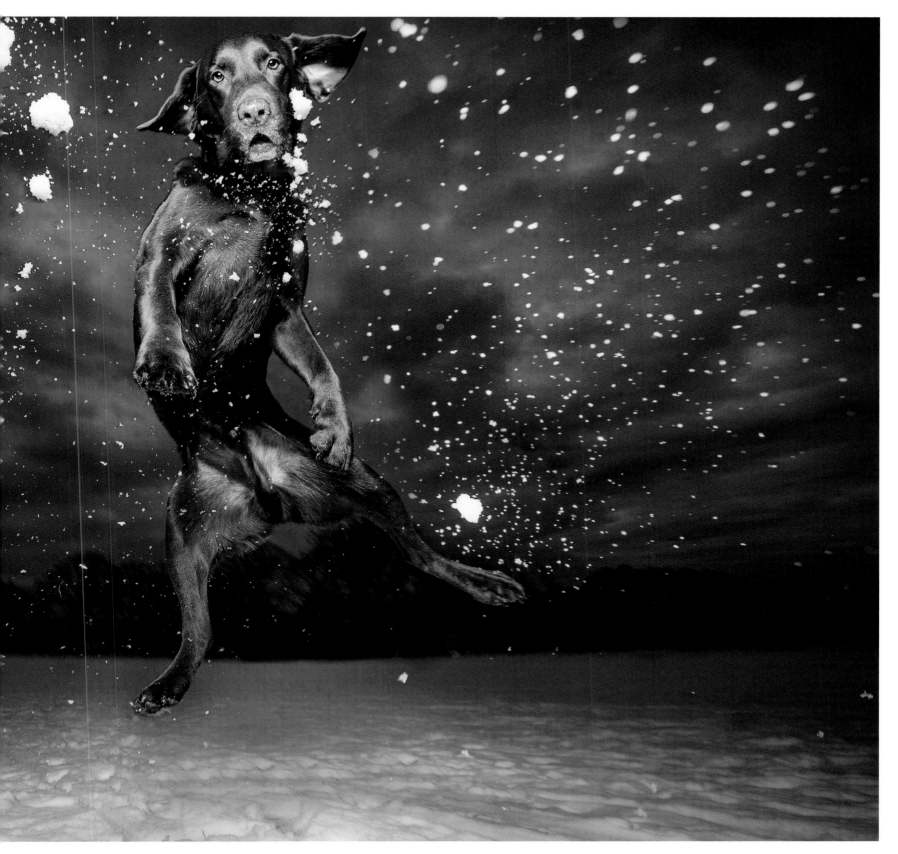

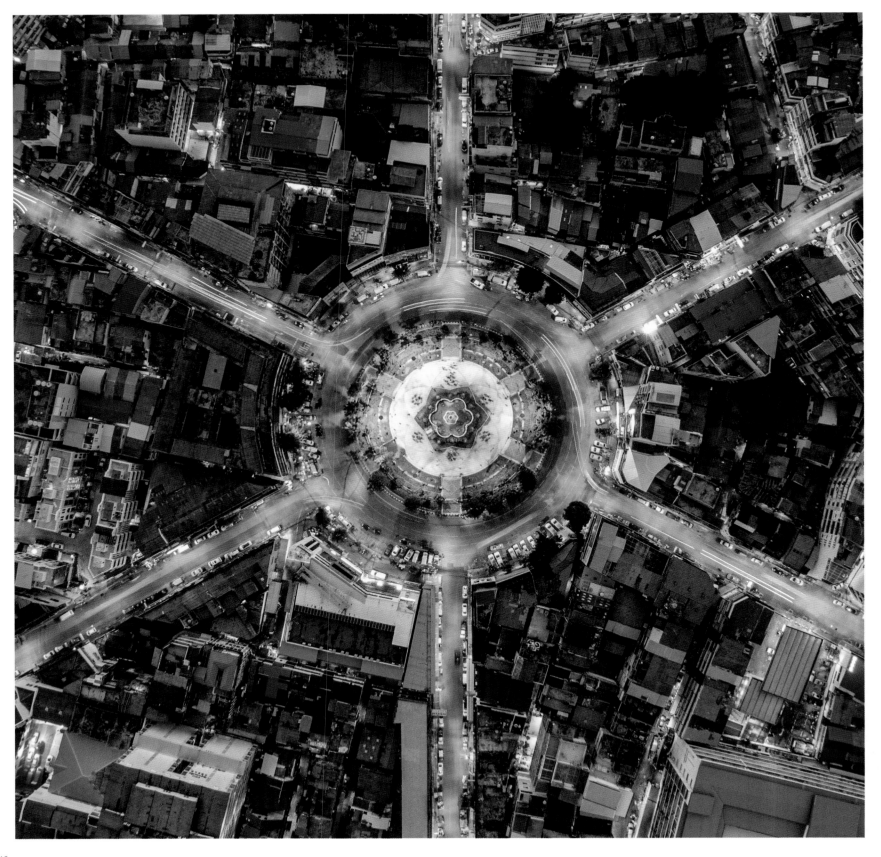

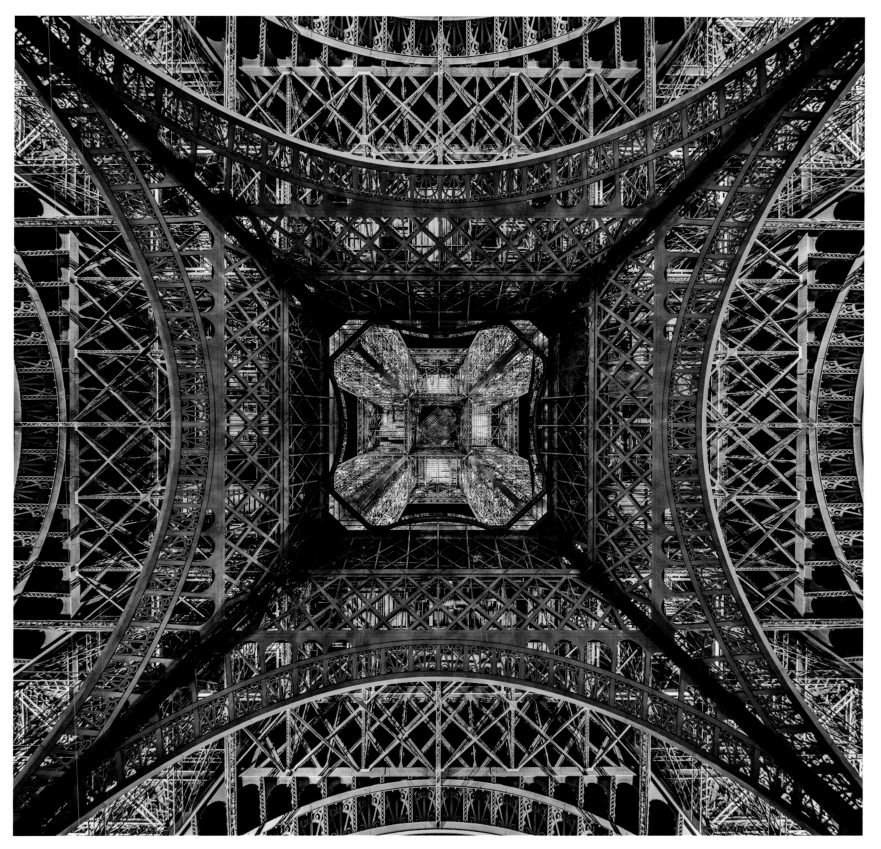

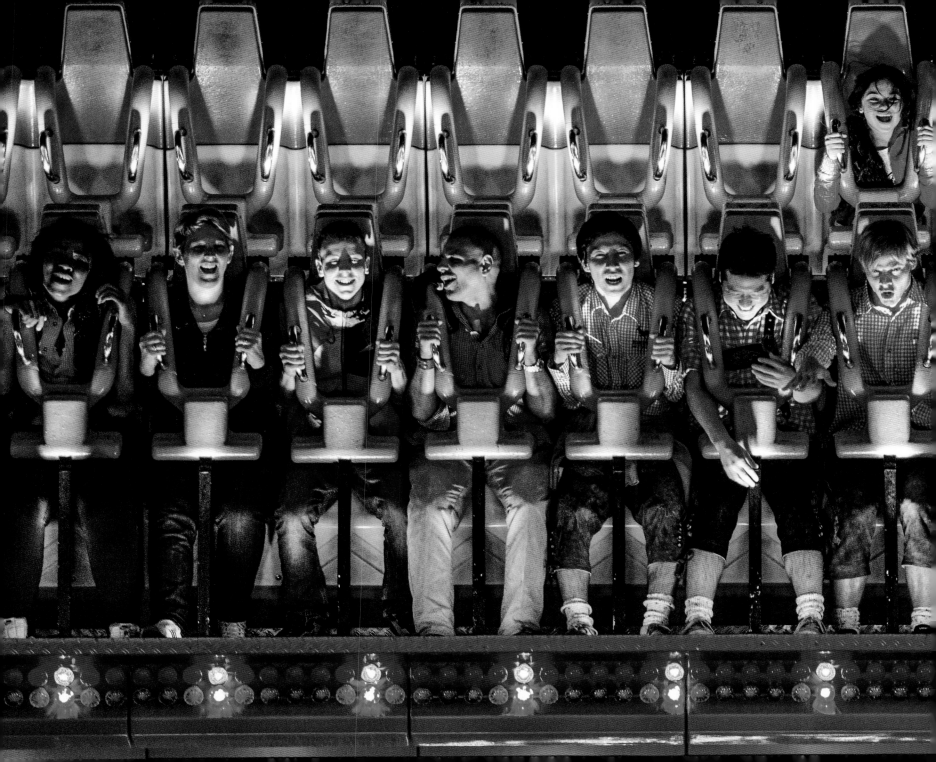

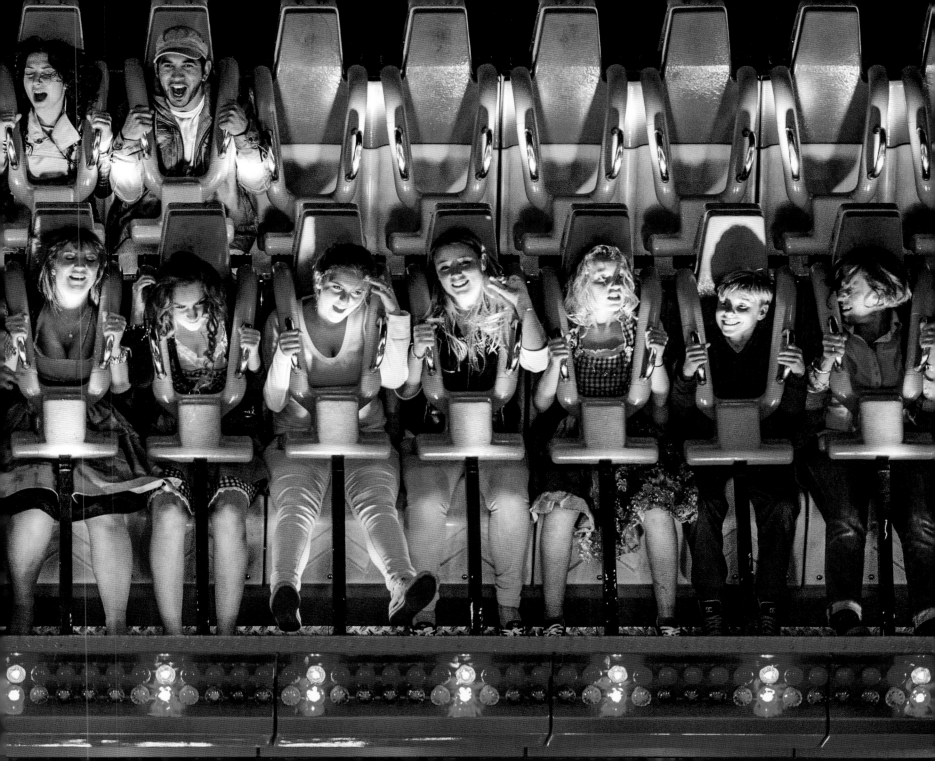

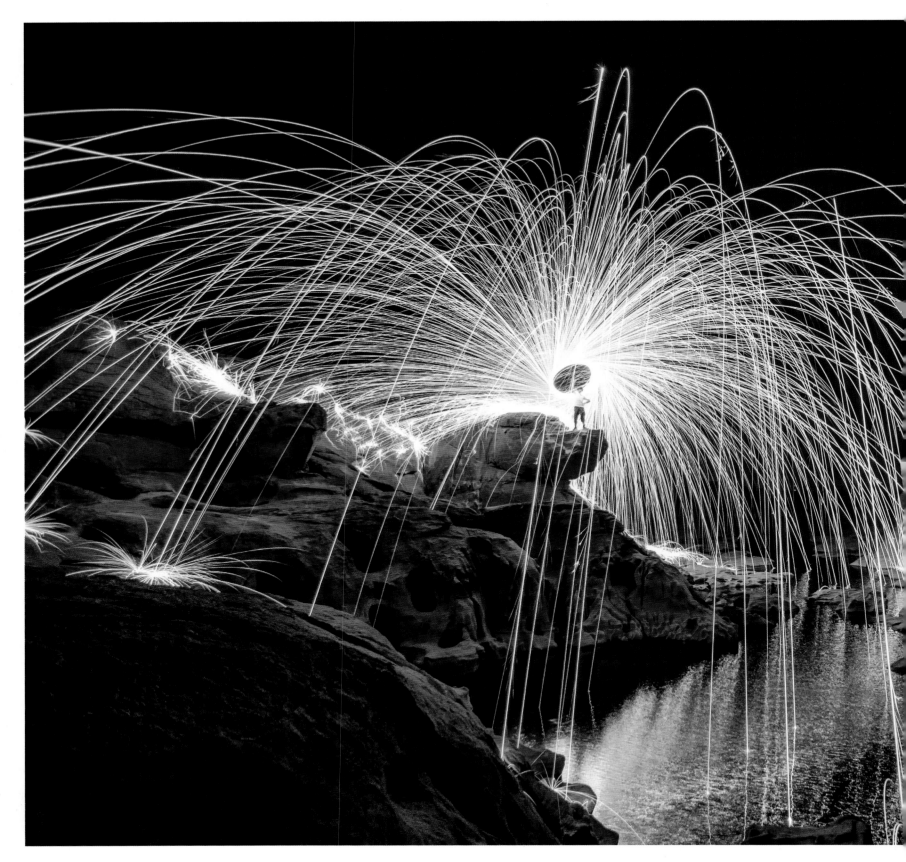

LEFT: **UBON RATCHATHANI PROVINCE, THAILAND** | Fire and spinning steel wool create a fountain of light in a rock canyon. | *Korawee Ratchapakdee*

PREVIOUS PAGES: **MUNICH, GERMANY** | Riders enjoy an amusement park thrill during Oktoberfest. | *Xu Jian*

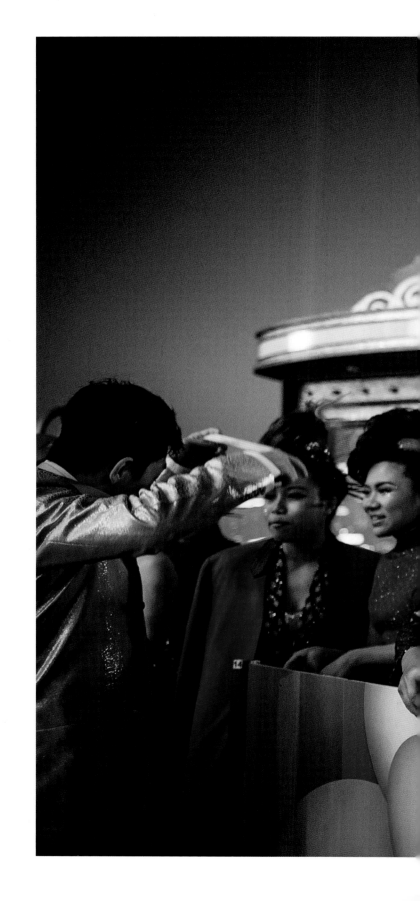

RIGHT: **HONG KONG** | Performers wait to begin the Cathay Pacific International Chinese New Year Night Parade. | *Anthony Kwan*

FOLLOWING PAGES: **YELLOWSTONE NATIONAL PARK** | Wispy mists from hot springs take on a blue hue under a starry sky. | *Ken Geiger*

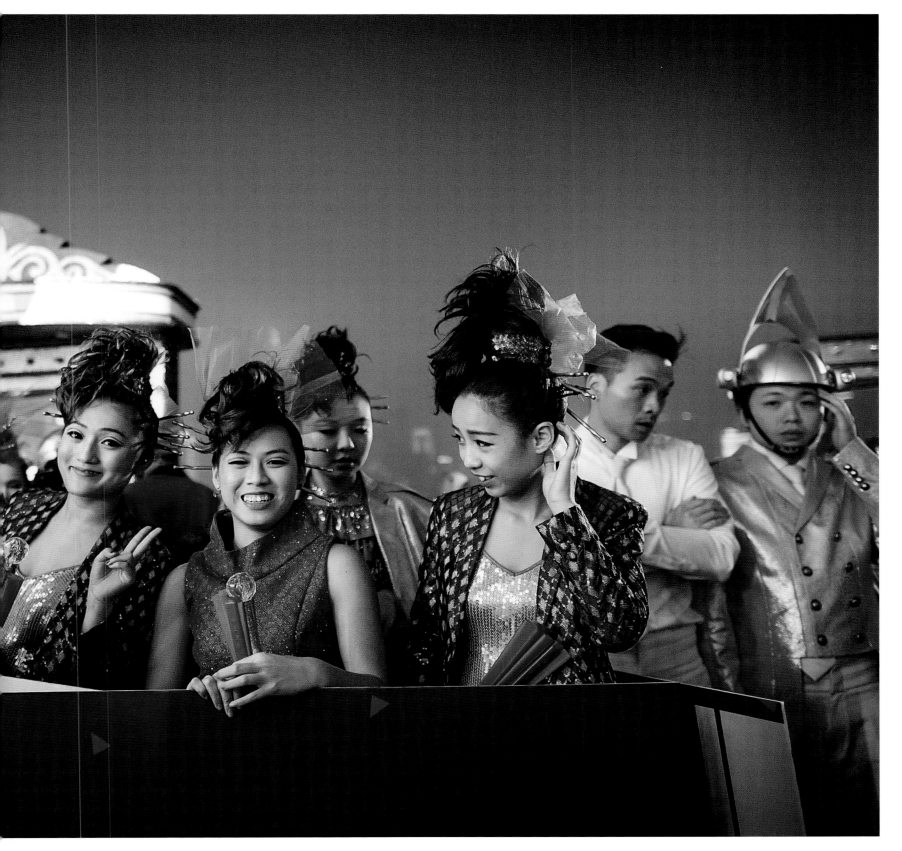

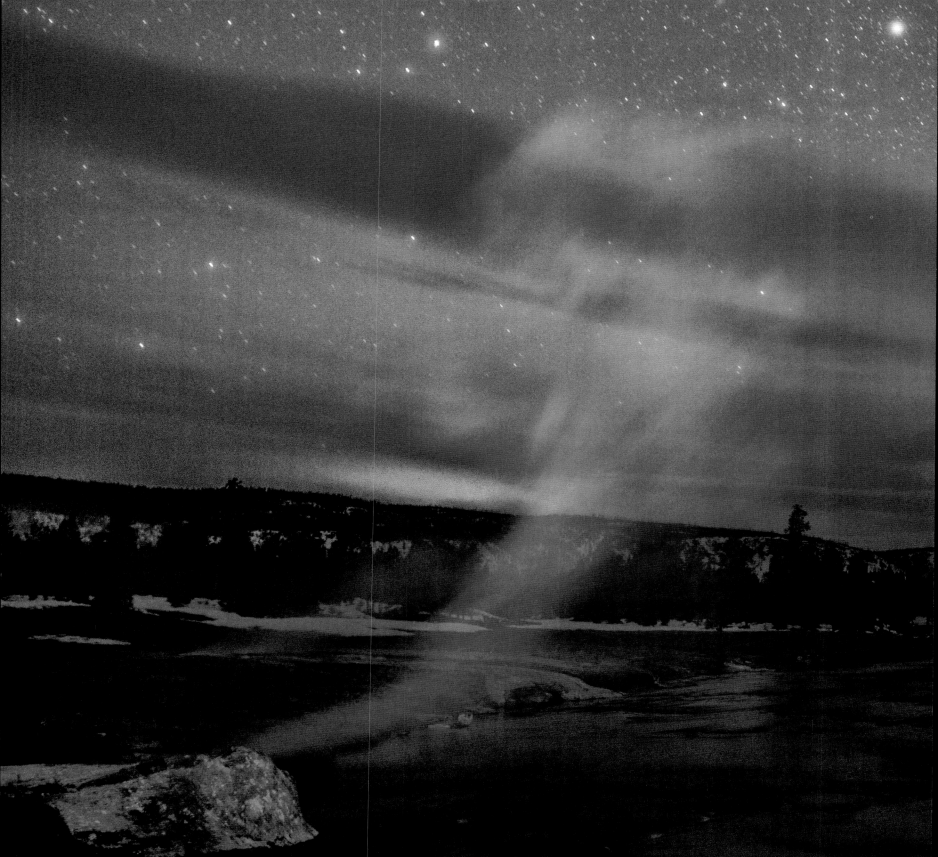

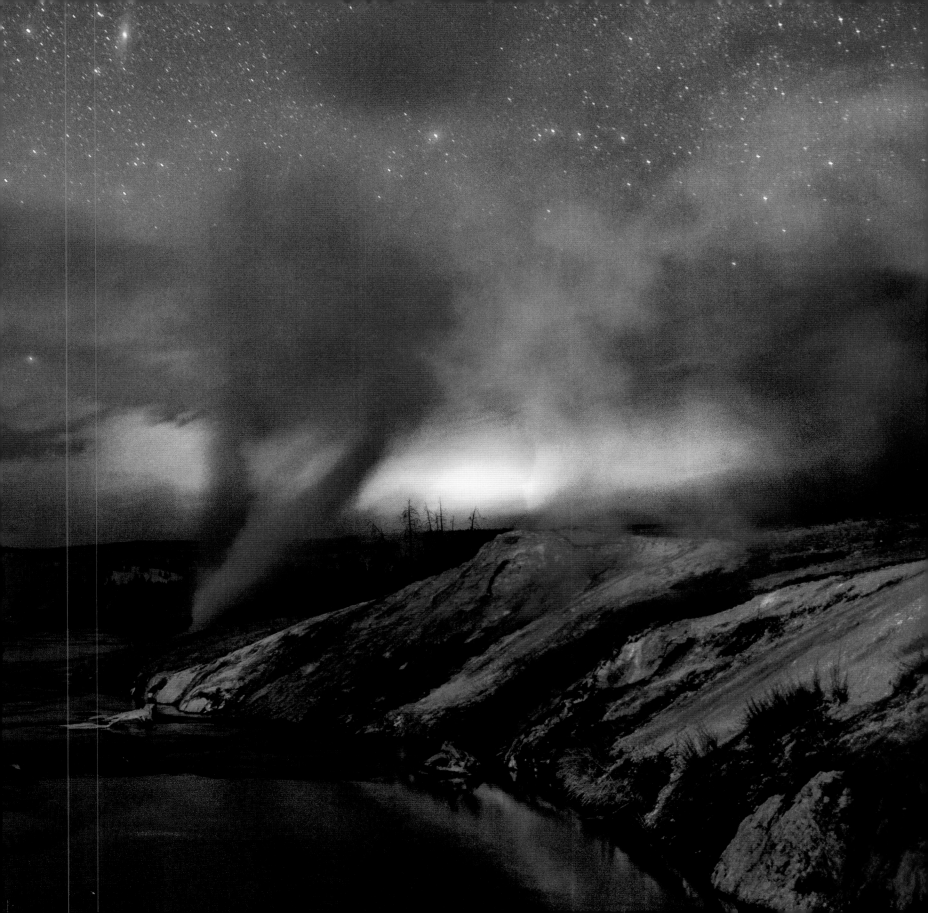

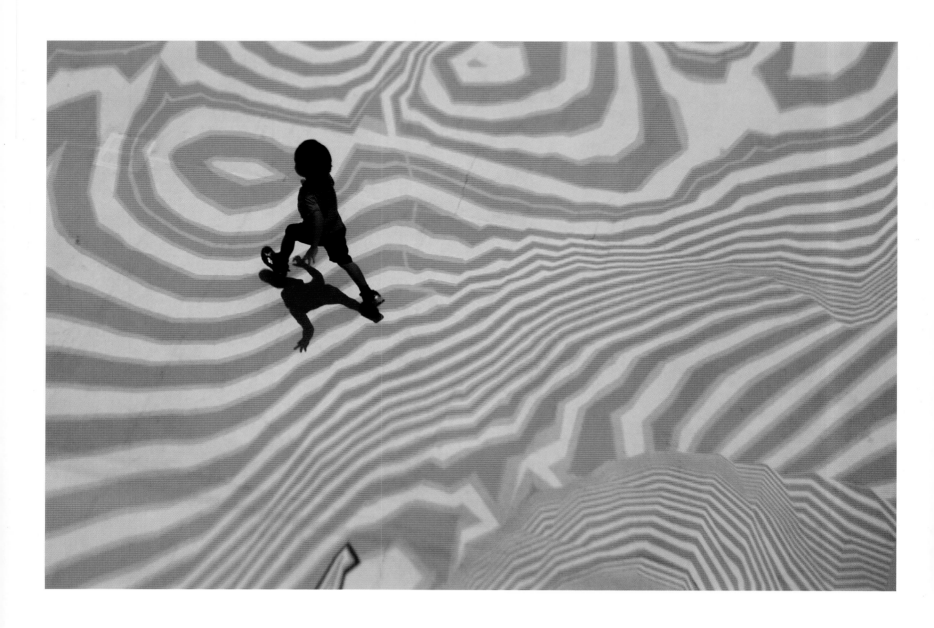

SINGAPORE | A young boy runs across an interactive light display created by
Miguel Chevalier, Carolyn Kan, and the fashion design label Depression
at the Singapore Night Festival. | *Roslan Rahman*

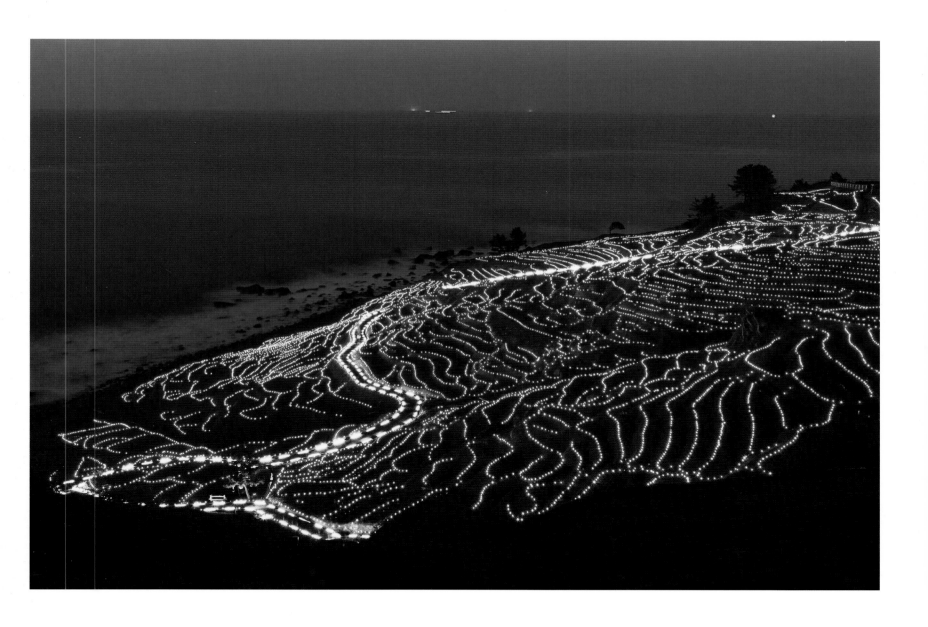

JAPAN | Illuminated pink lines on a terraced rice field
rise above a dark shoreline. | *Amana Images*

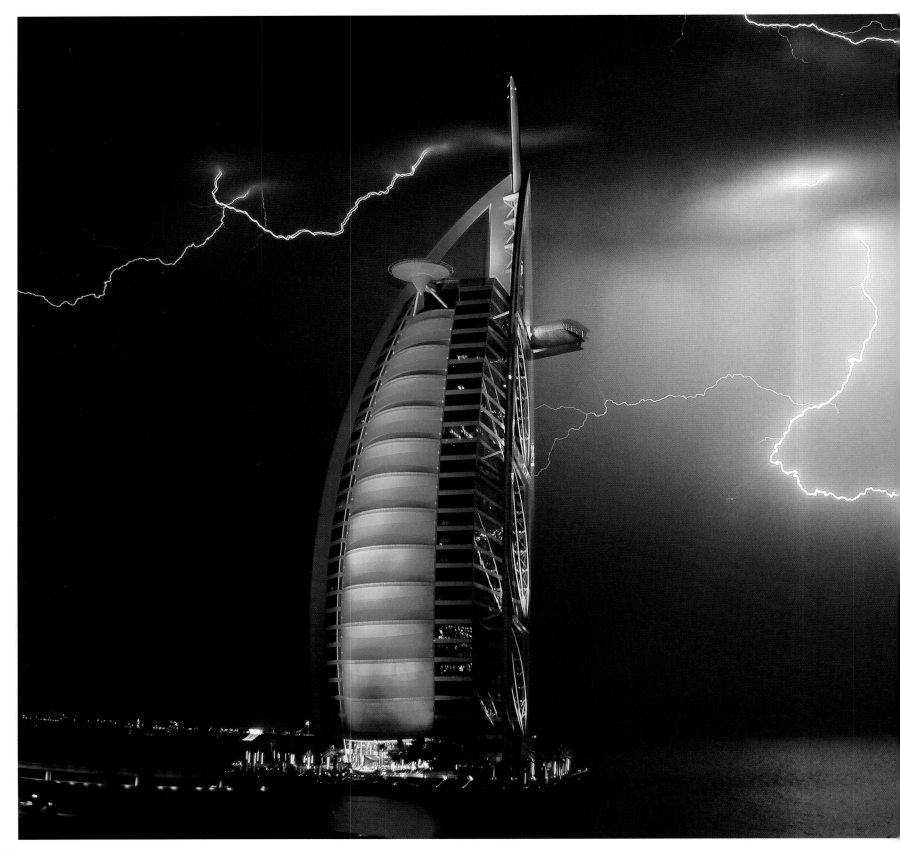

DUBAI, UNITED ARAB EMIRATES | The Burj Al Arab Jumeirah hotel appears like a sail in the middle of a lightning storm. | *Maxim Shatrov*

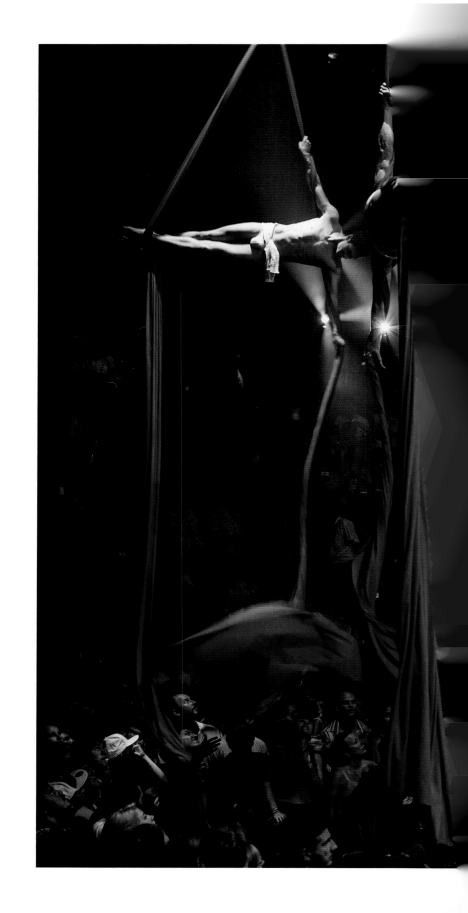

CANCÚN, MEXICO | Aerial artists twirl on red ribbons
as they entertain nightclub patrons. | *João Canziani*

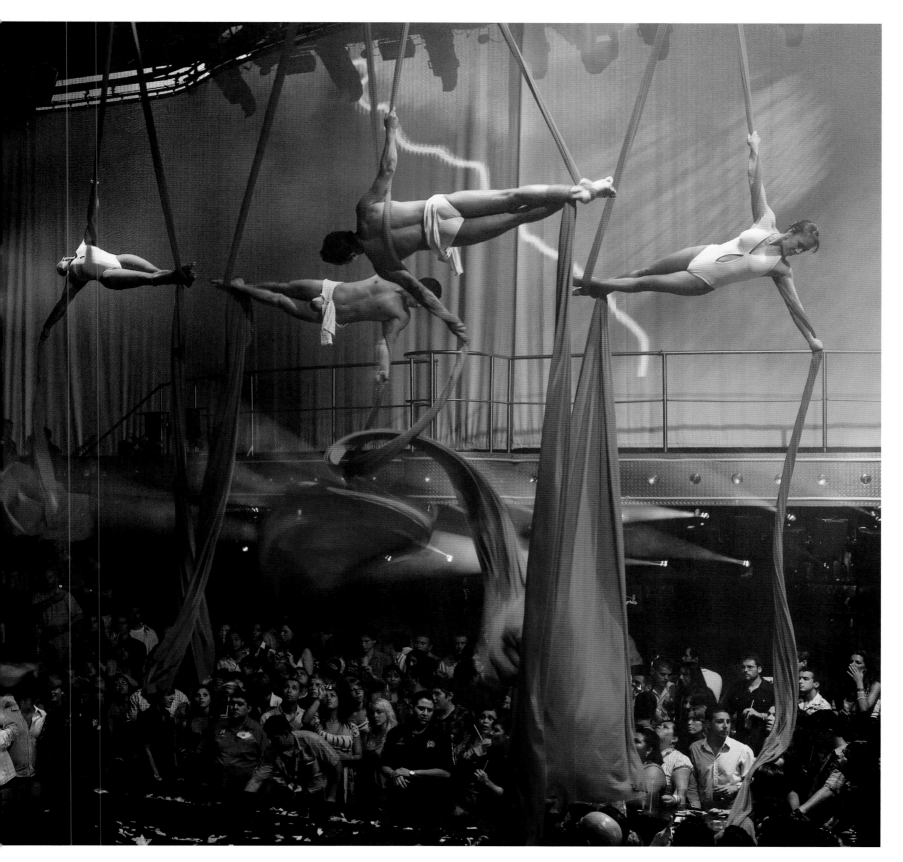

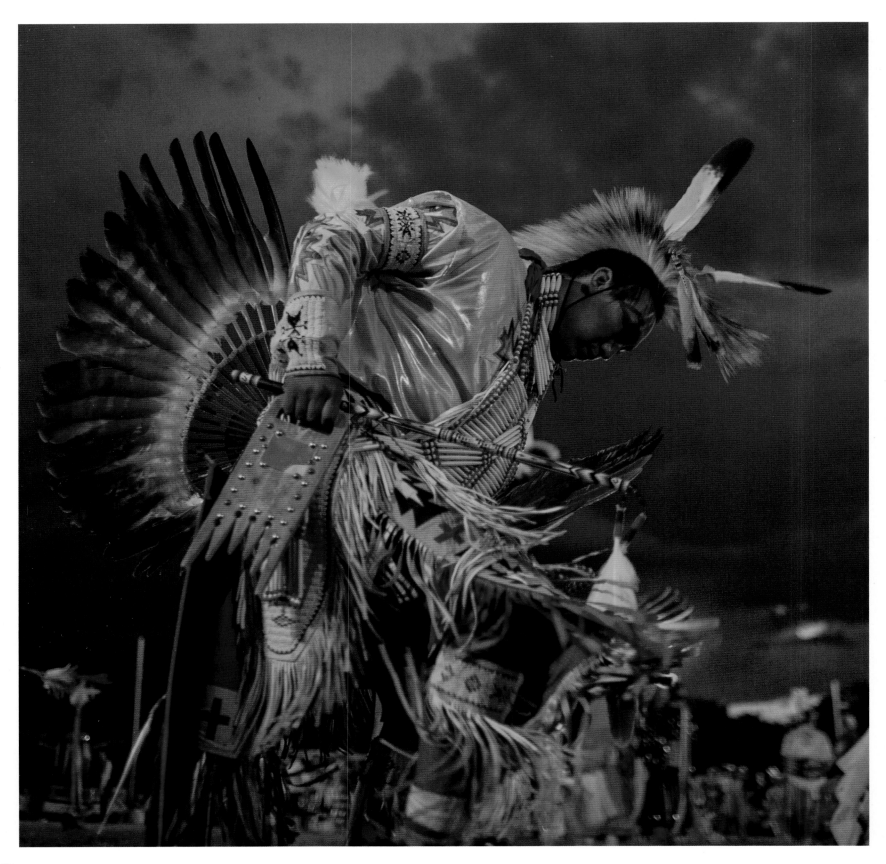

"NIGHT, THE BELOVED. NIGHT, WHEN WORDS FADE AND THINGS COME ALIVE . . . AND ALL THAT IS TRULY IMPORTANT BECOMES WHOLE AND SOUND AGAIN.

—ANTOINE DE SAINT-EXUPÉRY

OPPOSITE: **PINE RIDGE INDIAN RESERVATION, SOUTH DAKOTA** | Traditional dancers perform at an Oglala Lakota Nation powwow. | *Aaron Huey*

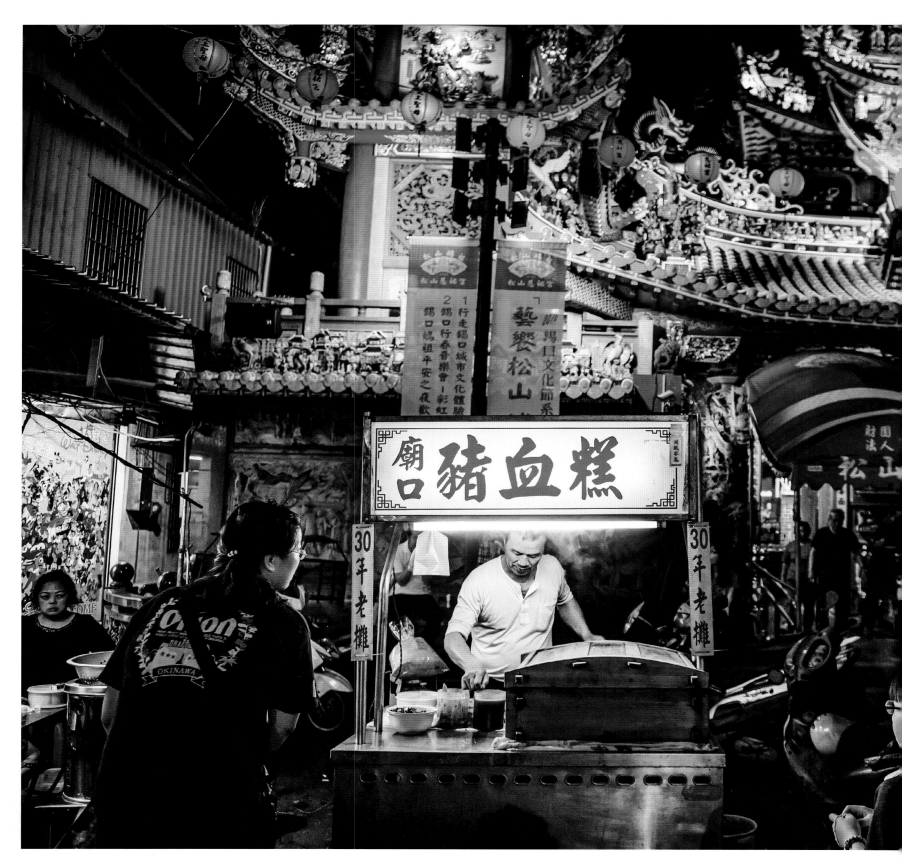

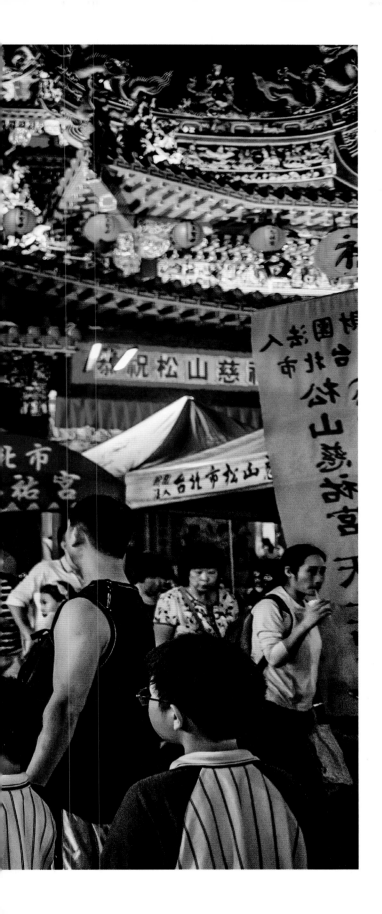

LEFT: TAIPEI, TAIWAN, CHINA | The streets fill with hungry people during the Raohe Street Night Market. | *Dina Litovsky*

FOLLOWING PAGES: NEW SOUTH WALES, AUSTRALIA | A wave curls back into the dark ocean. | *Ray Collins*

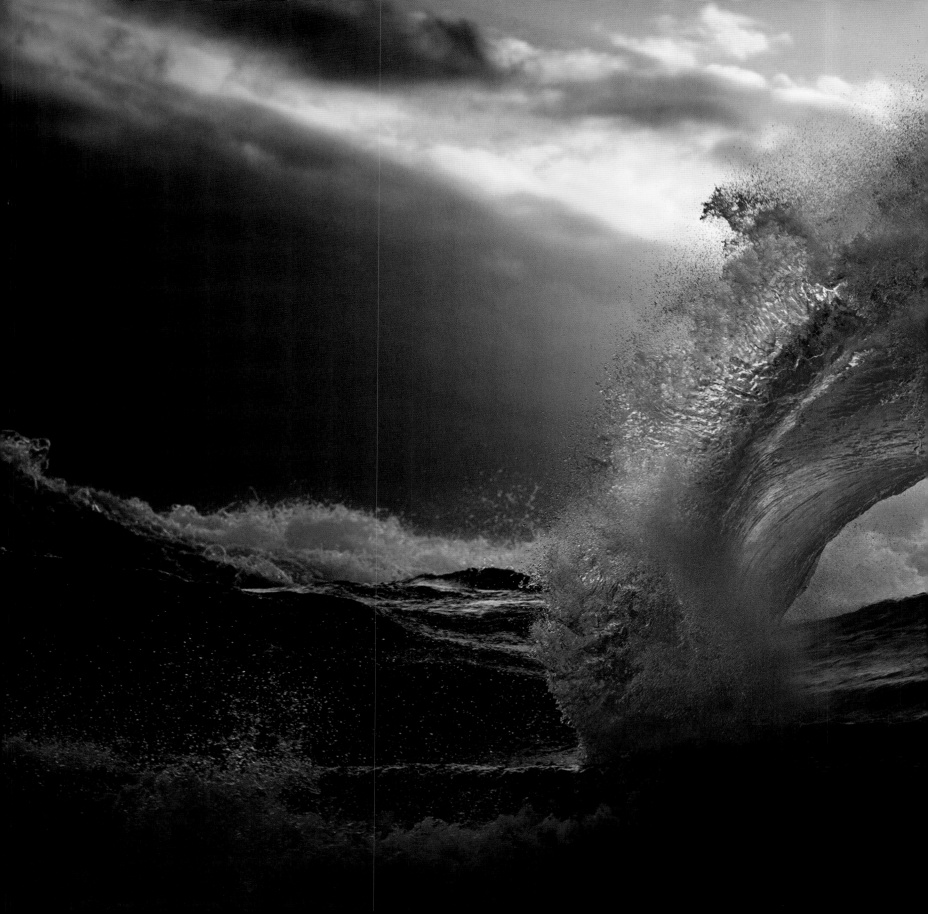

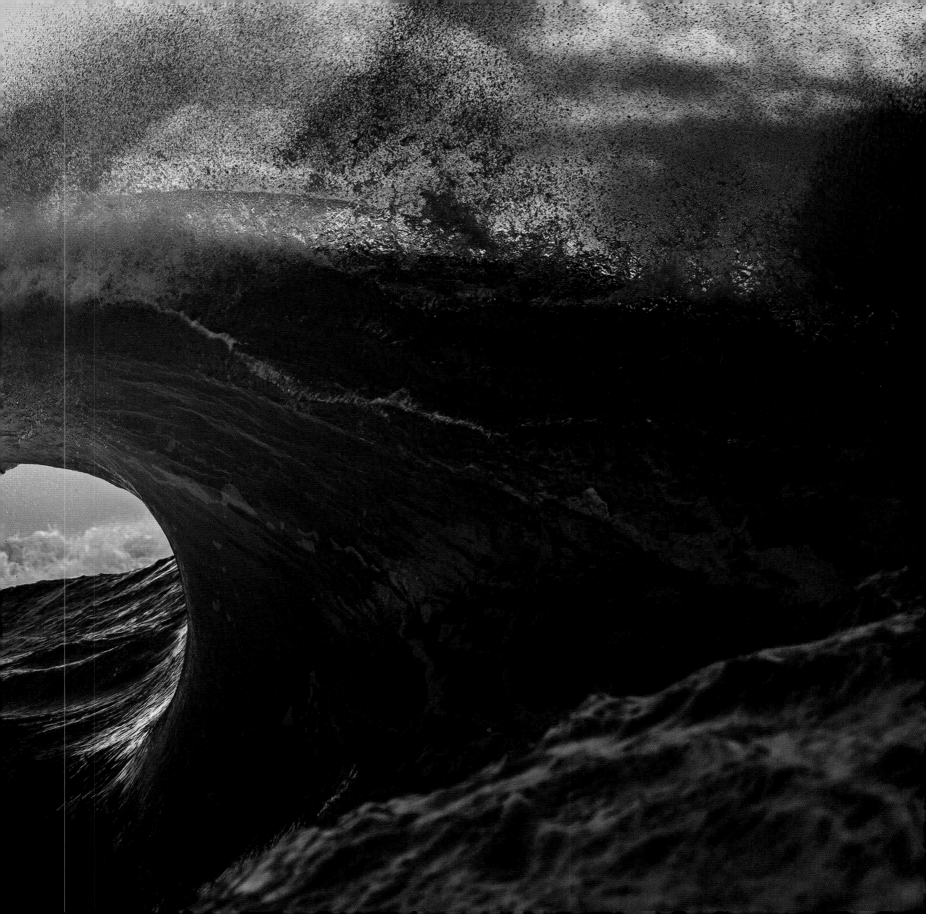

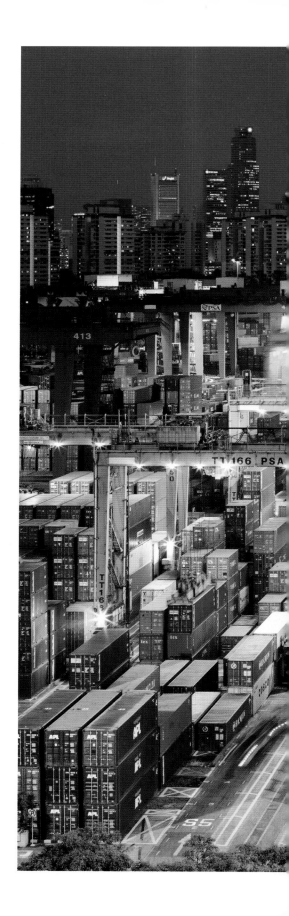

SINGAPORE | Streetlights illuminate shipping containers
at the Port of Singapore. | *Justin Guariglia*

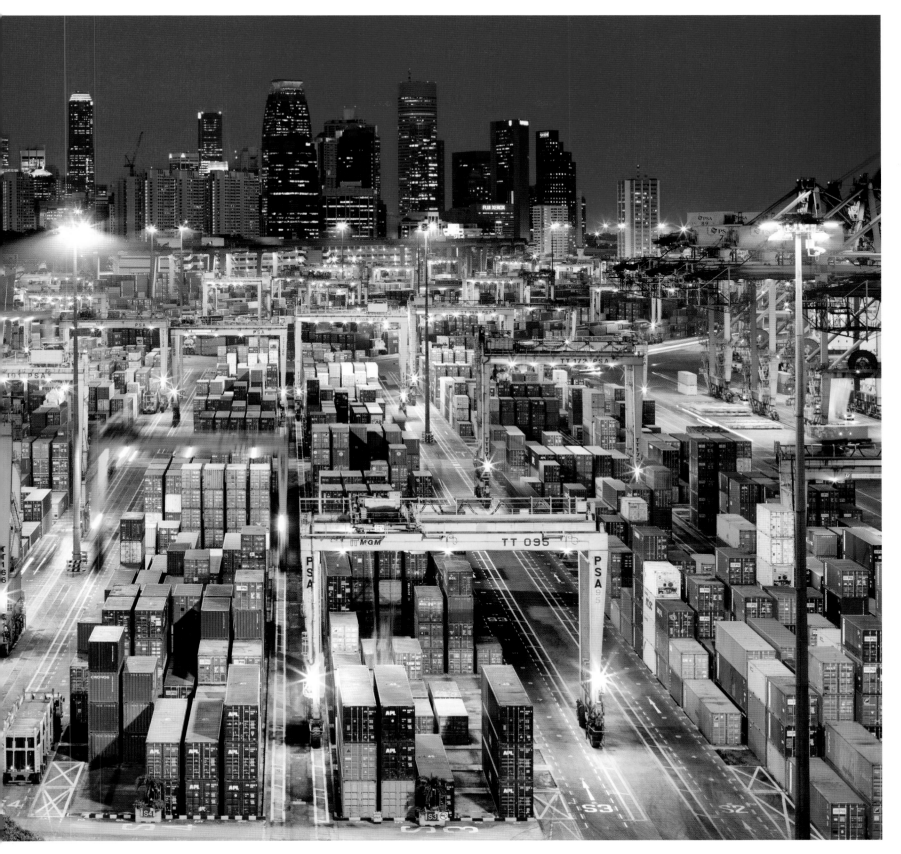

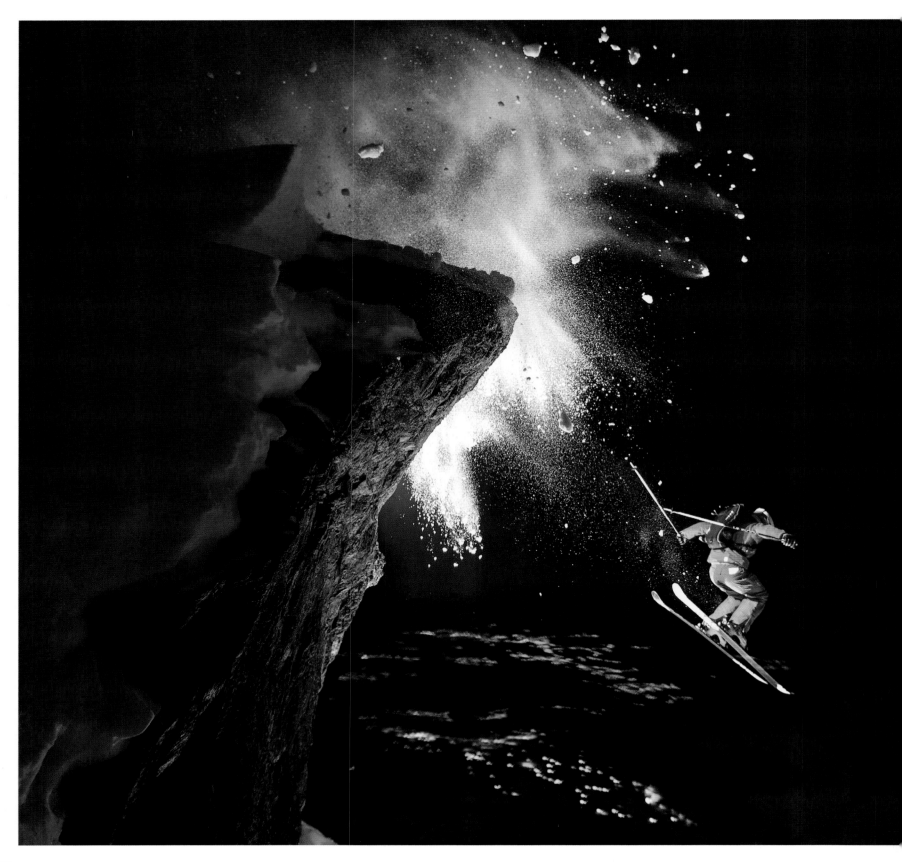

CHANDOLIN, SWITZERLAND | As the lights of the city stretch below, a skier takes to the air. | *Christoph Jorda*

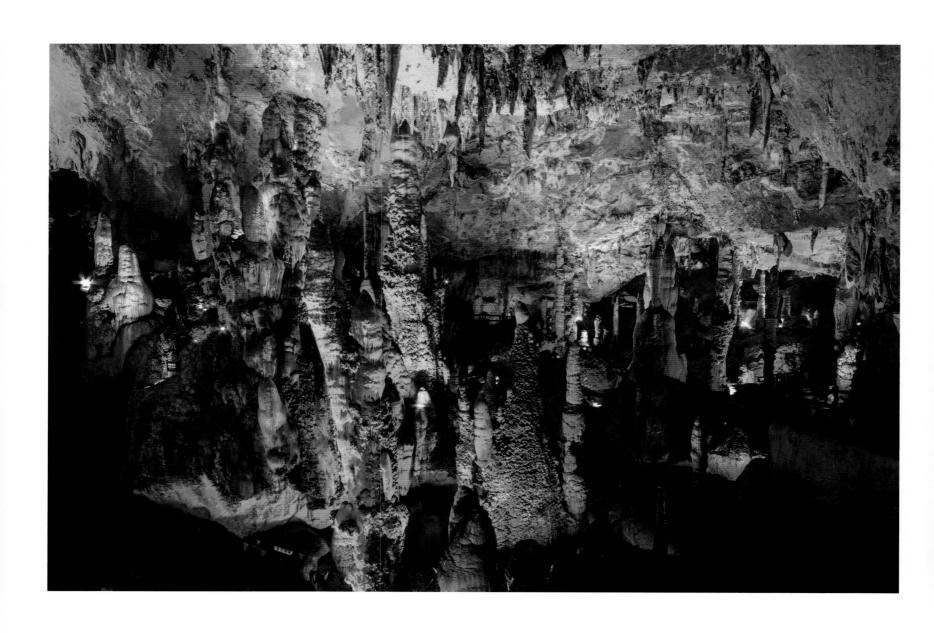

JIUJIANG CAVE, CHINA | Colored lights shine on stalactites and stalagmites
in a karst cave, creating an out-of-this-world scene. | *ImpaKPro*

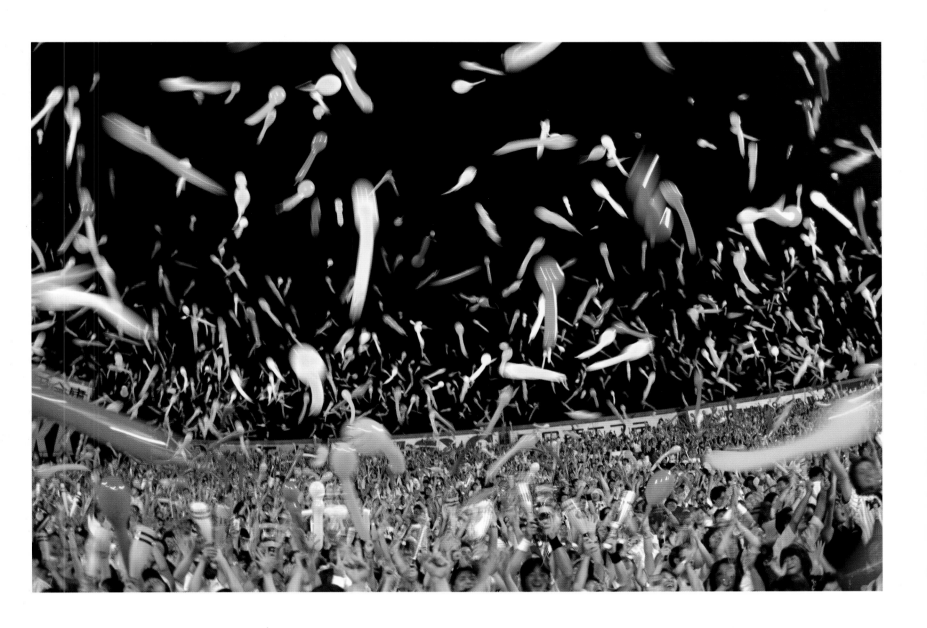

NISHINOMIYA, JAPAN | Baseball fans at Hanshin Koshien Stadium
celebrate the game with colorful balloons. | *Robert Essel*

BURNABY, BRITISH COLUMBIA, CANADA | Looking for prey,
a female barred owl swoops through a forest. | *Connor Stefanison*

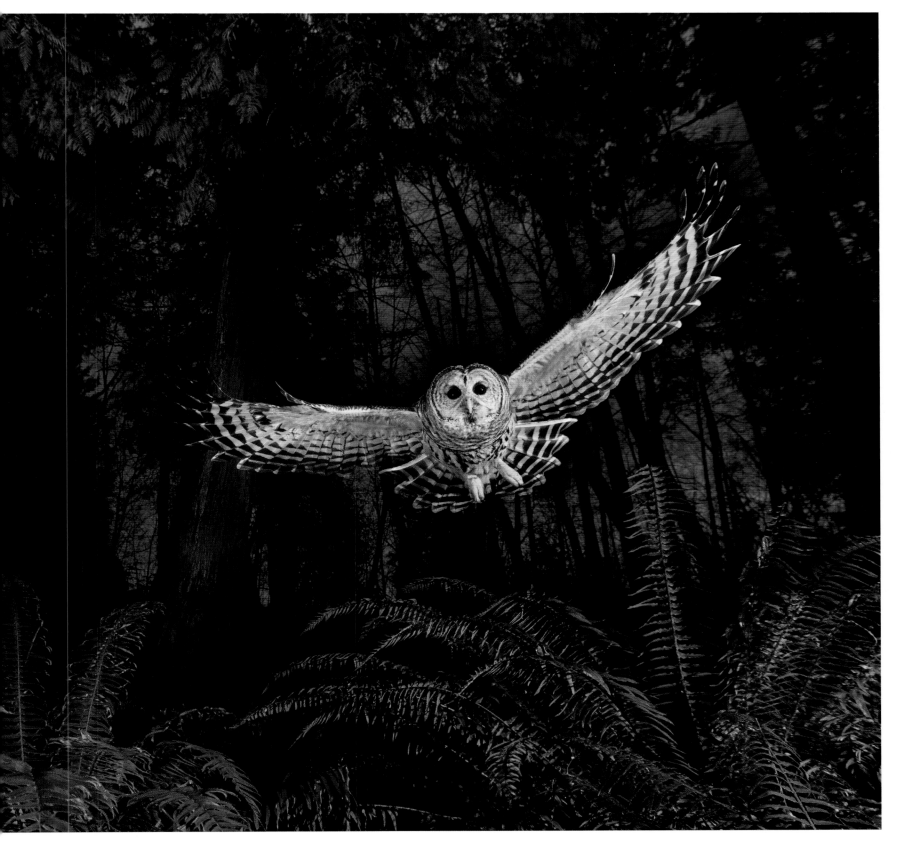

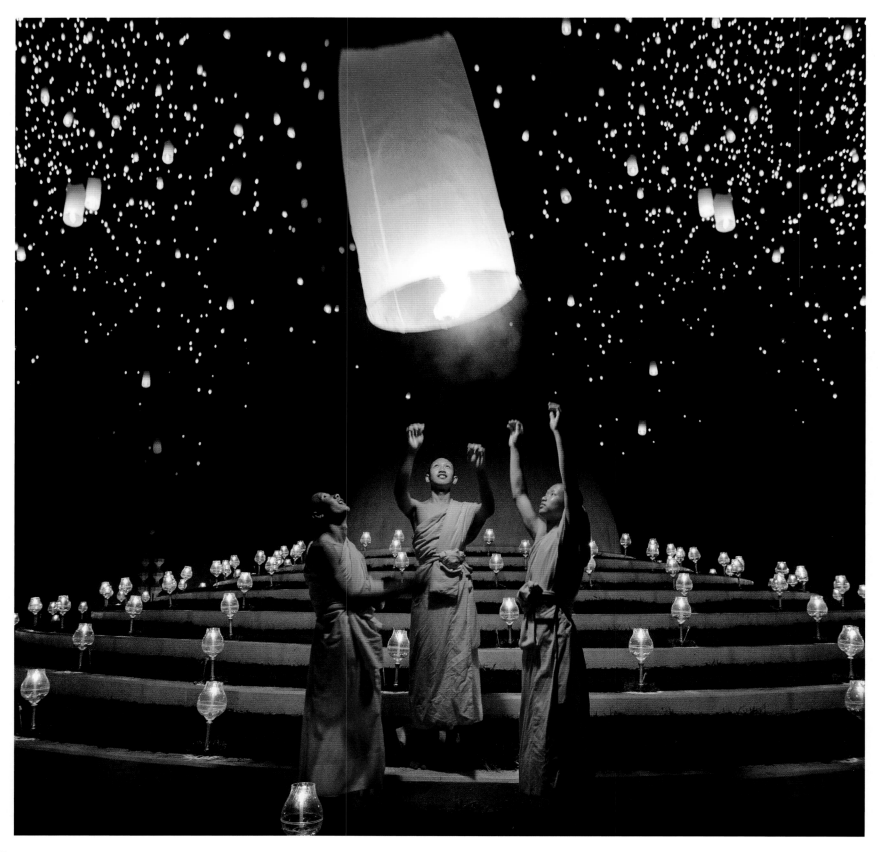

"O RADIANT DARK!
O DARKLY FOSTERED RAY!
THOU HAST A JOY TOO DEEP
FOR SHALLOW DAY.

—GEORGE ELIOT

OPPOSITE: CHIANG MAI, THAILAND | Monks release a lantern
to join the hundreds of others dotting the sky during a festival. | *Franciscus Tran*

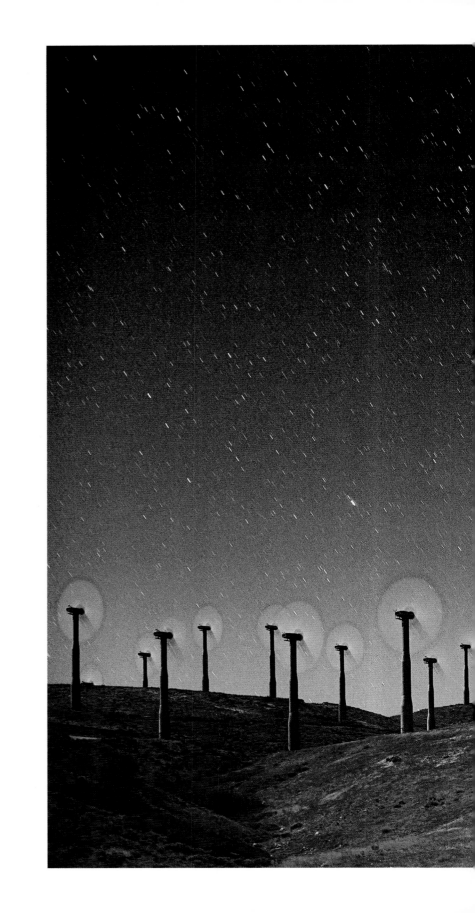

TEHACHAPI, CALIFORNIA | The blades of wind turbines
look like spinning discs in this long exposure. | *Jeff Kroeze*

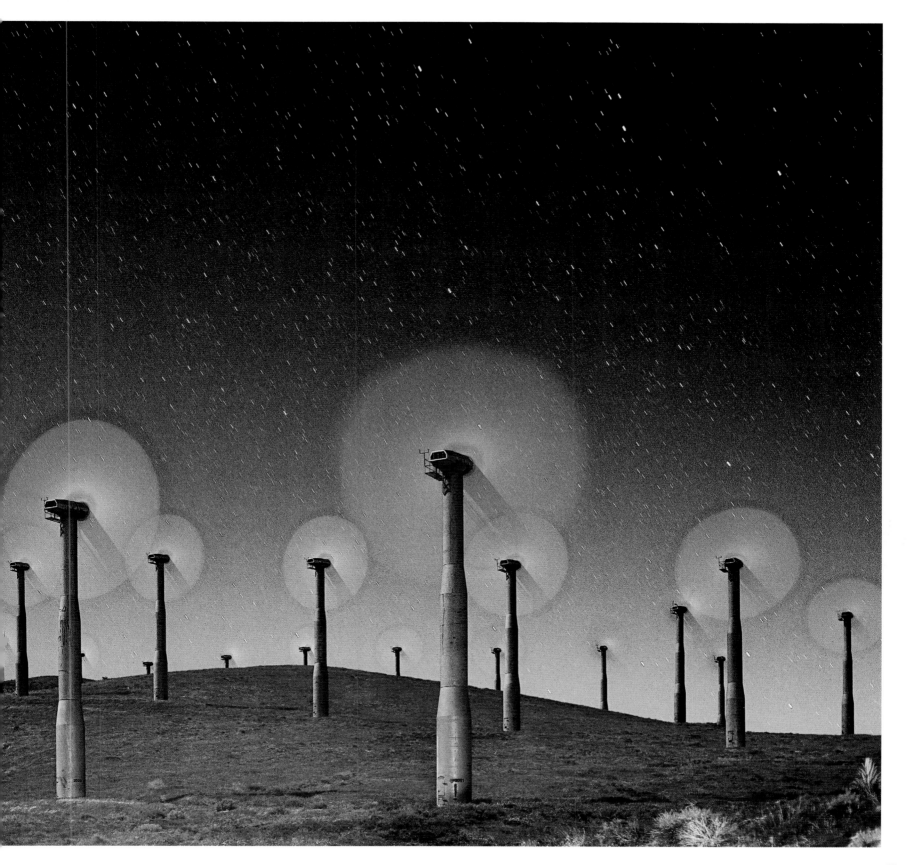

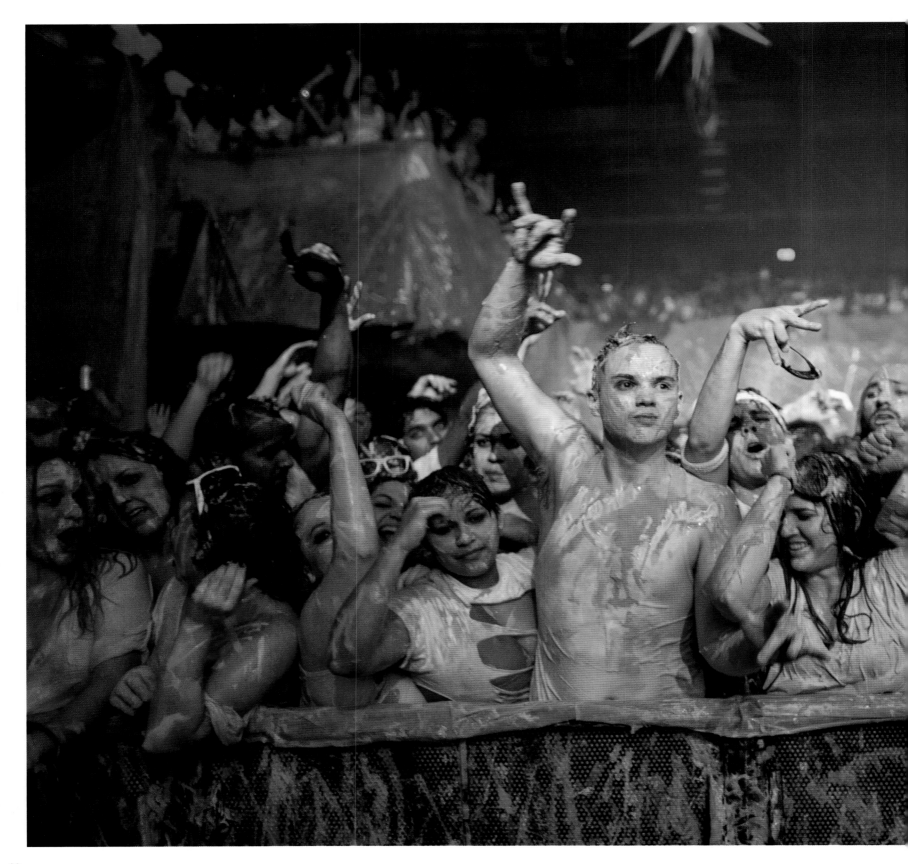

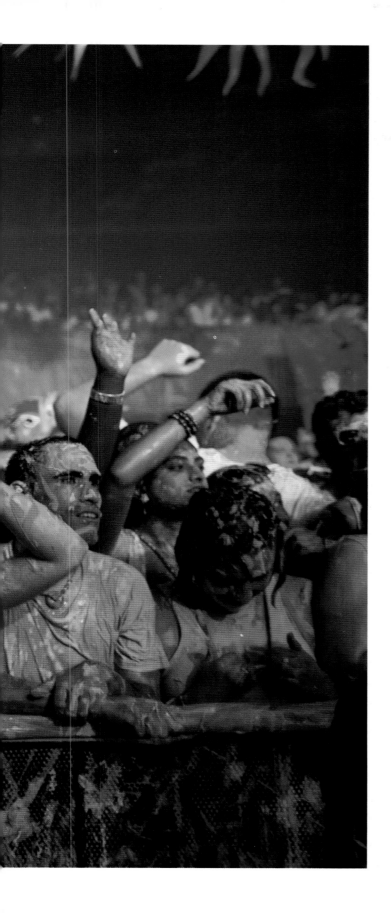

LEFT: **AUSTIN, TEXAS** | Teenagers dance while doused in neon paints at the Dayglow Music Festival. | *Kitra Cahana*

FOLLOWING PAGES: **OKAVANGO, BOTSWANA** | A leopard runs under the cover of darkness in the Khwai Concession. | *Sergio Pitamitz*

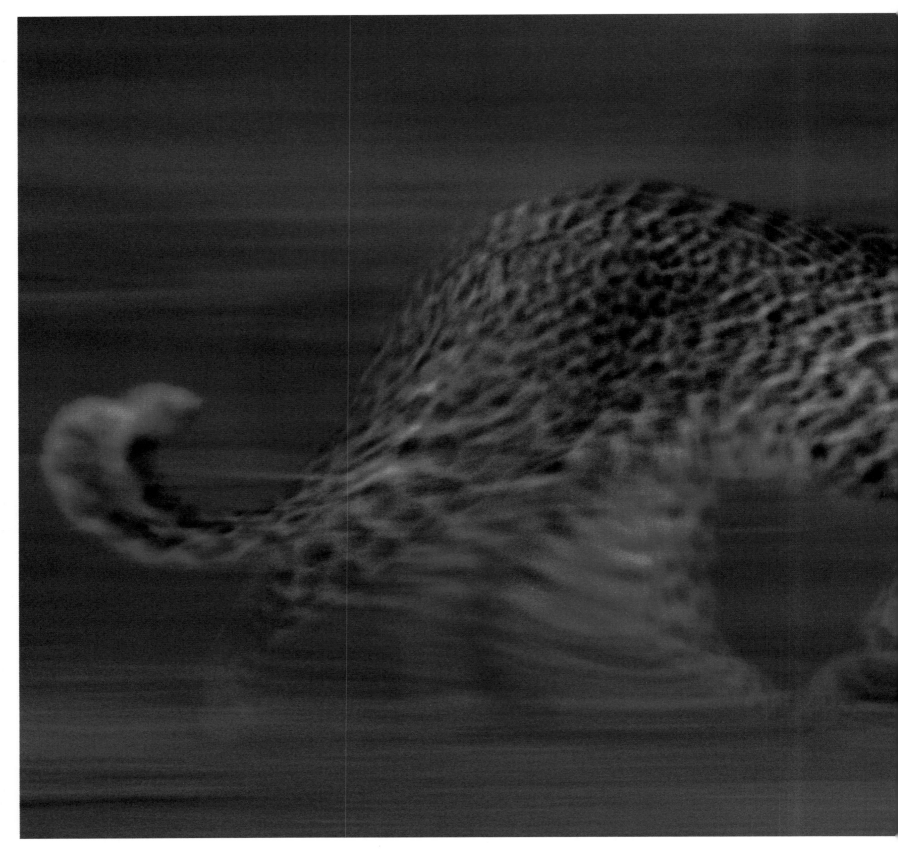

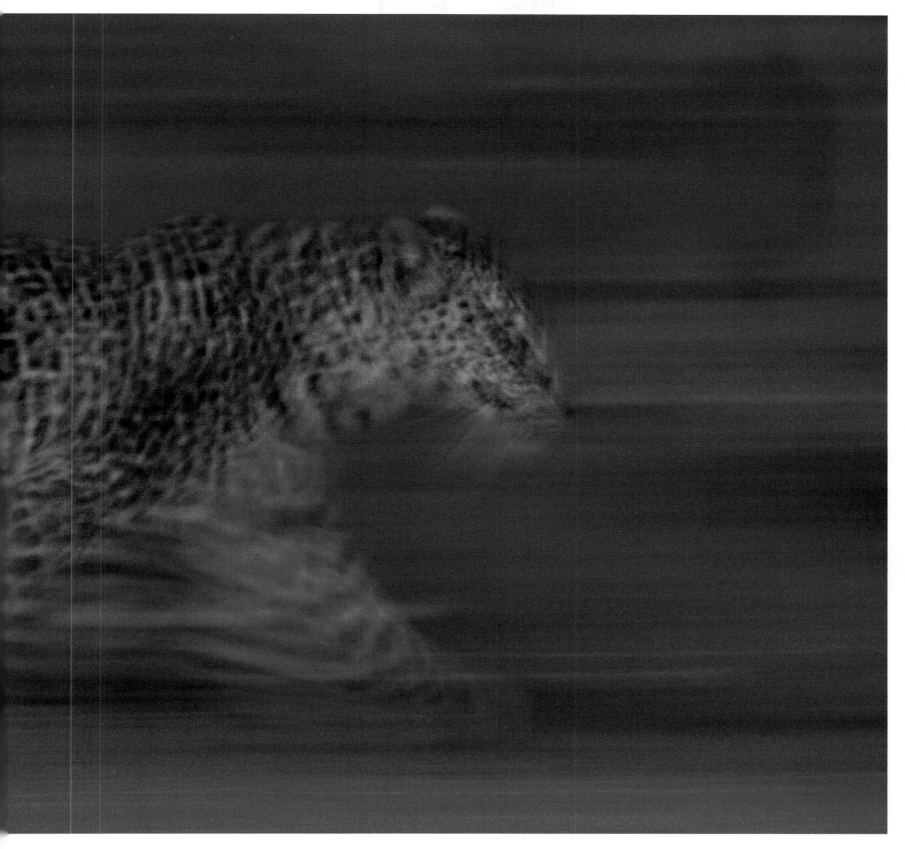

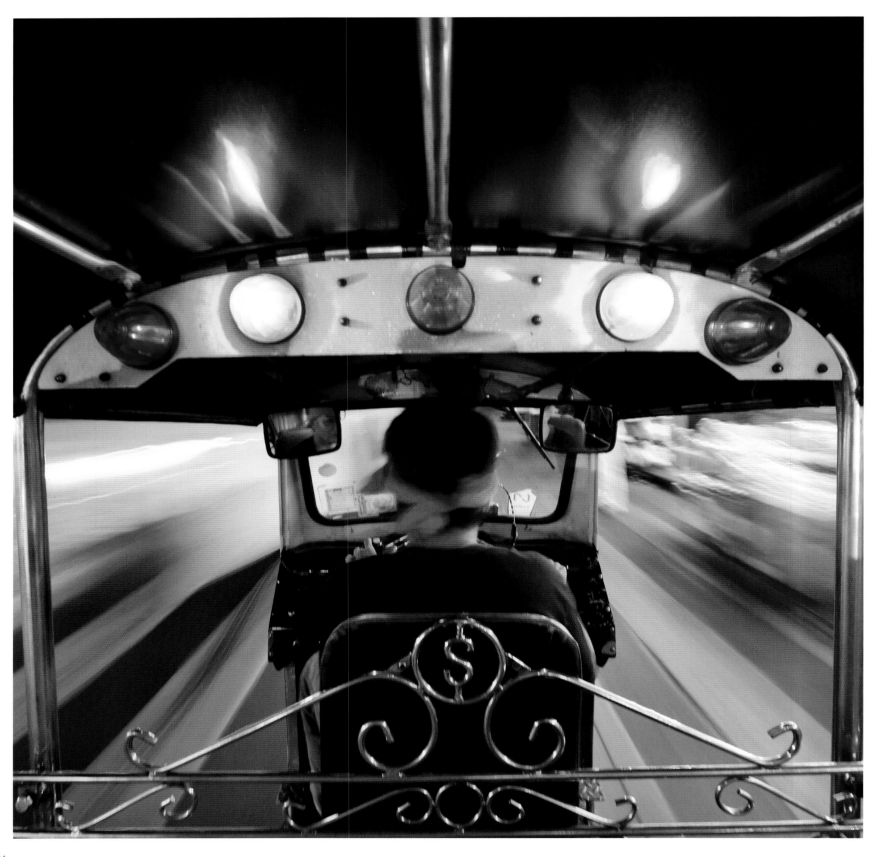

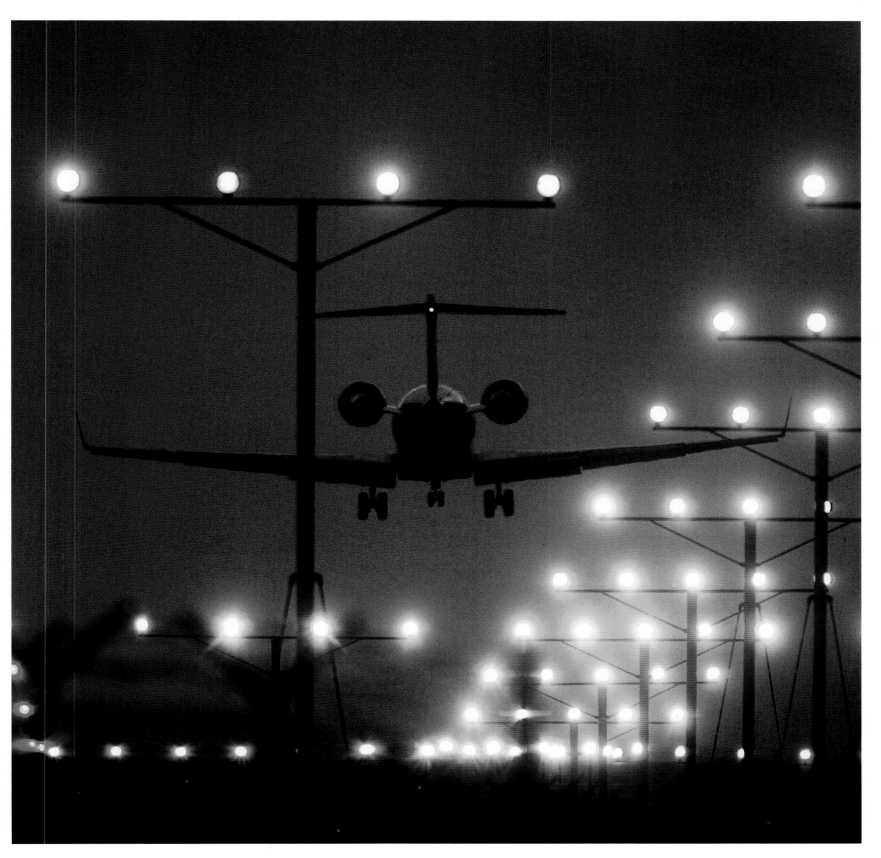

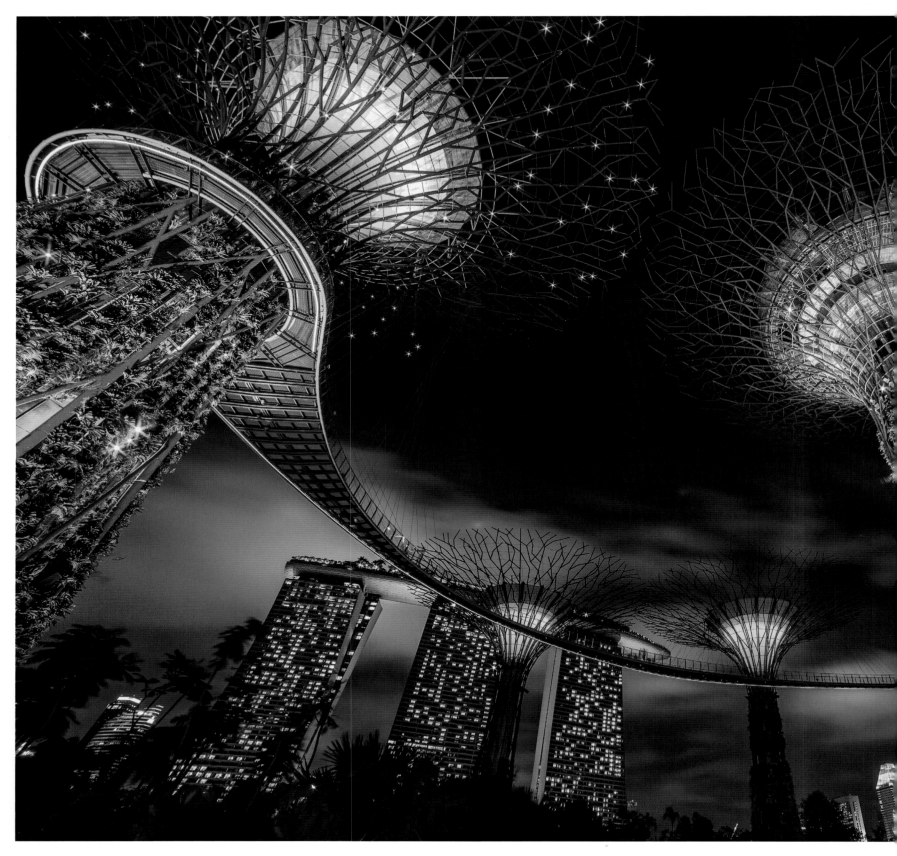

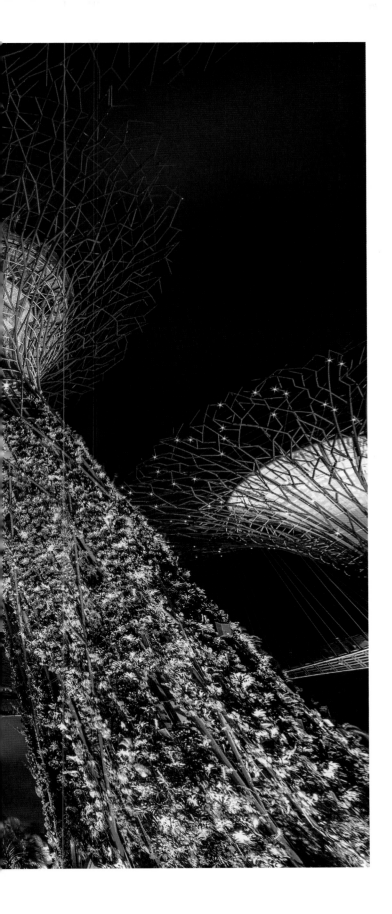

LEFT: SINGAPORE | At night the vertical electric gardens of the supertree grove at the botanical park Gardens by the Bay come alive with light and sound. | *Peter Stewart*

PAGE 84: BANGKOK, THAILAND | An auto rickshaw flies through the city streets. | *Gavin Hellier*

PAGE 85: LOS ANGELES, CALIFORNIA | Lights on a runway at Los Angeles International Airport guide a jet to landing. | *David McNew*

"FOR THE HAPPIEST LIFE, RIGOROUSLY PLAN YOUR DAYS, LEAVE YOUR NIGHTS OPEN TO CHANCE.

—MIGNON McLAUGHLIN

OPPOSITE: **MOSCOW, RUSSIA** | A fire dancer spins two handles of flame at a club. | *Gerd Ludwig*

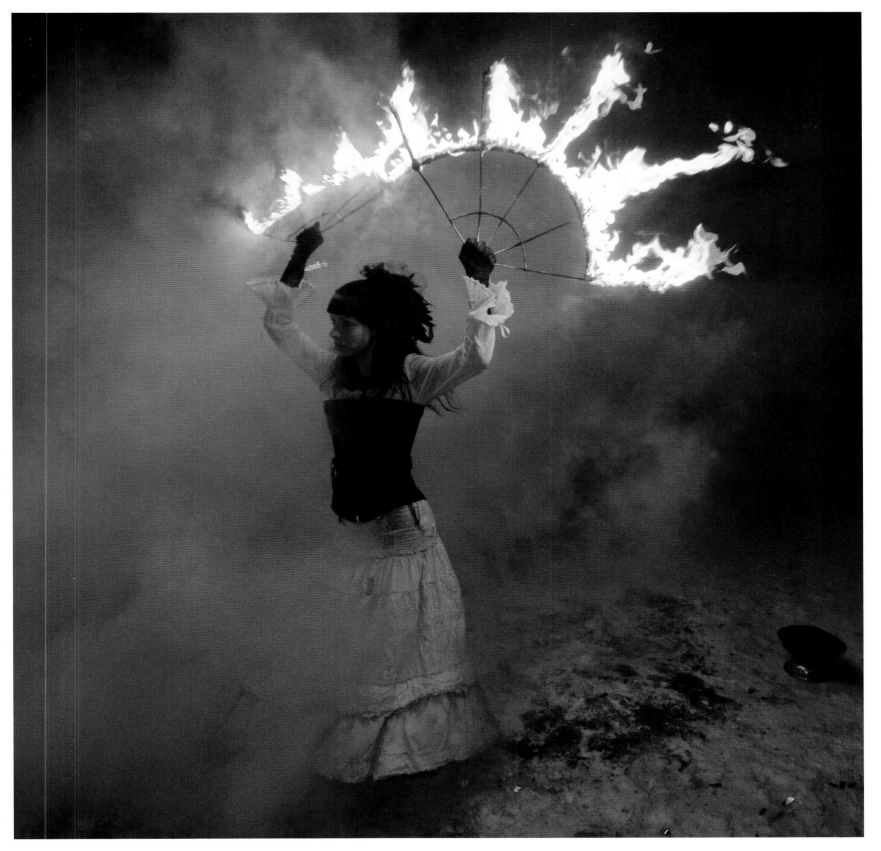

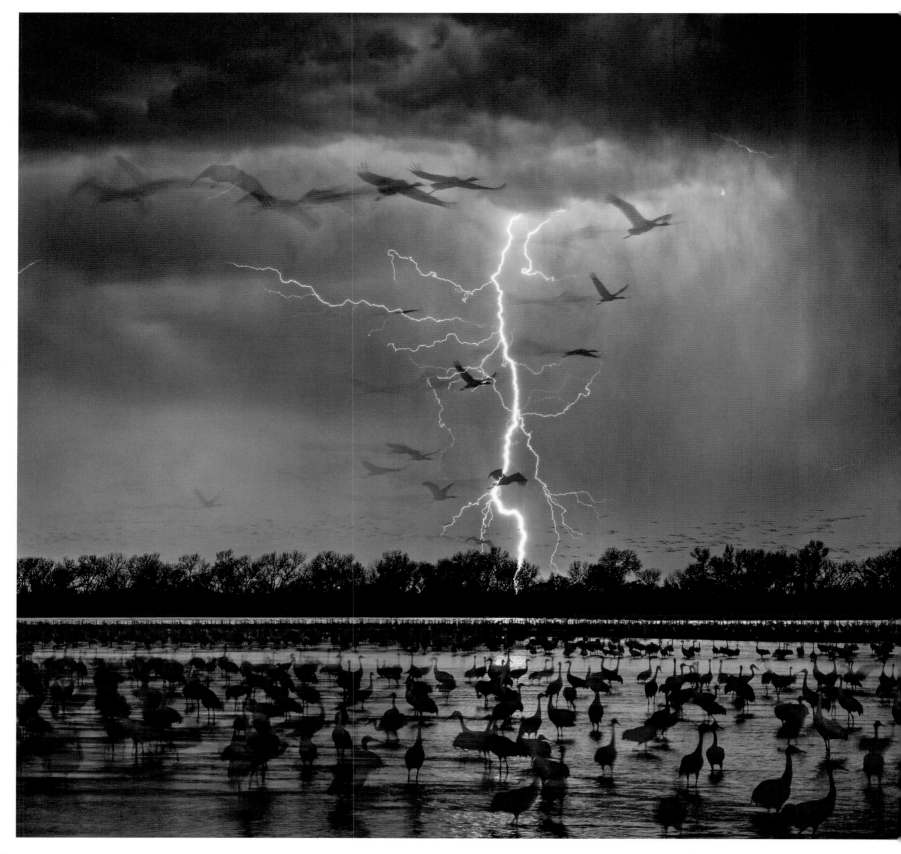

PLATTE RIVER, NEBRASKA | Thousands of sandhill cranes congregate
on the Platte River during their annual spring migration. | *Randy Olson*

RIGHT: NEW YORK, NEW YORK | The windows of a taxi reflect an American flag. | *Ira Block*

FOLLOWING PAGES: RISHIKESH, INDIA | Hindus gather on the banks of the Ganges River during the nightly arti, a celebration of light that features song and fire. | *Pete McBride*

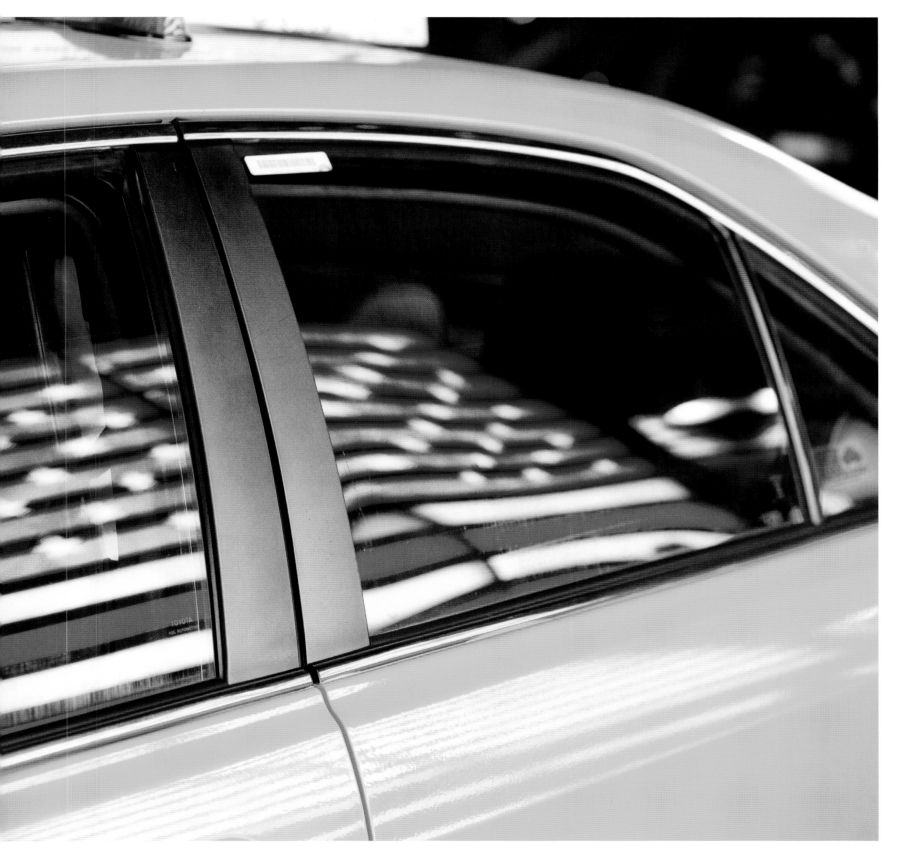

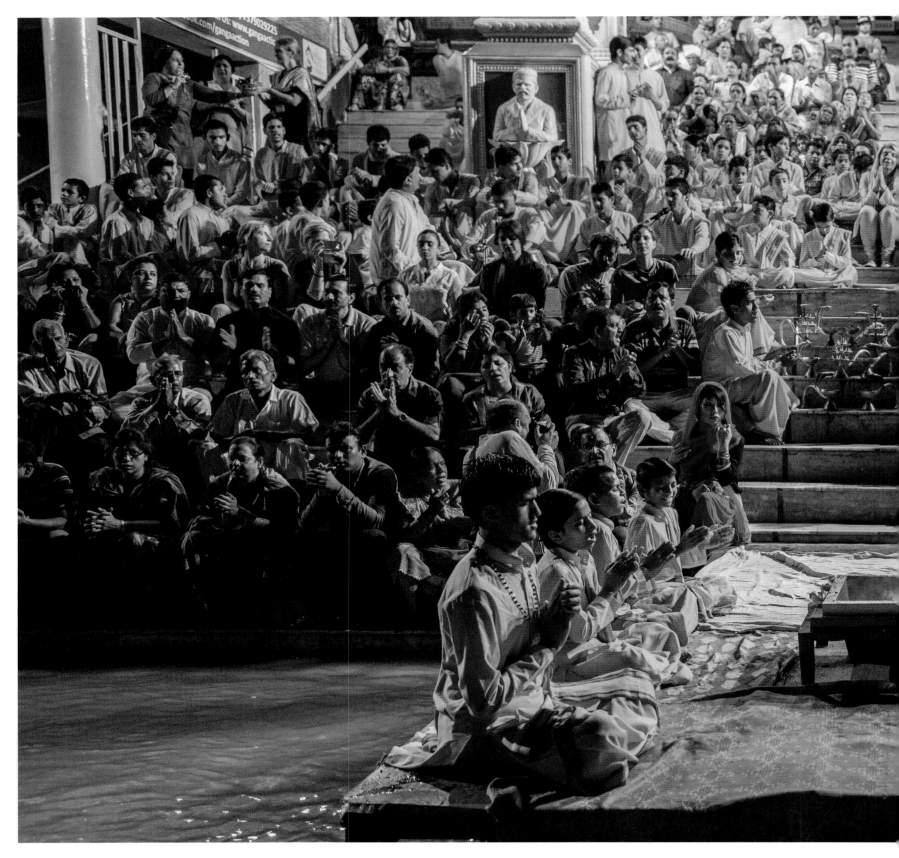

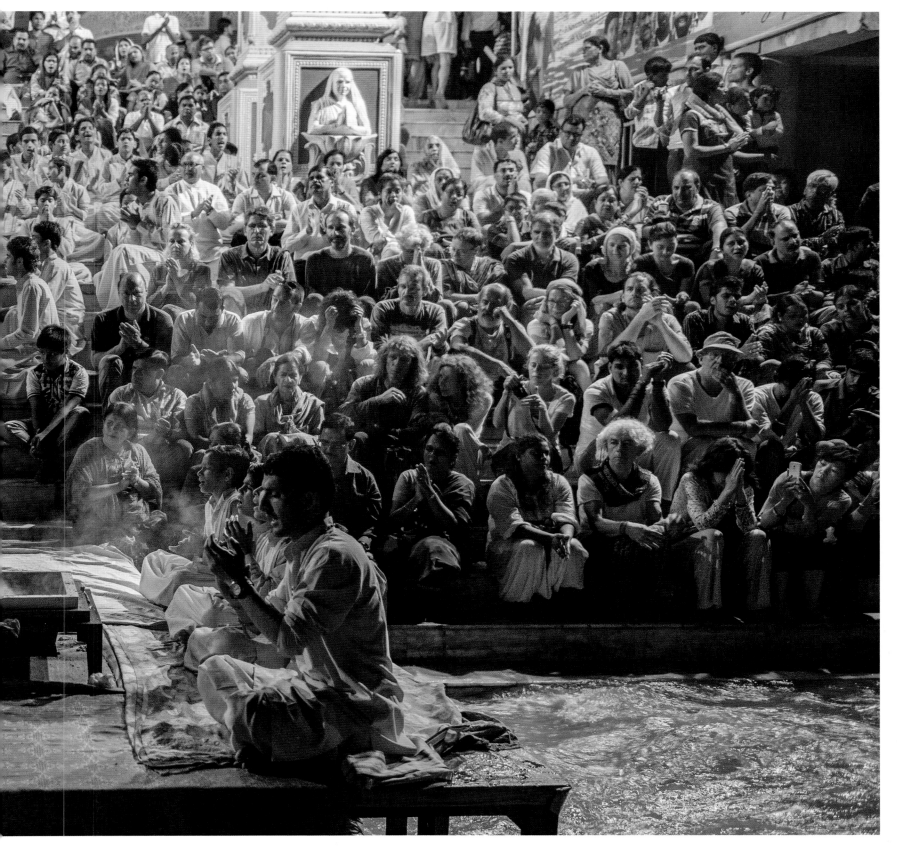

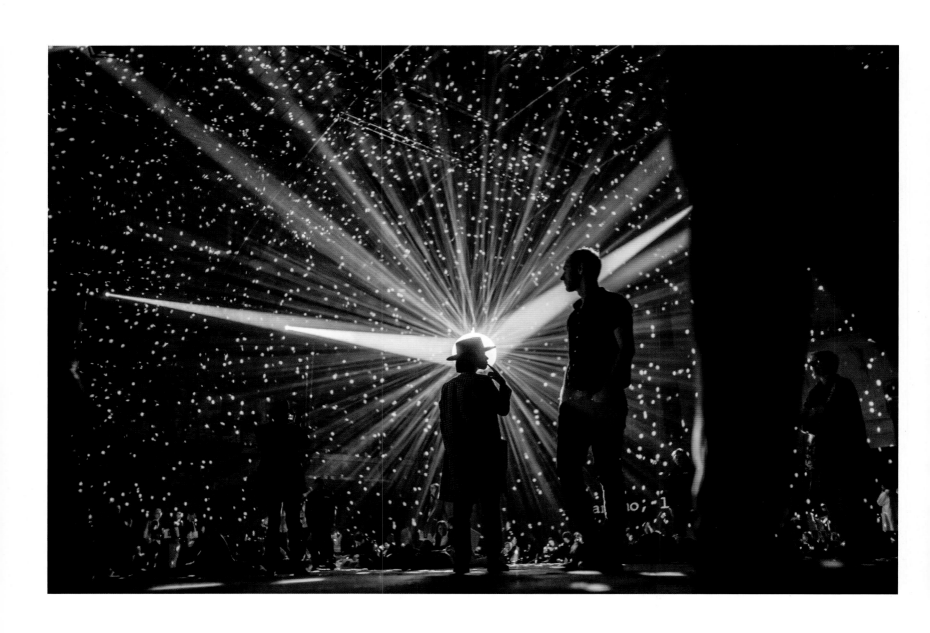

NEW YORK, NEW YORK | A crowd enjoys Laurie Anderson's installation, "Habeas Corpus" —
the story of a prisoner at Guantánamo Bay. | *Michael Christopher Brown*

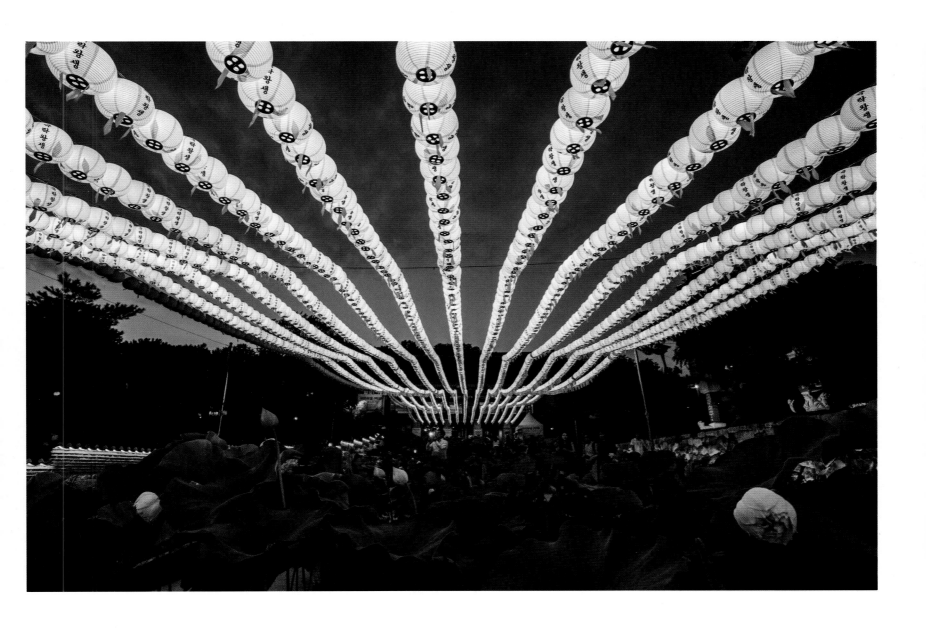

SEOUL, SOUTH KOREA | Hundreds of bright lanterns fan out overhead at Bongeunsa, a Buddhist temple. | *Ed Norton*

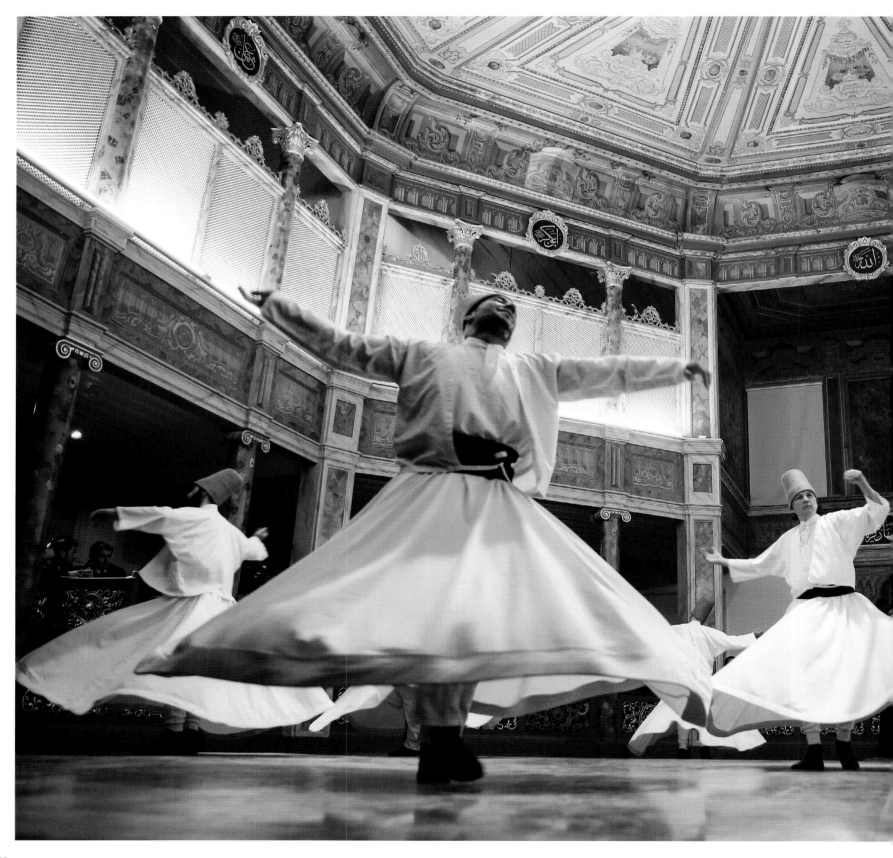

LEFT: **ISTANBUL, TURKEY** | Whirling dervishes dance during the Night of Union
ceremony at the Galata Mawlavi House Museum. | *Berk Özkan*

FOLLOWING PAGES: **DEMOCRATIC REPUBLIC OF THE CONGO** | A lava lake in
Nyiragongo glows red and orange. | *Martin Rietze*

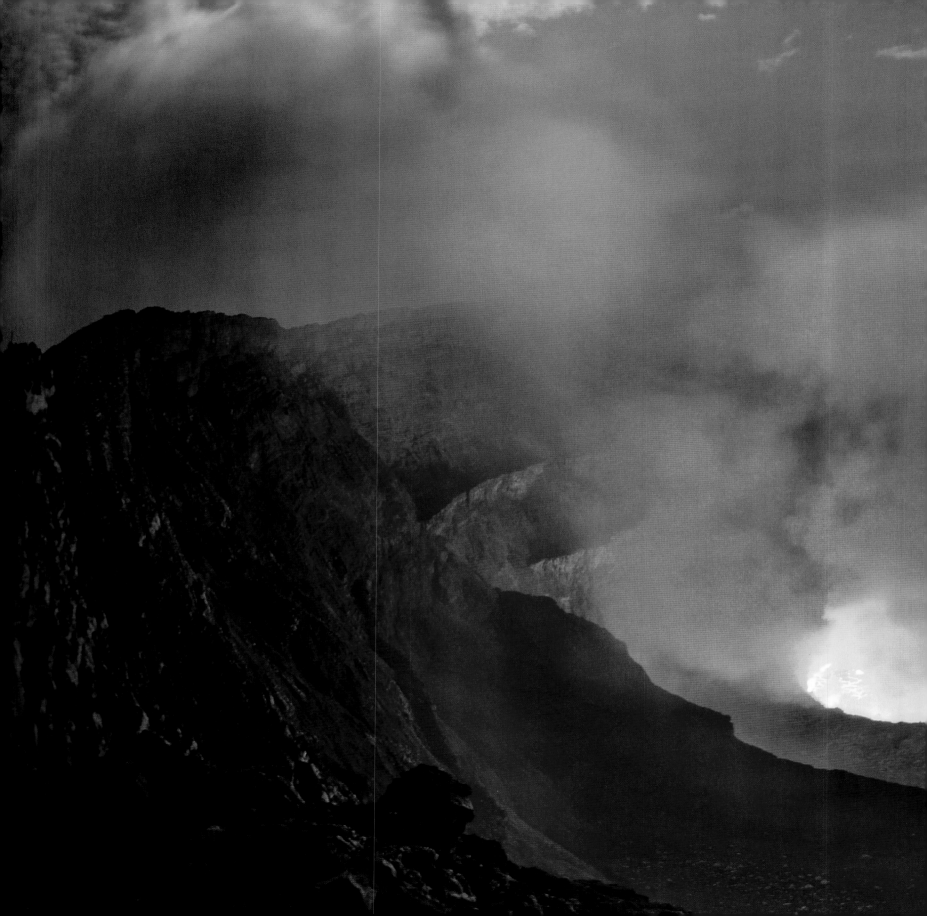

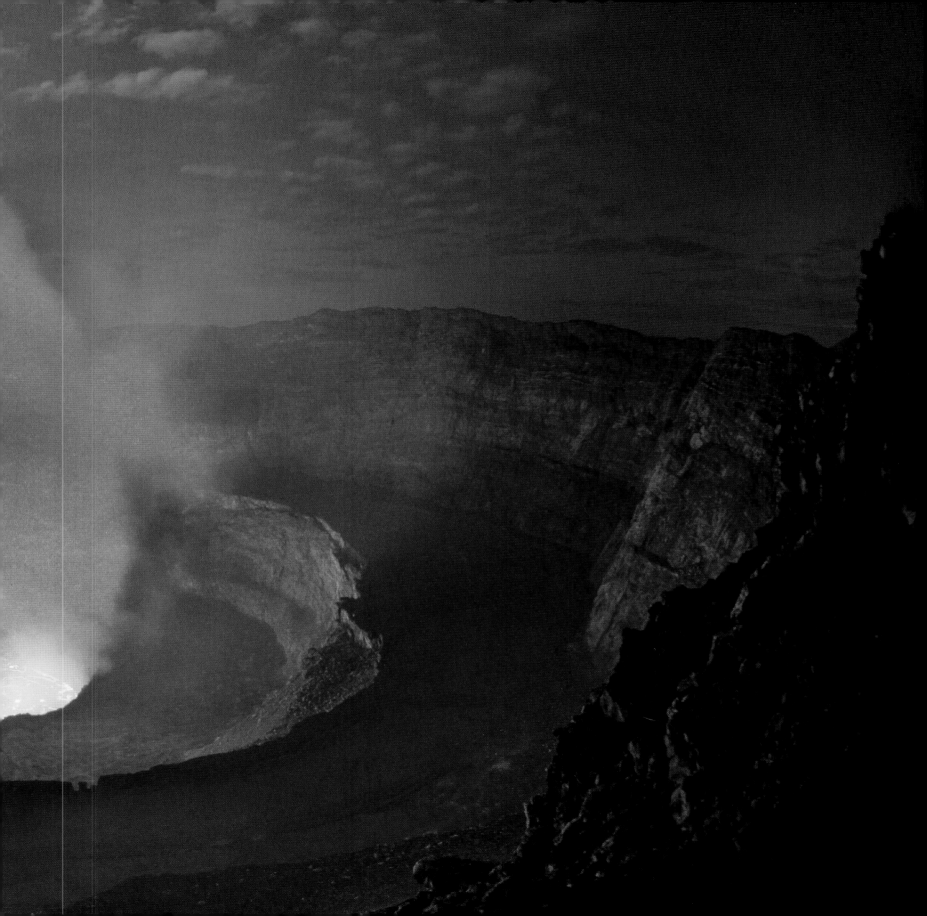

"NIGHT IS A WORLD LIT BY ITSELF.

—ANTONIO PORCHIA

OPPOSITE: **NEW HAVEN, CONNECTICUT** | A thermal image of a house shows which areas are leaking heat (red) and those that are better insulated. | *Tyrone Turner*

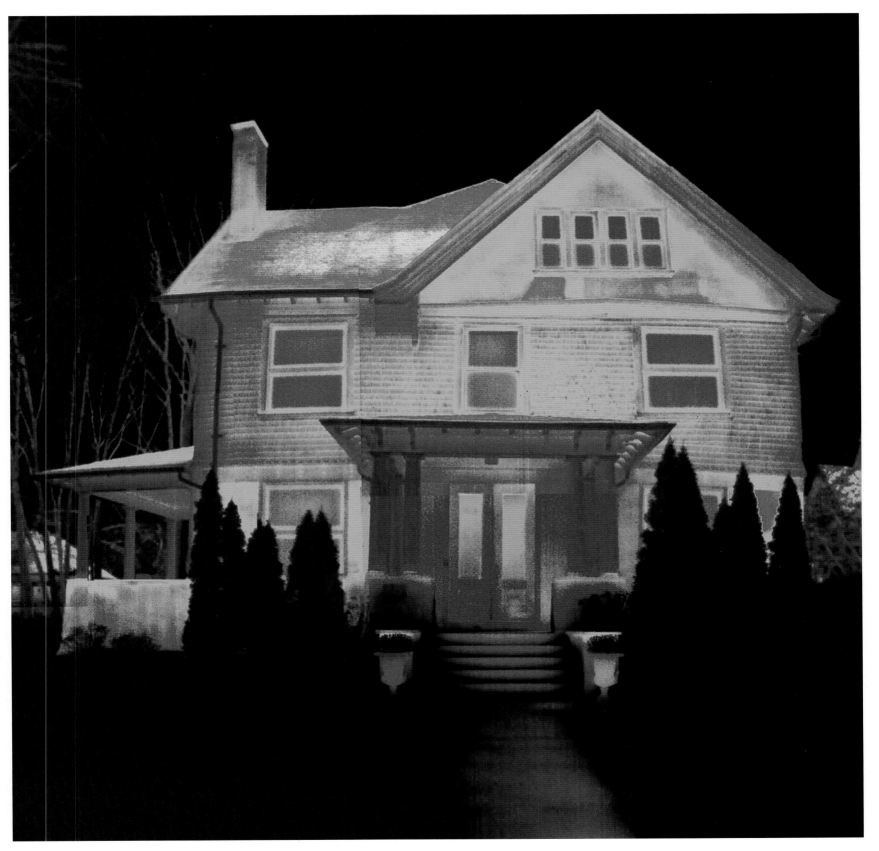

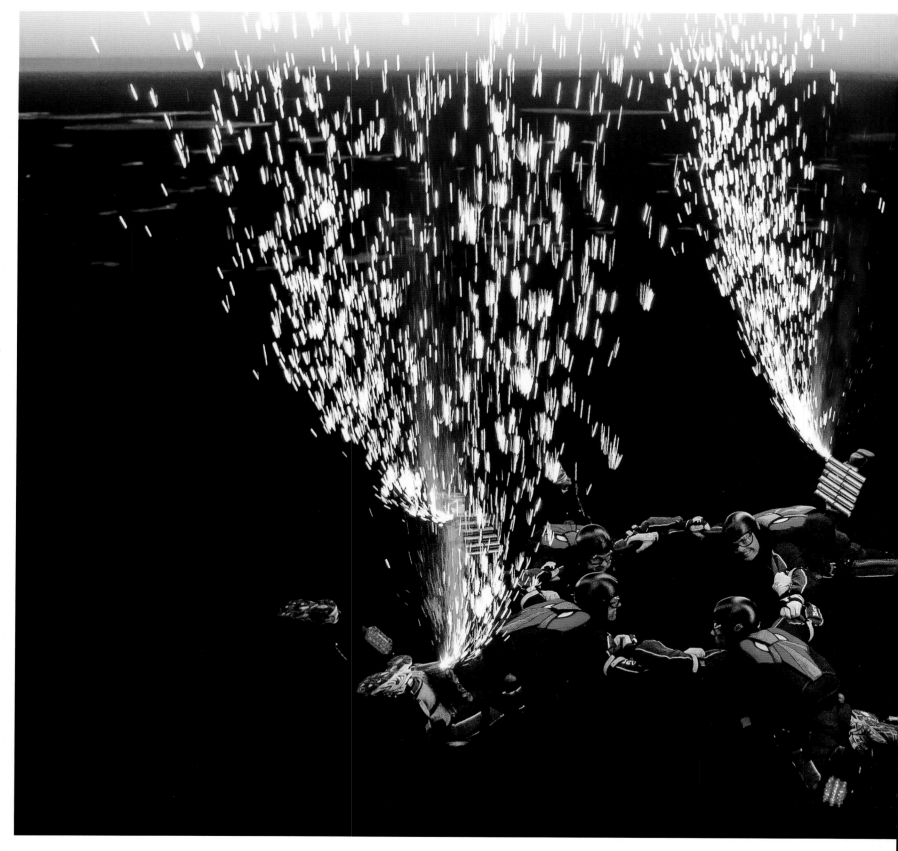

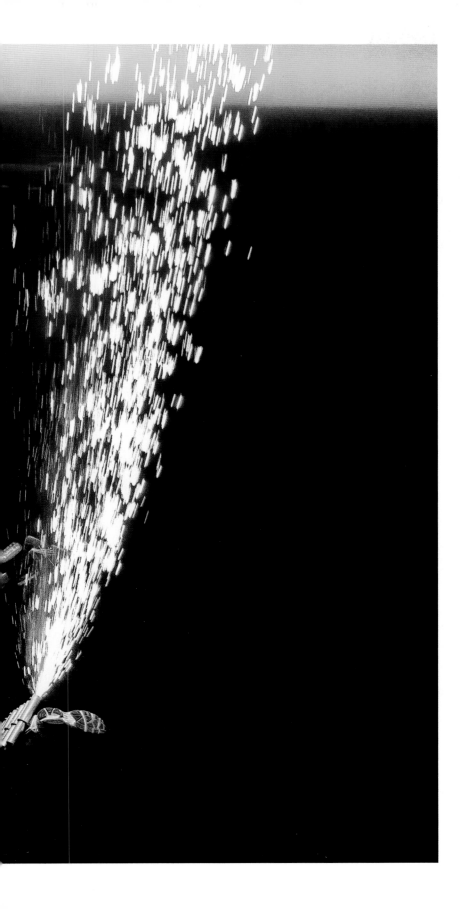

PALATKA, FLORIDA | Team Fastrax skydivers make their jump more extreme by lighting off fireworks and joining hands in the night sky. | *Norman Kent*

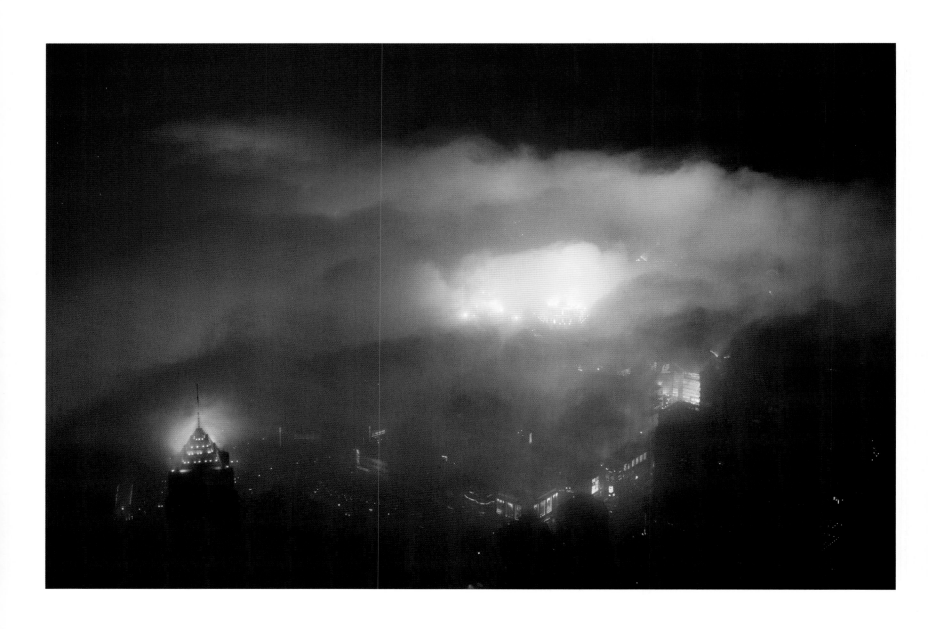

SHANGHAI, CHINA | The lights of the city peek
through low-level clouds. | *Feifei Cui-Paoluzzo*

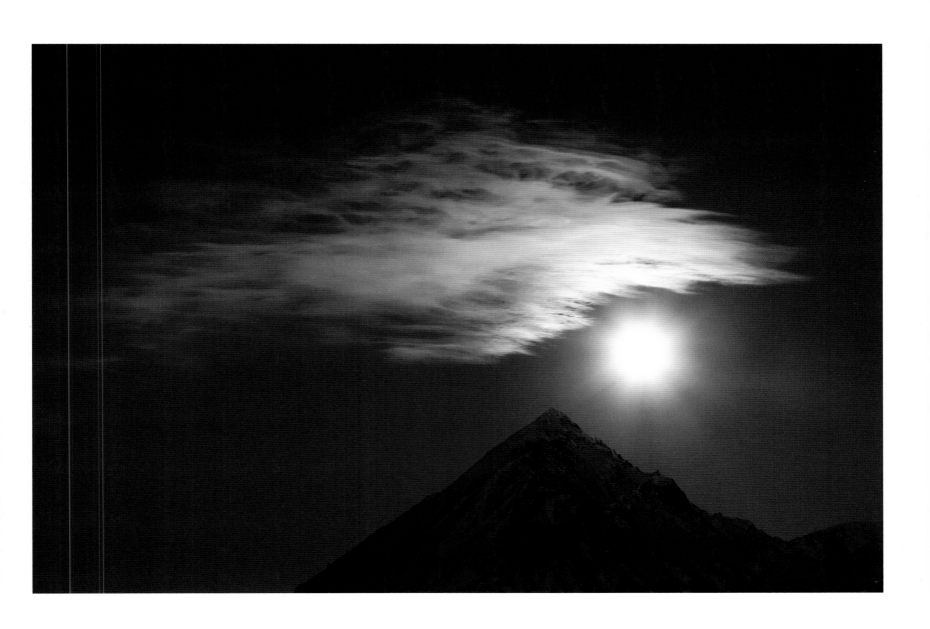

YUKON TERRITORY, CANADA | A full moon and rainbow clouds
hang above the Ogilvie Mountains. | *Joseph Bradley*

RIGHT: **SHIRAKAWA-GO VILLAGE, JAPAN** | Snowflakes fall in front of a thatched-roof house in an isolated village in Central Japan. | *Masaru Yamauchi*

FOLLOWING PAGES: **NAGOYA, JAPAN** | A multitude of lights arch over a walkway in Nabana no Sato, a flower park, during winter illumination. | *Suttipong Sutiratanachai*

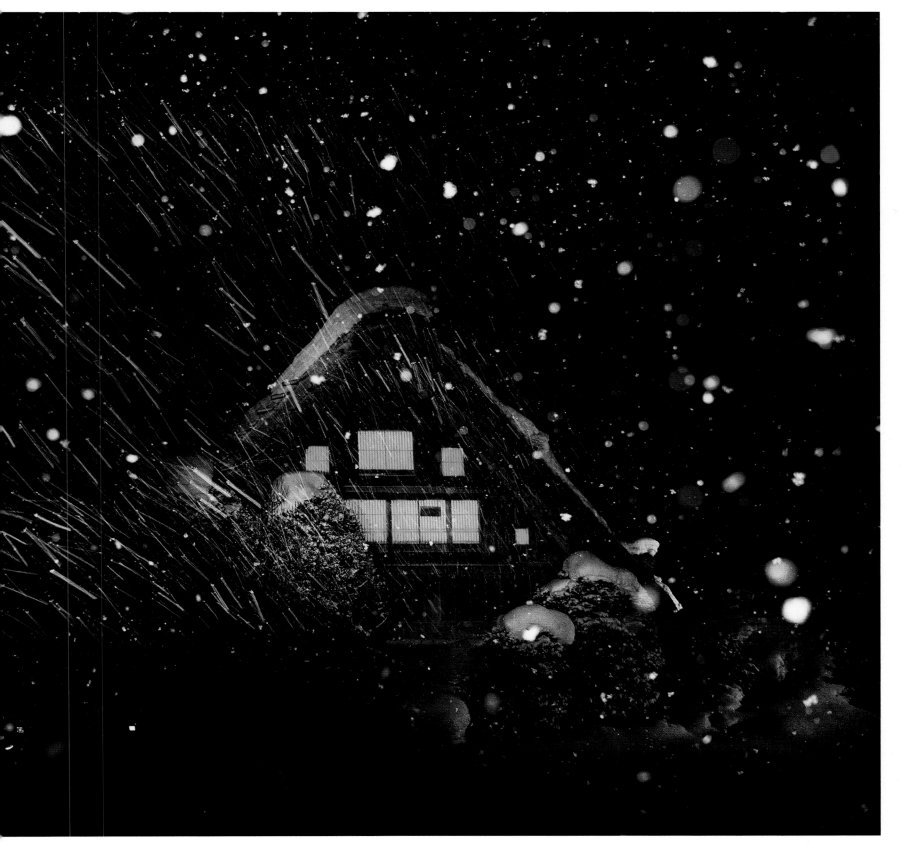

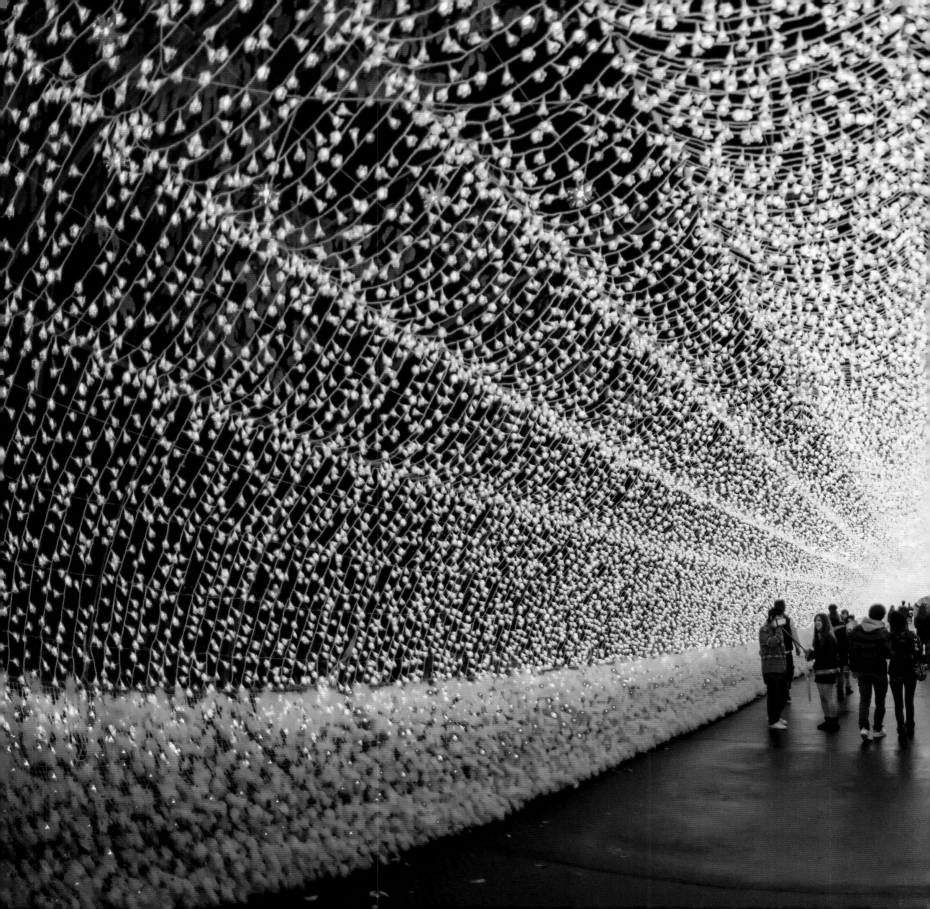

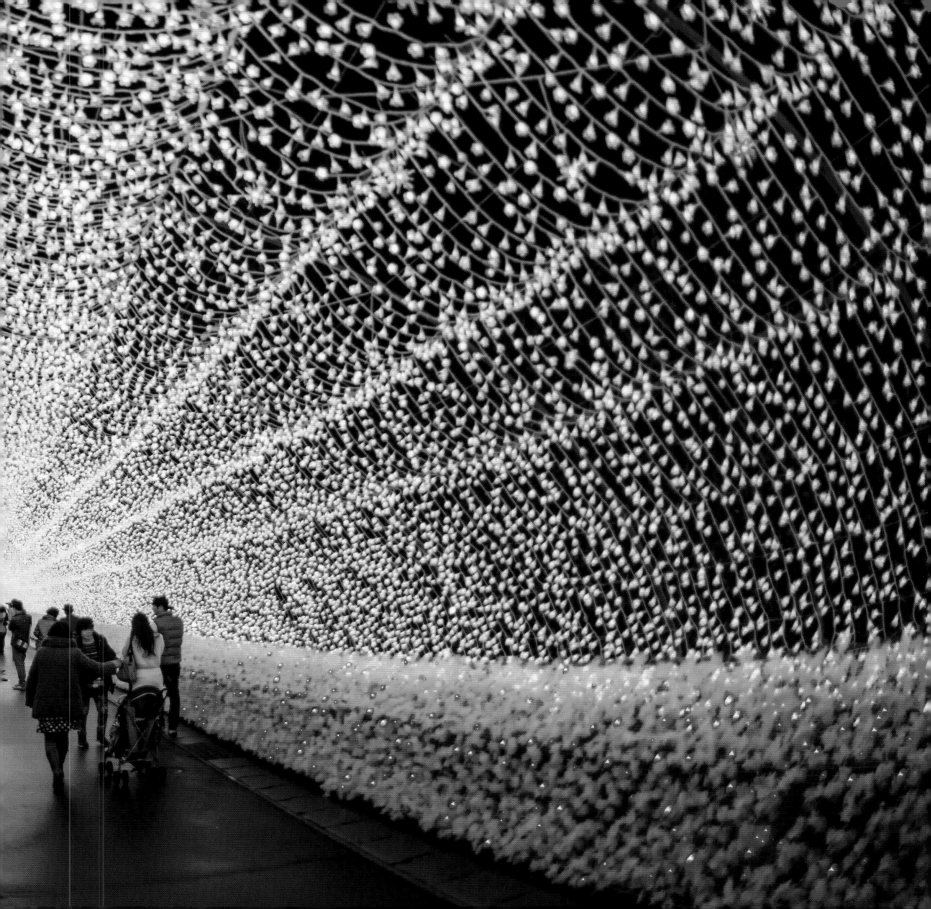

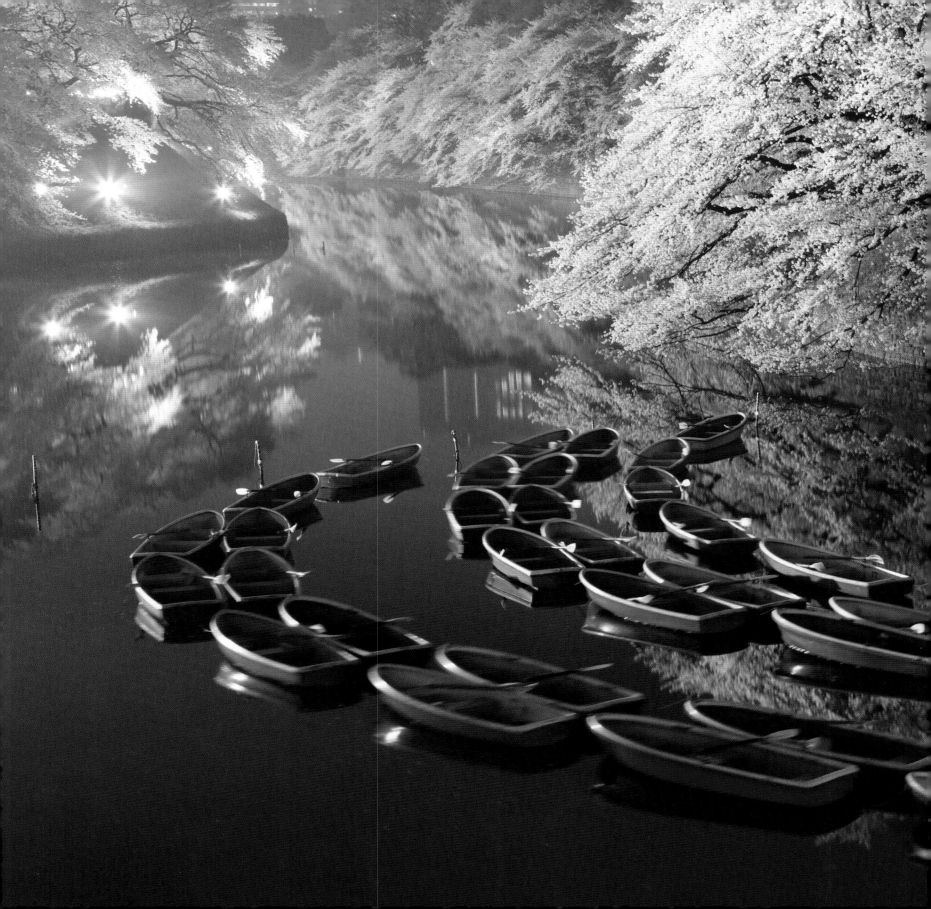

I CHAPTER TWO I

HARMONY

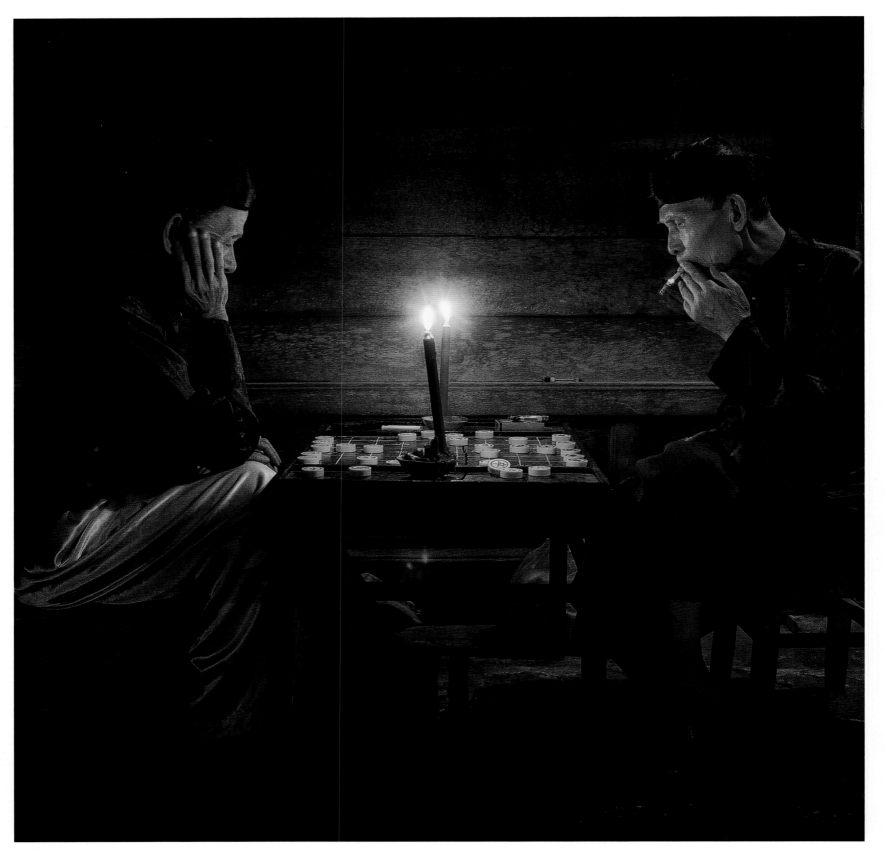

At night, our differences fall away: All are equal, all are related. Creatures meet in the mute observance of darkness. An owl floats from tree to tree. Herons tiptoe through the shallows. Day-loving blossoms fold in to rest, while night-bloomers open and bask in the cold light of the moon and stars. Somewhere in the savannah, the lion arises from sleep. Nature offers the deep silence of still water, of snow-covered peaks stretching up to meet the slim crescent moon.

We, too, unite in the darkness; deep night means the same in every language. As we have for many thousands of years, humans gather around the fire, creating community by sharing the warmth and light. Close your eyes: Your dreams take shape, belonging to you alone. Now, open them: We are all entering the realm of spirit, where the many become one. We sing our songs, we tell our stories. Shared memories cast meaning on what happened yesterday and conjure a sense of what may happen tomorrow. We light candles to find the way, and in so doing we find each other. Friends, family, fellow travelers—all serve as the beacons we need to guide us through the night.

OPPOSITE: HỘI AN, VIETNAM | Two villagers play a game by candlelight. | *Michal Witkowski*

PREVIOUS PAGES: TOKYO, JAPAN | Cherry blossoms hang over rowboats docked in a moat in Japan's Imperial Palace. | *JTB Media Creation*

SPAIN | Bright colors light up a spiral staircase. | *Alfredo Garcia*

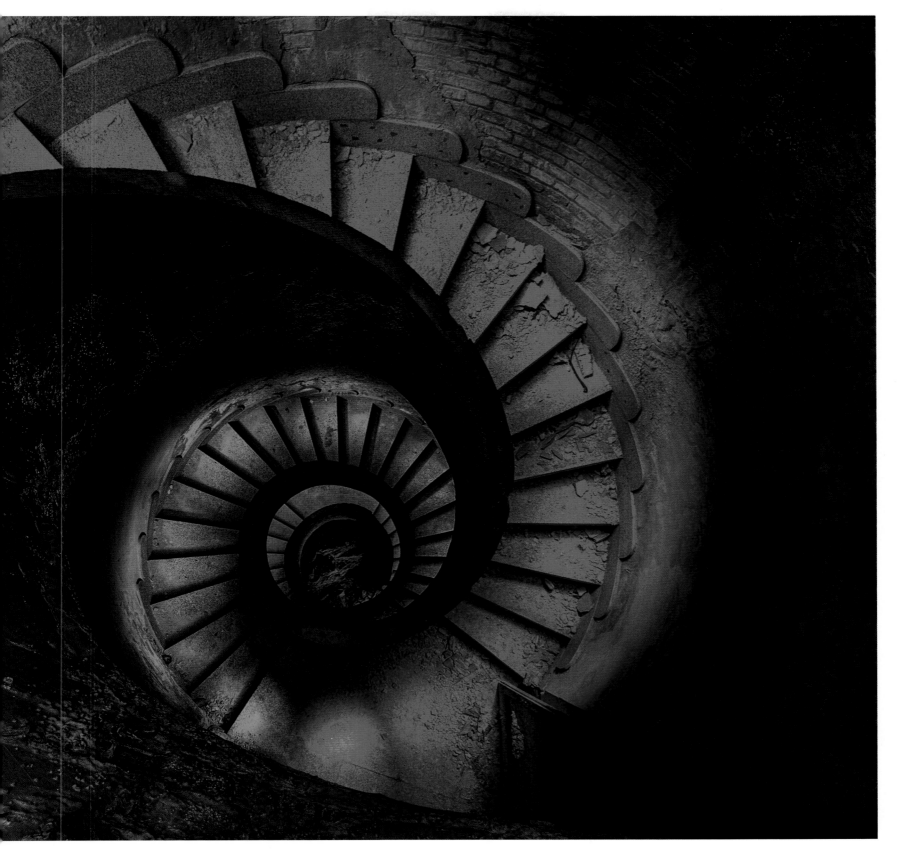

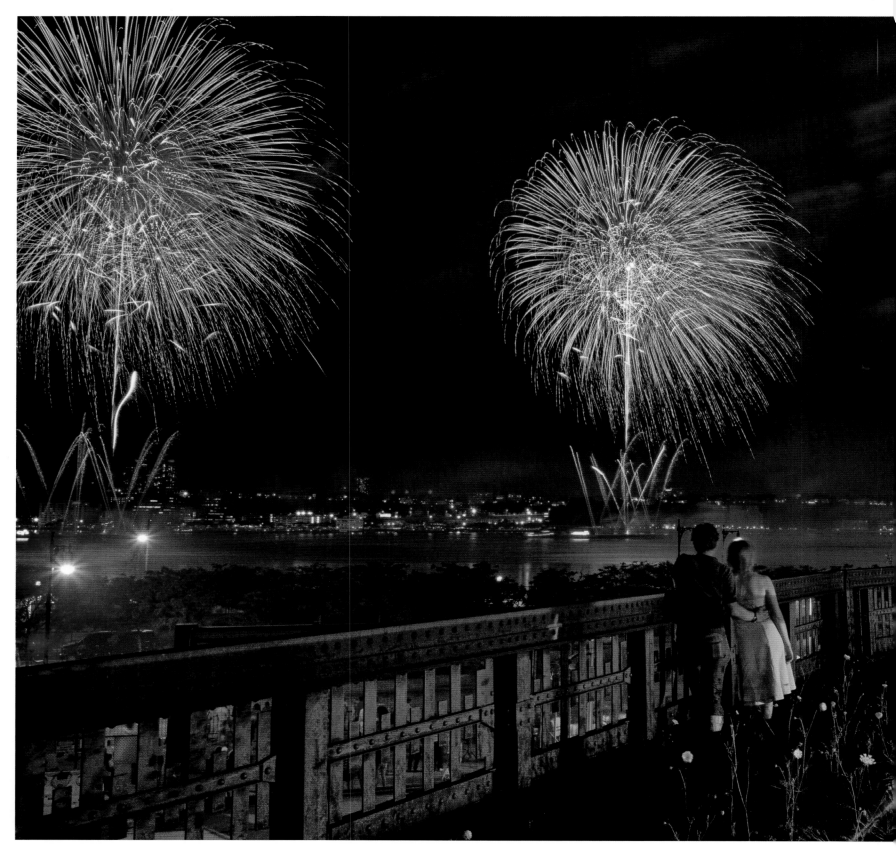

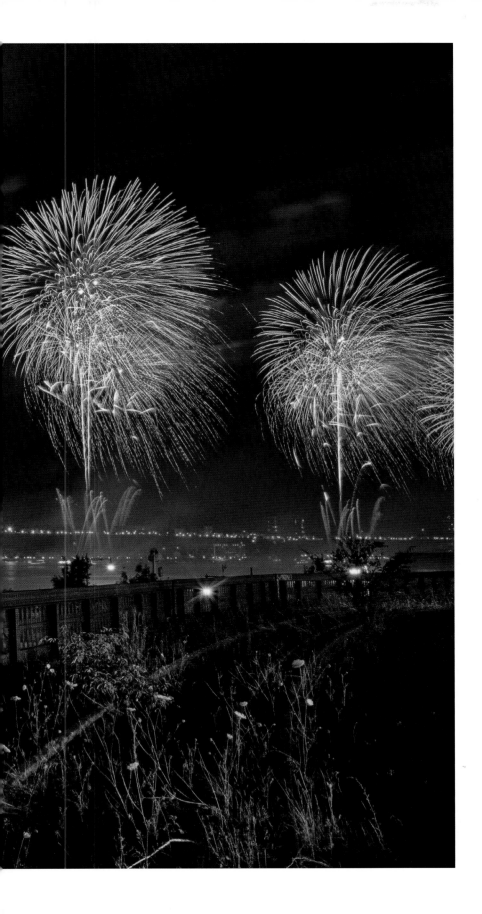

LEFT: **NEW YORK, NEW YORK** | Atop the High Line, a couple watches
Fourth of July fireworks burst above the Hudson River. | *Diane Cook & Len Jenshel*

FOLLOWING PAGES: **HONG KONG** | A colorful apartment complex encircles
the ground and offers a window to the night sky above. | *Peter Stewart*

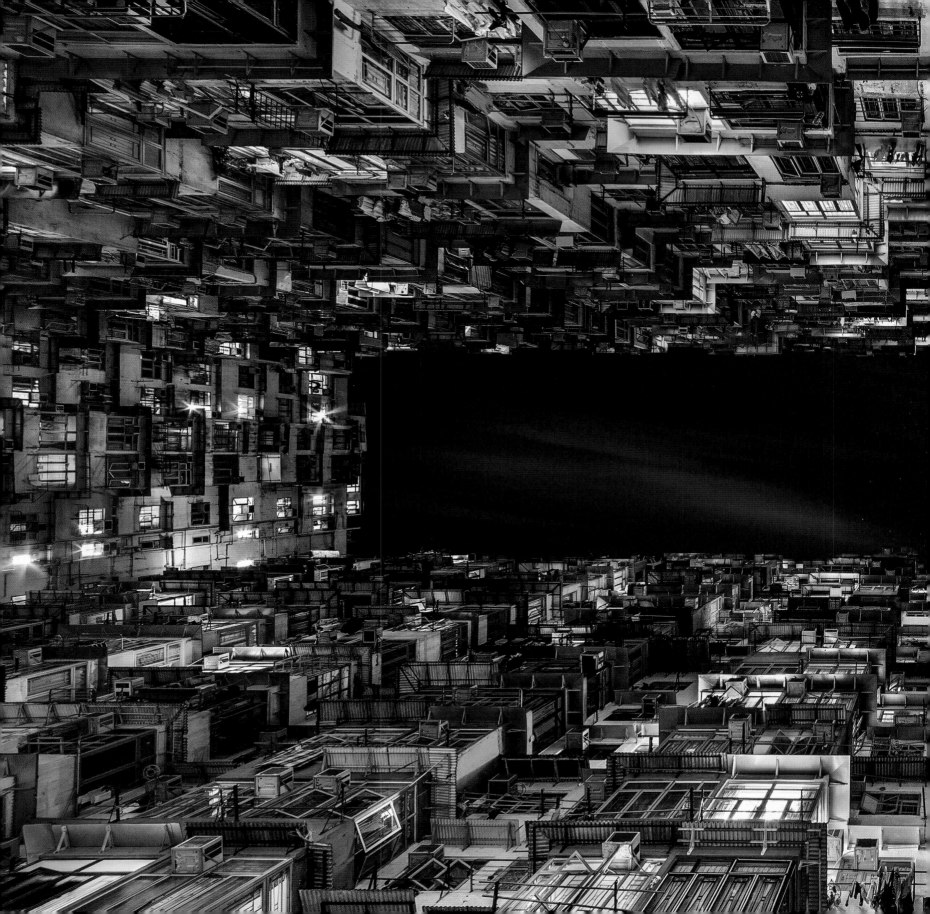

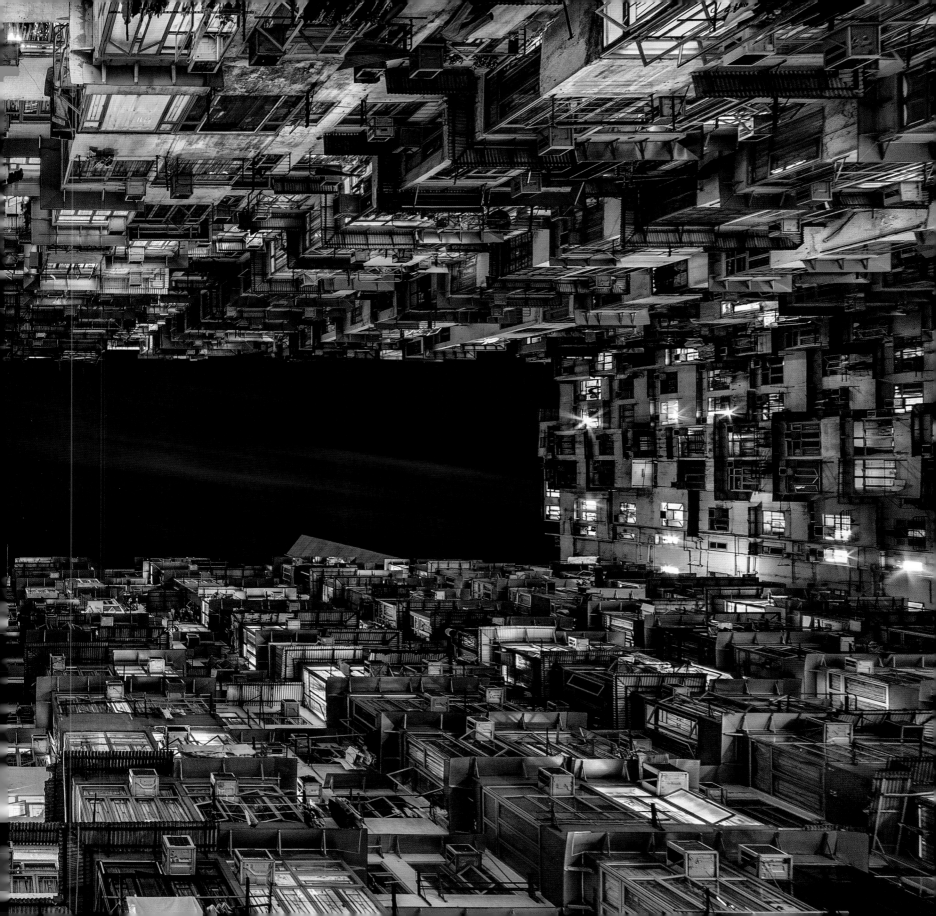

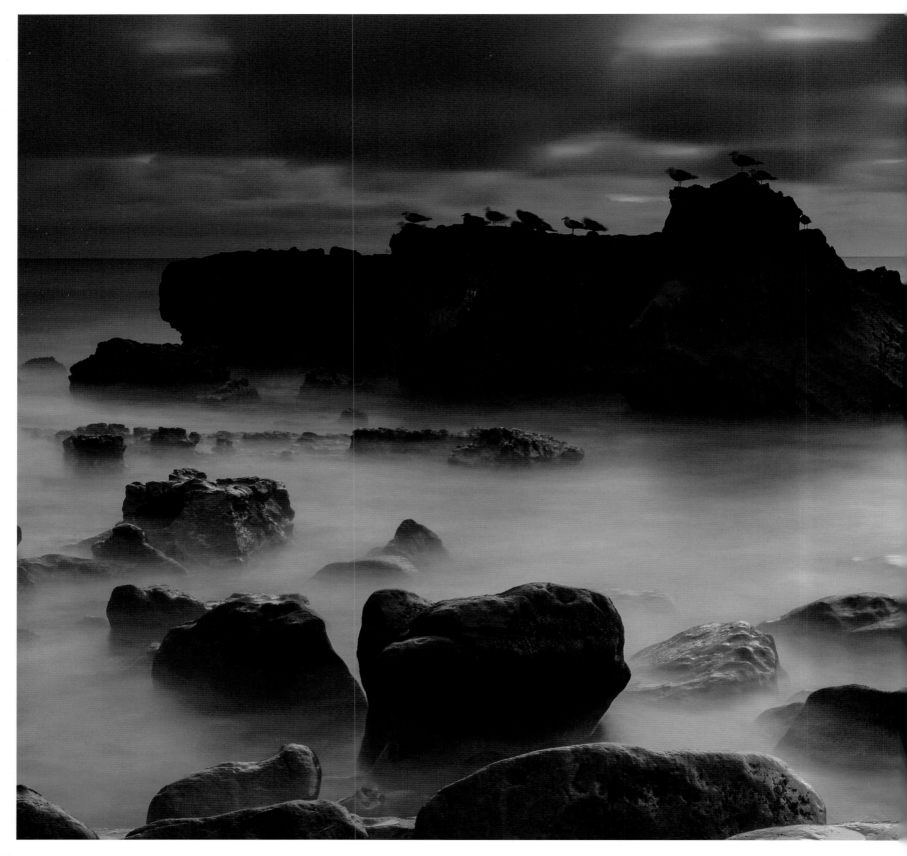

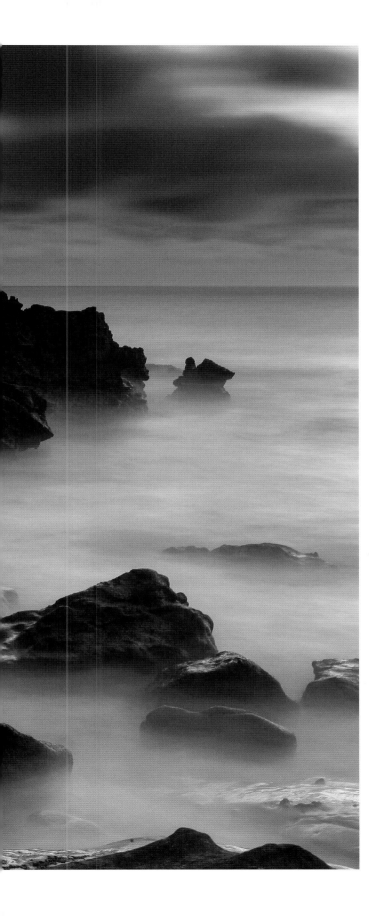

LAGUNA BEACH, CALIFORNIA | Fog settles in on a rocky coastline. | *Eric Foltz*

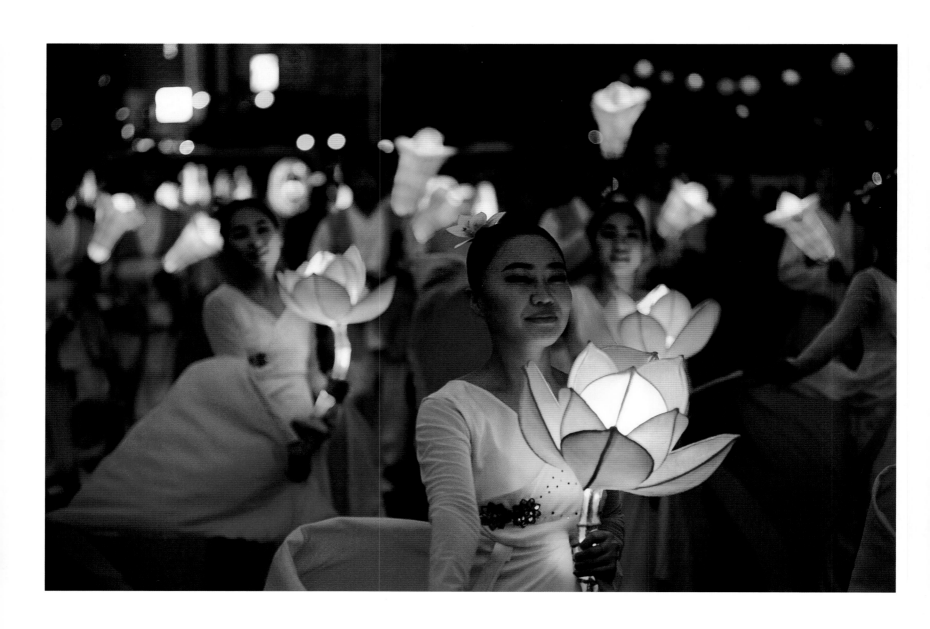

SEOUL, SOUTH KOREA | Participants hold lit flowers during the Lotus Lantern Festival, a traditional celebration of the Buddha's birthday. | *Oliver Hirtenfelder*

HONG KONG | A white water lily in full bloom at night. | *Mag Yip*

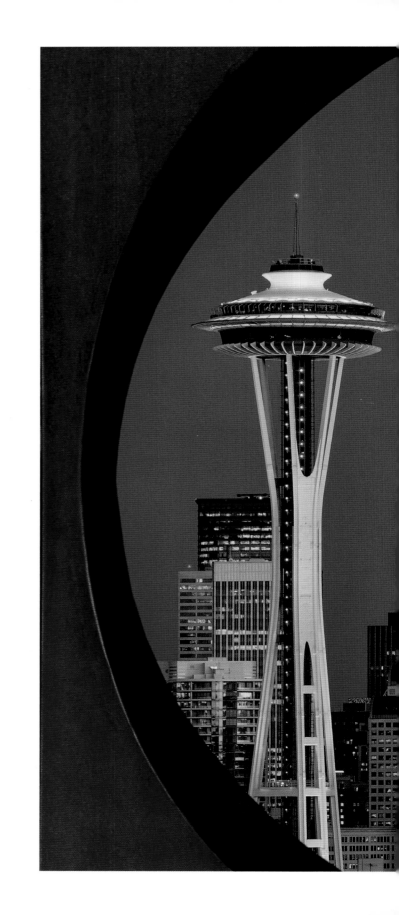

SEATTLE, WASHINGTON | The Seattle skyline and a luminous moon appear
through the steel sculpture "Changing Form," by Doris Chase. | *Michael Weber*

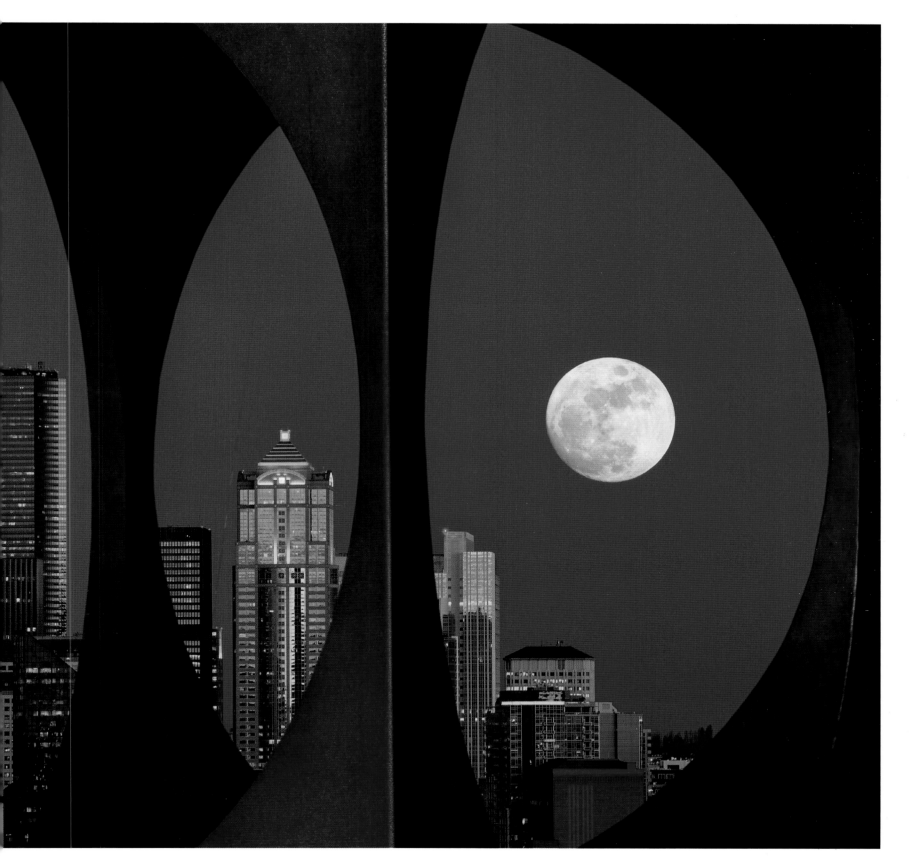

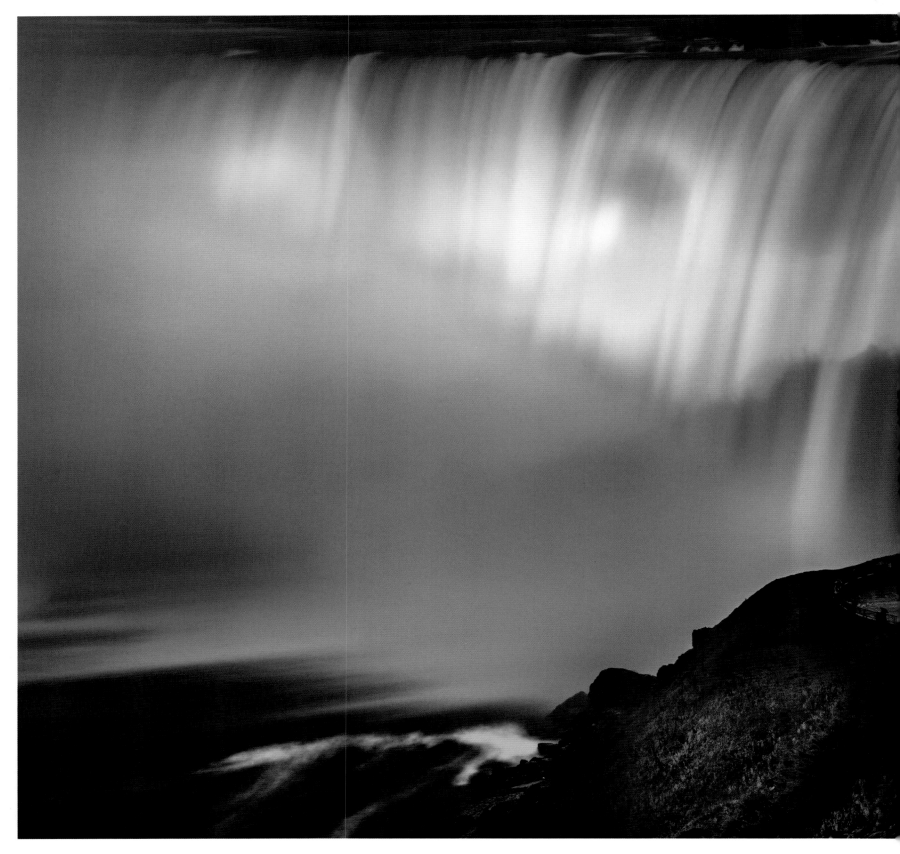

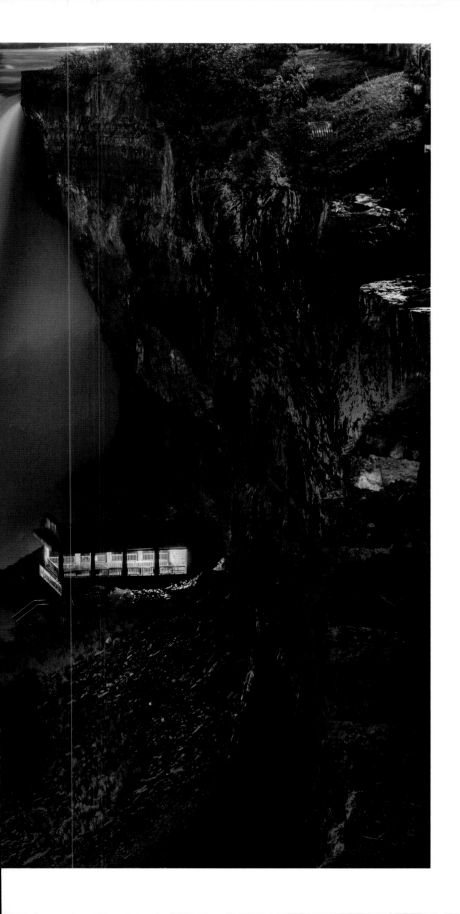

NIAGARA FALLS, CANADA | The Journey Behind the Falls observation building overlooks the colorfully lit rushing water. | *Leonardo Patrizi*

"THE FIRST AND FUNDAMENTAL LAW OF NATURE . . . IS TO SEEK PEACE AND FOLLOW IT.

—THOMAS HOBBES

OPPOSITE: LAKE CLARK NATIONAL PARK AND PRESERVE, ALASKA | The still waters of an Alaskan lake reflect a full moon and the Chigmit Mountains. | Carl Johnson

130

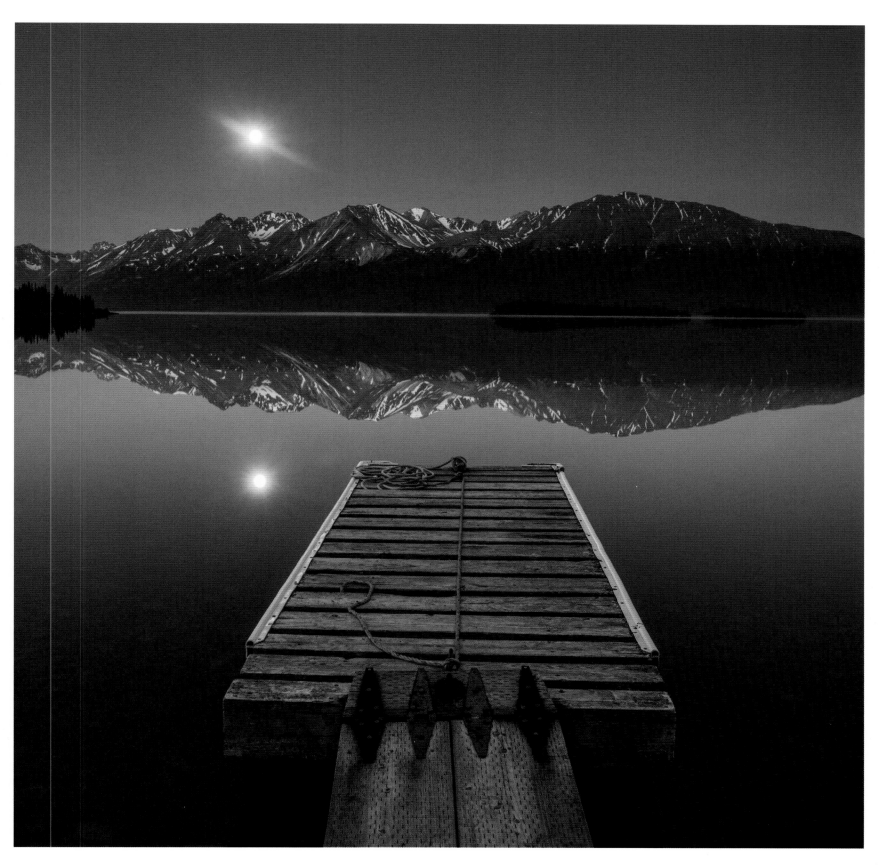

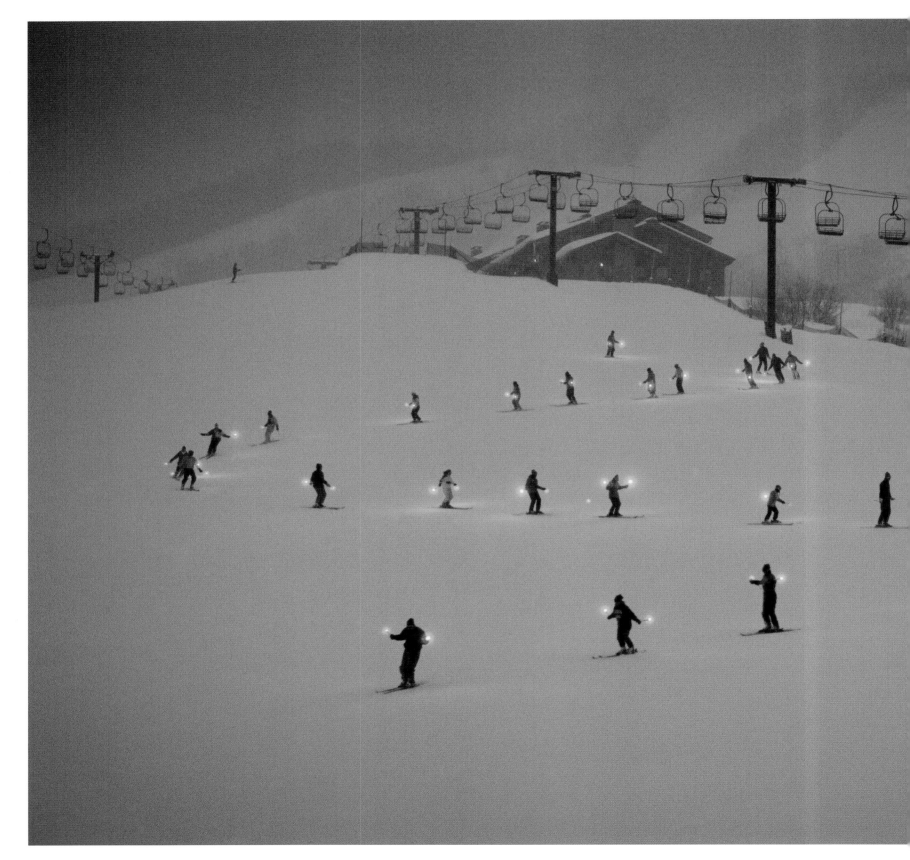

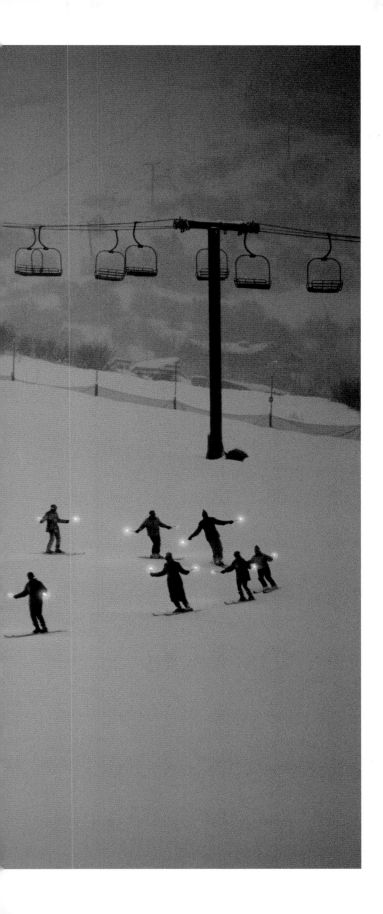

LEFT: **STEAMBOAT SPRINGS, COLORADO** | Skiers holding lights form an S curve as they make their way down the slope. | *Paul Chesley*

FOLLOWING PAGES: **BAGAN, MYANMAR** | The Gawdawpalin, a Buddhist temple, shines like a jewel from the forested plain. | *Experience unlimited*

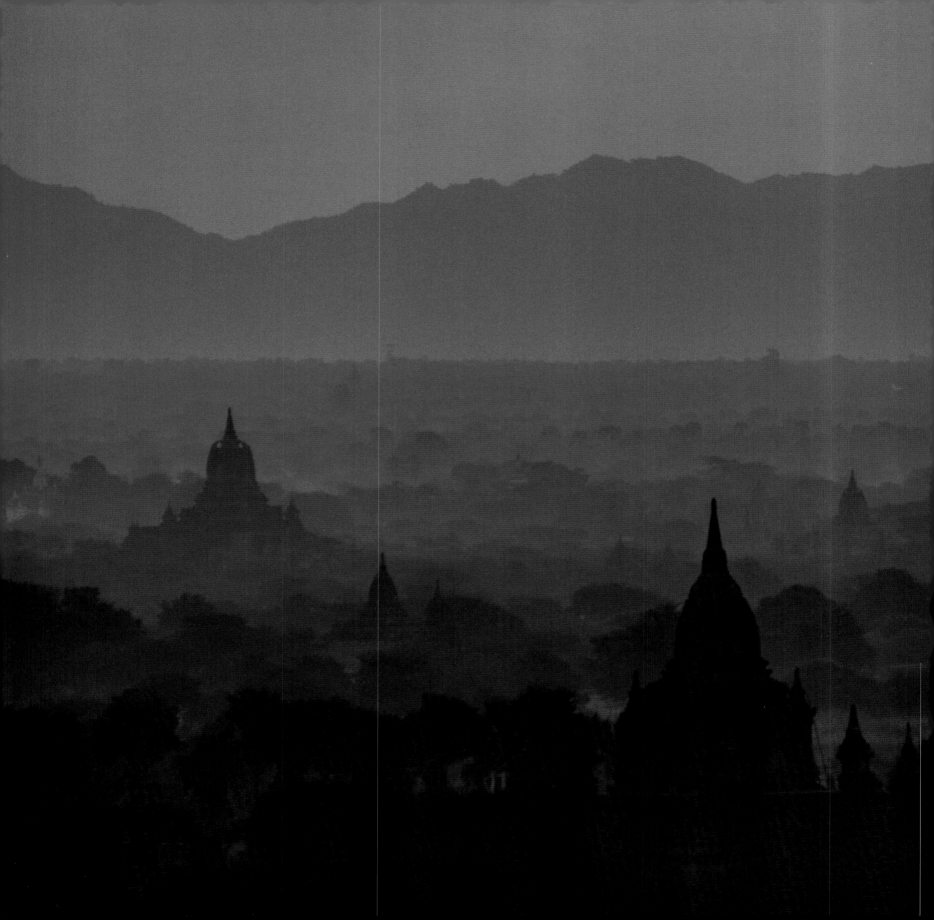

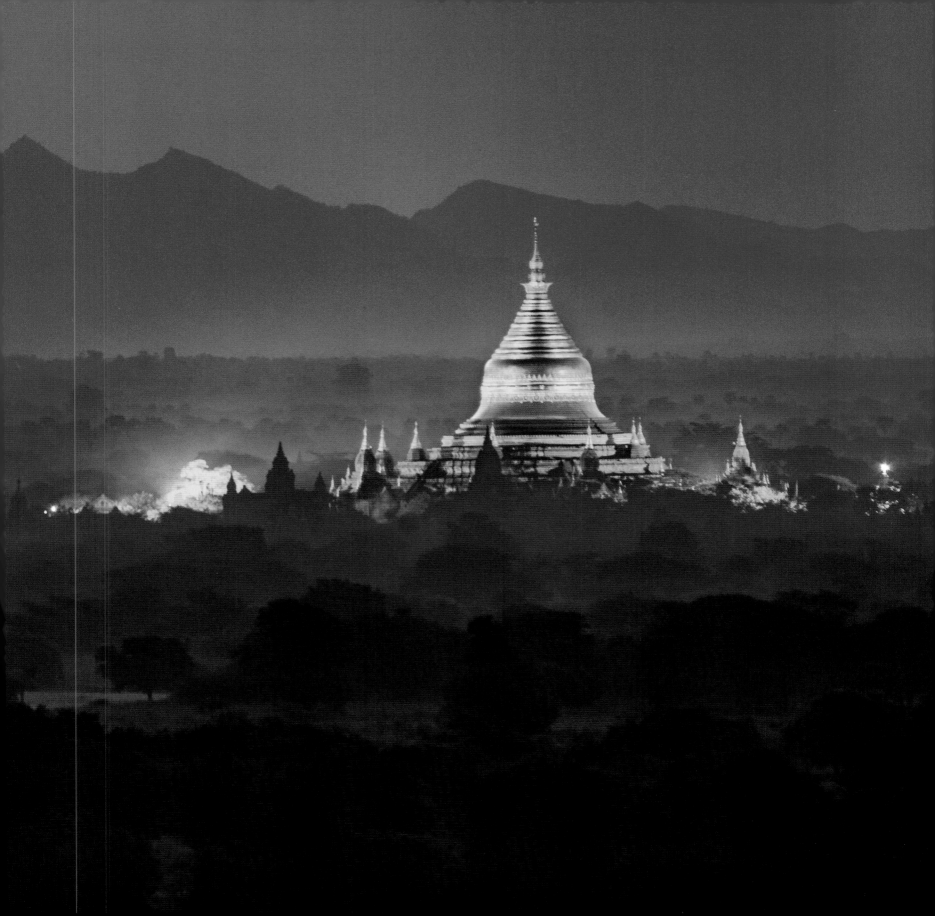

RIGHT: **PHILIPPINES** | As the sun sets, a sea turtle swims just below the ocean's surface. | *Andrey Narchuk*

PAGE 138: **VENICE, CALIFORNIA** | A broken fire hydrant offers relief from the heat—and a reason to dance. | *David Zentz*

PAGE 139: **LLANBADRIG, UNITED KINGDOM** | Tents in a Peace Camp along the Welsh coast stand out in the dark. | *Kristofer Williams*

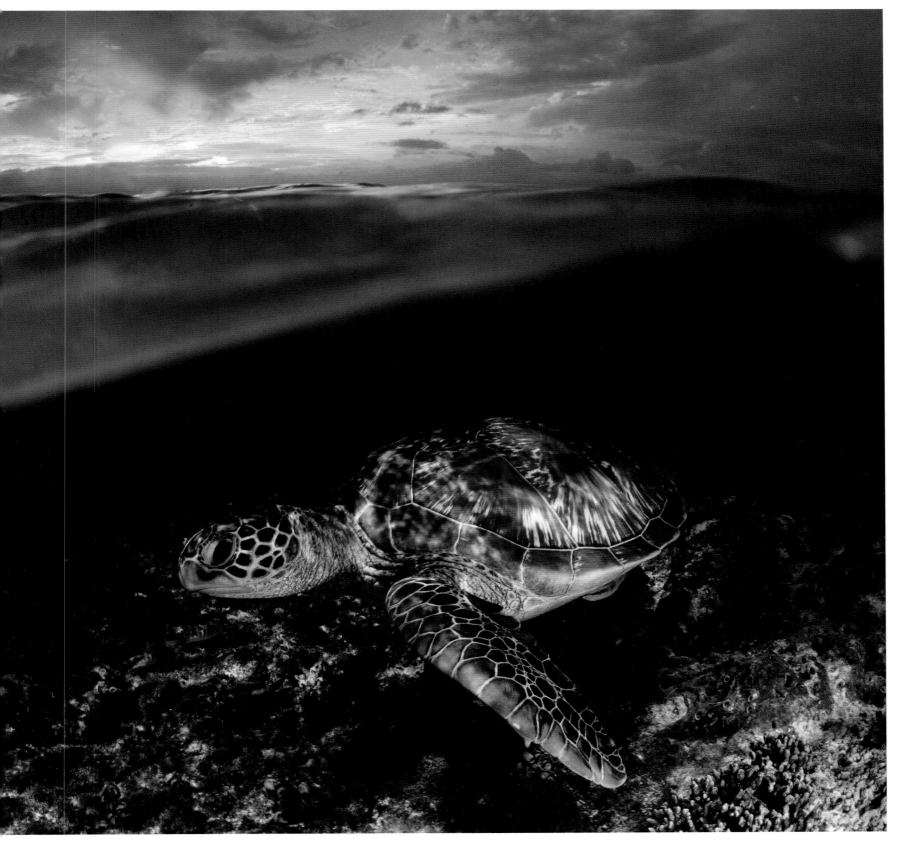

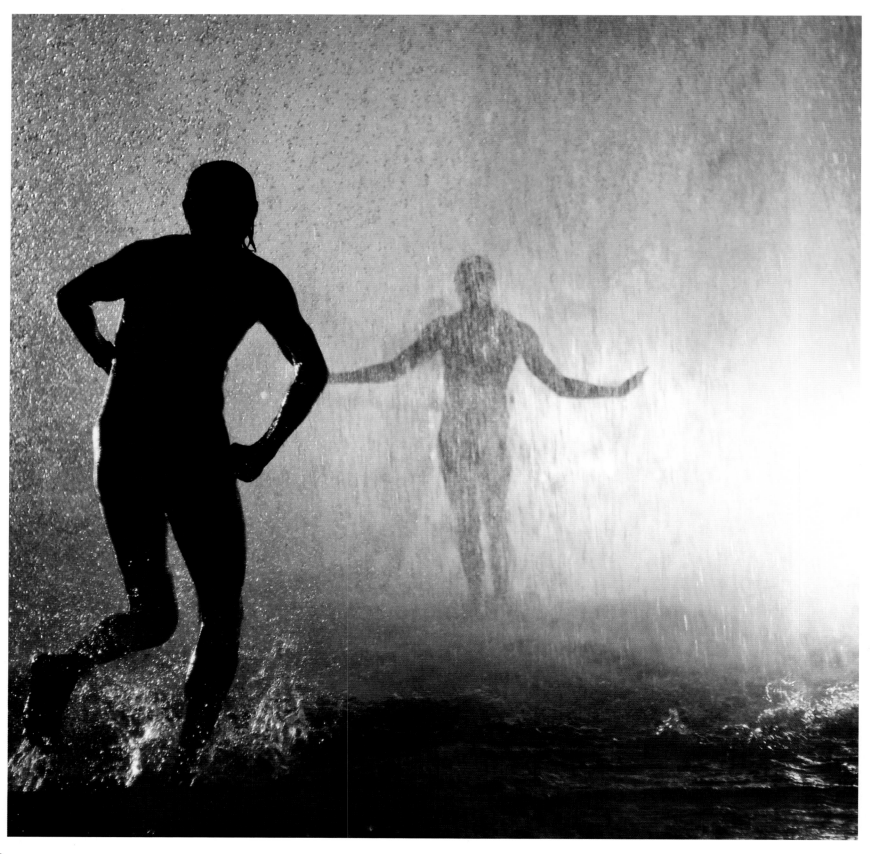

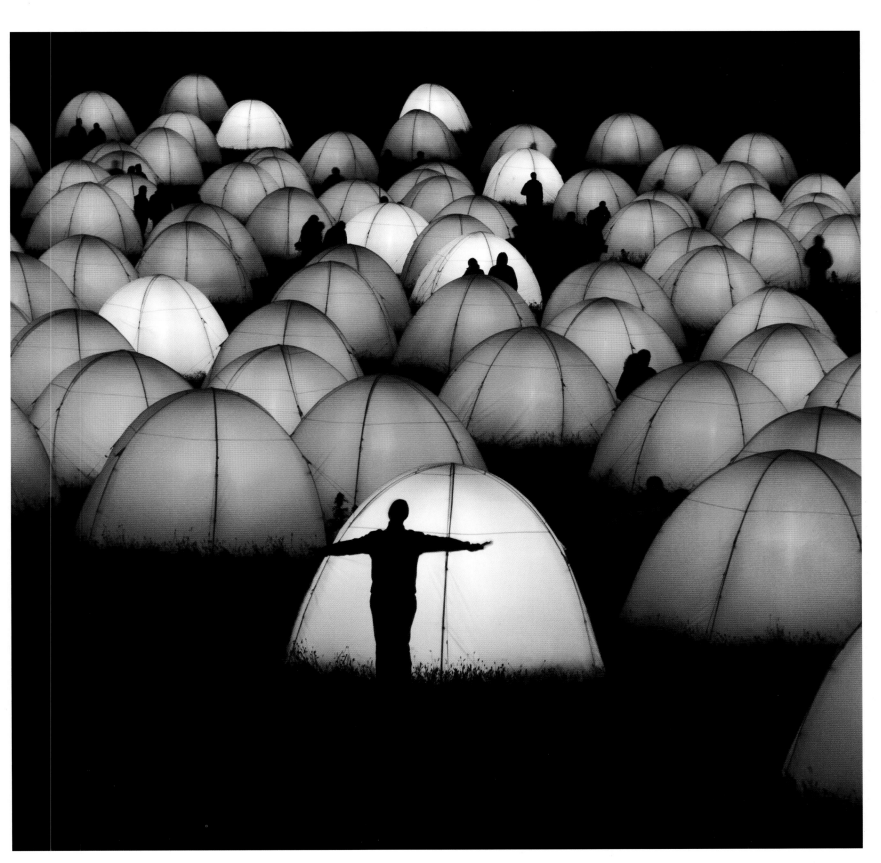

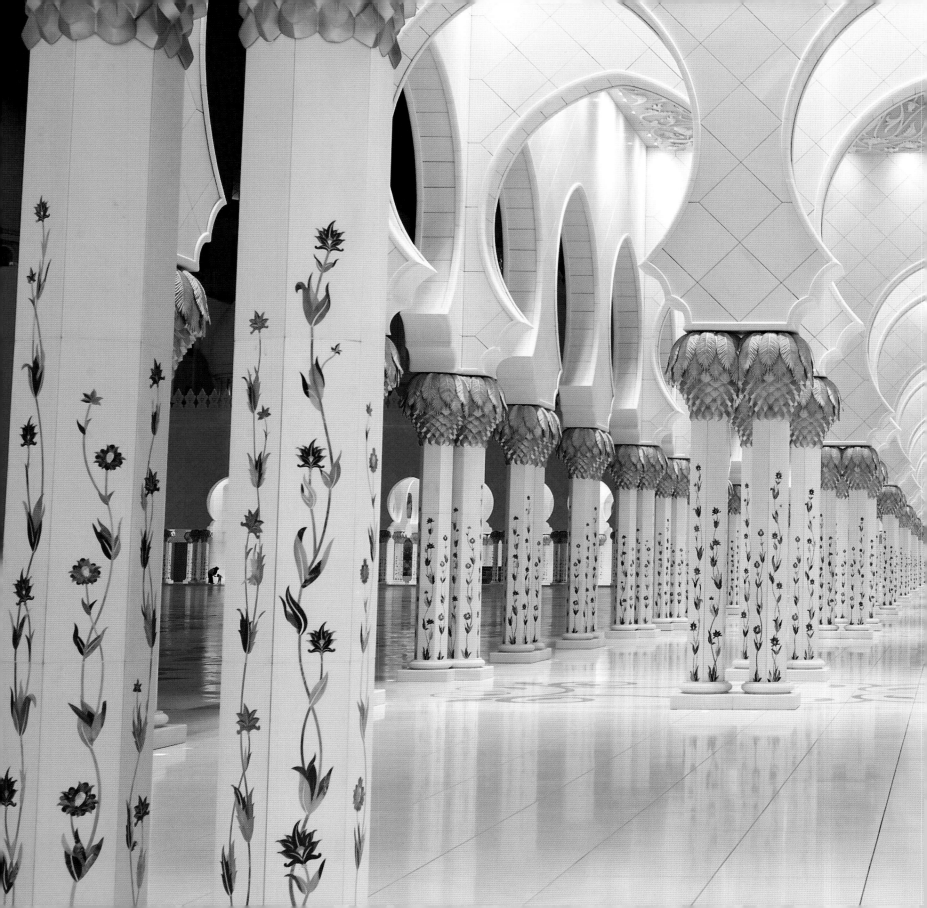

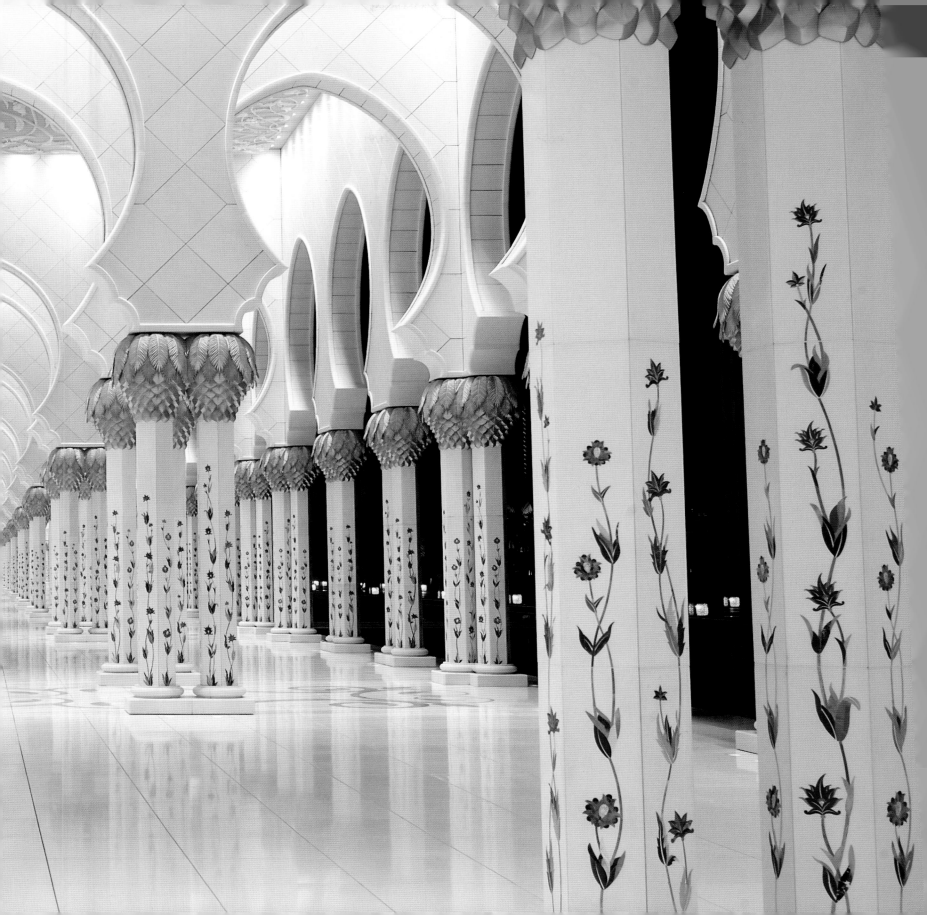

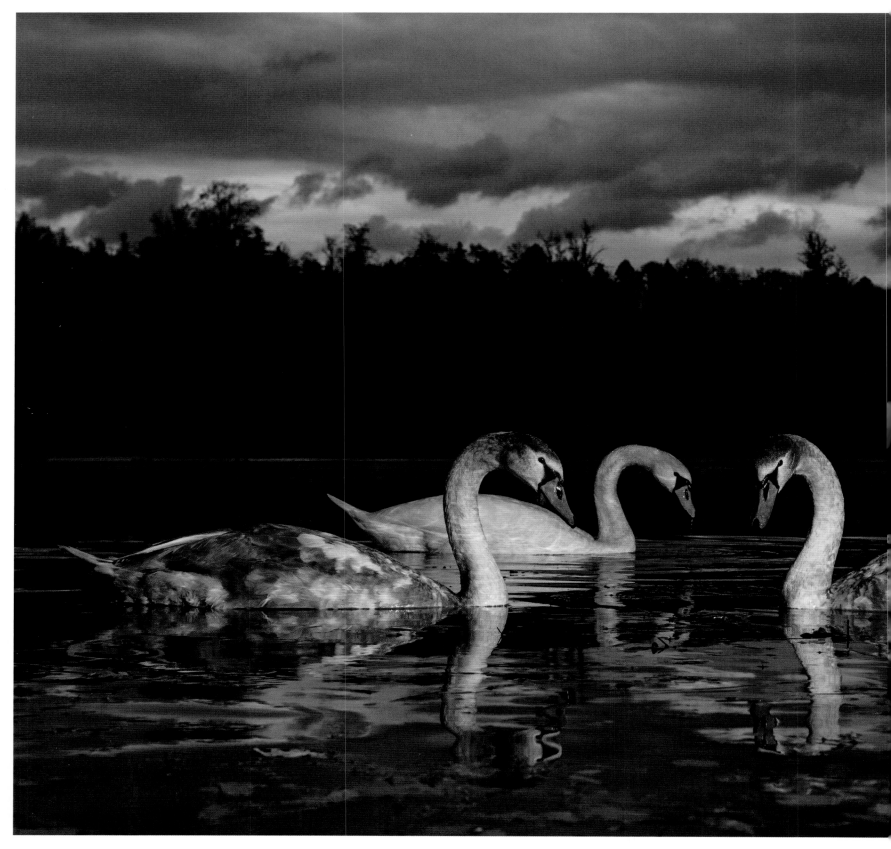

LEFT: **LOWER SILESIA, POLAND** | A family of mute swans feeds in the still waters of a quiet pond. | *Oscar Dominguez*

PREVIOUS PAGES: **ABU DHABI, UNITED ARAB EMIRATES** | The elaborately decorated and gilded columns of the Sheikh Zayed Grand Mosque stretch along a reflecting pool. | *Chinagarn Kunacheva*

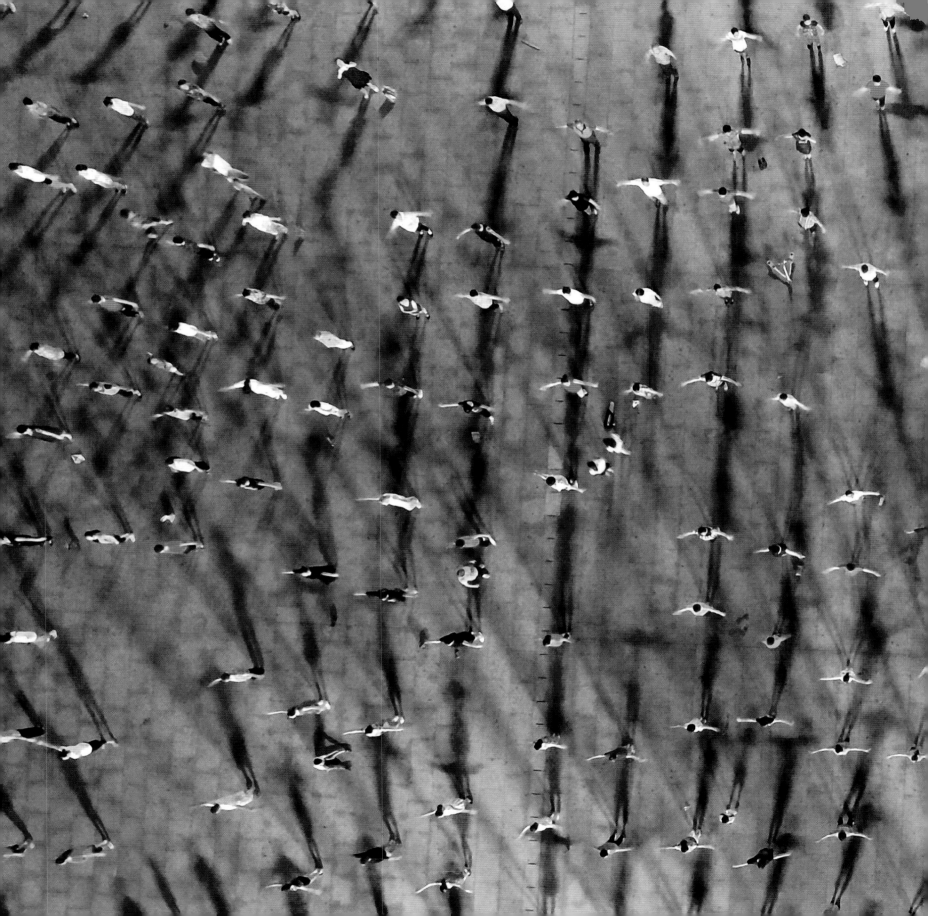

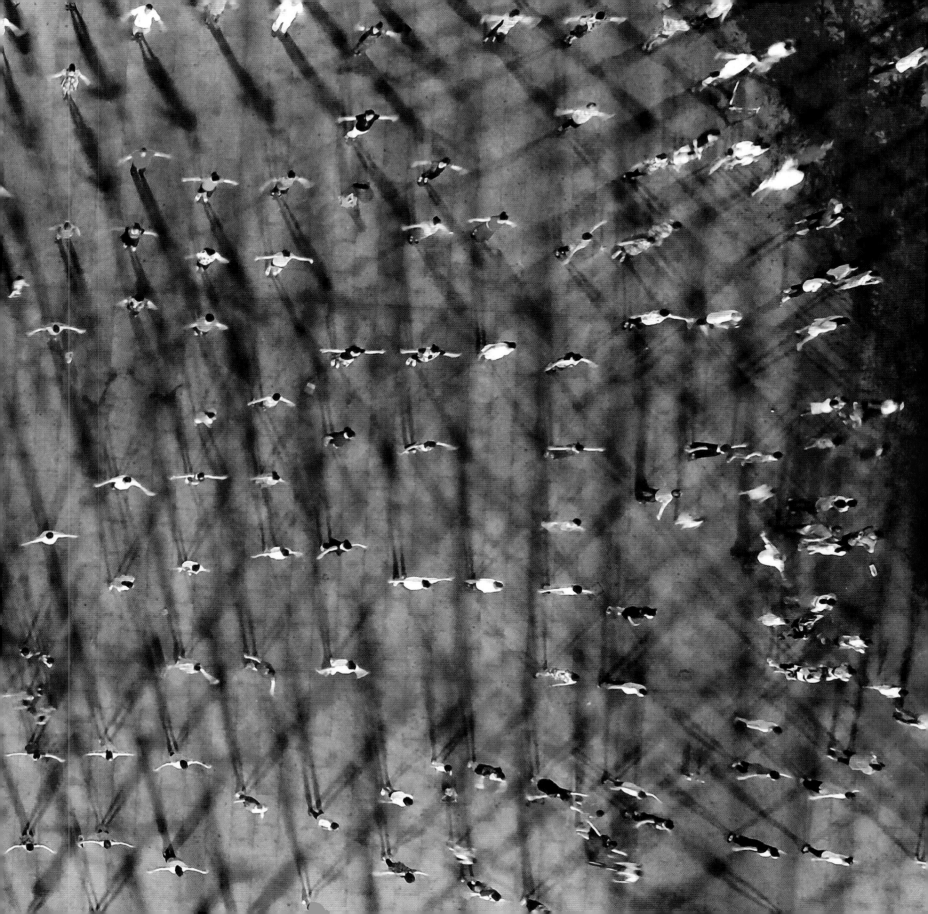

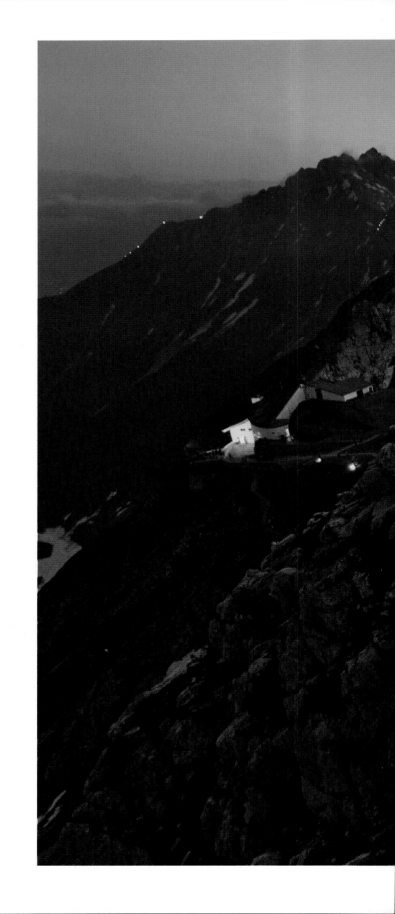

RIGHT: INNSBRUCK, AUSTRIA | Hikers welcome the night during summer solstice with a fire. | *Robbie Shone*

PREVIOUS PAGES: HUNAN PROVINCE, CHINA | A town square full of people dancing is viewed from above. | *Jie Zhao*

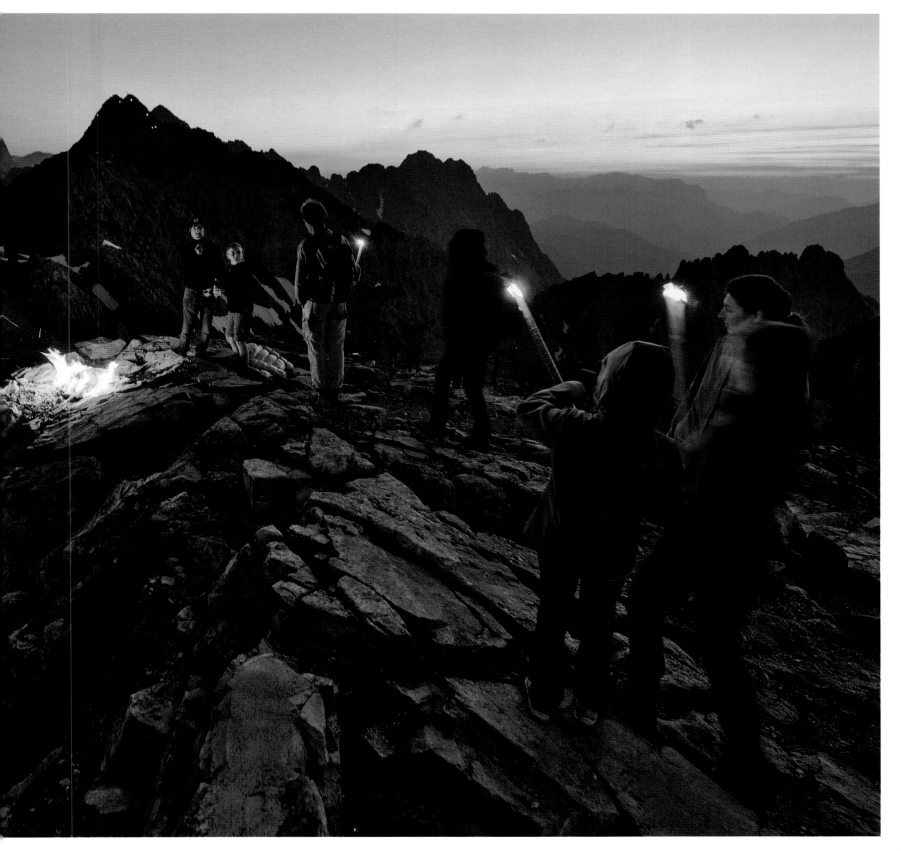

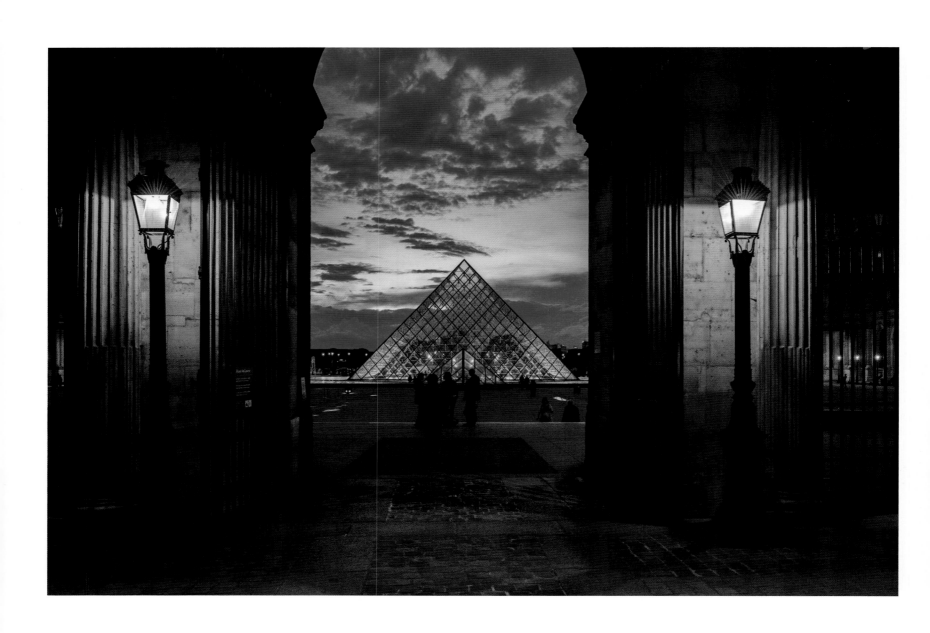

PARIS, FRANCE | The night surrounds late visitors to the Louvre. | *Paul S. Bartholomew*

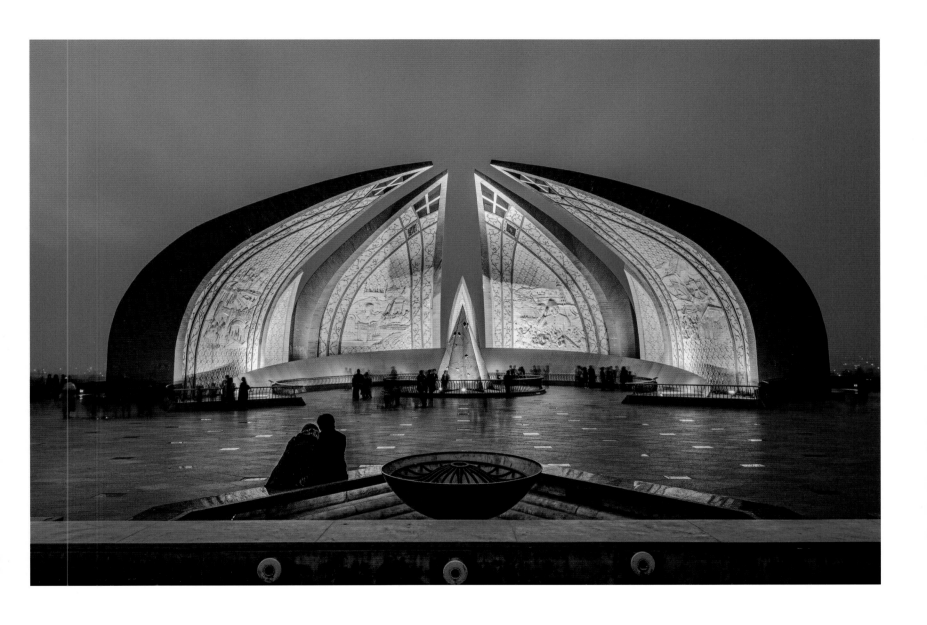

ISLAMABAD, PAKISTAN | The Pakistan Monument softly glows as it welcomes twilight visitors. Its four petals represent the country's four provinces. | *Shahid Khan*

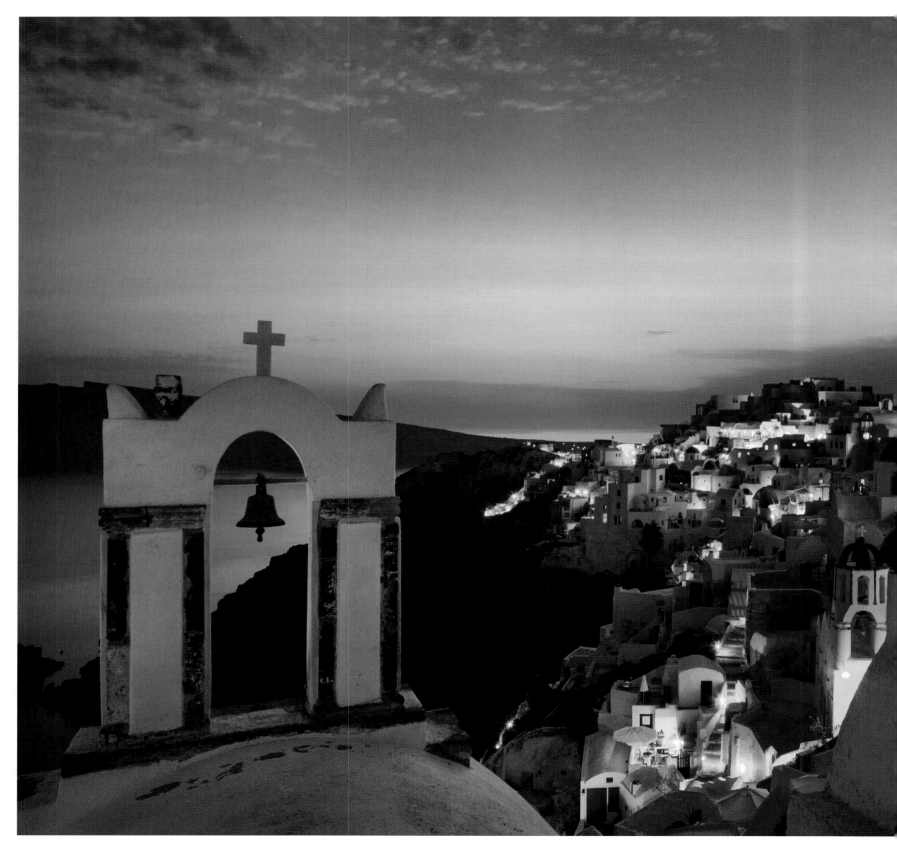

SANTORÍNI, GREECE | The village of Oia on the Aegean Sea glows softly at sunset. | *Slow Images*

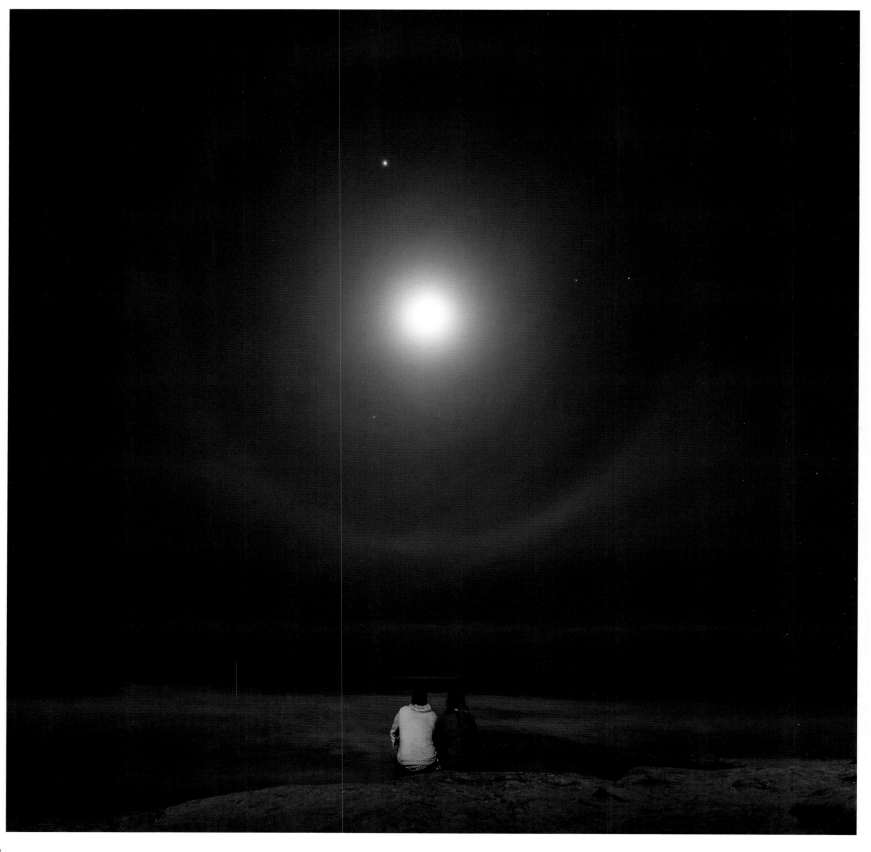

"MOONLIGHT IS SCULPTURE.

—NATHANIEL HAWTHORNE

OPPOSITE: **WINDANSEA BEACH, CALIFORNIA** | A couple looks out
at the ocean waters lit by radiant moonlight. | *Kris Bonnell*

153

RIGHT: GYEONGJU, SOUTH KOREA | Two trees stand in the rounded hills of the Daereungwon Tomb. | *Insung Jeon*

PAGE 156: SAN FRANCISCO, CALIFORNIA | Multicolored lights bring the night alive on a dance floor. | *Gina Ferazzi*

PAGE 157: HONG KONG | Yellow traffic lines, colored umbrellas, and the shop lights of Des Voeux Road create a vibrant city scene. | *Stefan Mokrzecki*

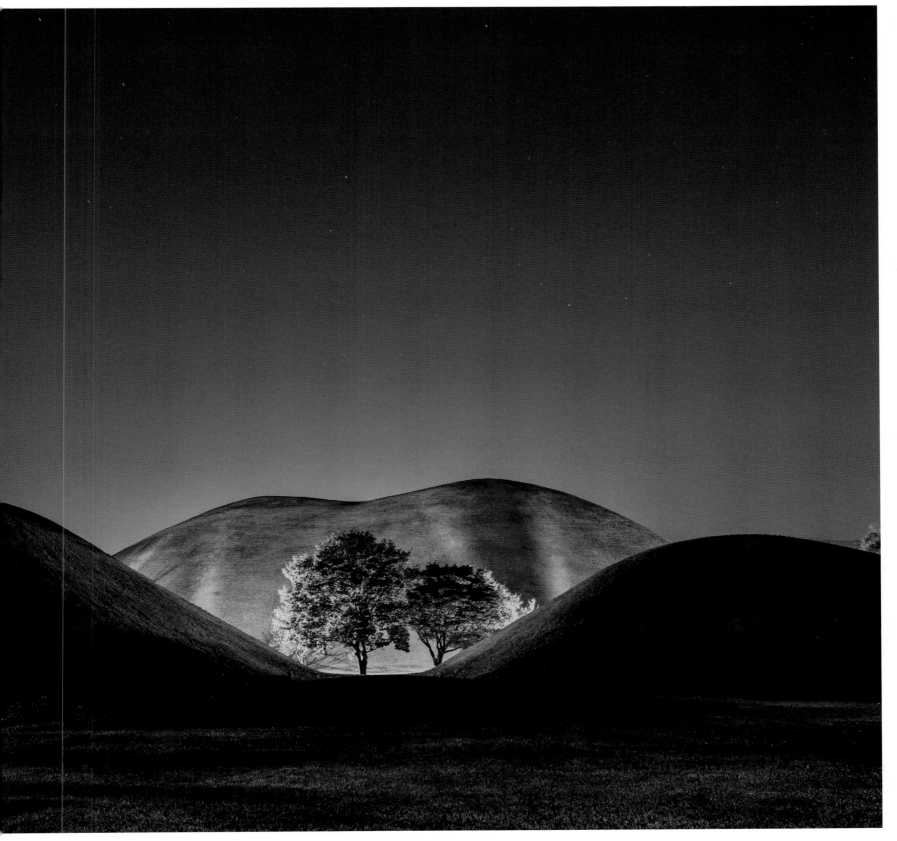

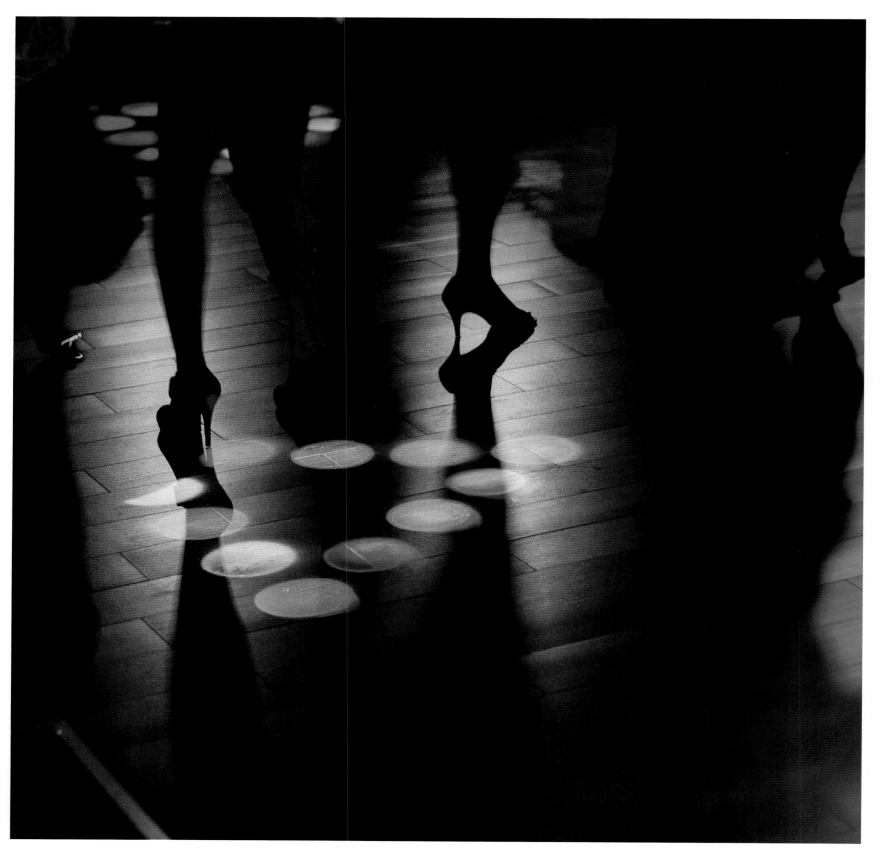

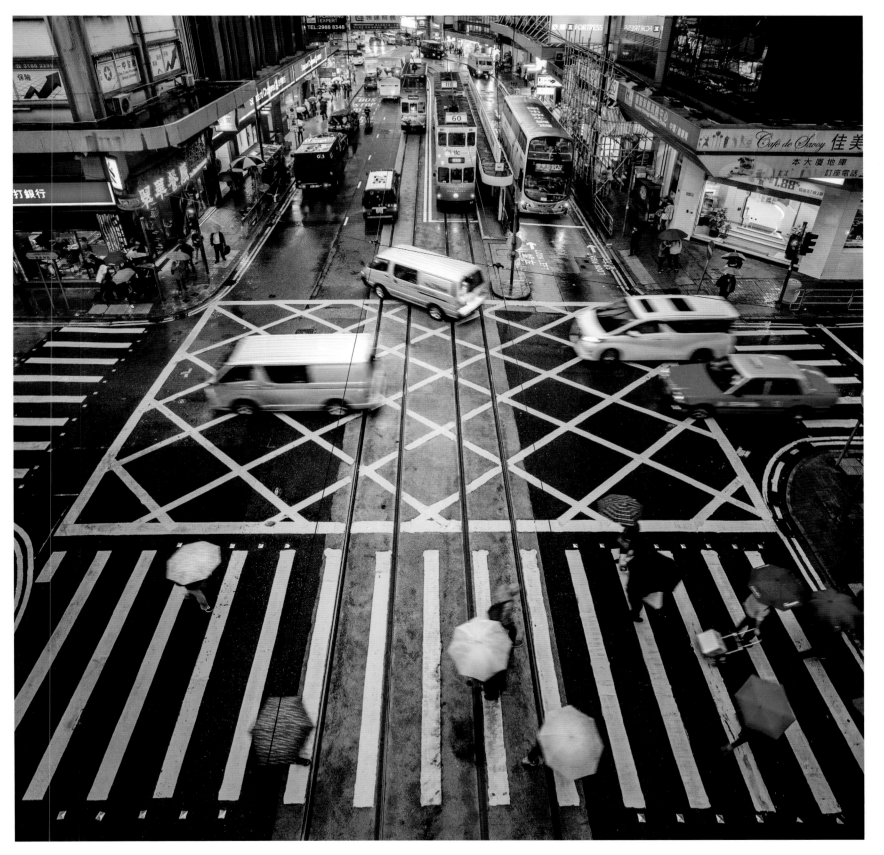

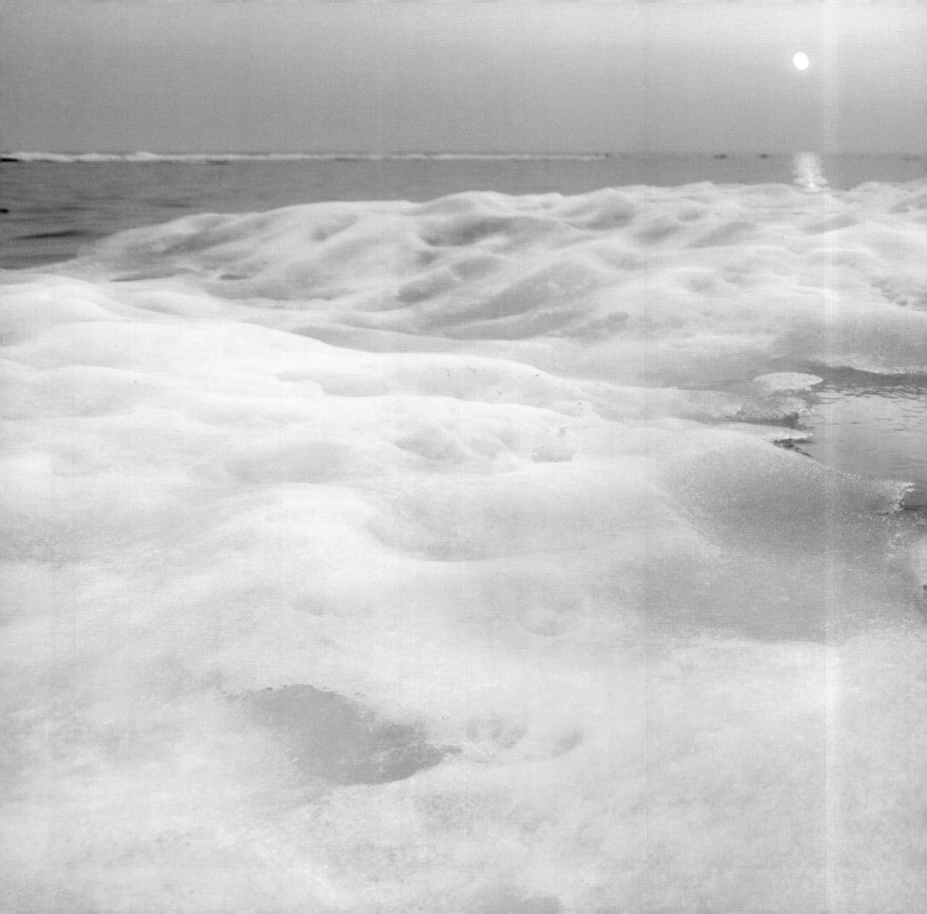

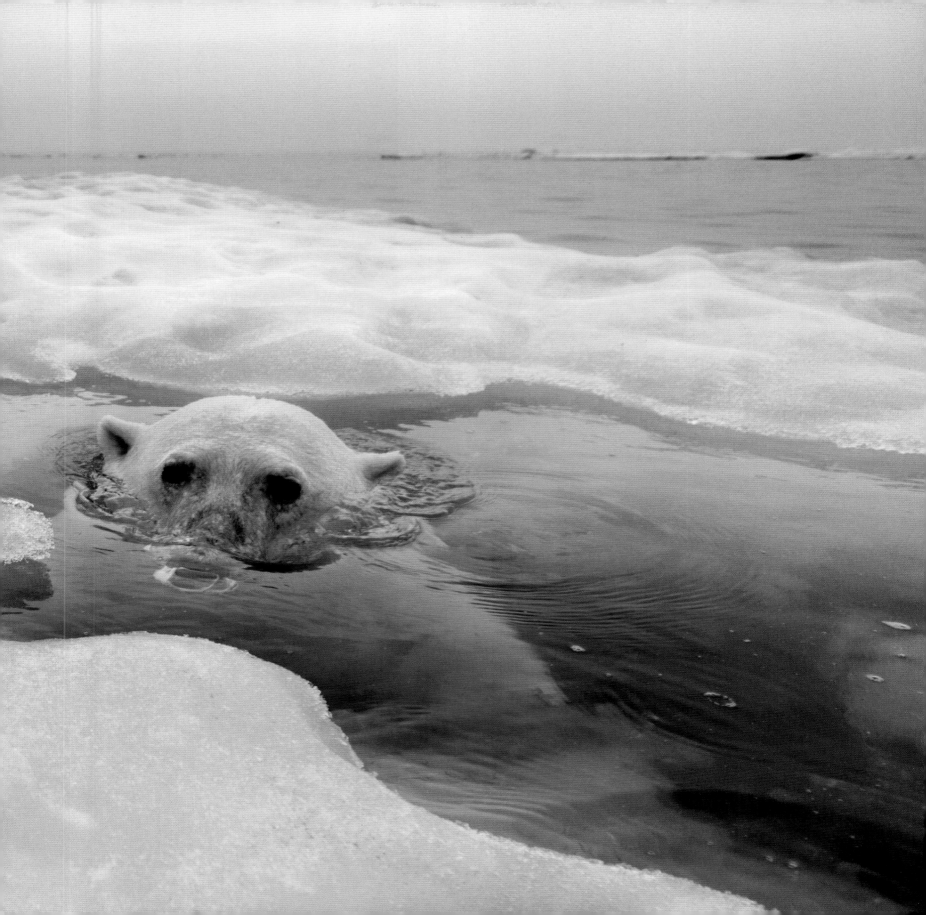

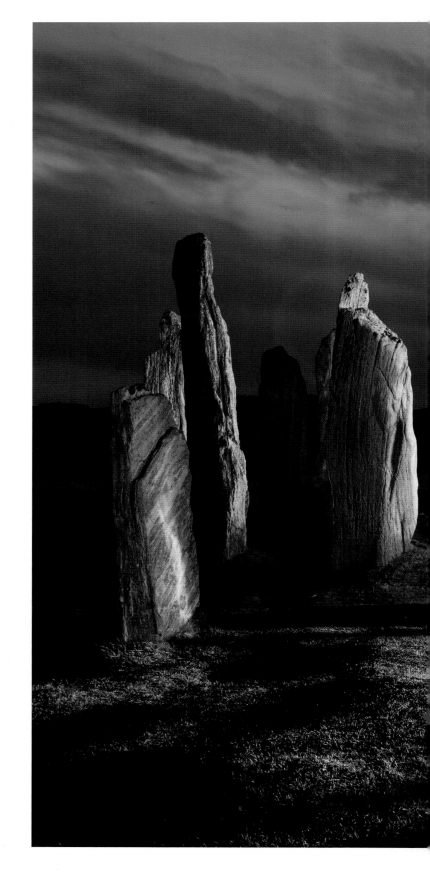

RIGHT: ISLE OF LEWIS, SCOTLAND | The Callanish Stones, an arrangement of late Neolithic standing stones on the Outer Hebrides, are thought to have kept astronomical time. | *David Clapp*

PREVIOUS PAGES: CHURCHILL, MANITOBA, CANADA | A polar bear peers up from a melting ice pack in the Hudson Bay during the region's long hours of summer, when daylight lasts well into the night. | *Paul Souders*

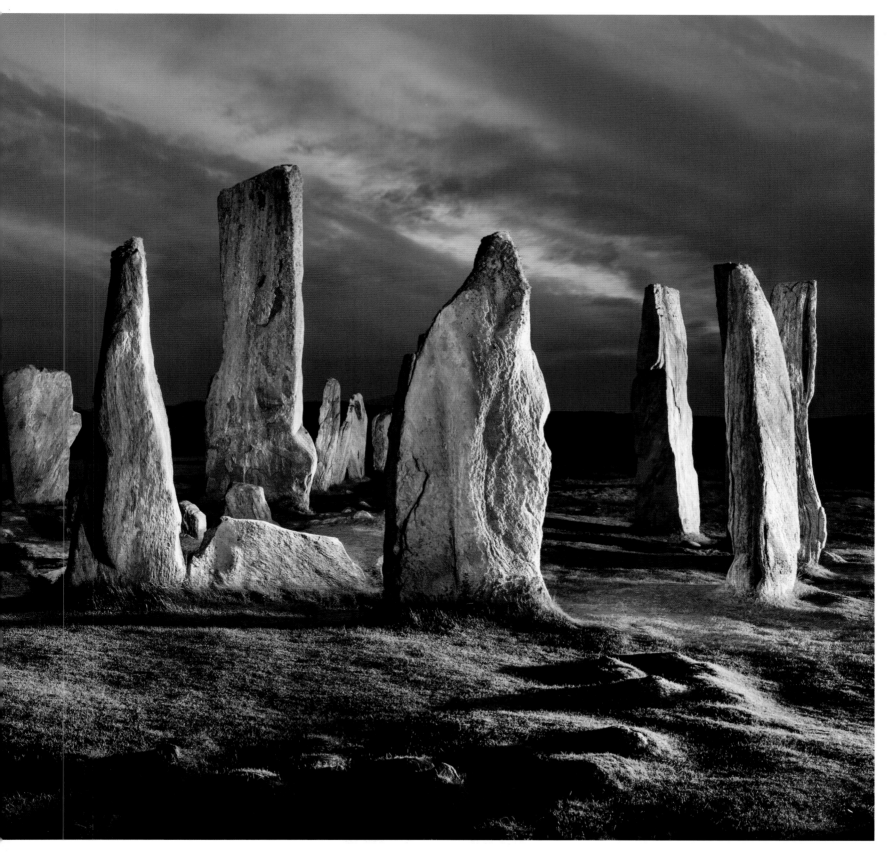

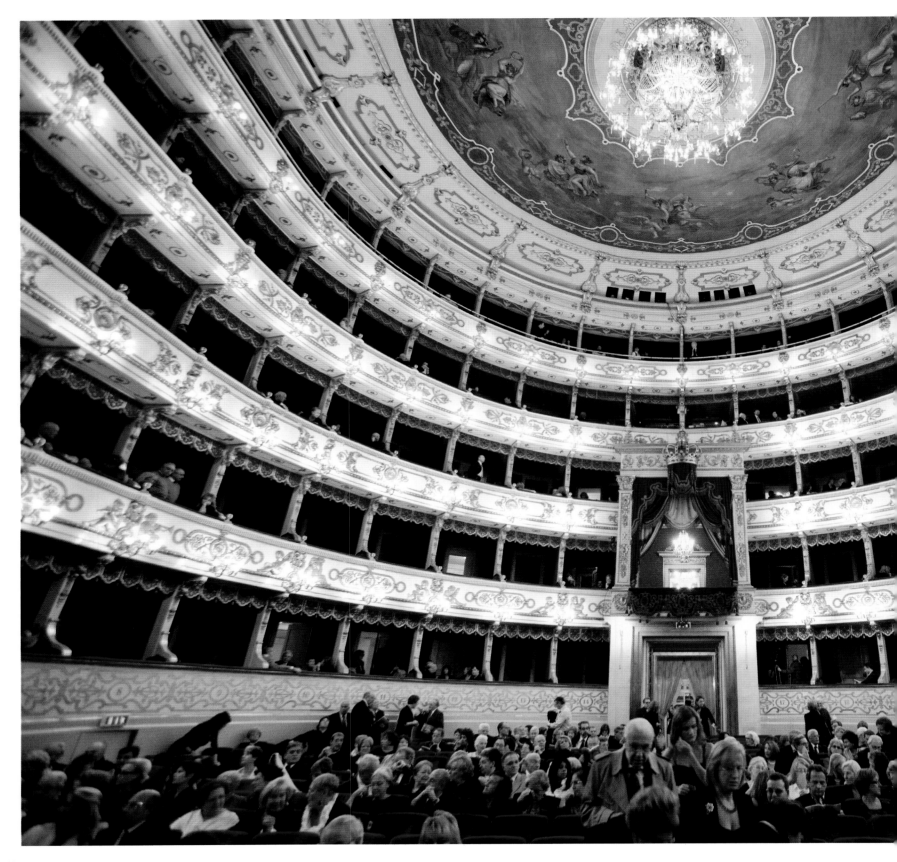

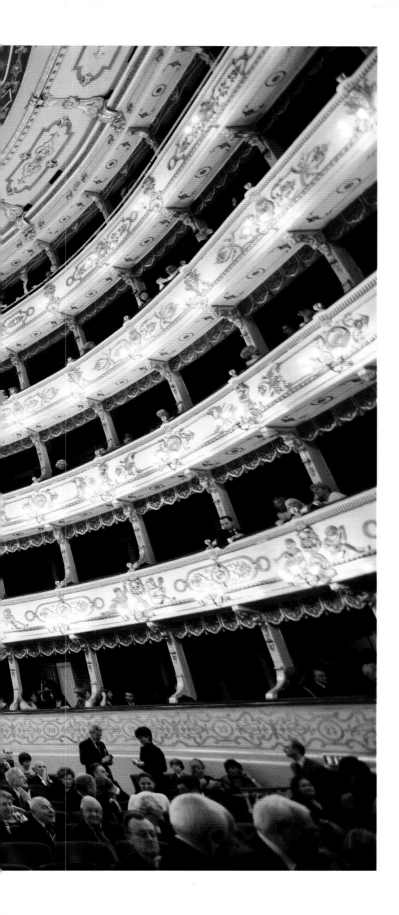

PARMA, ITALY | Concertgoers take their seats before a performance
of the works of Verdi at the Teatro Regio di Parma. | *Dave Yoder*

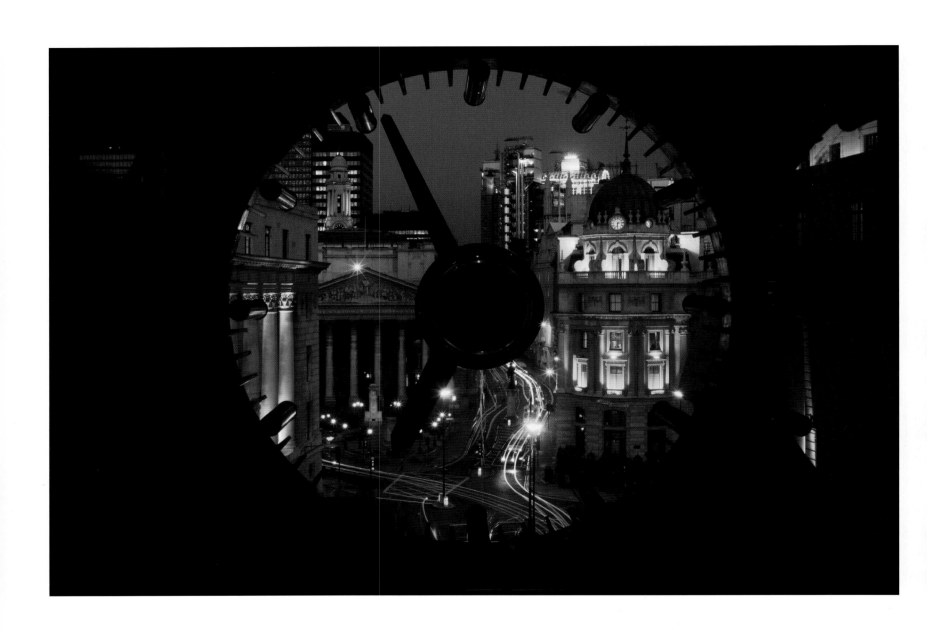

LONDON, ENGLAND | The lights of London's financial district shine
through the clock tower at the No 1 Poultry building. | *Richard Bryant*

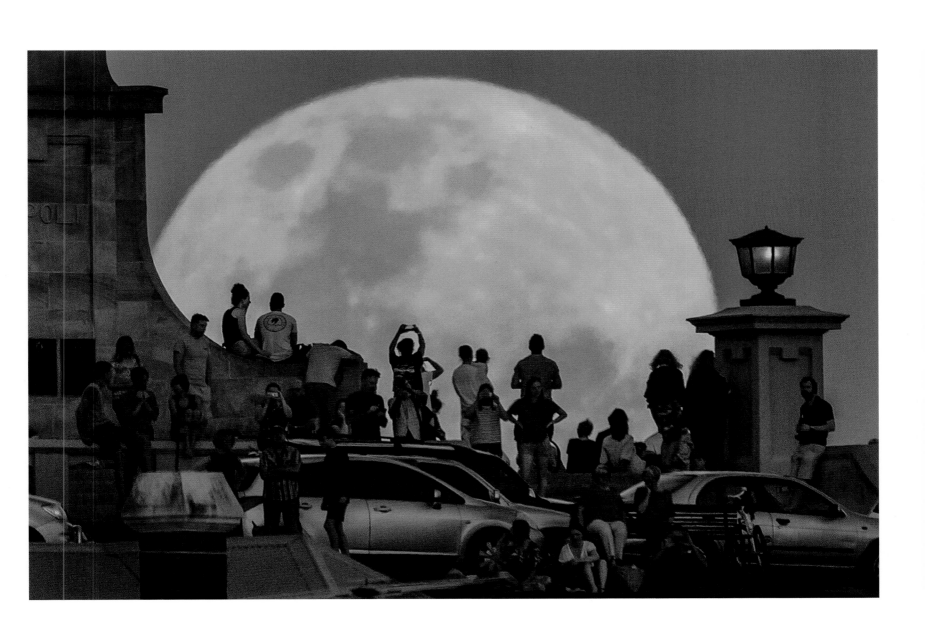

FREMANTLE, AUSTRALIA | Sky-watchers look out over a rising supermoon. | *Paul Kane*

" HALFWAY BETWEEN
THE DARK OF NIGHT AND
THE LIGHT OF MORNING,
ALL ANIMALS AND CRICKETS
AND BIRDS FALL INTO A
PROFOUND SILENCE AS IF
PRESSED QUIET BY THE DEEP
QUALITY OF THE BLACKEST
TIME OF NIGHT.

—ALEXANDRA FULLER

OPPOSITE: QUEEN ELIZABETH NATIONAL PARK, UGANDA | A lion climbs a tree
to find a safe sleeping spot. | *Joel Sartore*

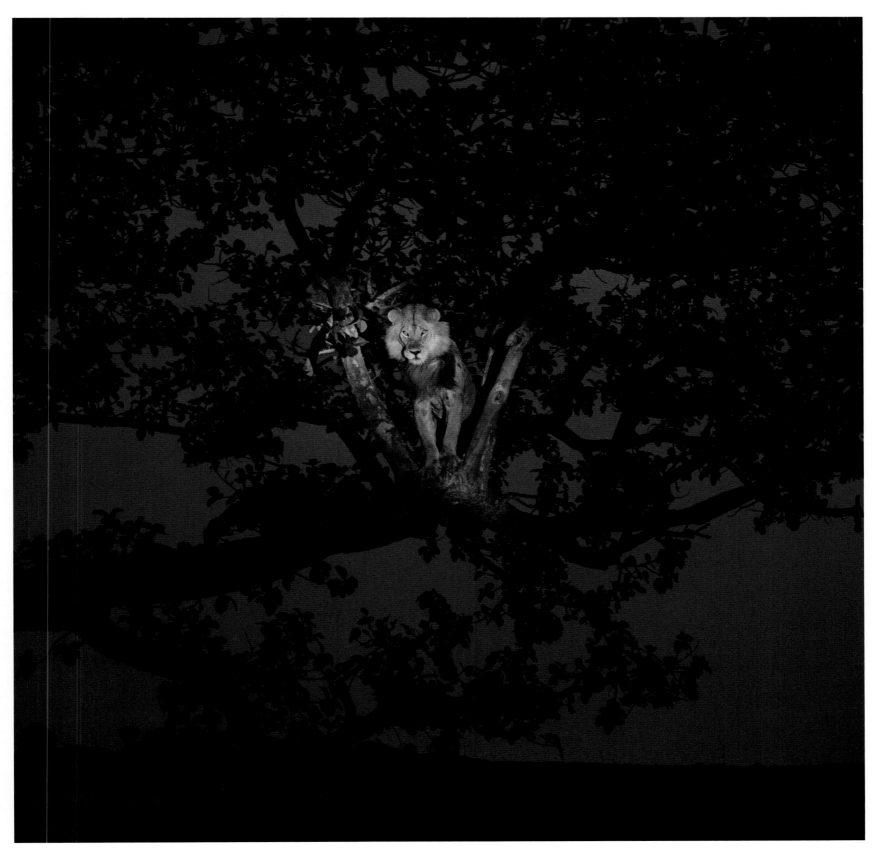

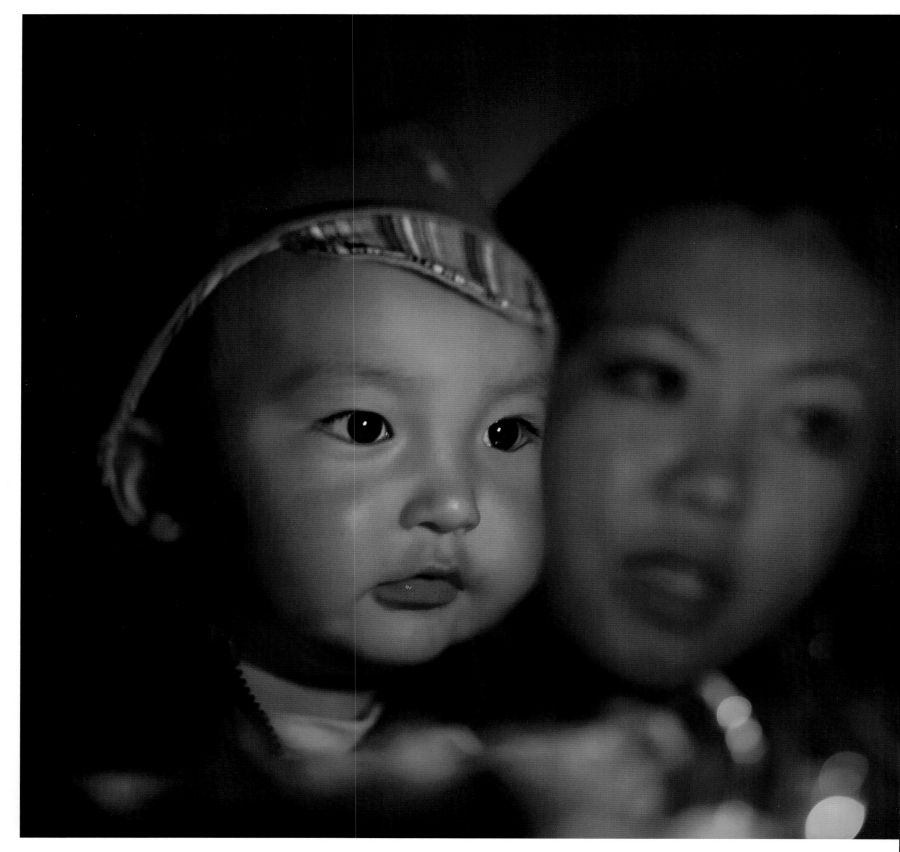

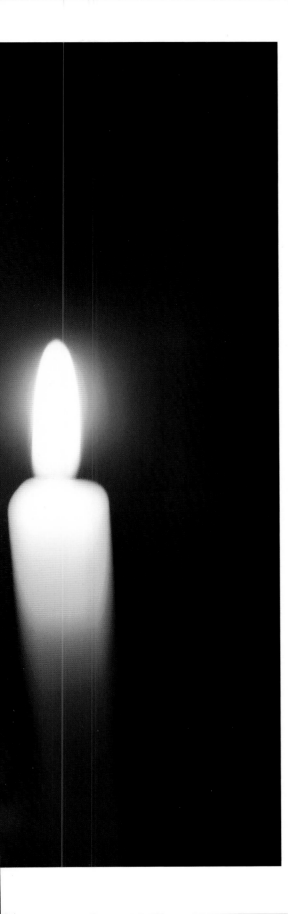

LEFT: BOKONBAYEVO, KYRGYZSTAN | A candle radiates warmth on the faces of a woman and infant. | *Sinue Serra*

FOLLOWING PAGES: GANGNEUNG, SOUTH KOREA | Rows of leafy green cabbage stretch toward the sea and darkening sky. | *Topic Images*

169

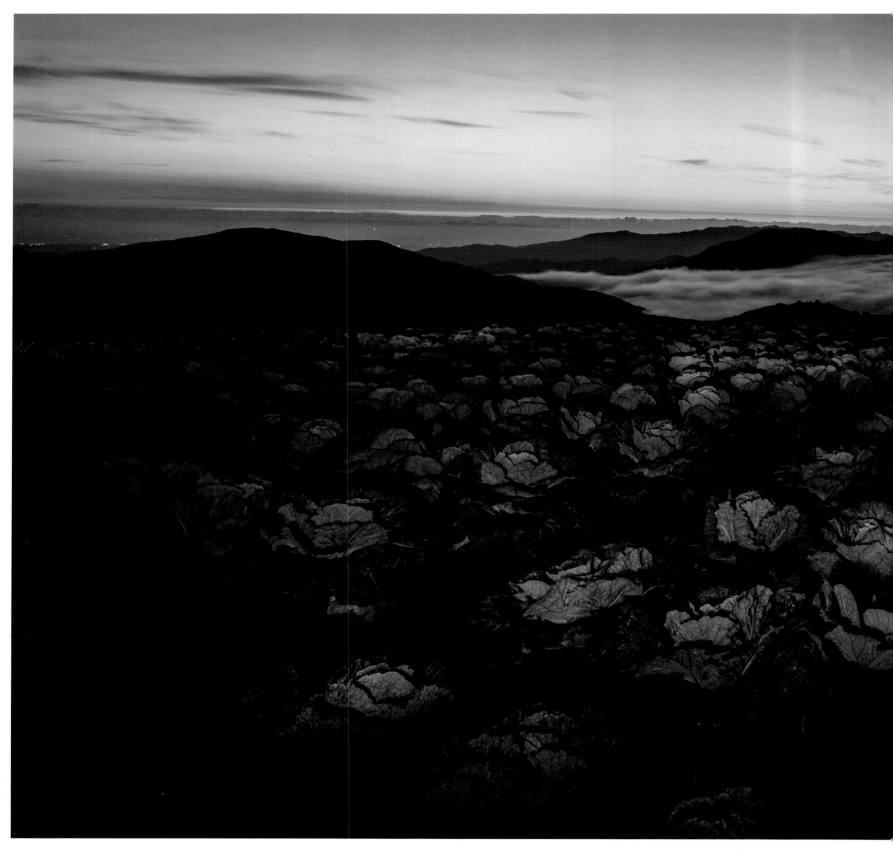

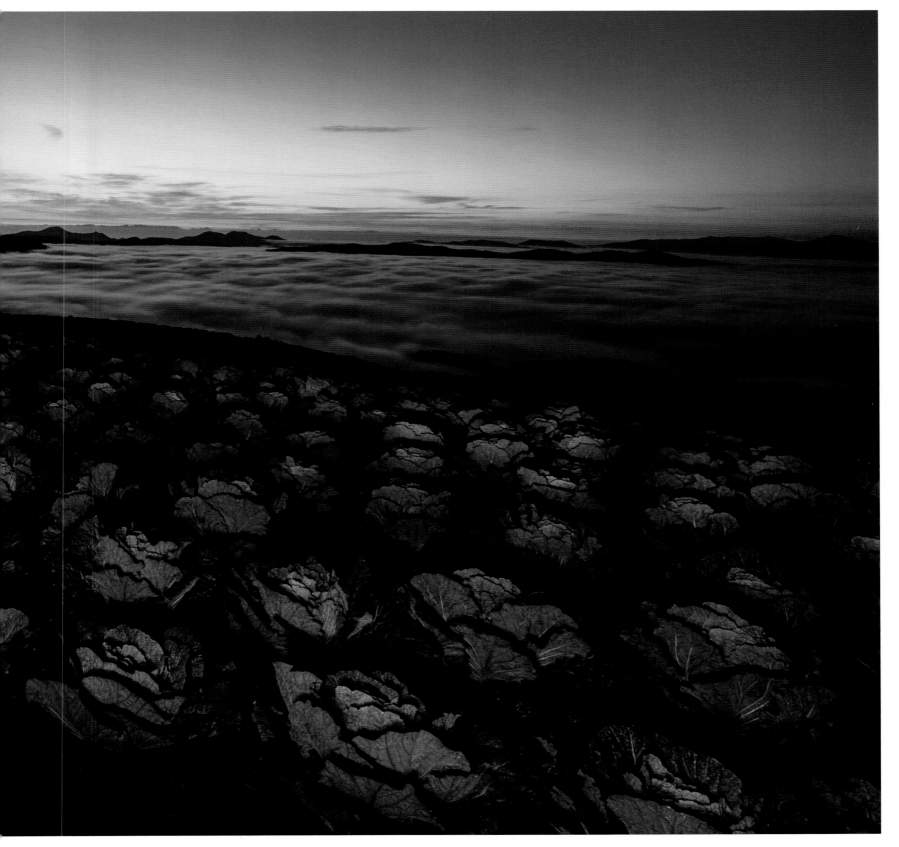

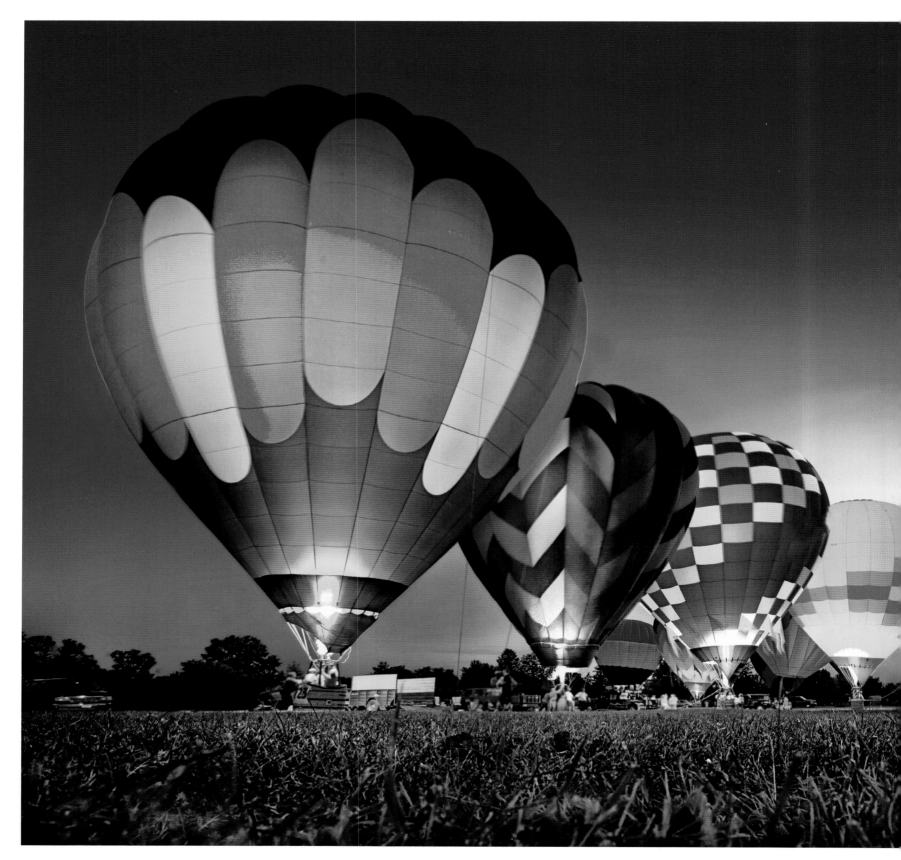

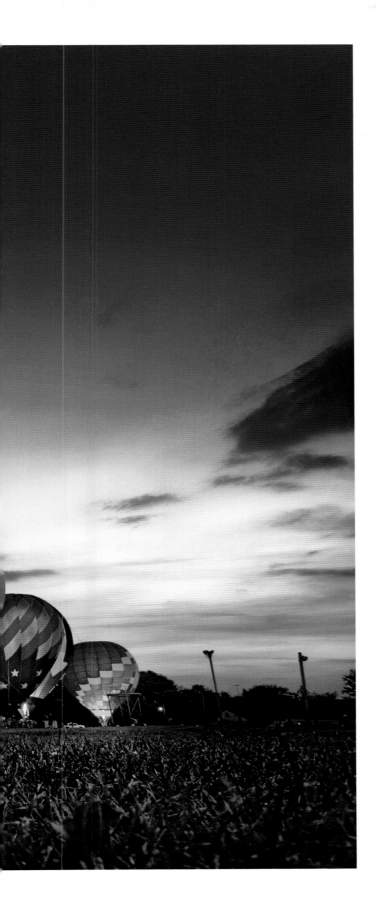

LEFT: **MONROE, WISCONSIN** | Colorful hot-air balloons await their riders in the cooling summer night. | *Matt Anderson*

PAGE 174: **MELBOURNE, AUSTRALIA** | A couple looks into a confectioner's display case, showcasing sweet cakes. | *Douglas Gimesy*

PAGE 175: **AGRA, INDIA** | A midnight view of the Taj Mahal provides time for quiet reflection. | *Per-Andre Hoffmann*

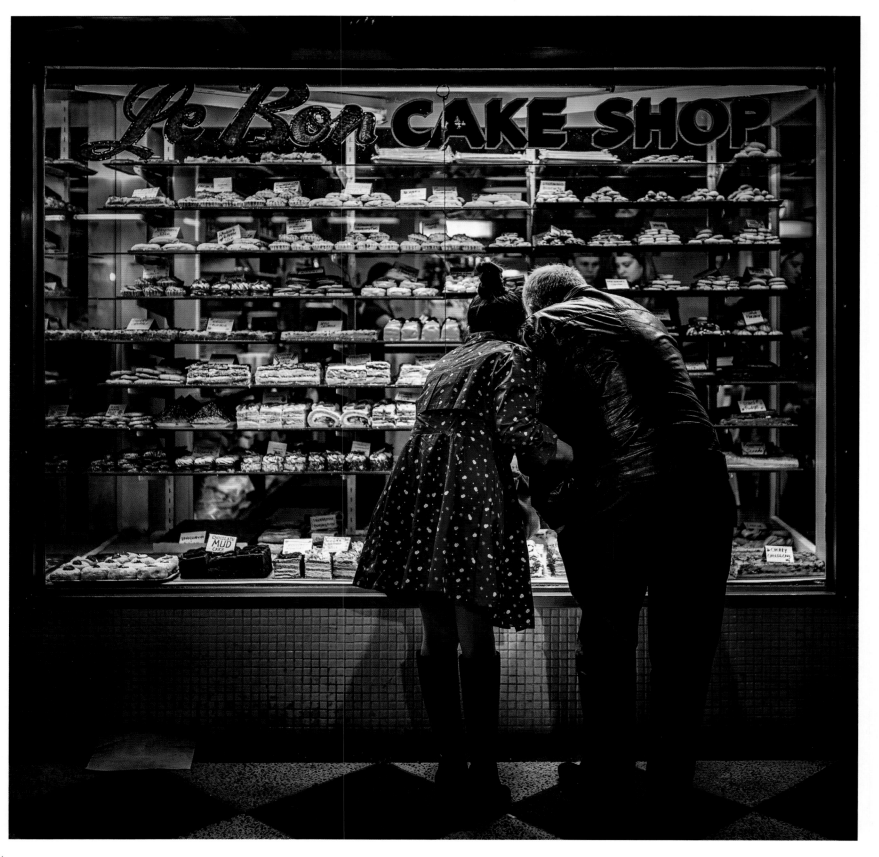

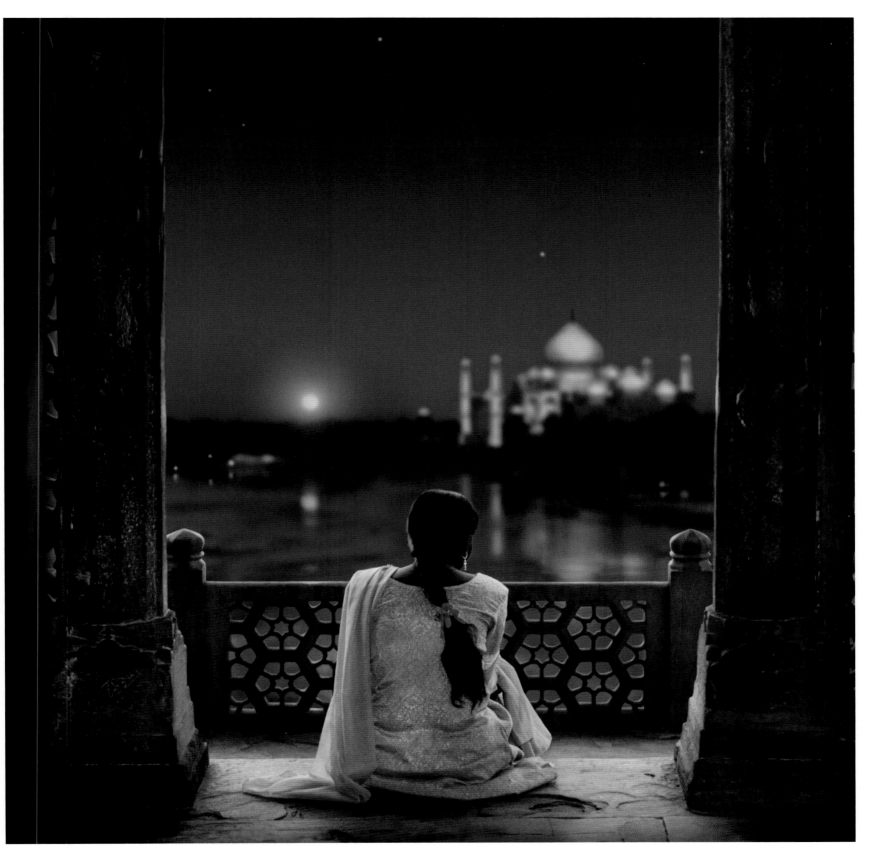

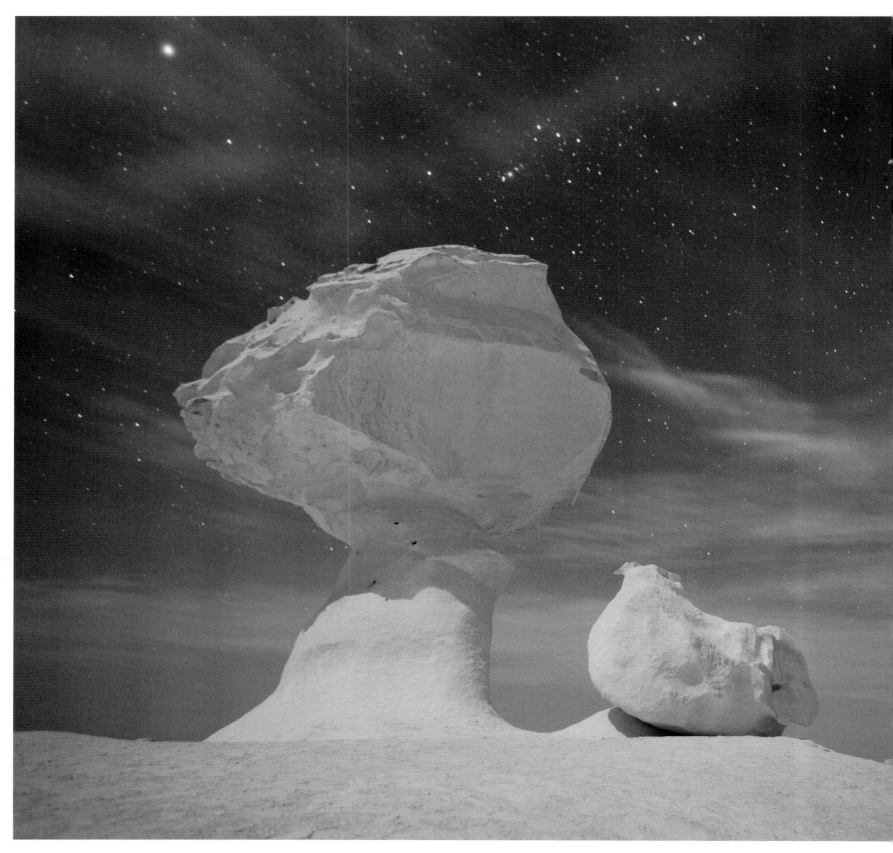

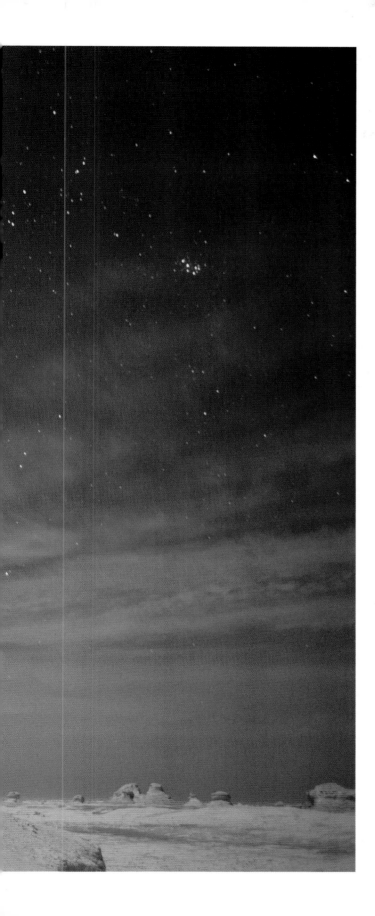

WHITE DESERT, EGYPT | Under a starry sky, the bright chalk spires of the White Desert look as if they belong in a lunar landscape. | *George Steinmetz*

" NIGHT WAS COME, AND
HER PLANETS WERE RISEN:
A SAFE, STILL NIGHT:
TOO SERENE FOR THE
COMPANIONSHIP OF FEAR.

—CHARLOTTE BRONTË

OPPOSITE: YALA NATIONAL PARK, SRI LANKA | A Buddha statue watches
over the Sithulpawwa rock temple. | Steve Winter

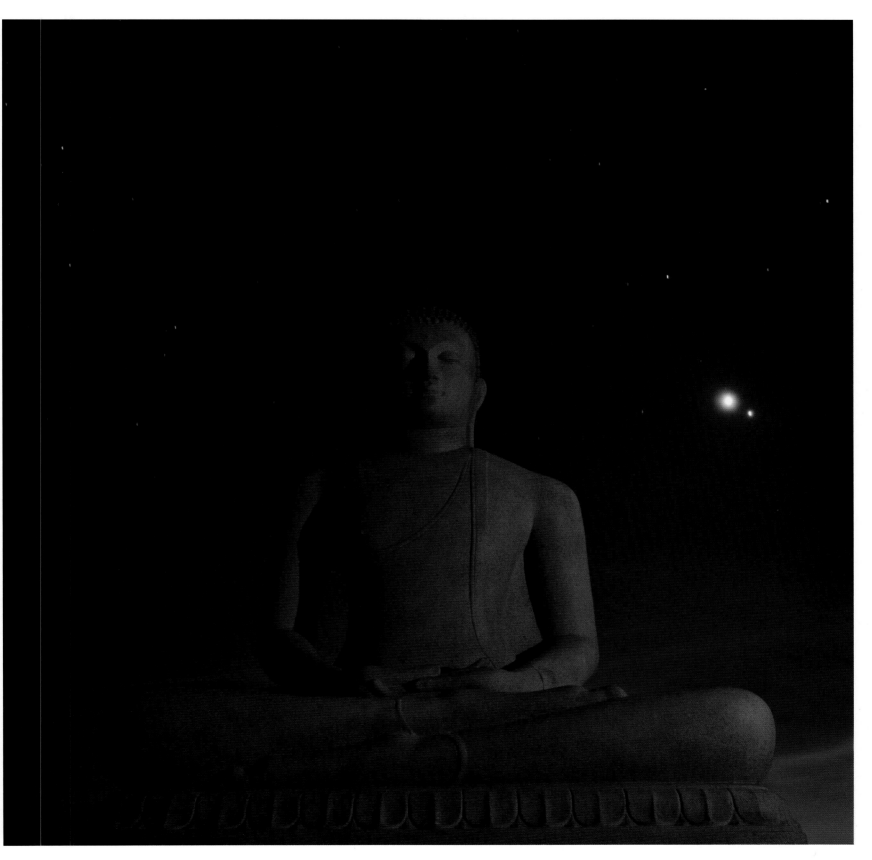

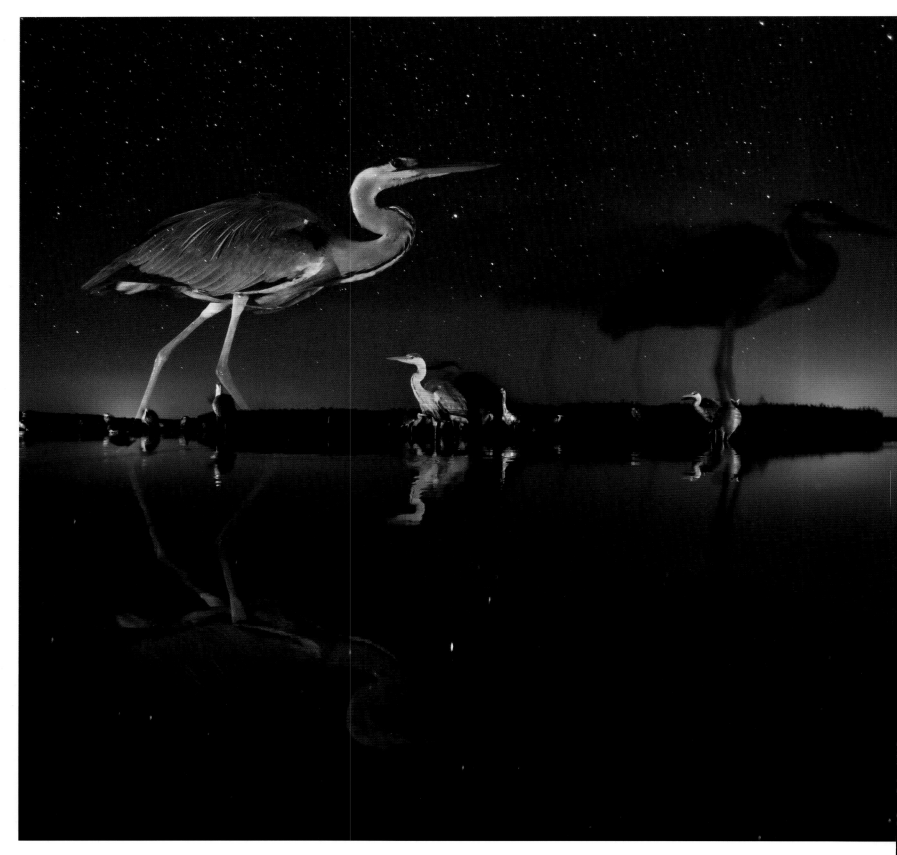

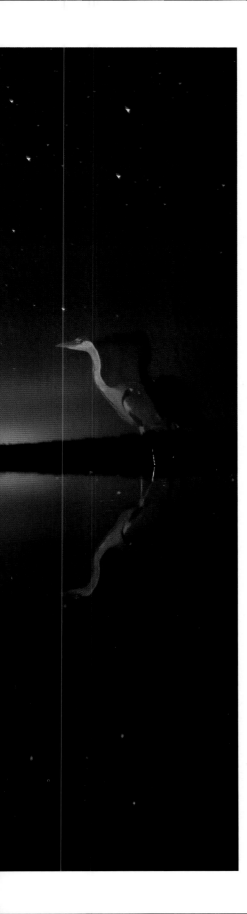

KISKUNSÁG NATIONAL PARK, HUNGARY | Herons take
to the still waters of Lake Csaj. | *Bence Mate*

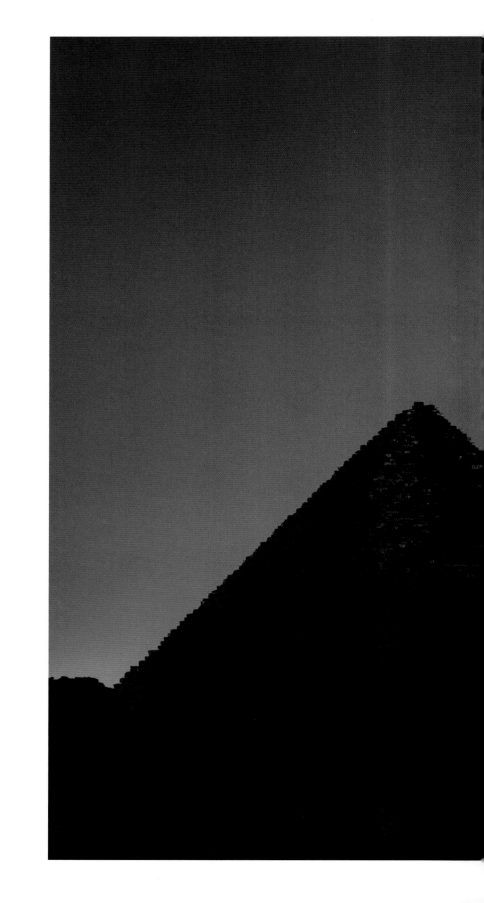

RIGHT: **GIZA, EGYPT** | The lights of Cairo turn the Pyramids at Giza into stunning silhouettes. | *David Degner*

FOLLOWING PAGES: **BALTIMORE, MARYLAND** | Created to promote a 1998 show at the American Visionary Art Museum, the Love sign continues to brighten the night. | *Tom Gregory*

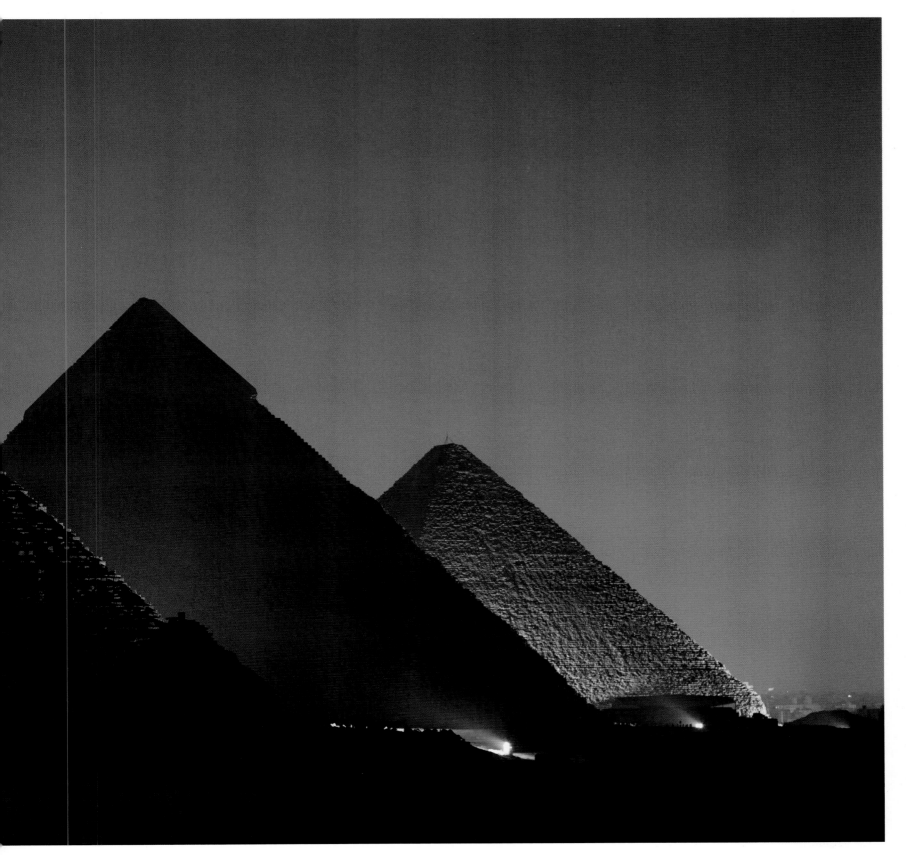

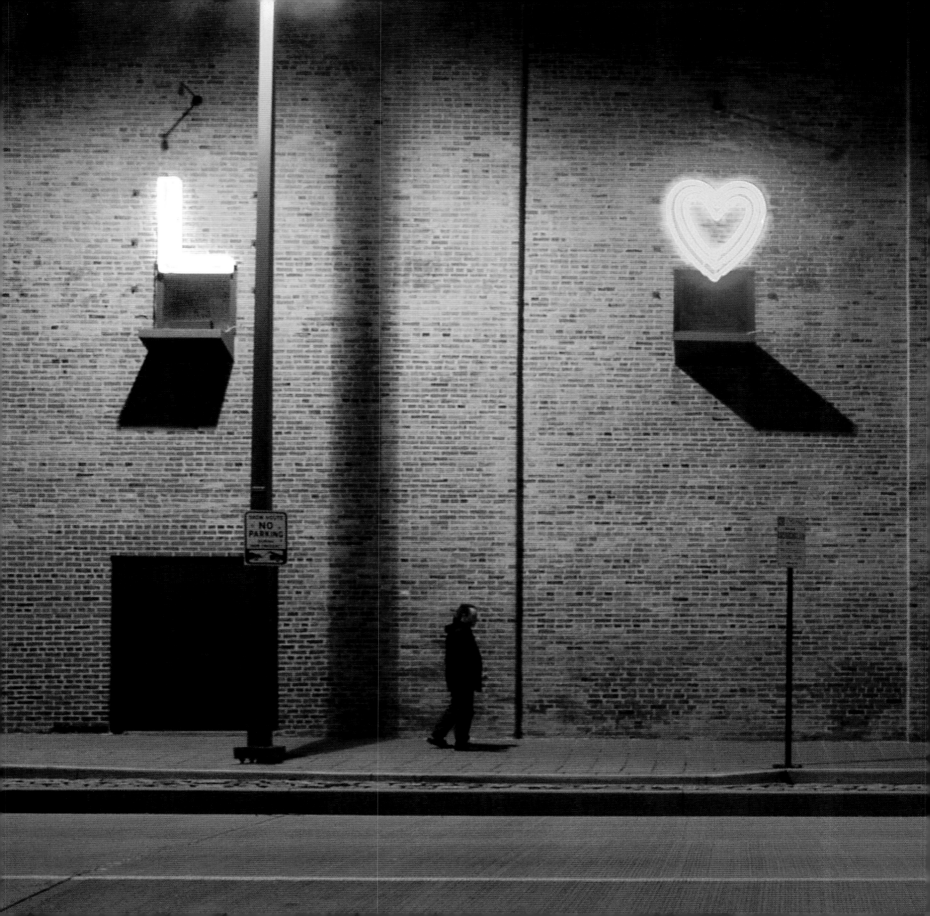

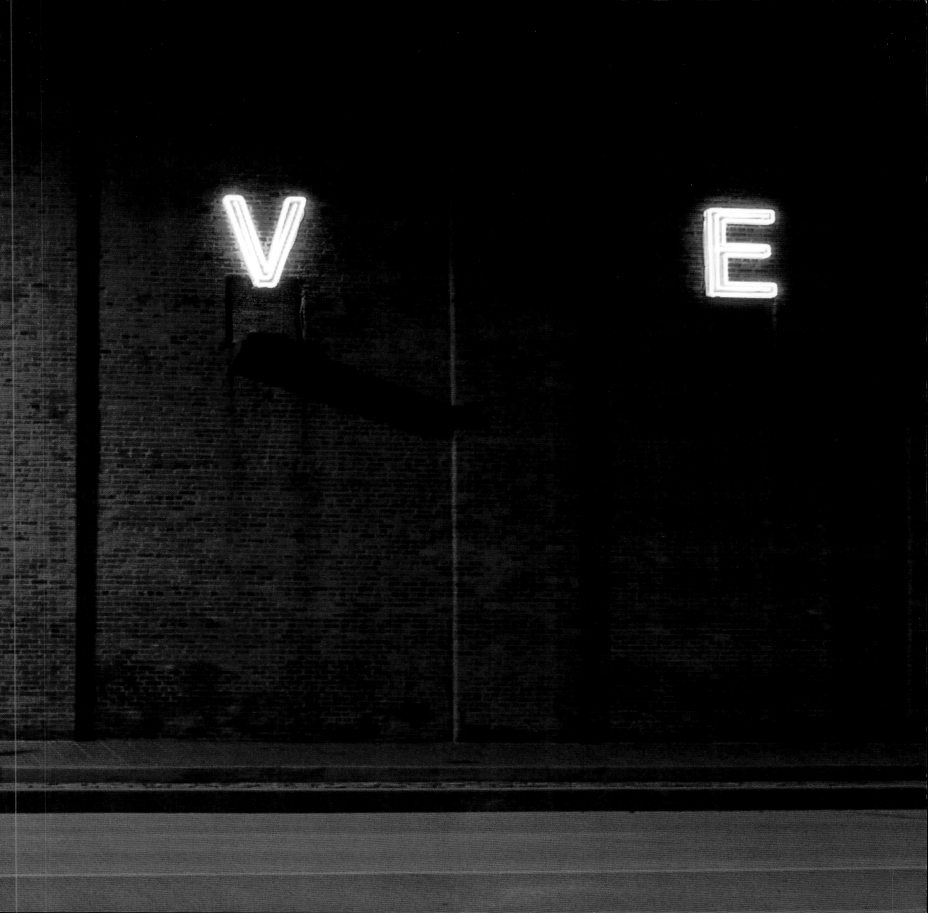

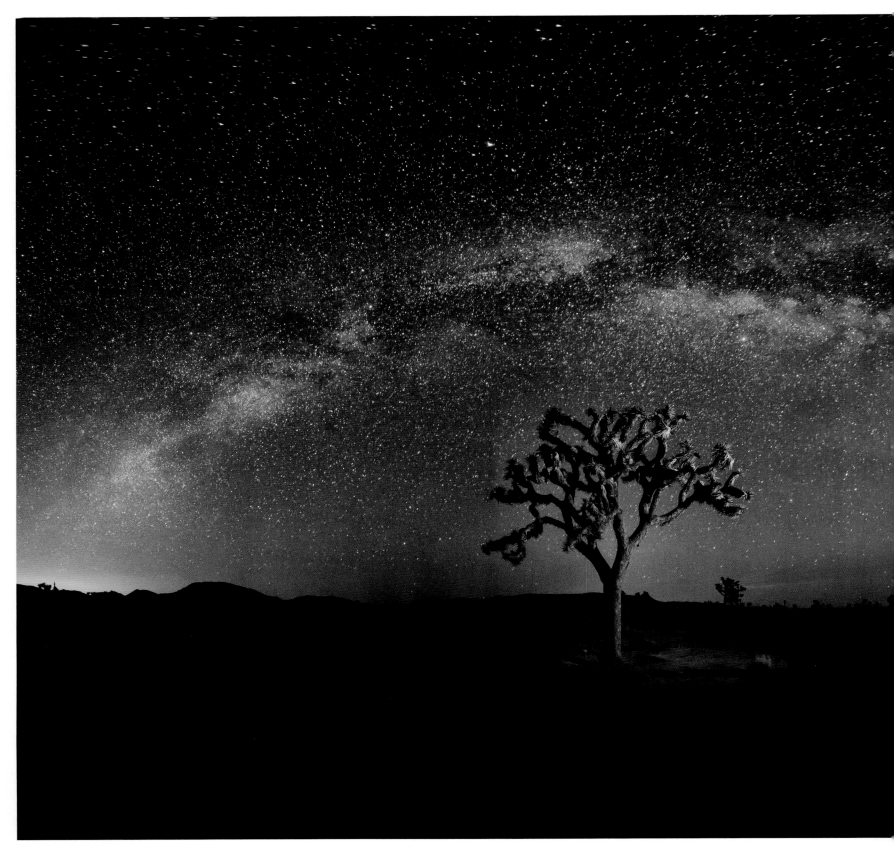

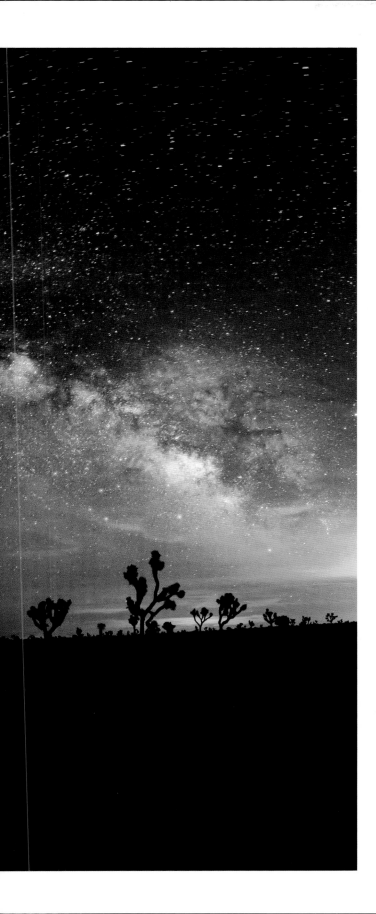

JOSHUA TREE NATIONAL PARK, CALIFORNIA | The Milky Way galaxy provides
a galactic frame for a solitary Joshua tree. | *Manish Mamtani*

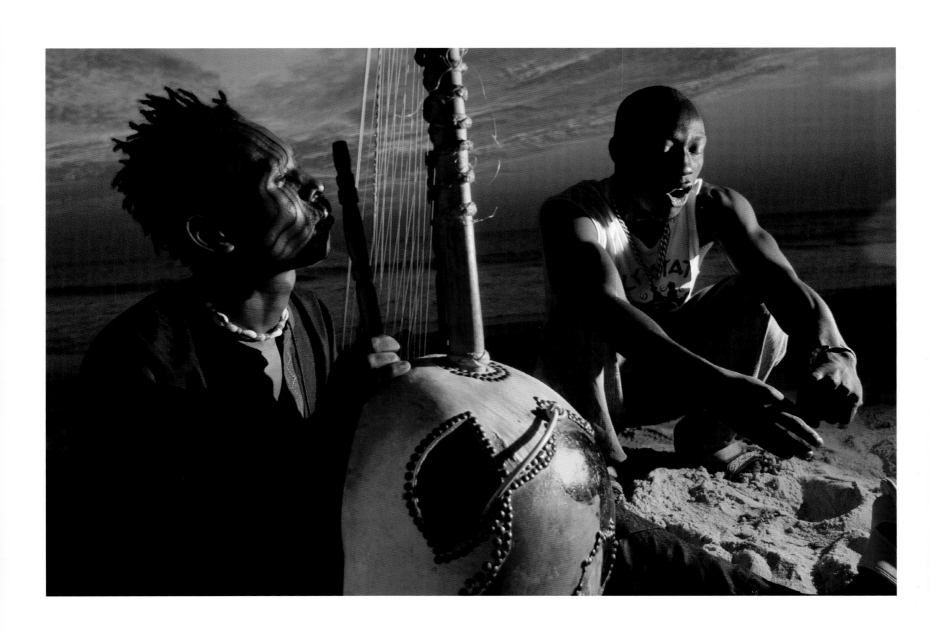

DAKAR, SENEGAL | As night arrives, musicians perform on the beach. | *David Alan Harvey*

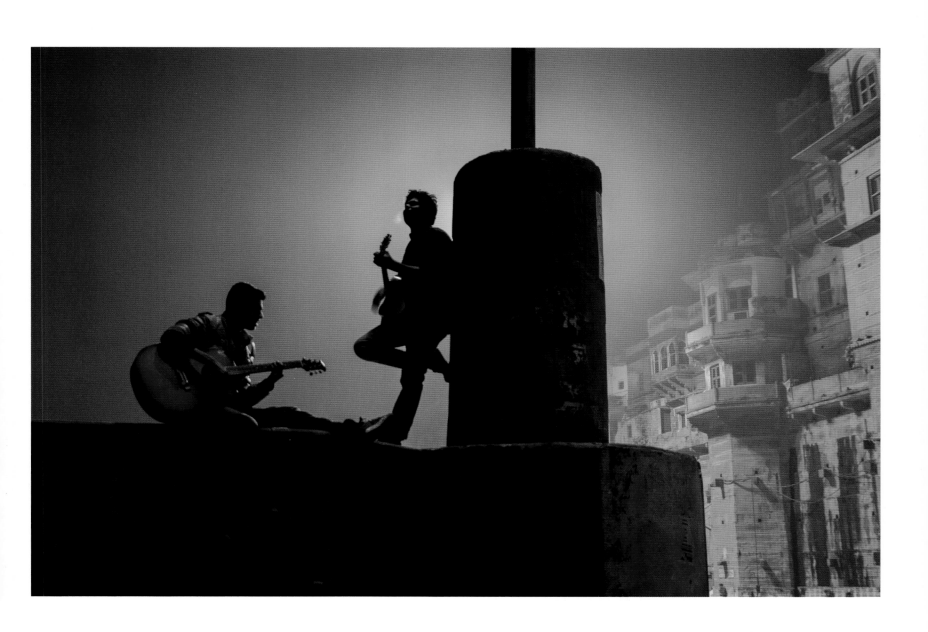

VARANASI, INDIA | Musicians head outside for a nighttime jam. | *Sankar Ghose*

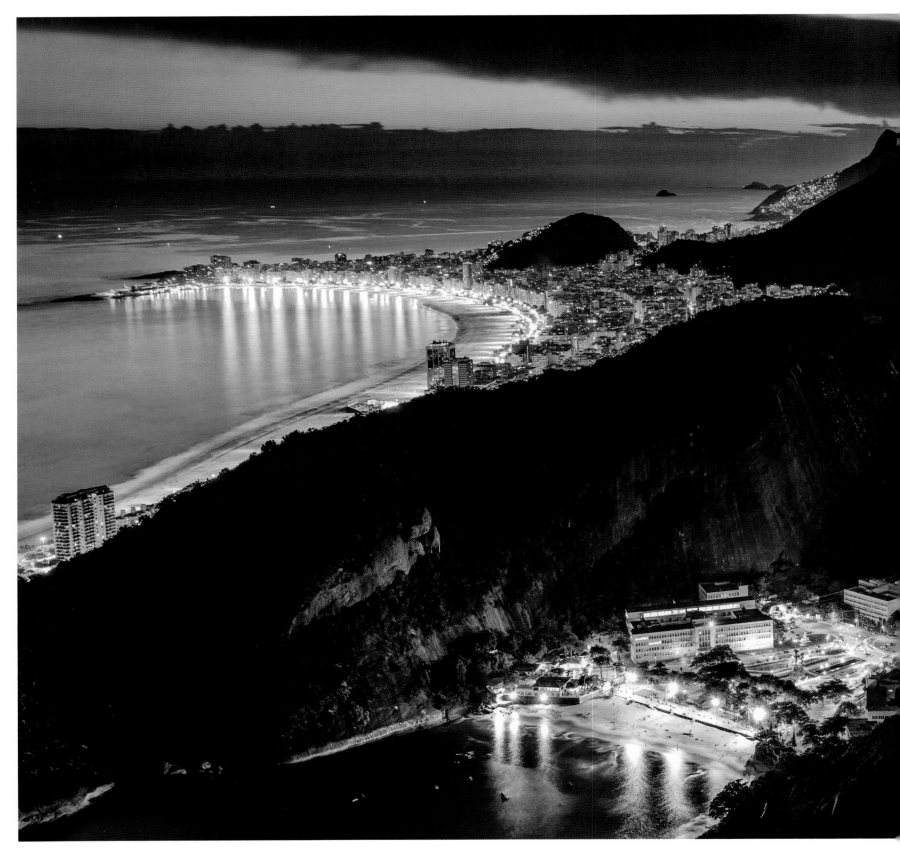

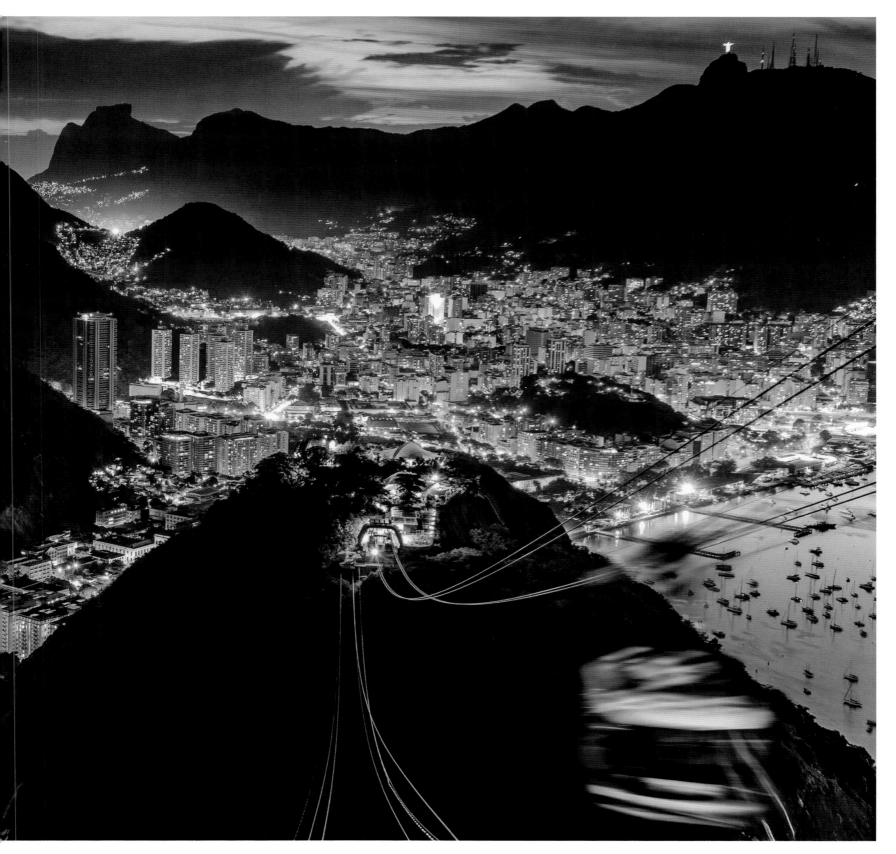

> **"THE LONGEST DAY
> AT LAST BENDS DOWN
> TO EVENING.**
>
> —JOHANN WOLFGANG VON GOETHE

OPPOSITE: **LOCATION UNKNOWN** | A ballerina uses a city bridge as her studio. | *Alexandra Petrakova*

PREVIOUS PAGES: **RIO DE JANEIRO, BRAZIL** | At night, the beach city comes to life between
the Atlantic Ocean and Sugarloaf Mountain. | *Antonino Bartuccio*

192

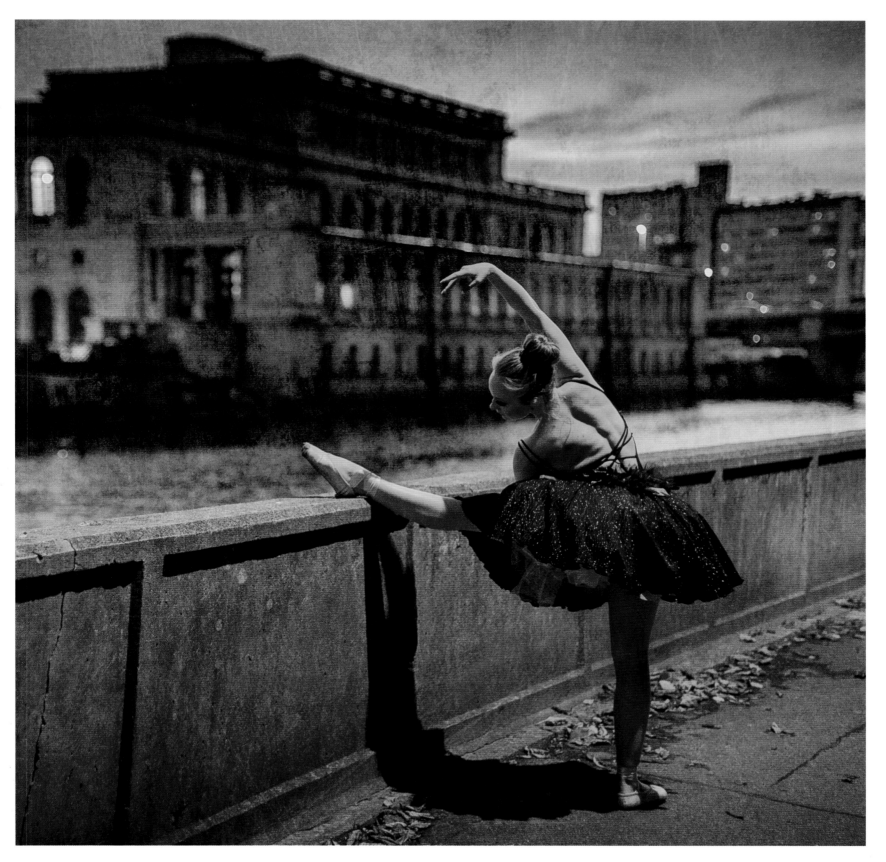

JERSEY CITY, NEW JERSEY | Rooftop water towers and
a crescent moon yield a study in shapes. | *Paul Souders*

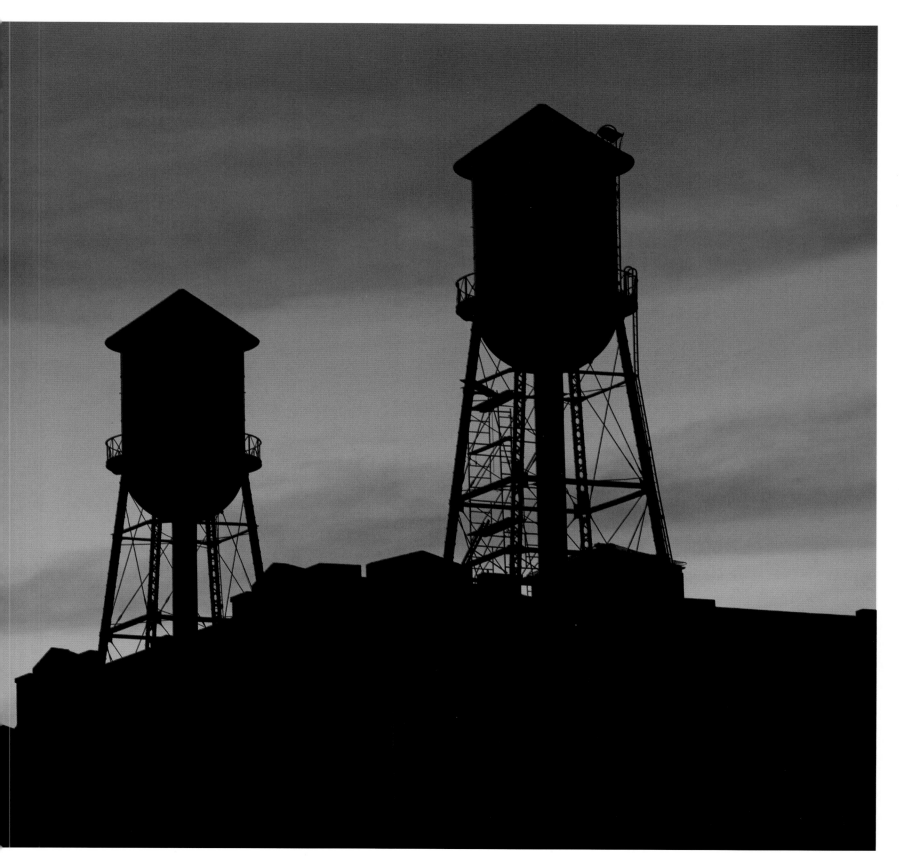

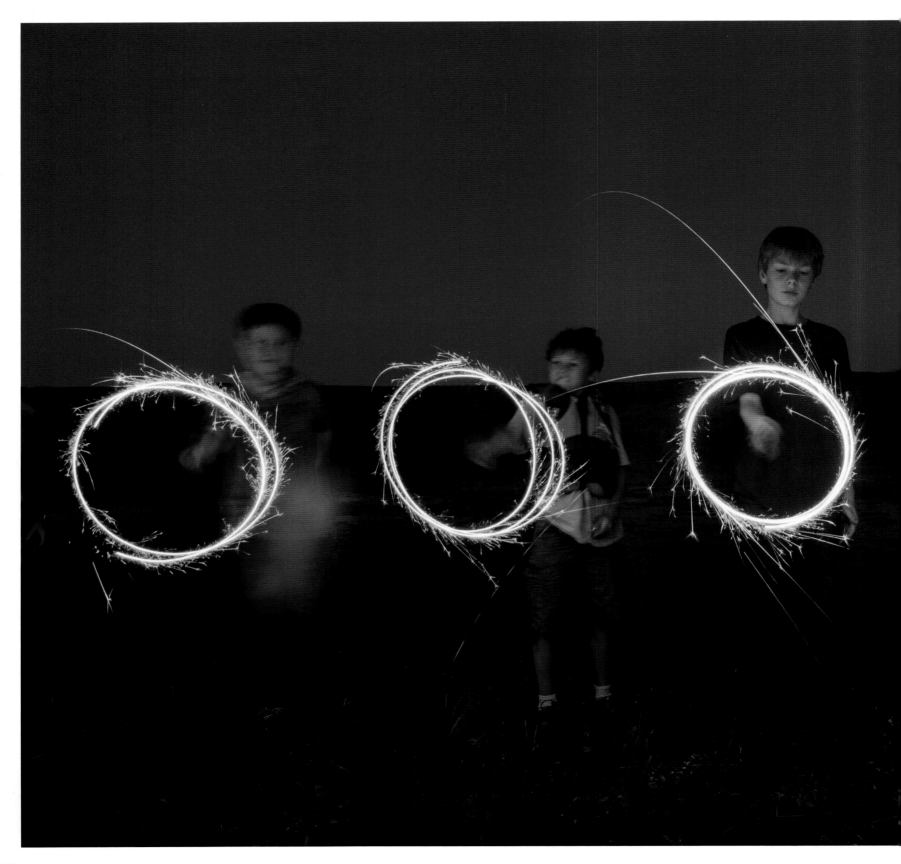

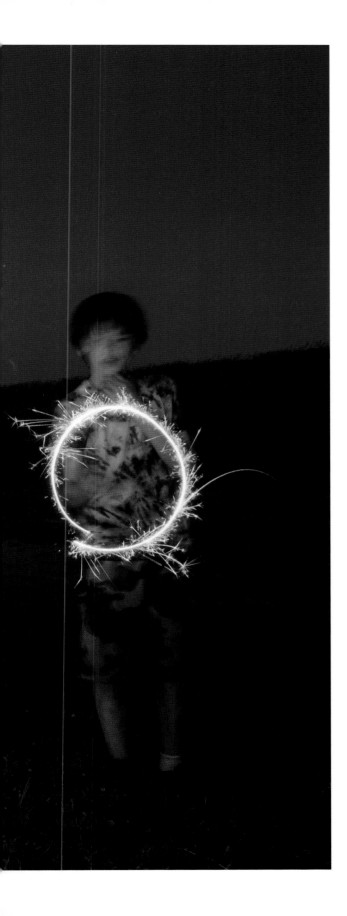

LEFT: **VALPARAISO, NEBRASKA** | Four boys turn sparklers into hoops in this long exposure. | *Joel Sartore*

PAGE 198: **PETER LOUGHEED PROVINCIAL PARK, ALBERTA, CANADA** | Large groupings of ice crystals on Upper Kananaskis Lake await the coming day. | *Wayne Simpson*

PAGE 199: **TAIPEI, TAIWAN** | A field full of calla lilies brightens a meadow. | *Hung Chei*

197

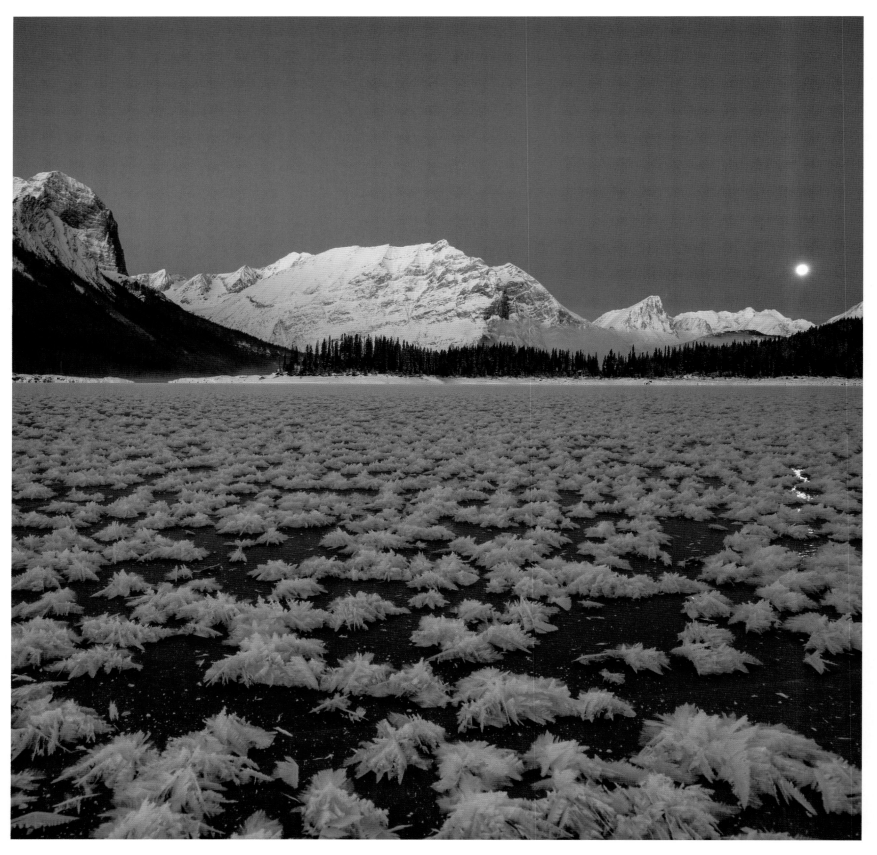

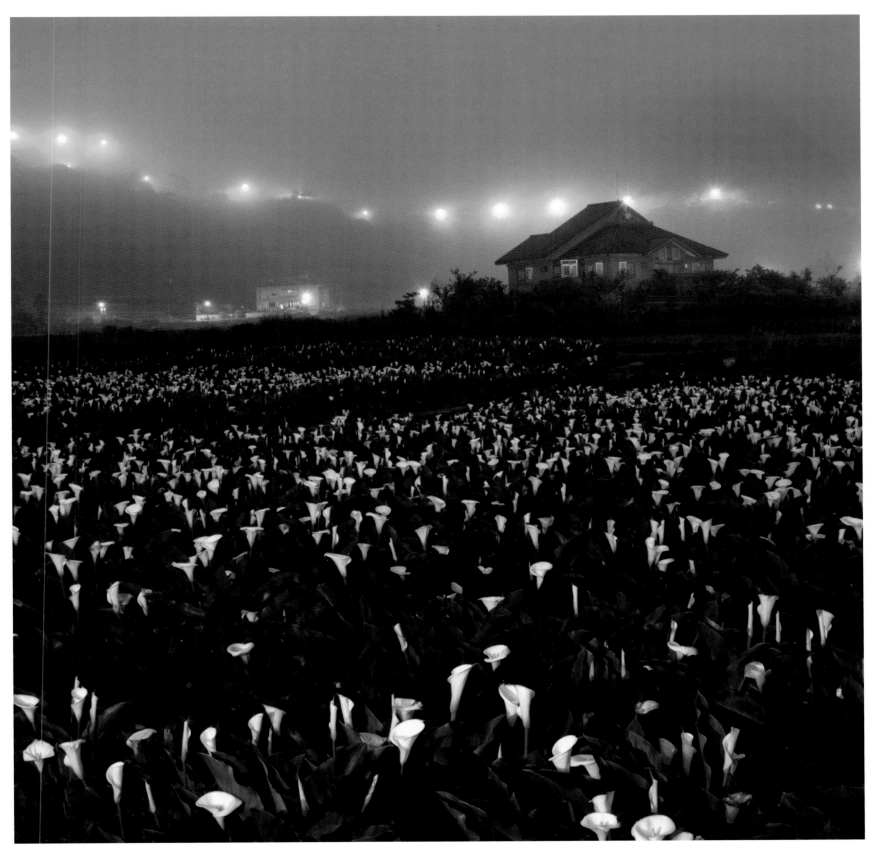

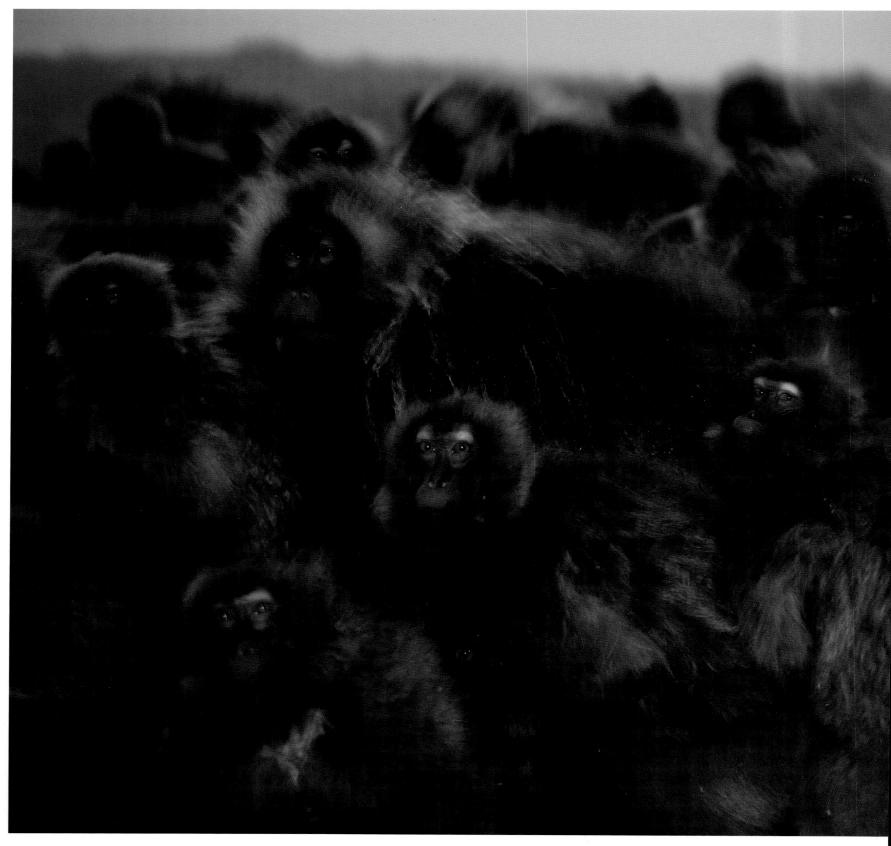

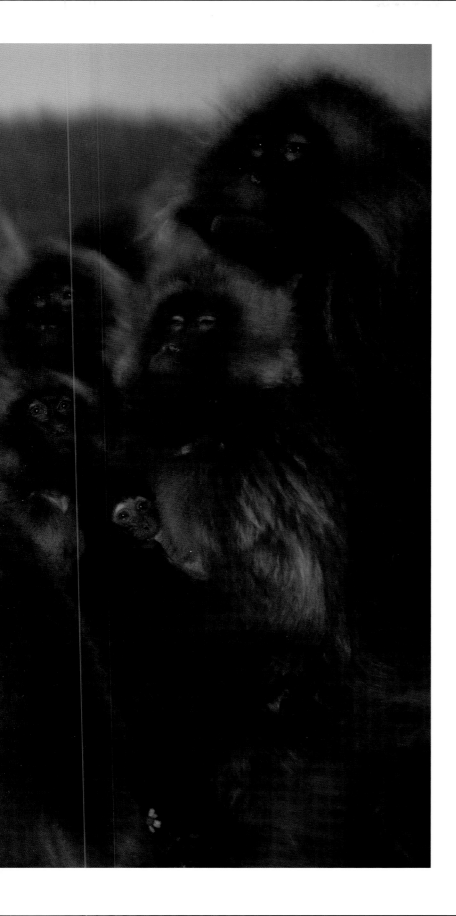

LEFT: **ETHIOPIA** | A family of gelada monkeys huddle to keep warm and safe from predators in the Ethiopian Highlands. | *Trevor Beck Frost*

FOLLOWING PAGES: **SEOCHEON-GUN, SOUTH KOREA** | An immense flock of Baikal teals takes wing in an indigo sky. | *Topic Images*

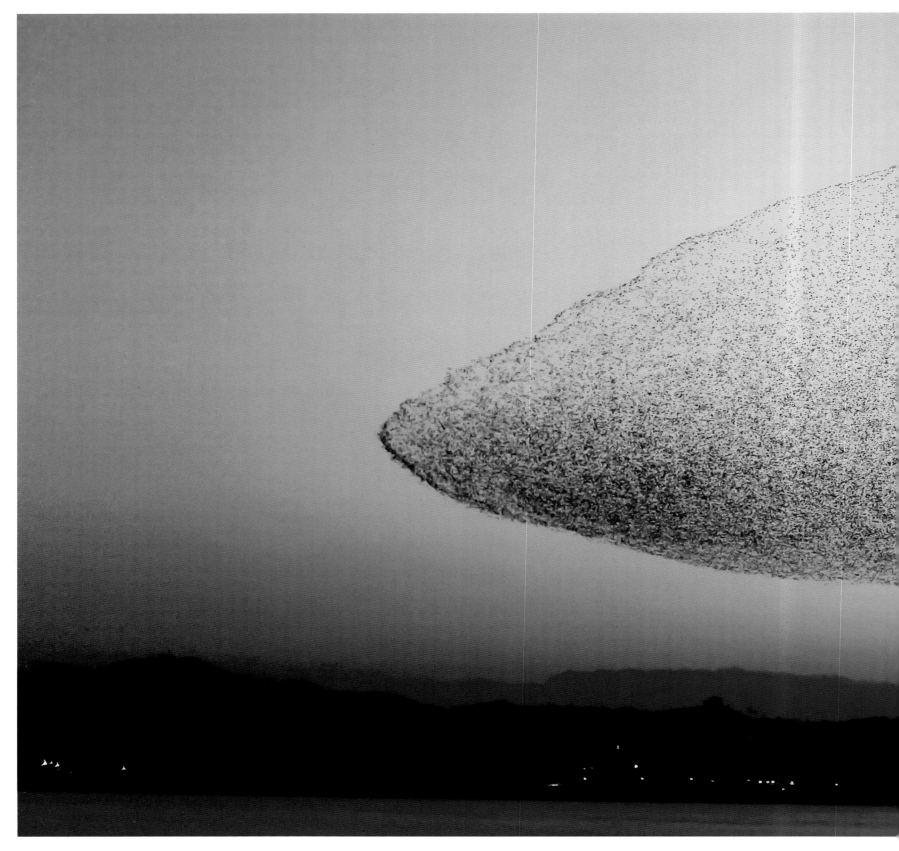

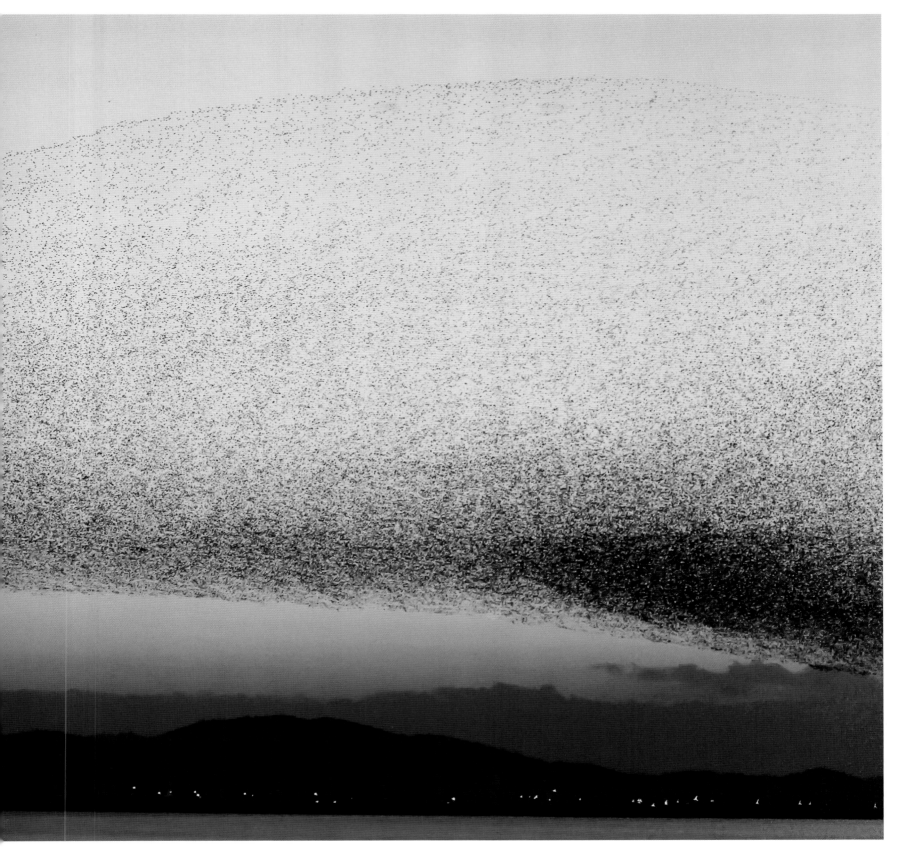

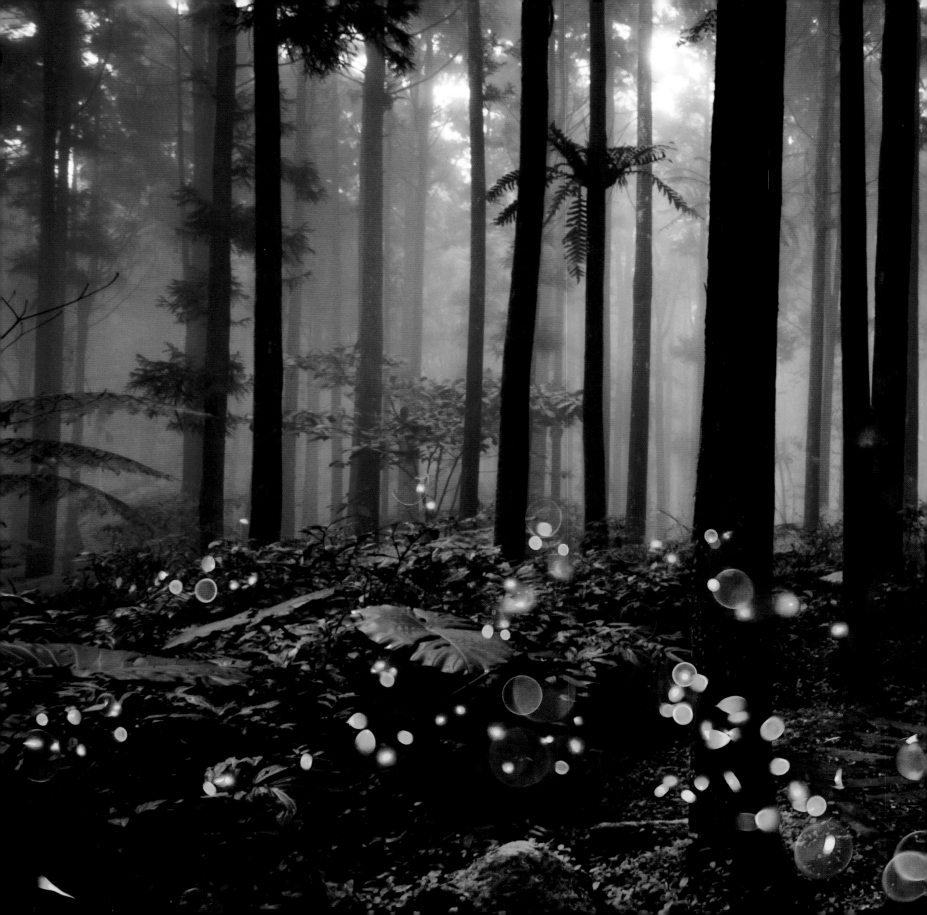

I CHAPTER THREE I

MYSTERY

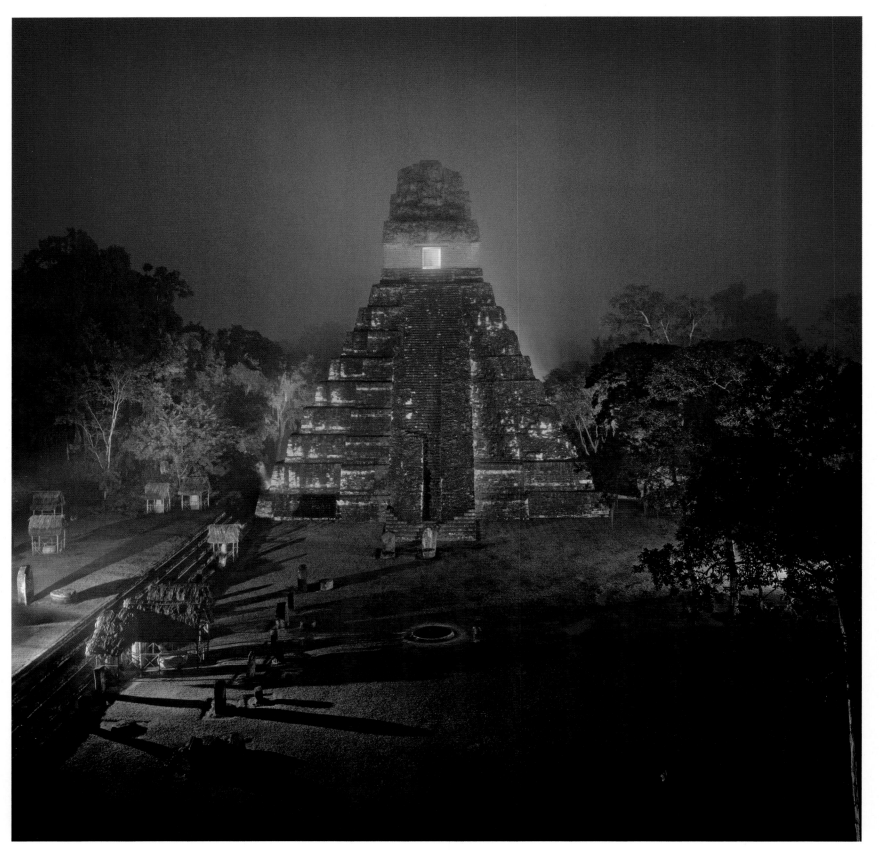

In the silence of night, there are secrets for which no one can find language. Try as we might to understand, the unknown engulfs us. Everyday locales—streets and sidewalks, bridges and buildings—reveal new magic, shades and shapes never seen in the light of day. Strangers pass by. Where are they going, what are they doing? Their eyes look beyond us. We dare not ask—and yet we already know.

And always, behind this passage of people, nature looks on, voicelessly representing the elements, the eternal, the sublime. Night can take daytime colors and infuse them anew, transmuting the ordinary into something we have never seen before. Then, it can splash those colors onto the palette of heaven. Were they there all along? They never showed through in broad daylight.

The sleek black crow observes, then wings away. The luna moth whispers its exquisite green. A spider weaves, and then centers and waits. Unimaginable life-forms swirl underwater.

Motionless stones and ever falling water speak ancient wisdom without words. Clocks tick on with a sound that assumes new meaning. The world of hustle and worry has faded away. Past, present, future—all coexist in night's mystery, inviting us to transcend the strictures of time.

OPPOSITE: **PETÉN, GUATEMALA** | Lights from the Temple of the Great Jaguar
cast a soft glow over the ancient Maya city of Tikal. | *Simon Norfolk*

PREVIOUS PAGES: **TAICHUNG, TAIWAN** | Fireflies transform a forest floor into a surreal light show. | *Htu*

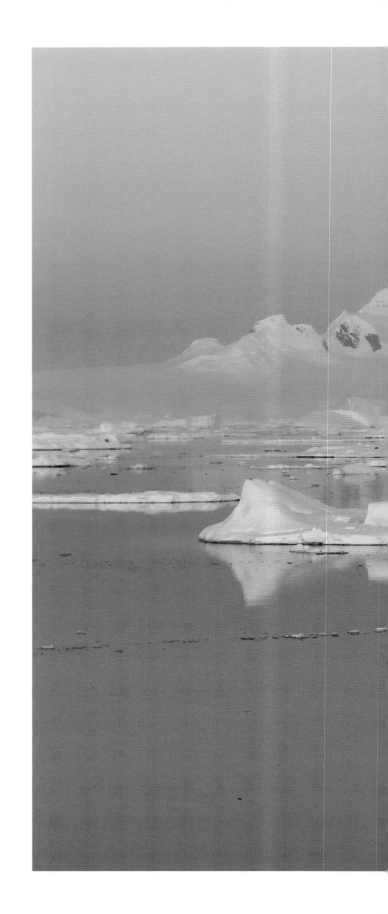

ANTARCTICA | A few penguins stand on an ice floe in the long—and often sun-kissed—evening hours of Antarctic summer. | *Francis King*

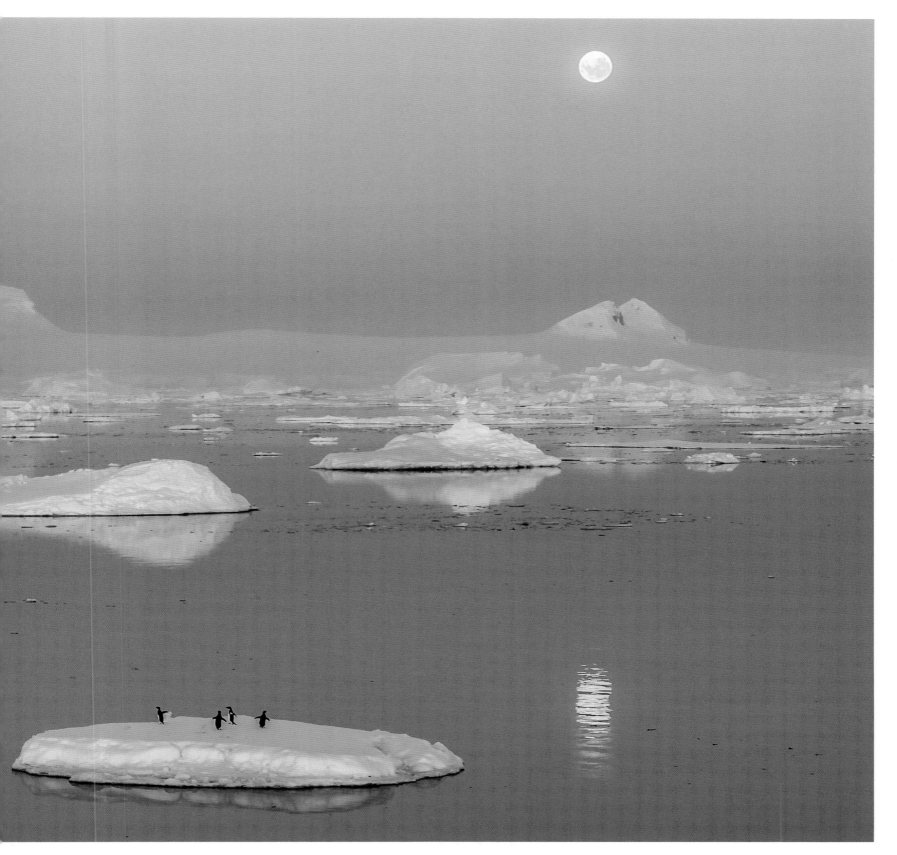

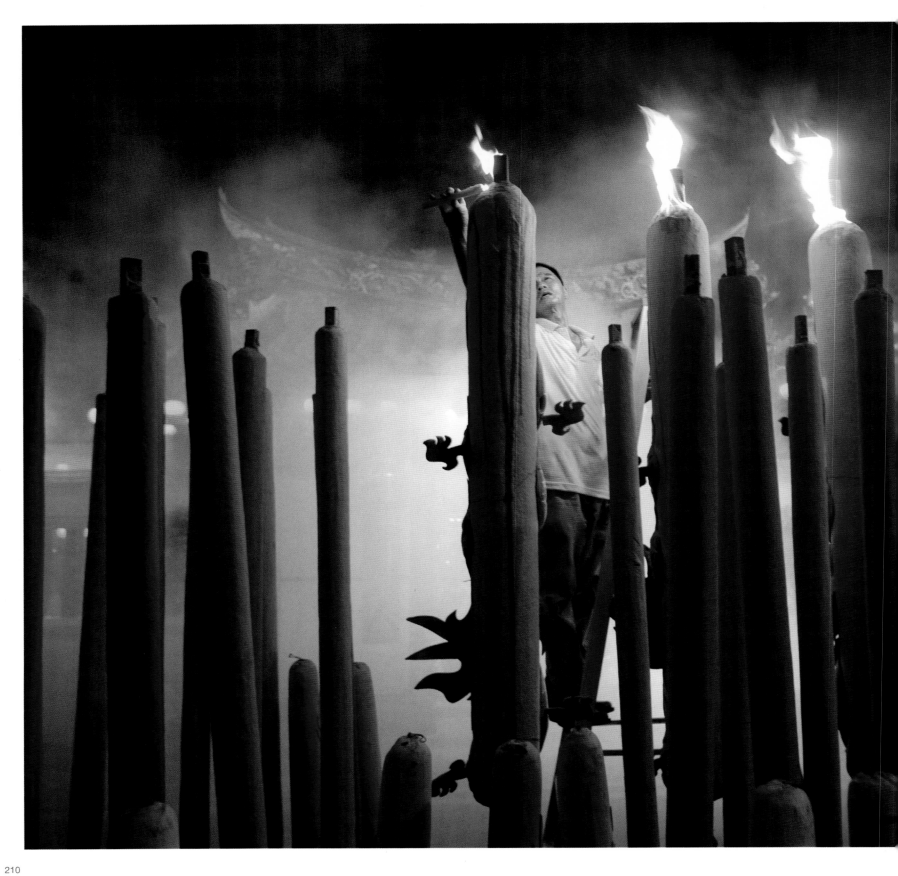

LEFT: MALACCA, MALAYSIA | A man lights giant incense sticks outside a temple to celebrate the Chinese New Year. | *John Stanmeyer*

FOLLOWING PAGES: DUBAI, UNITED ARAB EMIRATES | Two camels and their minder walk in front of the illuminated Dubai skyline. | *Buena Vista Images*

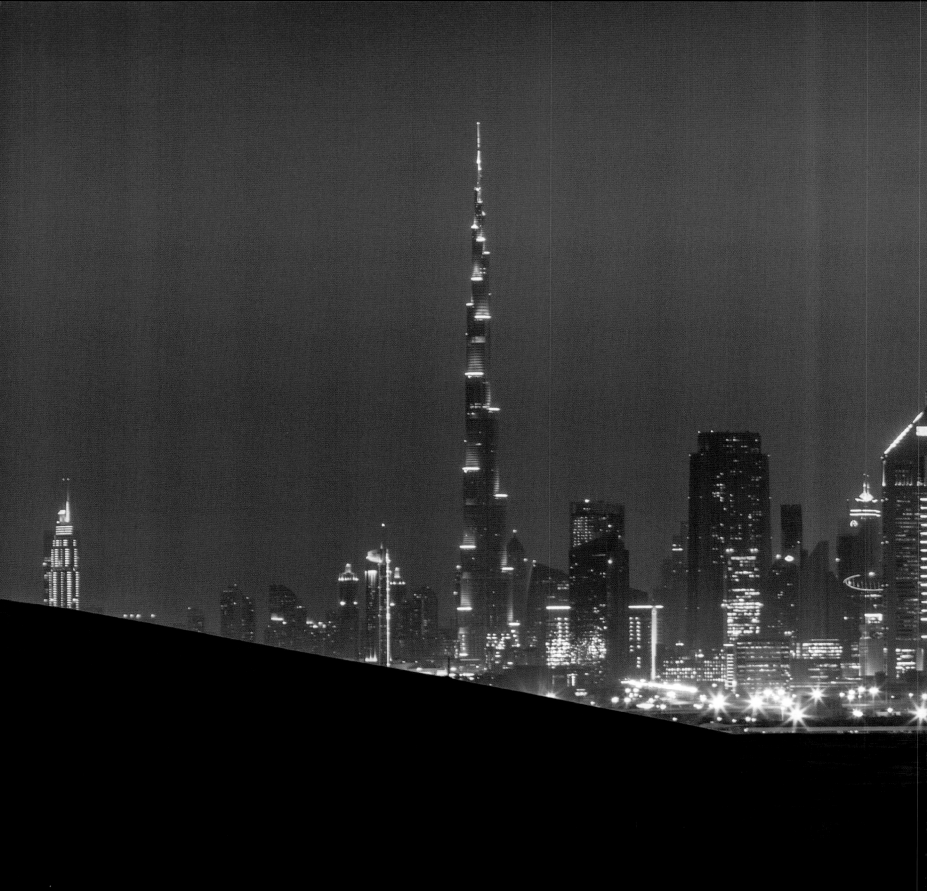

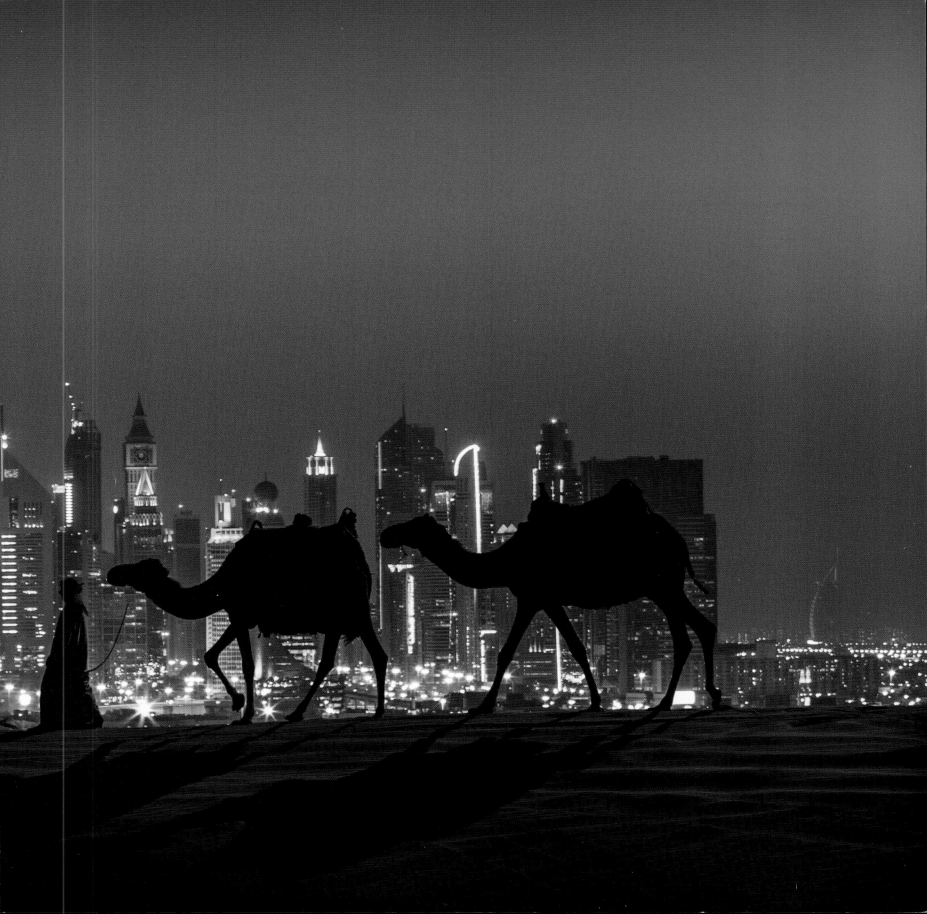

TUSCANY, ITALY | Towering pines provide a green frame
for the stars in a dark night sky. | *Busà Photography*

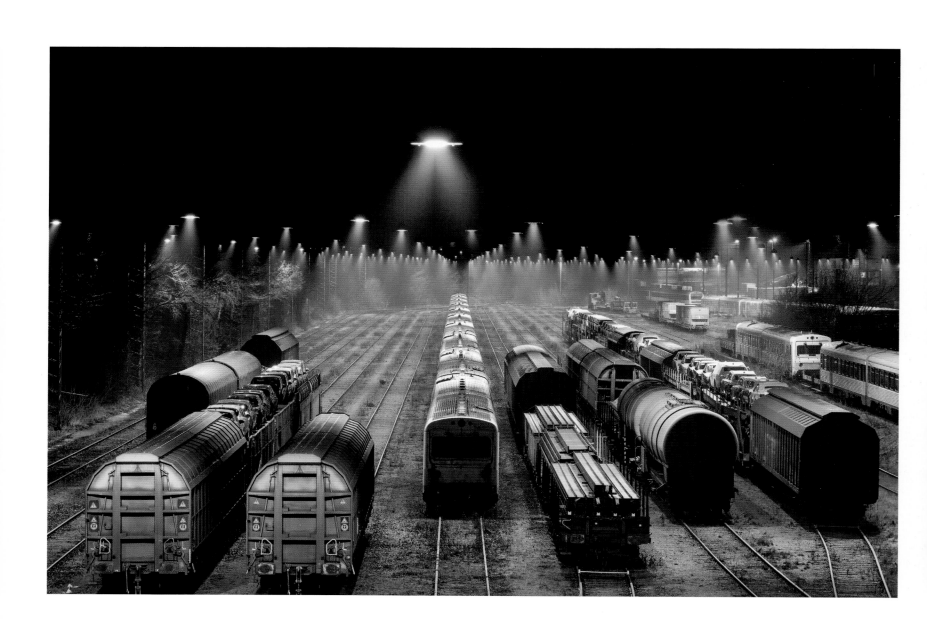

FREDERICIA, DENMARK | The bright lights of a rail yard
shine over off-duty parked trains. | *Michael Knudsen*

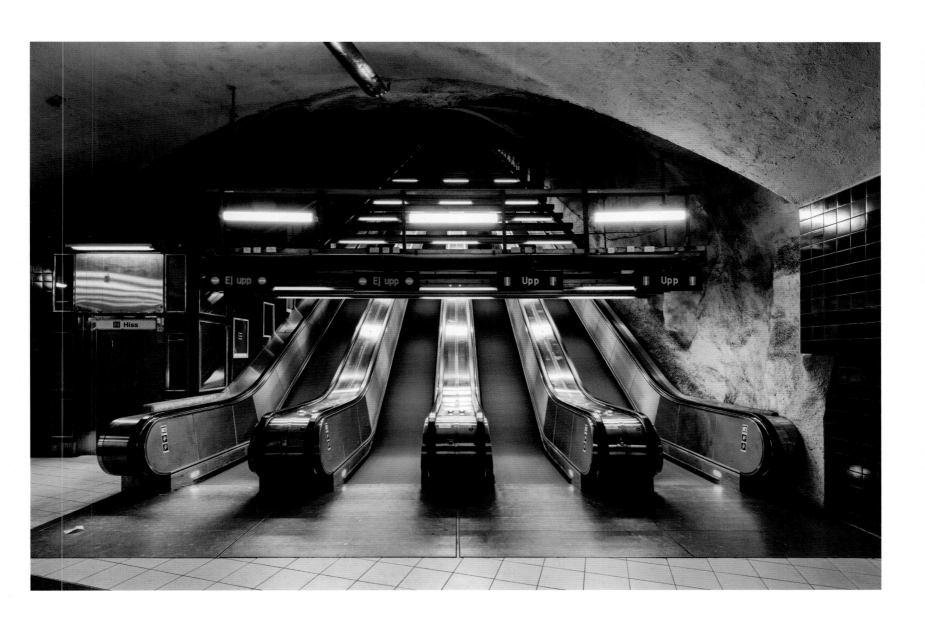

STOCKHOLM, SWEDEN | The fluorescent lights of a subway station
accentuate its sleek emptiness. | *Christian Åslund*

FAIRFAX, VIRGINIA | As if from an underwater dream, a young swimmer
materializes in silhouette. | *Kelsey Gerhard*

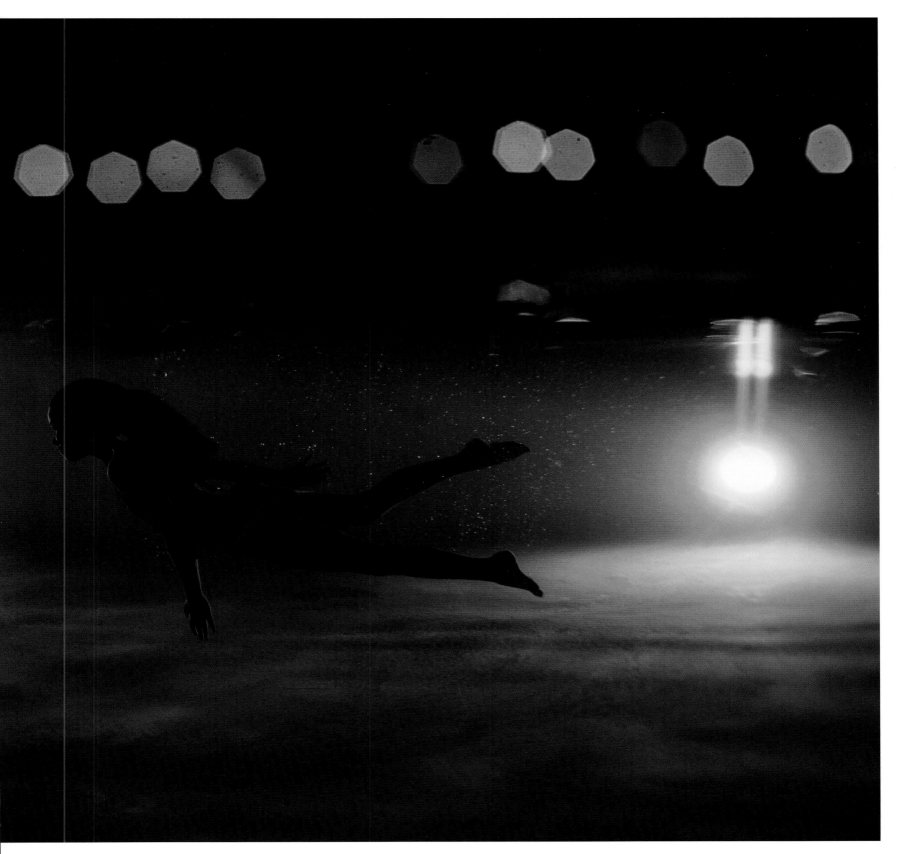

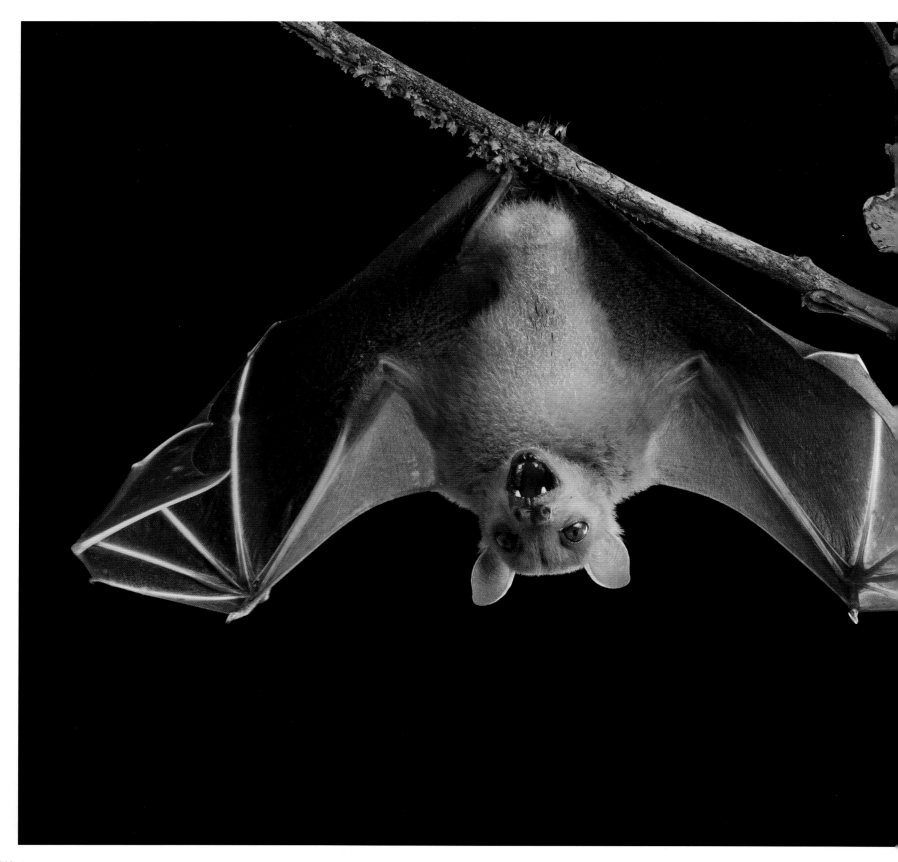

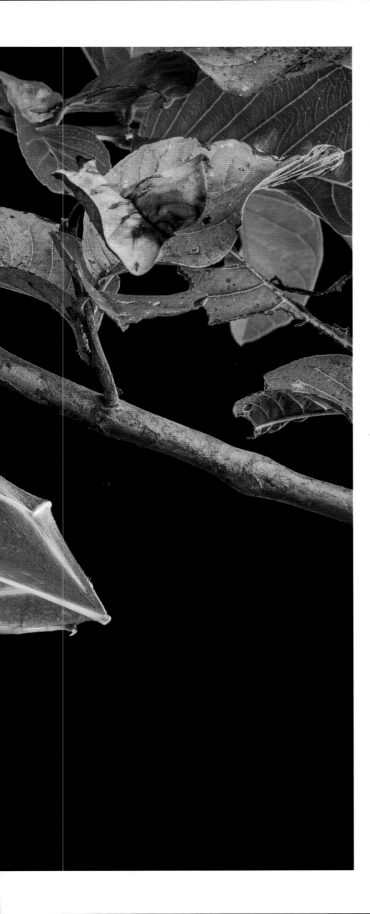

BORNEO, MALAYSIA | A fruit bat spreads its wings in the tropical night. | *Ch'ien Lee*

> **"THE MOON LOOKS UPON MANY NIGHT-FLOWERS; THE NIGHT-FLOWER SEES BUT ONE MOON.**
>
> **—SIR WILLIAM JONES**

OPPOSITE: **KENNETT SQUARE, PENNSYLVANIA** | Water lilies flower at night
in a pond at Longwood Gardens. | *Diane Cook & Len Jenshel*

222

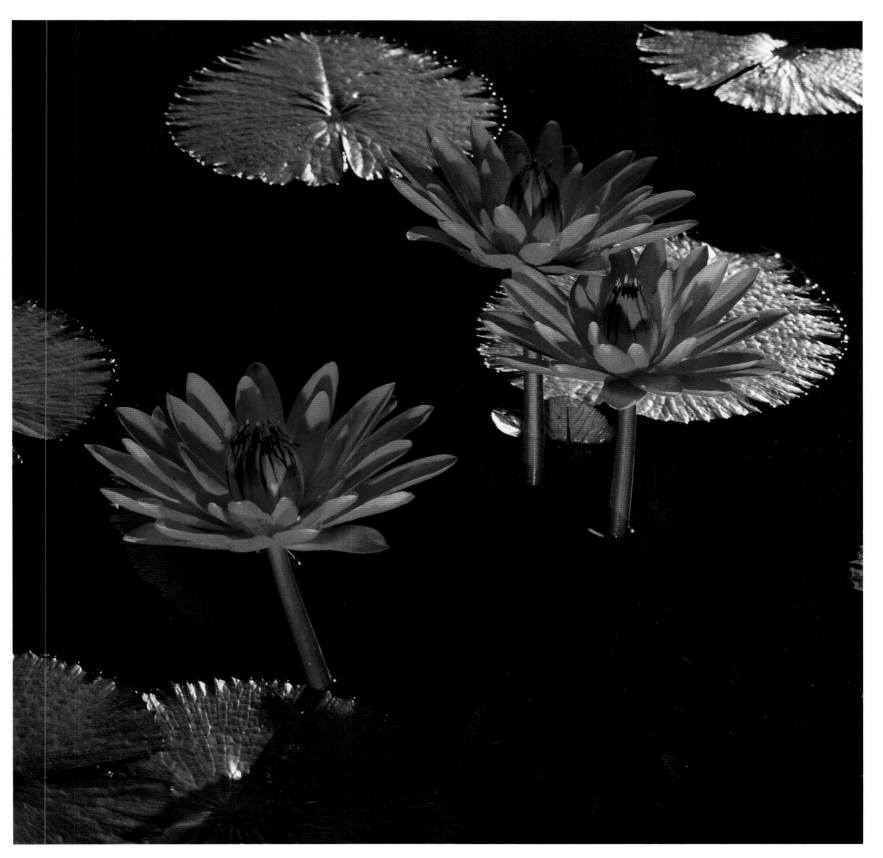

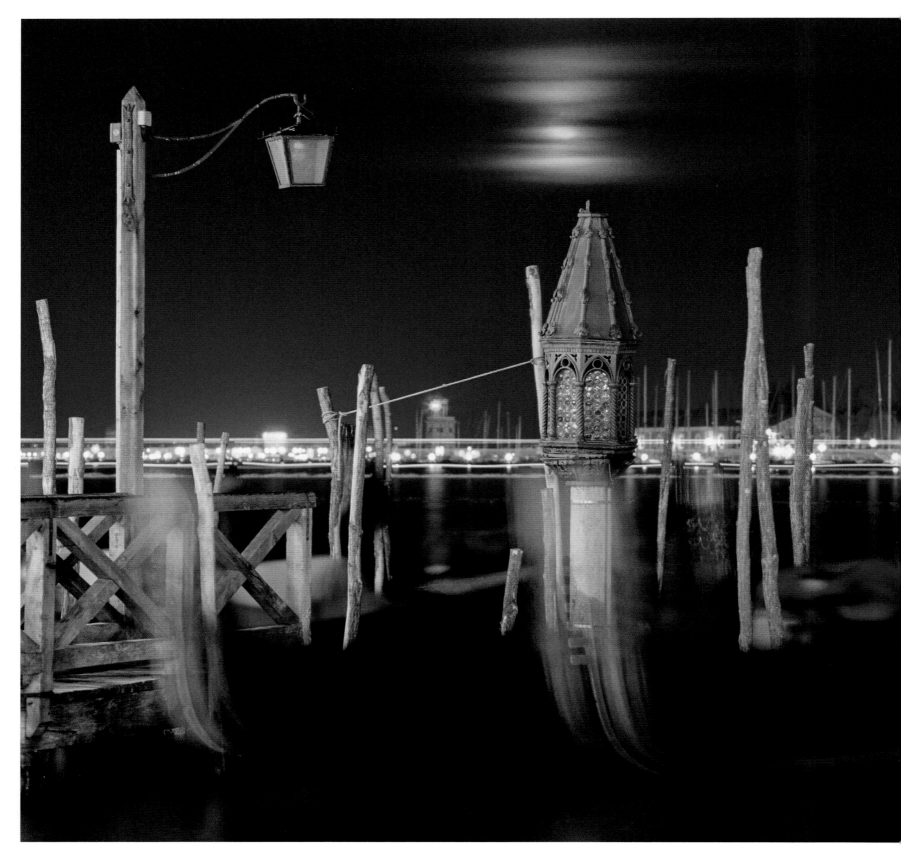

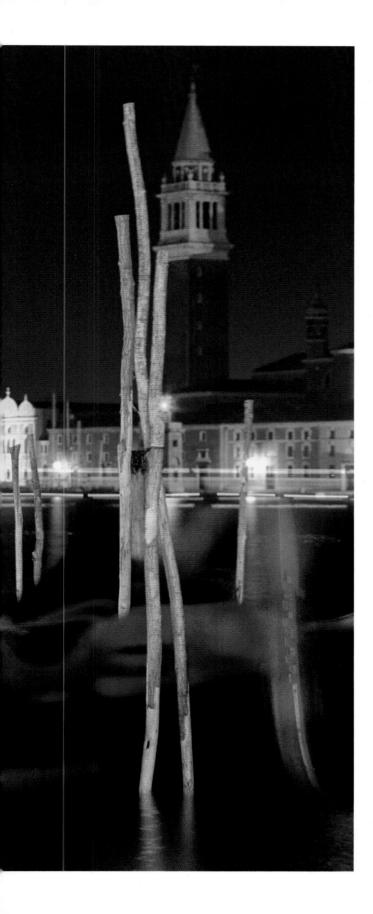

LEFT: **VENICE, ITALY** | A long exposure blurs the night scene of Venice's Grand Canal. | *Steve Winter*

FOLLOWING PAGES: **CASTELLUCCIO INFERIORE, ITALY** | Cold moonlight, snow-covered peaks, and wispy clouds loom over a mountain village. | *Francesco Santini*

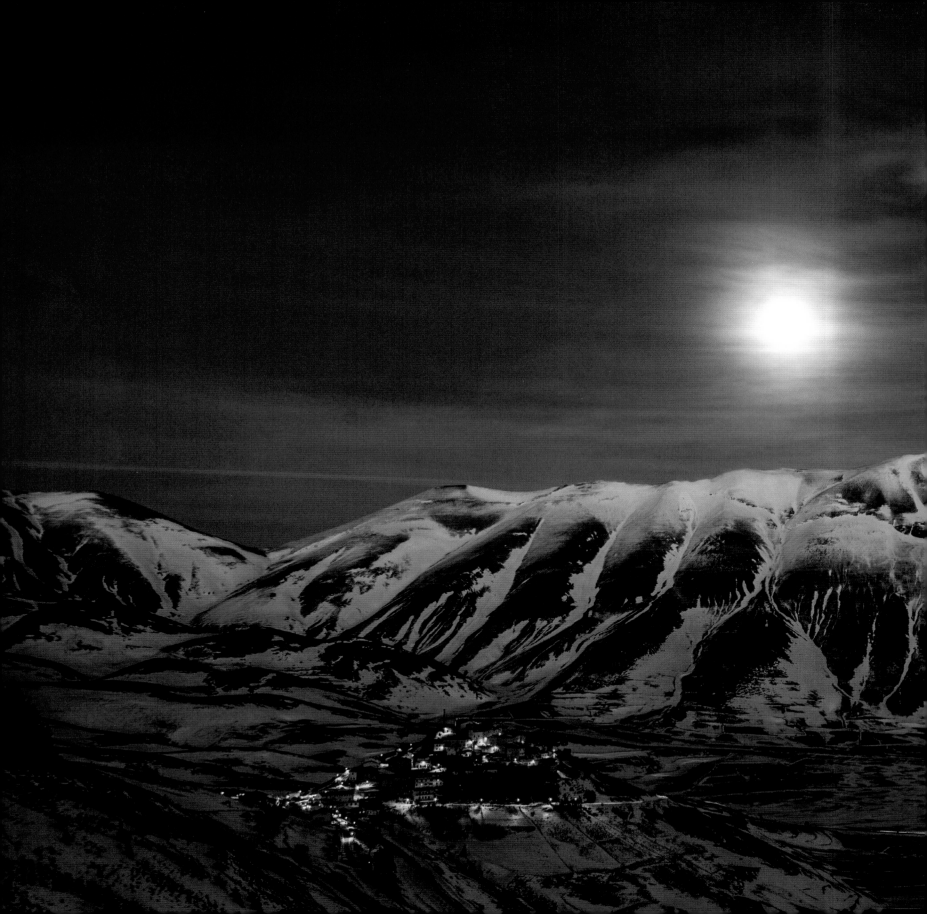

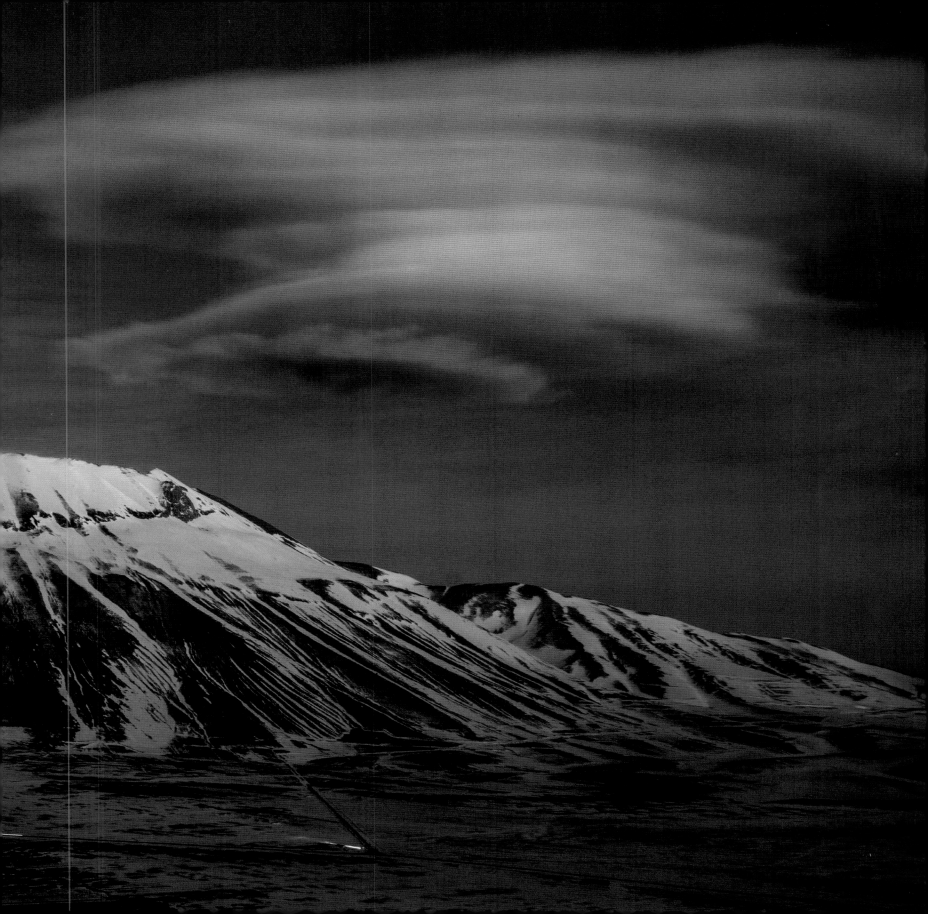

SEYCHELLES | Swimming at night, a blacktip shark hovers above the sand of an atoll. | *Imran Ahmad*

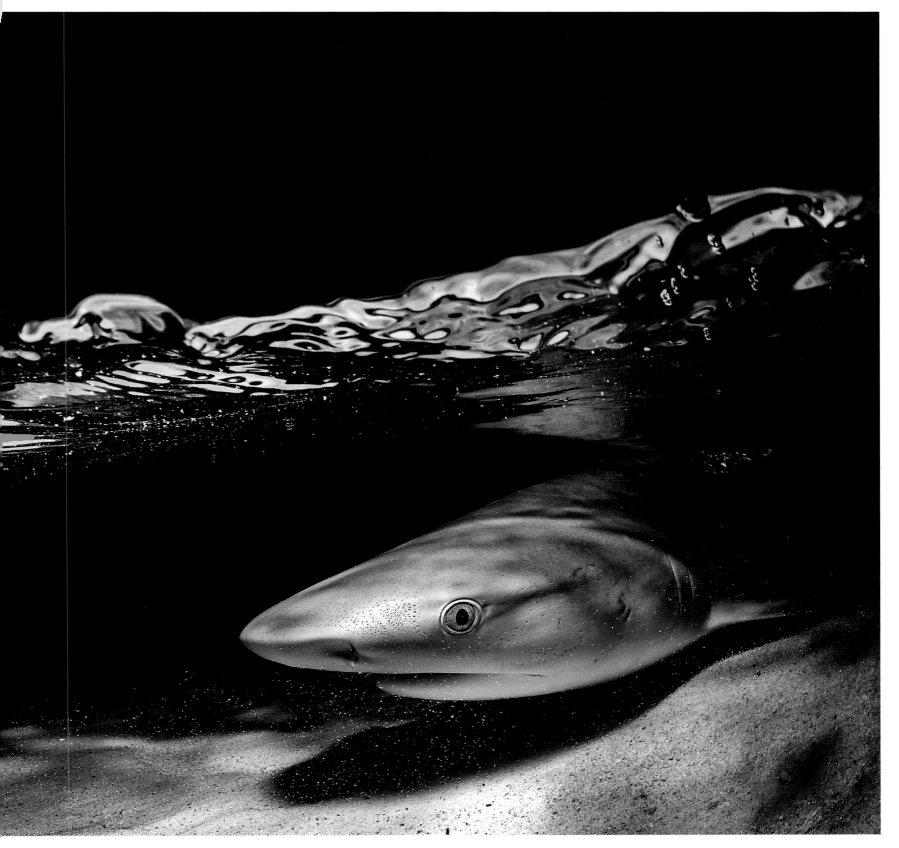

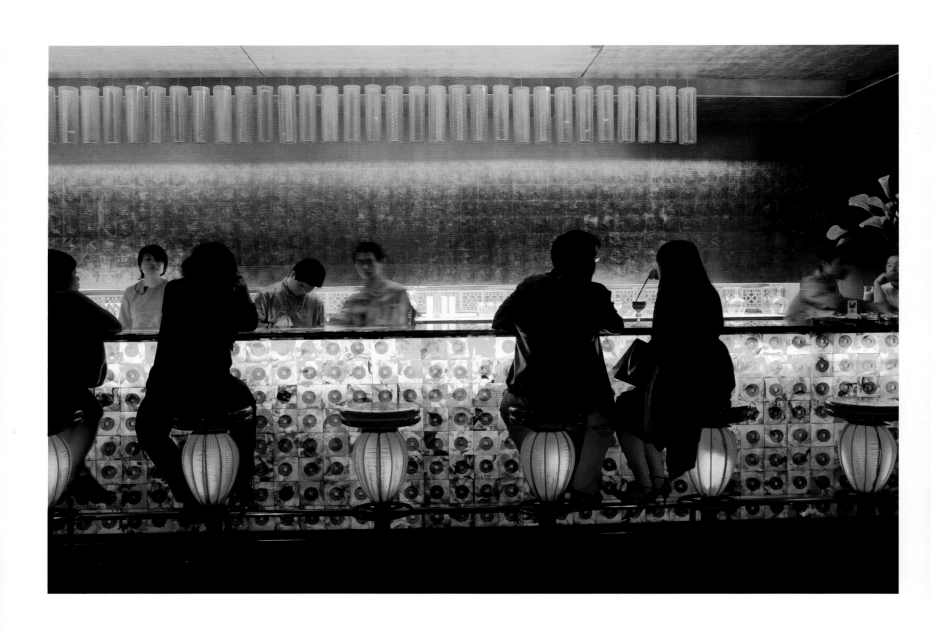

SHANGHAI, CHINA | Patrons enjoy an evening at a restaurant
in Shanghai's shopping district. | *Karl Johaentges*

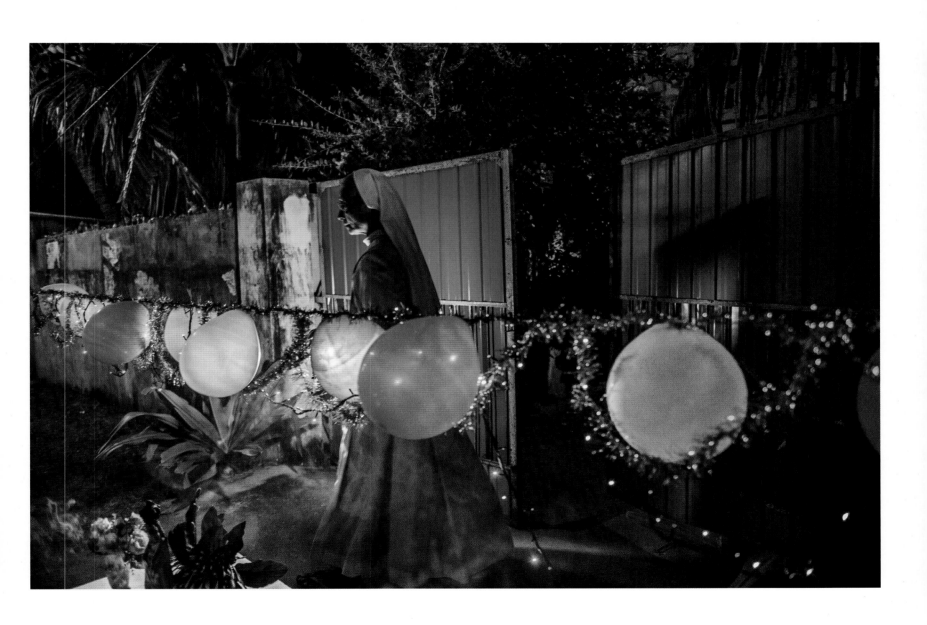

JAFFNA, SRI LANKA | A Catholic nun waits for a procession to pass on the feast day of St. Sebastian. | *Ami Vitale*

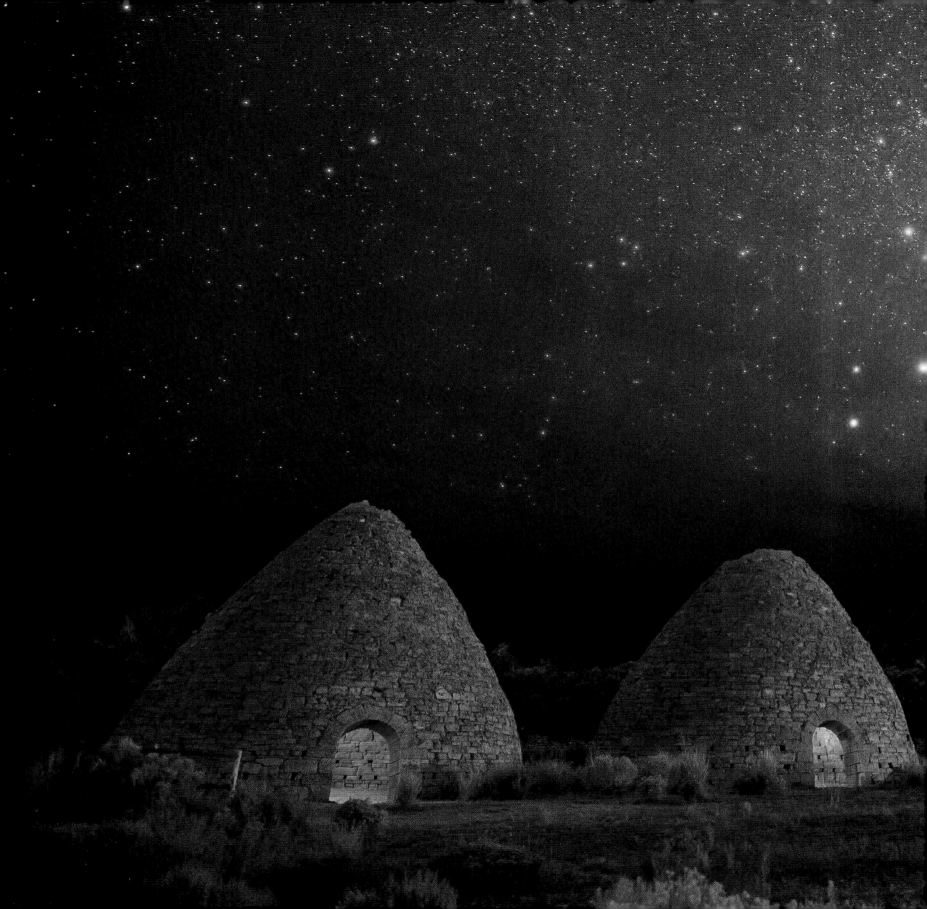

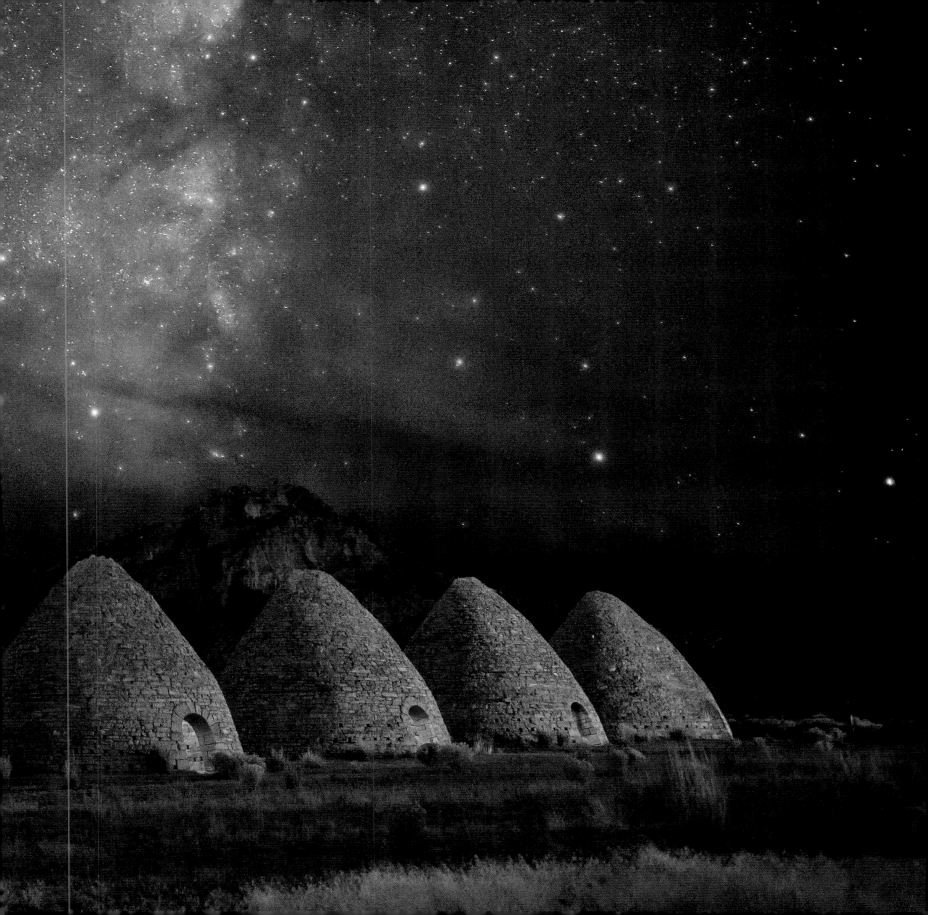

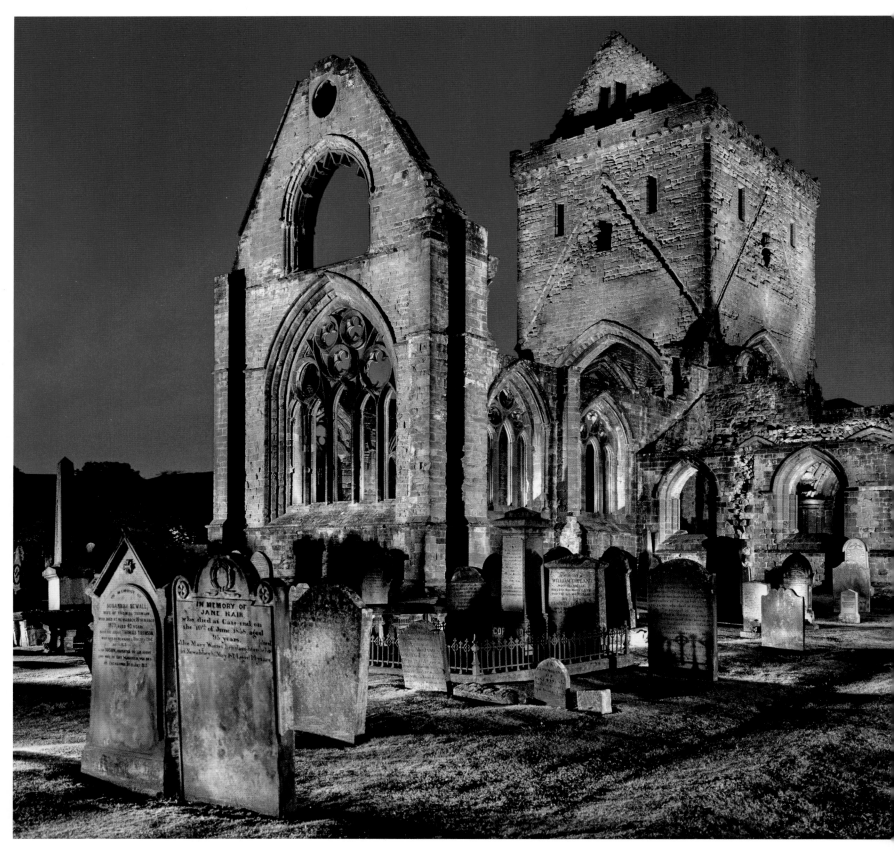

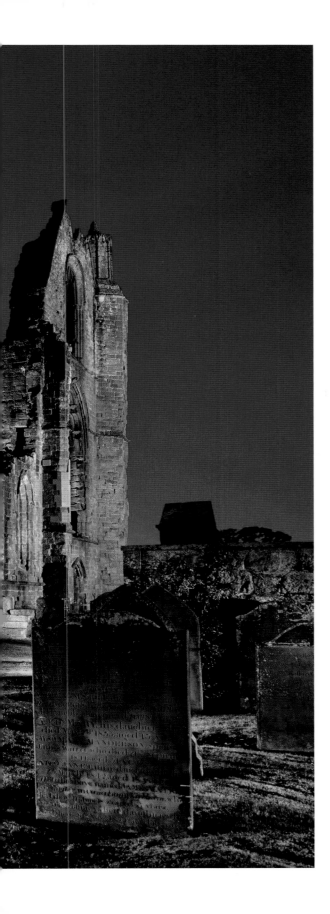

LEFT: **GALLOWAY, SCOTLAND** | Subtle night lightning accentuates the remains of Abbey Church, a former Cistercian monastery. | *Berthold Steinhilber*

PREVIOUS PAGES: **NEVADA** | The Milky Way illuminates Nevada's historic Ward Charcoal Ovens. | *Royce Bair*

RIGHT: **YELLOWSTONE NATIONAL PARK** | The mists from Dunanda Falls form a nighttime rainbow. | *Tom Murphy*

FOLLOWING PAGES: **PATHUM THANI, THAILAND** | Buddhist monks hold candles during a vigil at the Wat Phra Dhammakaya temple during the Makha Bucha holy day. | *Luke Duggleby*

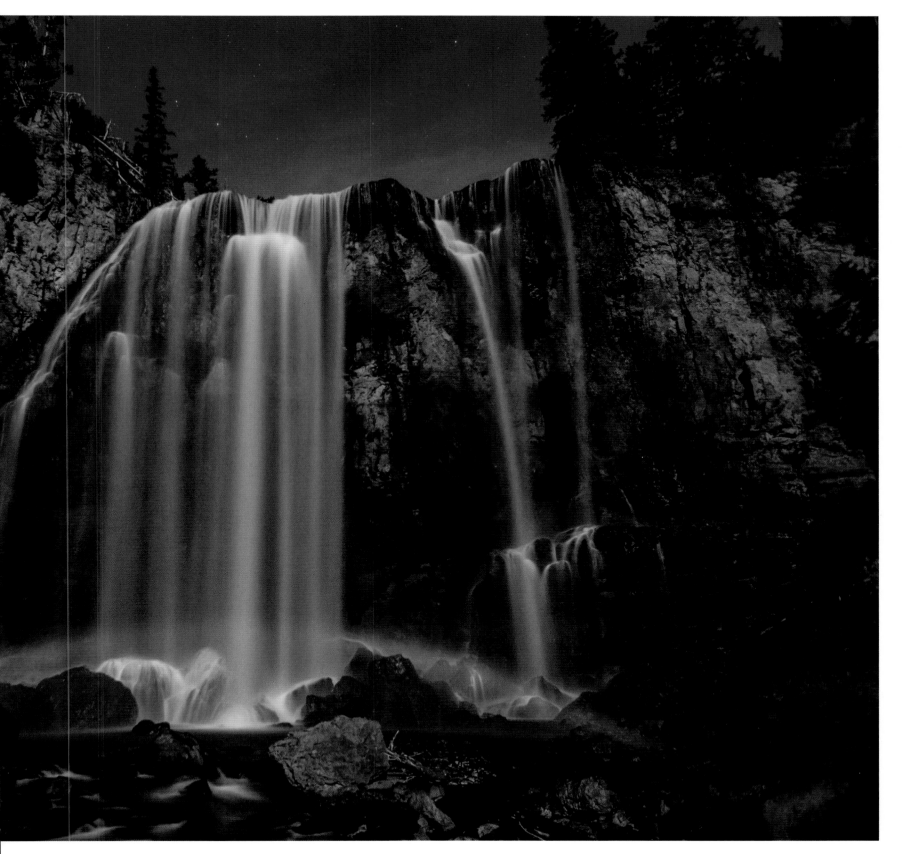

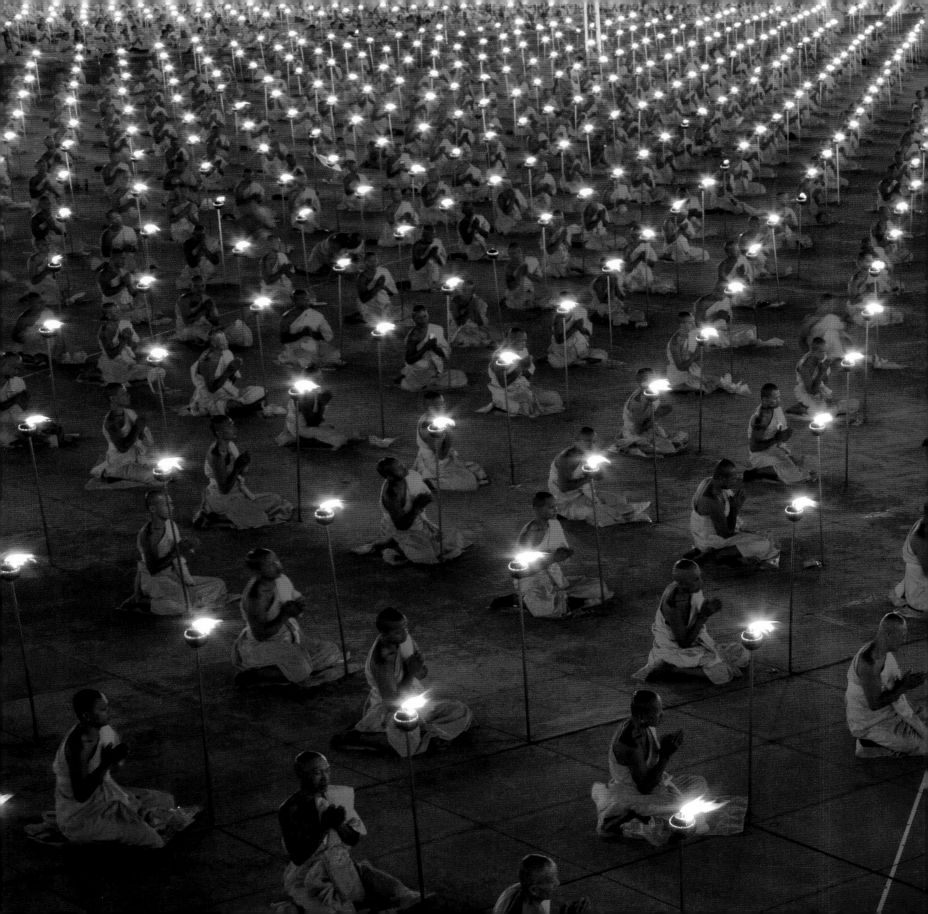

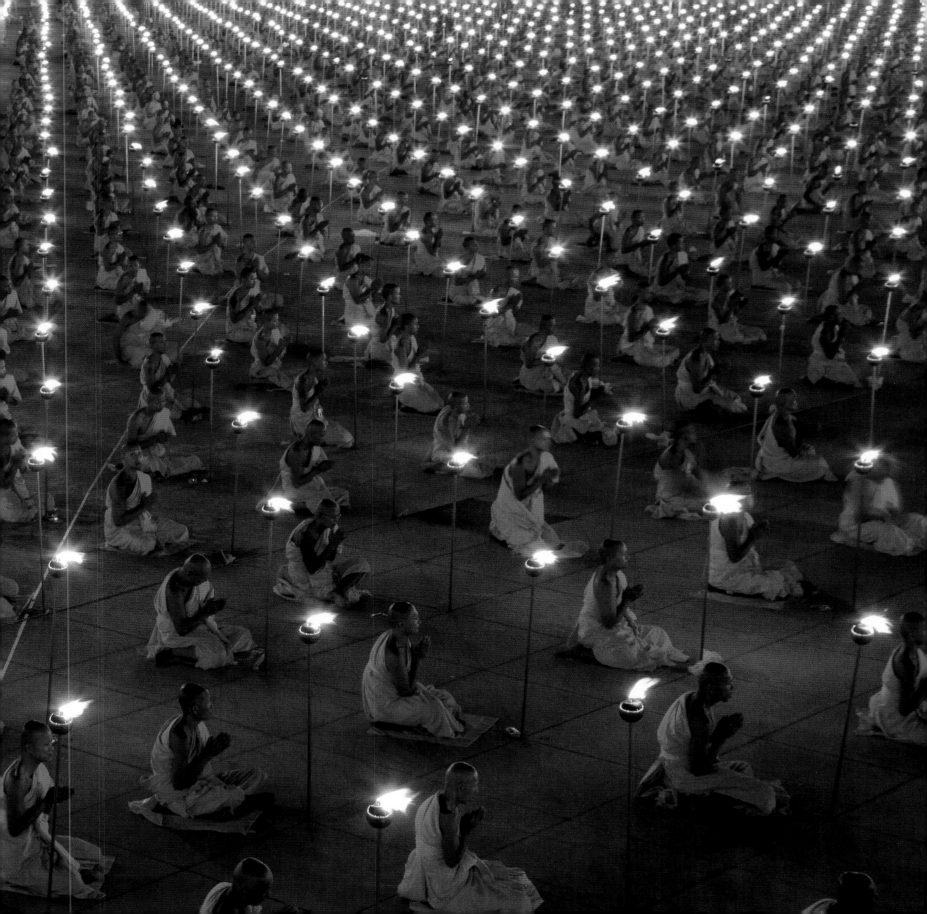

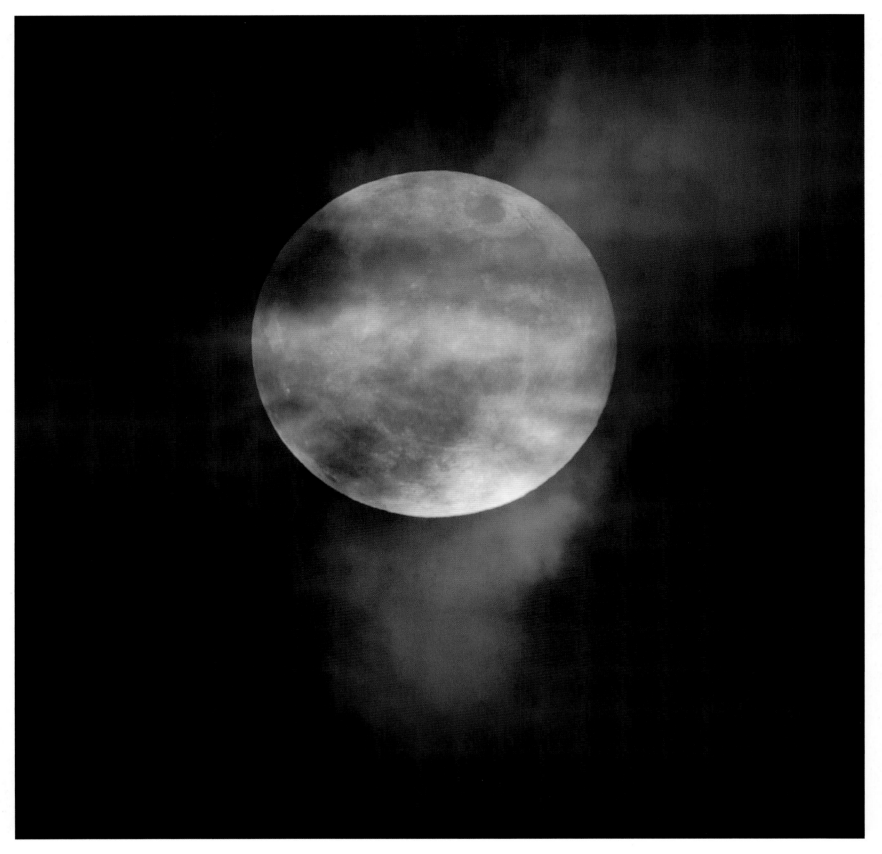

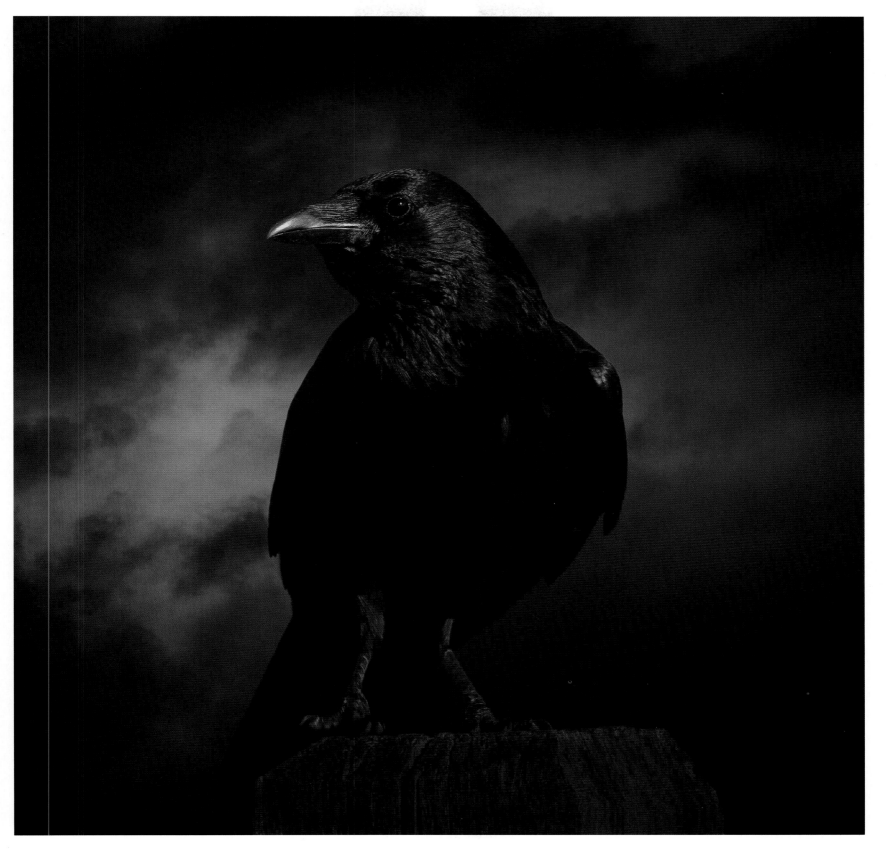

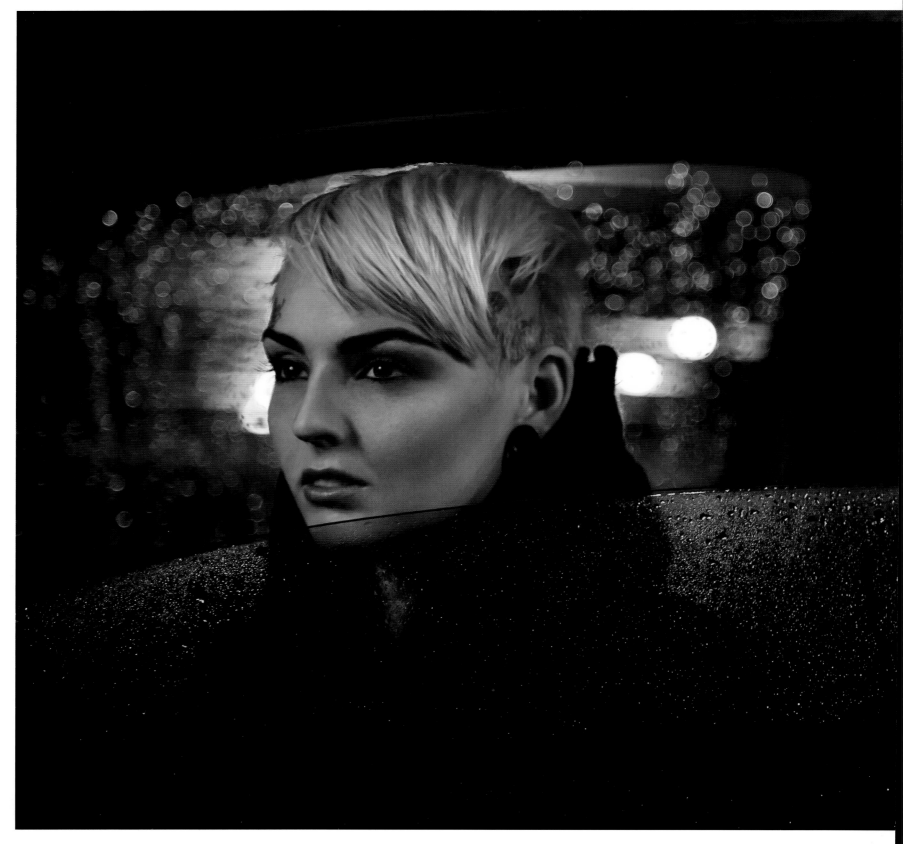

LEFT: LONDON, ENGLAND | A woman looks out a car window on a rainy evening. | *Phillip Suddick*

PAGE 240: GRONINGEN, NETHERLANDS | A full moon fills the night sky. | *Luc Hoogenstein*

PAGE 241: SWITZERLAND | A jet-black crow perches against an equally black sky. | *Brigitte Blättler*

> # "THE THINGS OF THE NIGHT CANNOT BE EXPLAINED IN THE DAY, BECAUSE THEY DO NOT THEN EXIST.
>
> ## —ERNEST HEMINGWAY

OPPOSITE: **FAIRVIEW, NORTH CAROLINA** | A lime green luna moth settles on a fern. | *Al Petteway & Amy White*

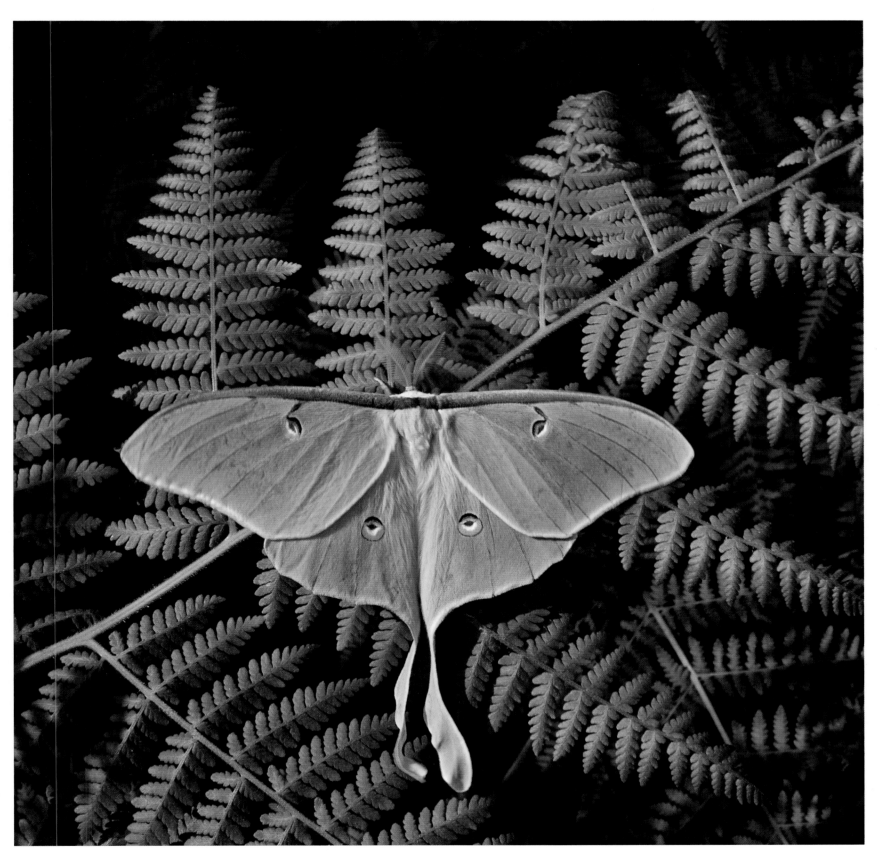

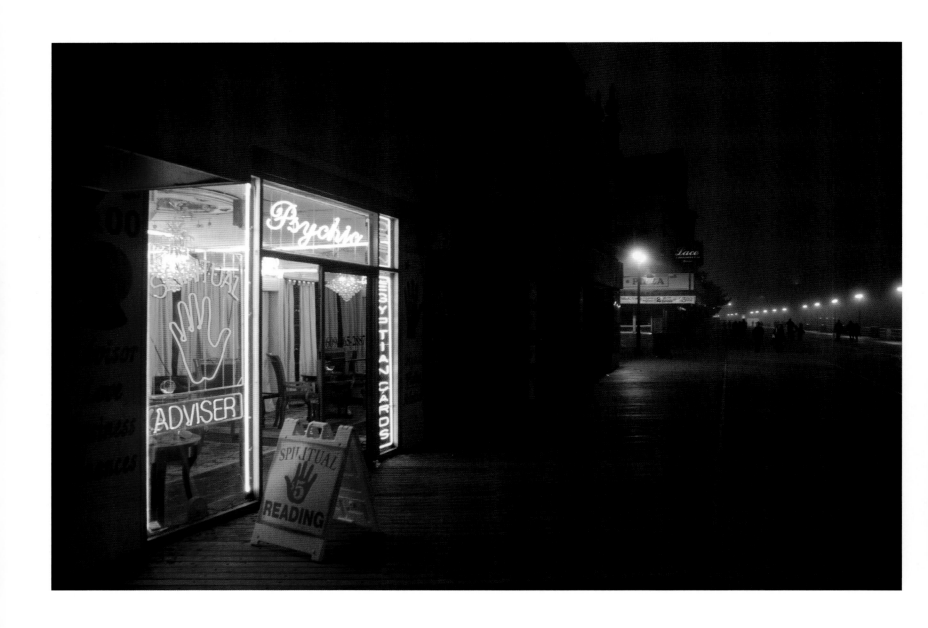

ATLANTIC CITY, NEW JERSEY | The neon lights of a storefront shine
onto the wooden planks of the seaside boardwalk. | *Nick Pedersen*

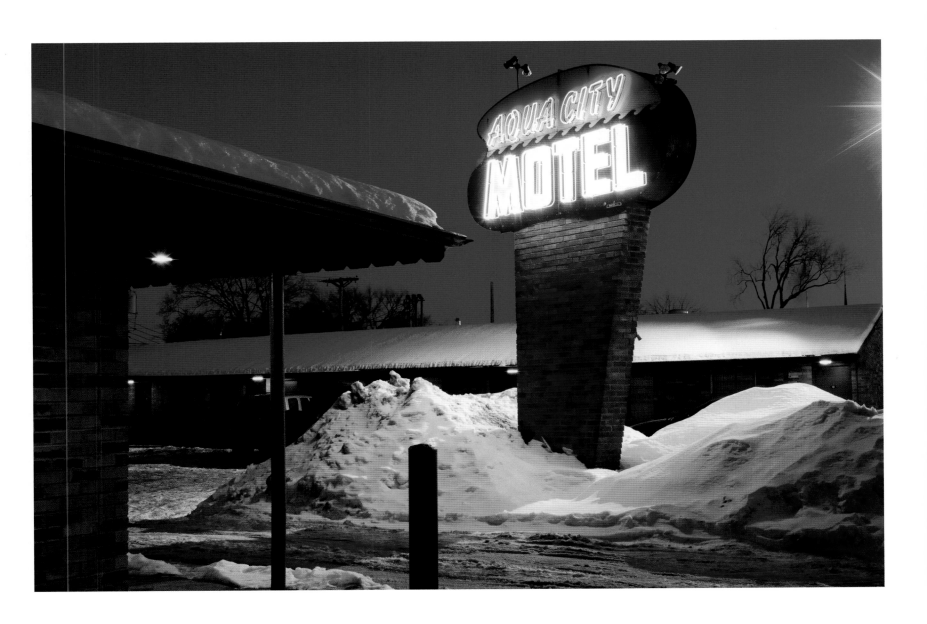

MINNEAPOLIS, MINNESOTA | A sign for the Aqua City Motel
adds a pink tinge to the white snow. | *David Bowman*

RIGHT: MAZĀR-E SHARĪF, AFGHANISTAN | The lights of the Hazrat-e Ali shrine, or Blue Mosque, paint the night scene. | *Farshad Usyan*

FOLLOWING PAGES: GRUNDARFJÖRDUR, ICELAND | The aurora borealis colors the night sky green over conical Kirkjufell Mountain. | *David Clapp*

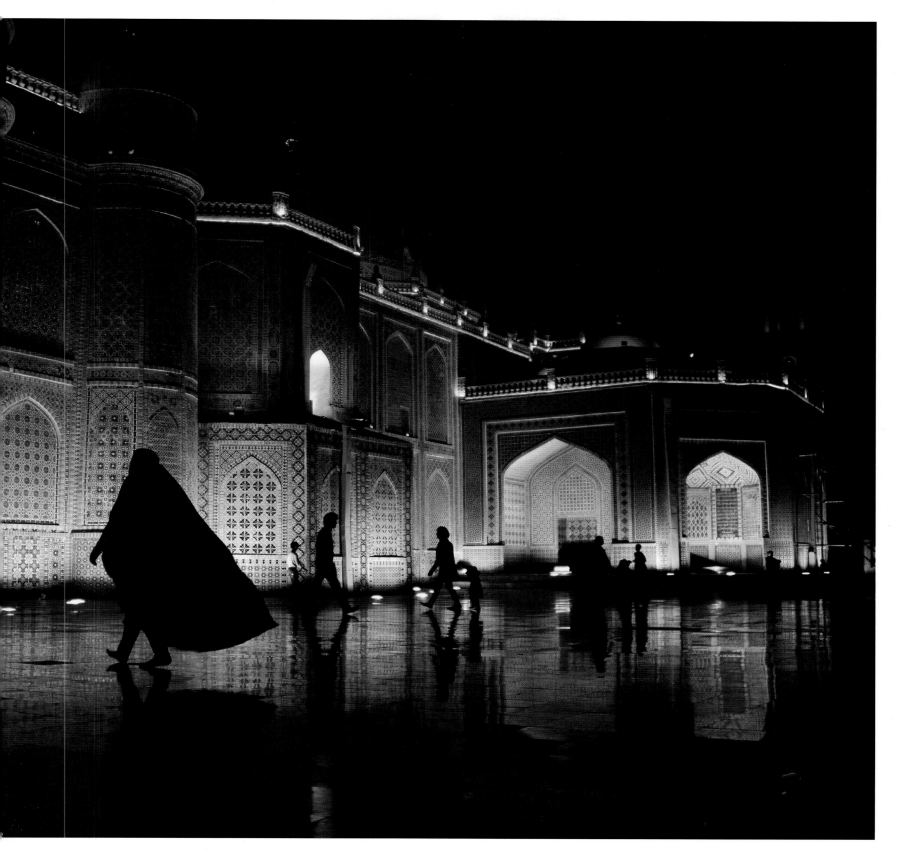

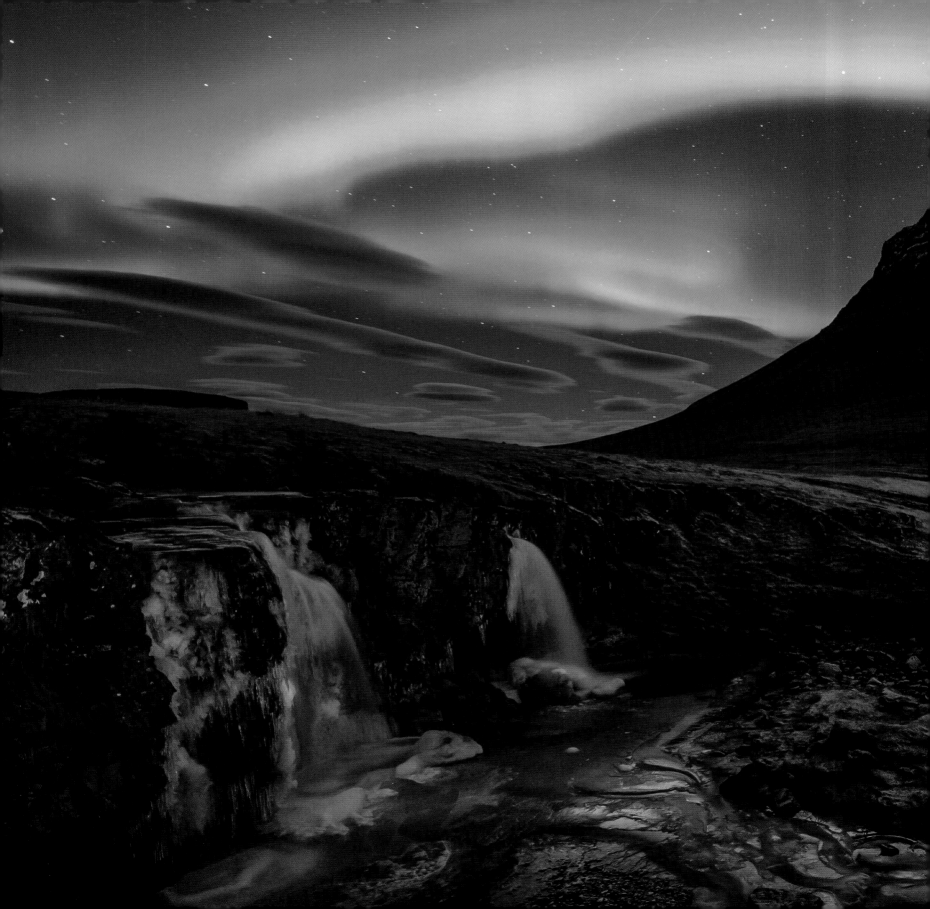

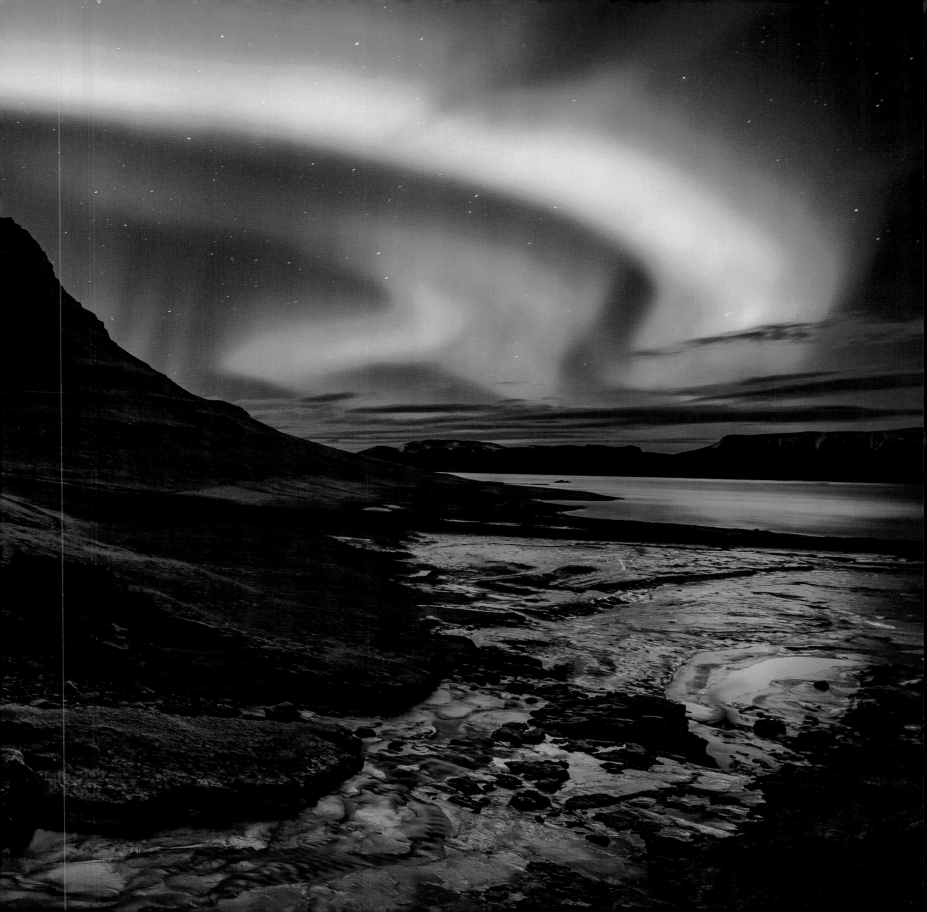

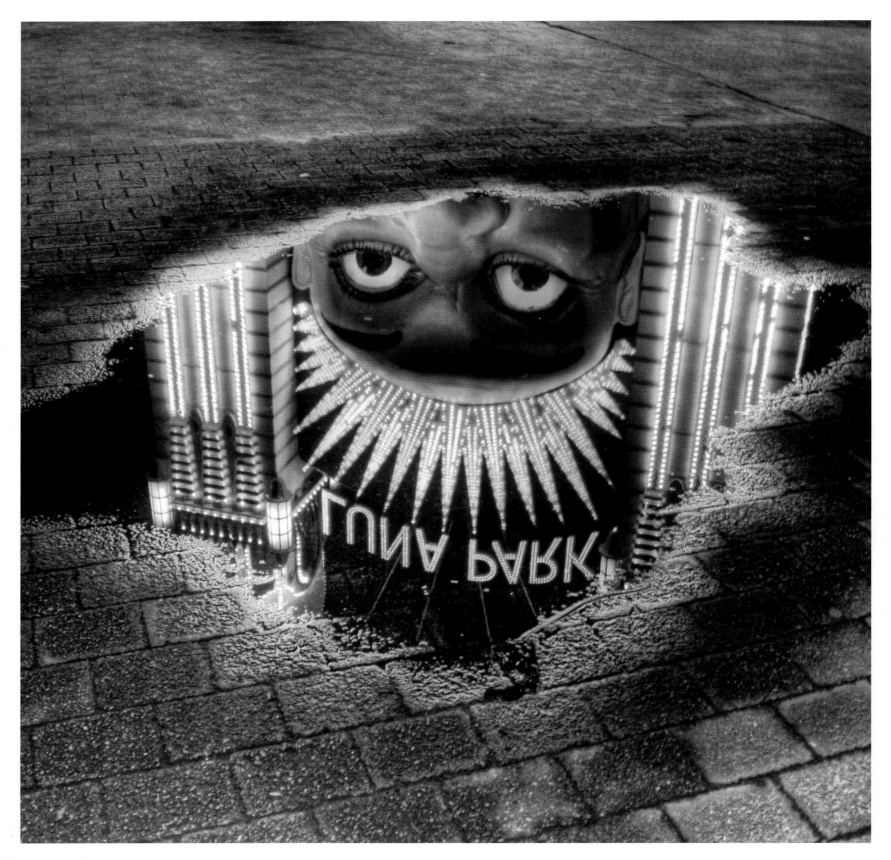

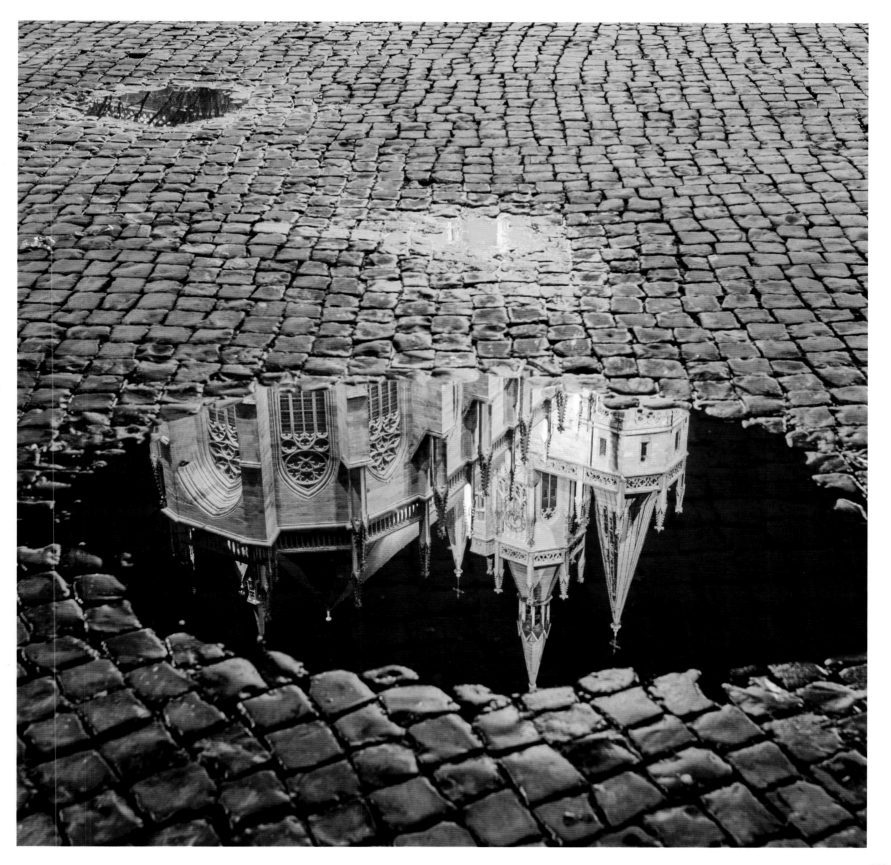

RIGHT: **LONDON, ENGLAND** | As night descends, a crescent moon shines through the cables of Albert Bridge. | *Amos Chapple*

PAGE 252: **NORTH SYDNEY, AUSTRALIA** | A puddle reflects a neon sign in Luna Park. | *Demosthenes Mateo, Jr.*

PAGE 253: **THURINGIA, GERMANY** | The spires of Erfurt Cathedral are reflected in a puddle on a cobblestone street. | *Henryk Sadura*

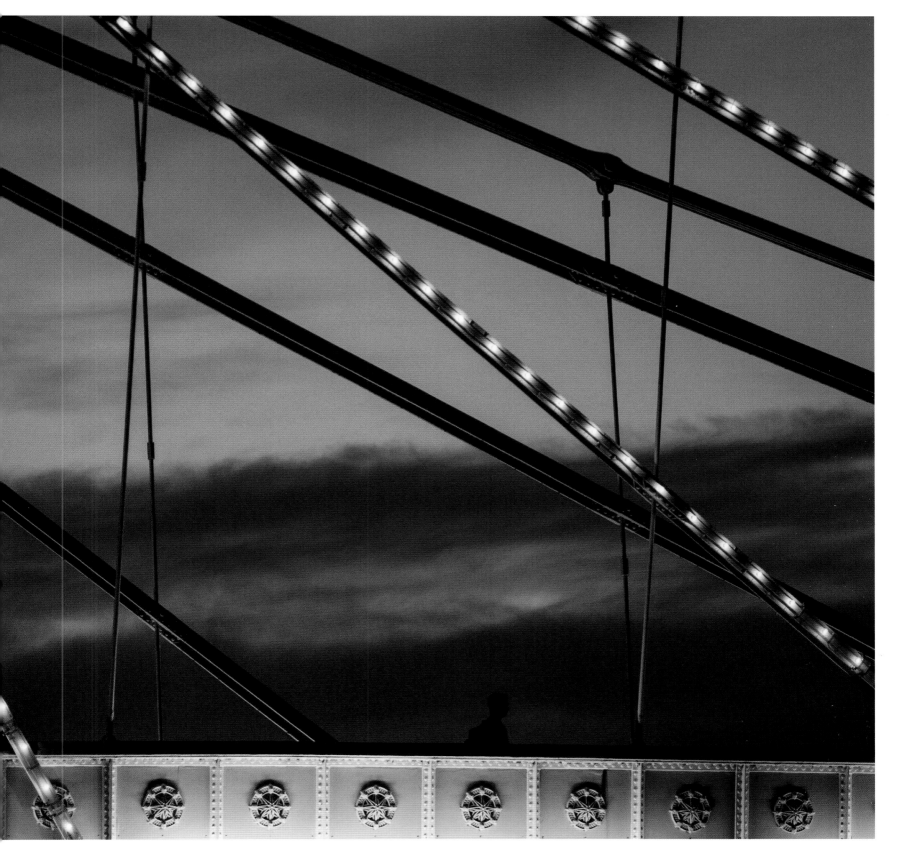

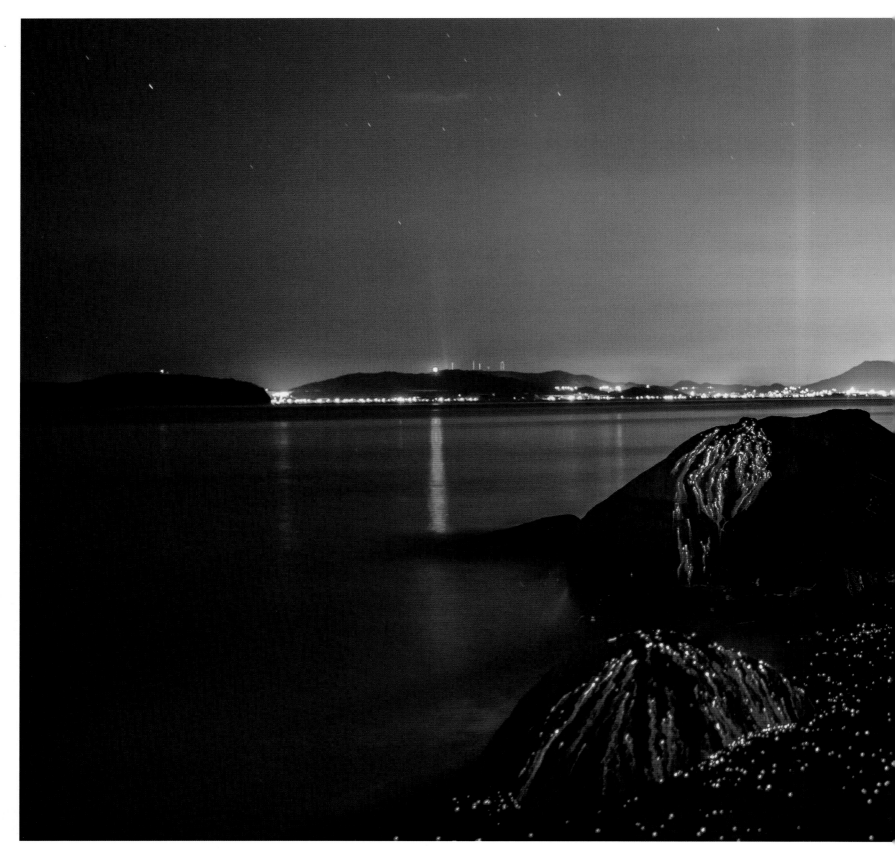

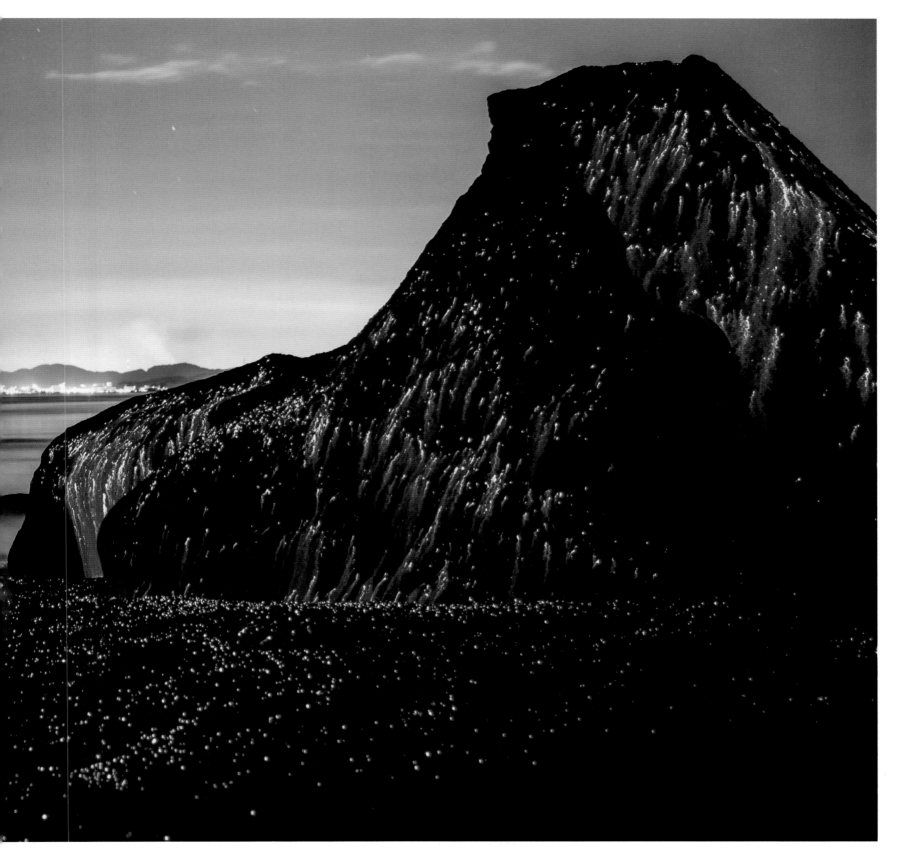

> " THE ONLY TRUE VOYAGE
> OF DISCOVERY . . . WOULD BE
> NOT TO VISIT STRANGE LANDS
> BUT TO POSSESS OTHER EYES.

—MARCEL PROUST

OPPOSITE: HAMPTON BAYS, NEW YORK | Empty swings await the next day's carnival riders. | *Stephanie Keith*

PREVIOUS PAGES: OKAYAMA, JAPAN | Stones on the beach glow blue with trails left by bioluminescent shrimp. | *Trevor Williams & Jonathan Galione*

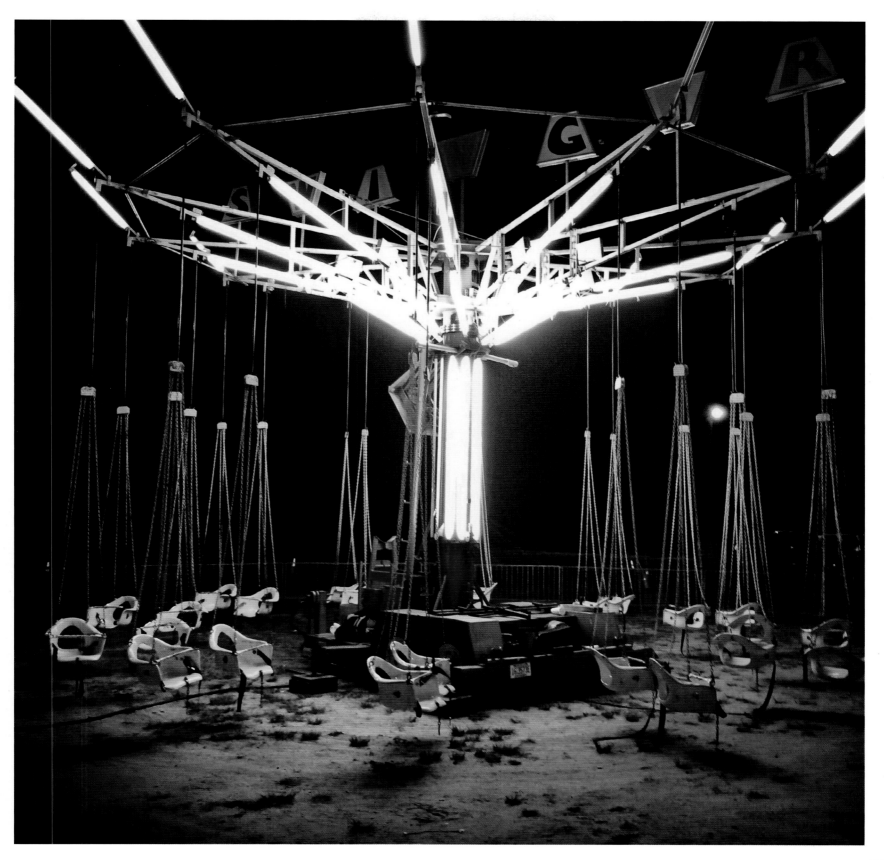

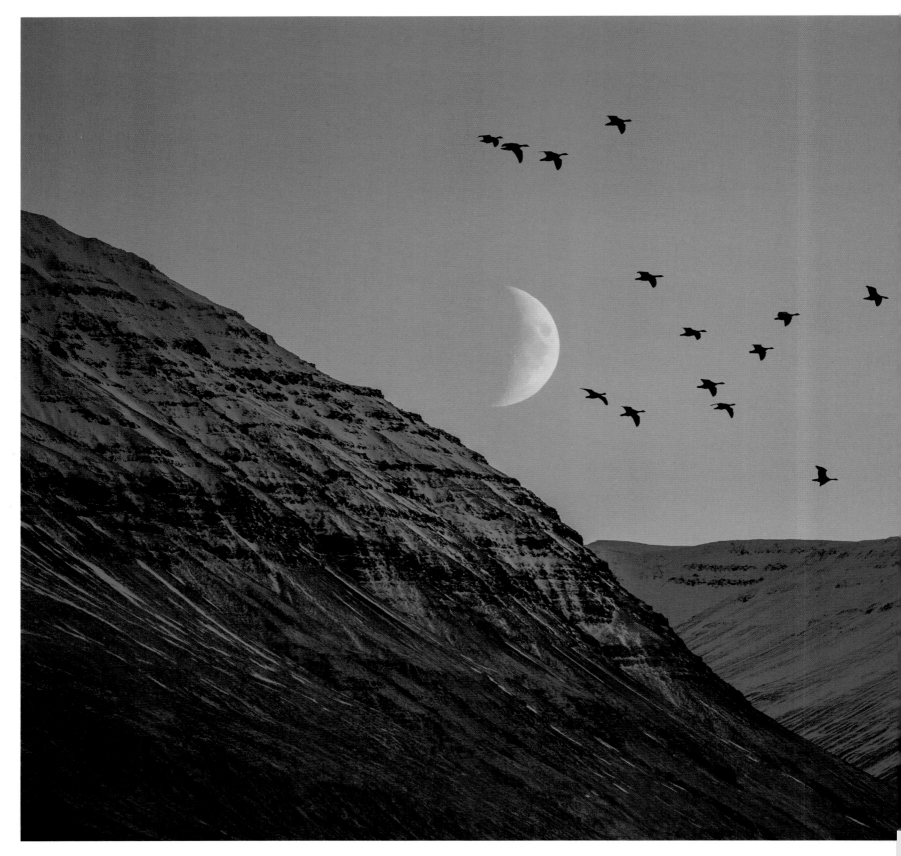

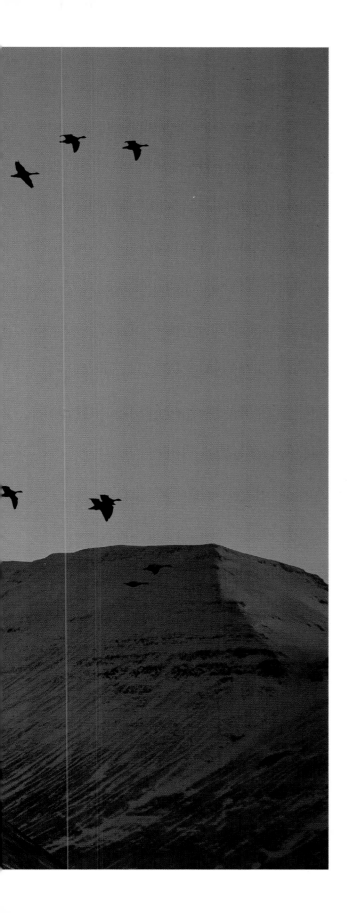

LEFT: AKUREYRI, ICELAND | Isolated, snow-covered mountains look out over both the moon and birds in flight. | *Ragnar Th. Sigurdsson*

PAGE 262: MANHATTAN, NEW YORK | A bikeway on the Brooklyn Bridge reflects the colors of the streetlights. | *Andrew C. Mace*

PAGE 263: DLEBTA, LEBANON | The silky spirals of a spiderweb wait patiently for prey. | *Alex Kik*

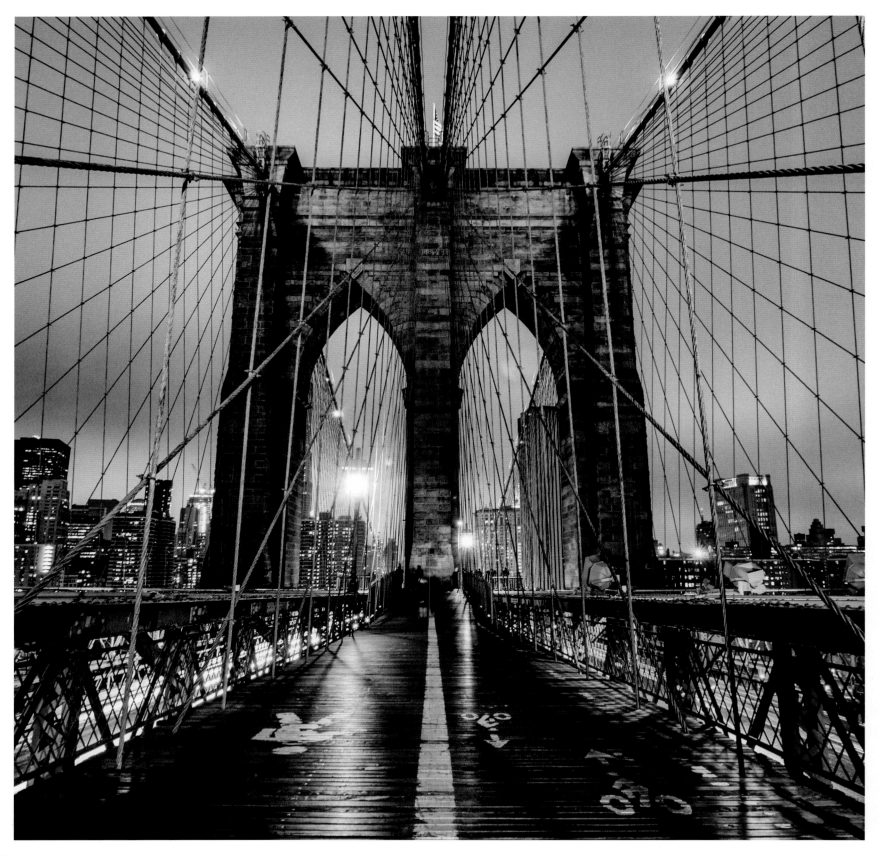

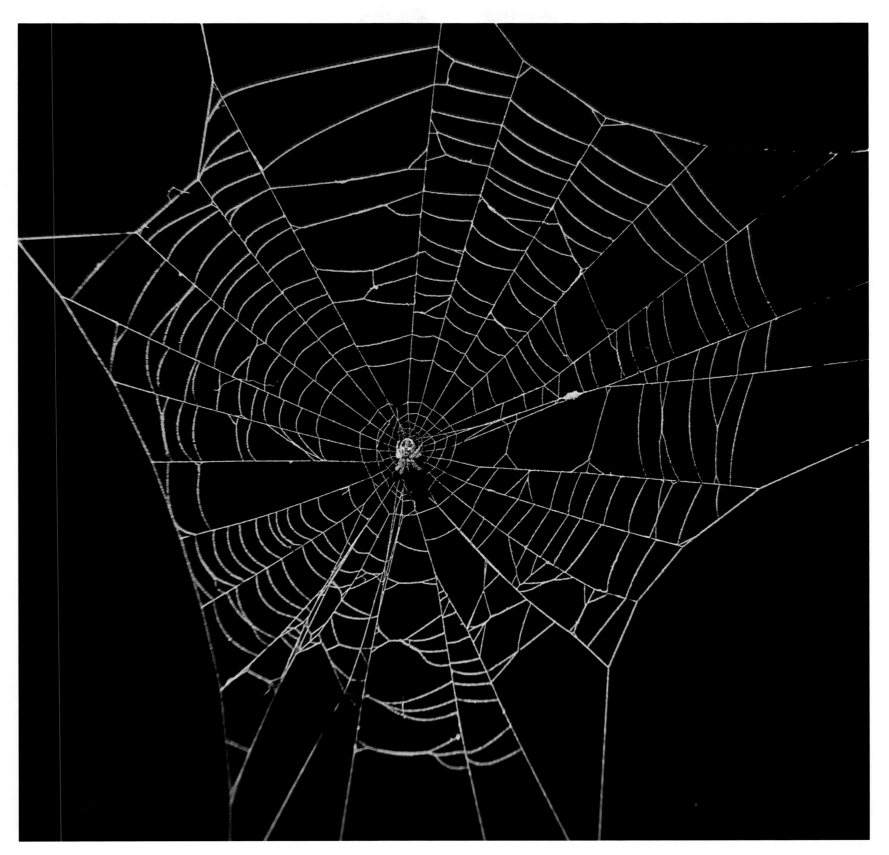

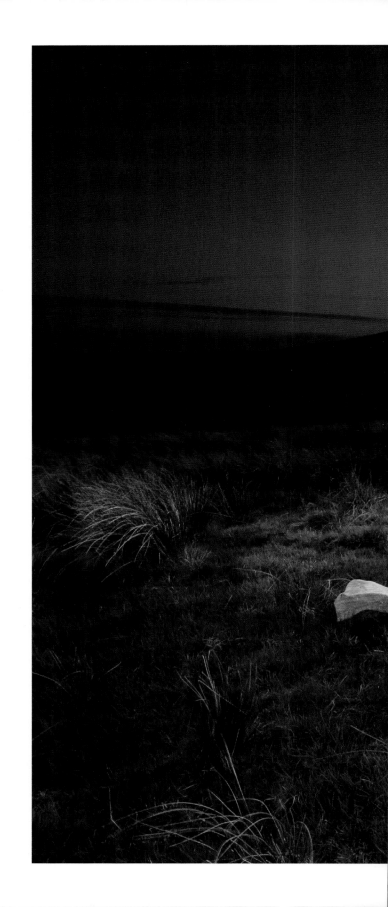

LANCASHIRE, ENGLAND | A stone circle on Pendle Hill
catches the last light as night falls. | *Nigel Flory*

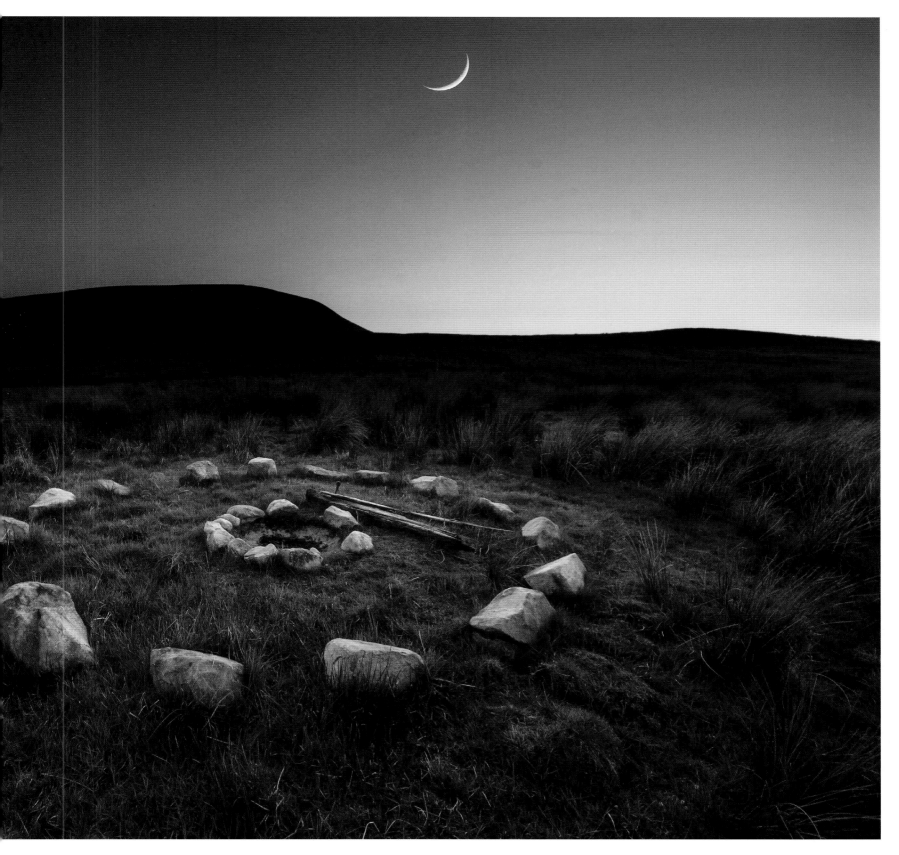

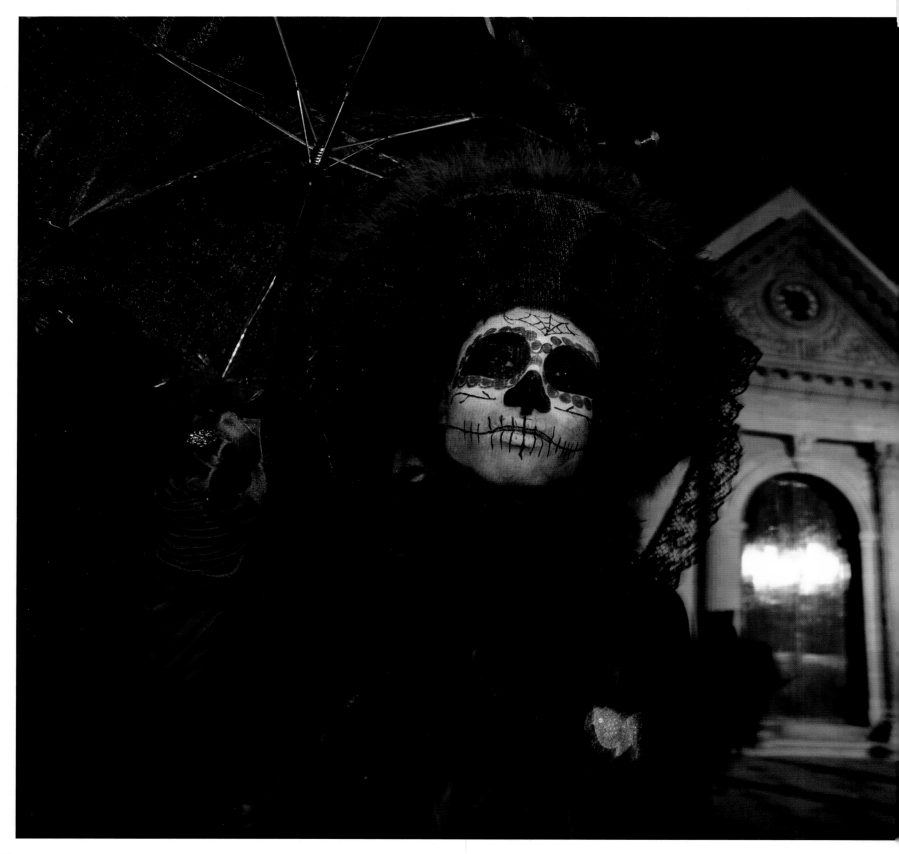

OAXACA, MEXICO | A woman is elaborately made up
for a Day of the Dead street parade. | *Raul Touzon*

> **"MIDNIGHT . . . THE WATERSHED OF TIME, FROM WHICH THE STREAMS OF YESTERDAY AND TOMORROW TAKE THEIR WAY.**
>
> **—HENRY WADSWORTH LONGFELLOW**

OPPOSITE: **NORMANDY, FRANCE** | A dark-blue serpentine stream winds its way toward the island of Le Mont-Saint-Michel. | *Mathieu Rivrin*

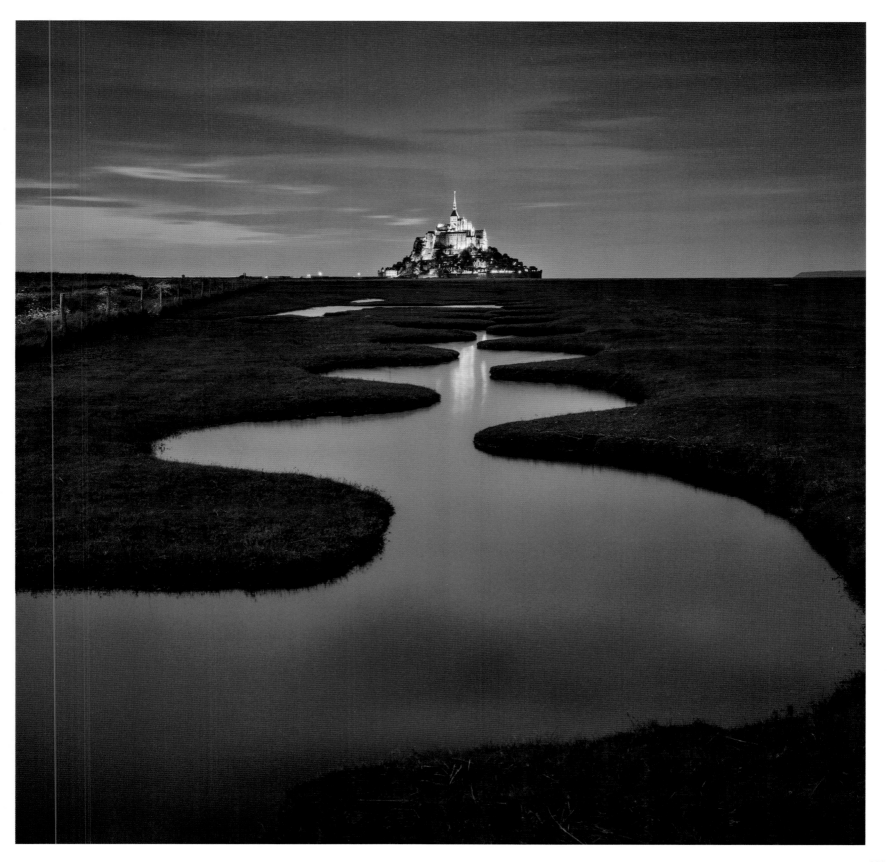

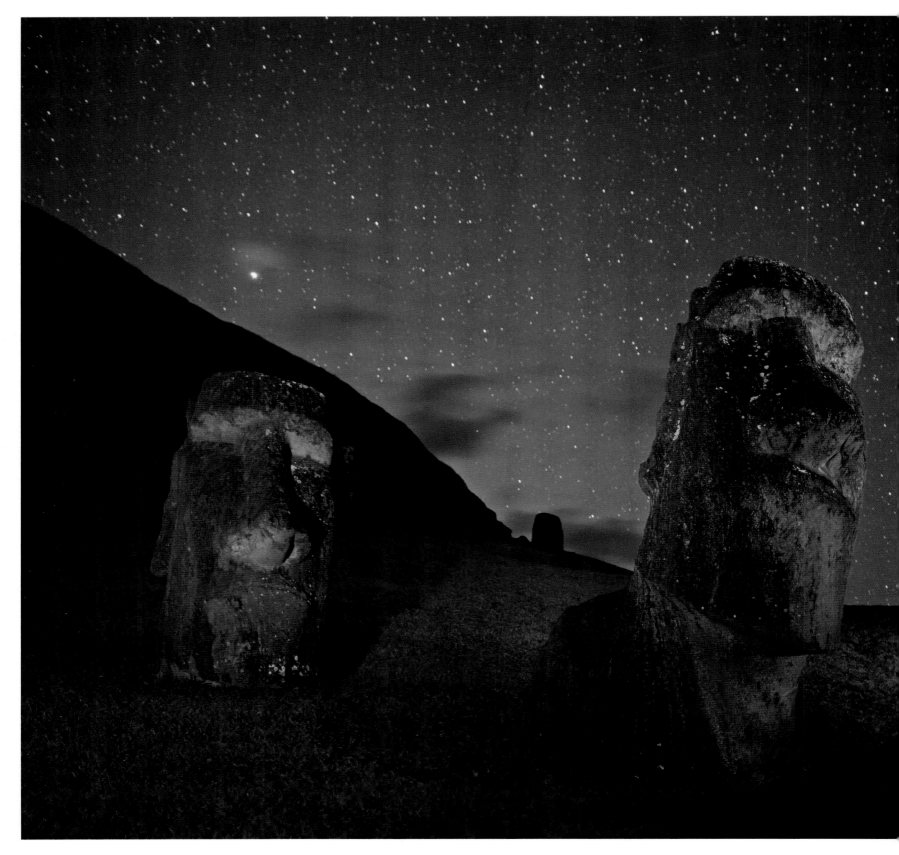

EASTER ISLAND, PACIFIC OCEAN | Prehistoric Moai statues
look out over a sky splashed with stars. | *Randy Olson*

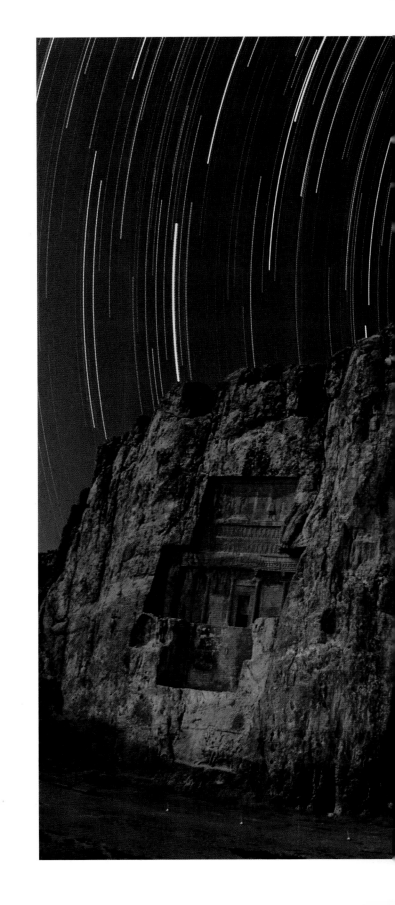

RIGHT: **PERSEPOLIS, IRAN** | Stars swirl above the 2,500-year-old colossal tombs of the kings of ancient Persia in Naqsh-e Rostam. | *Babak Tafreshi*

FOLLOWING PAGES: **SORRENTO, BRITISH COLUMBIA, CANADA** | Lights of a train reflect off the falling snow and through an abandoned church in the late night hours before sunrise. | *Kevin McElheran*

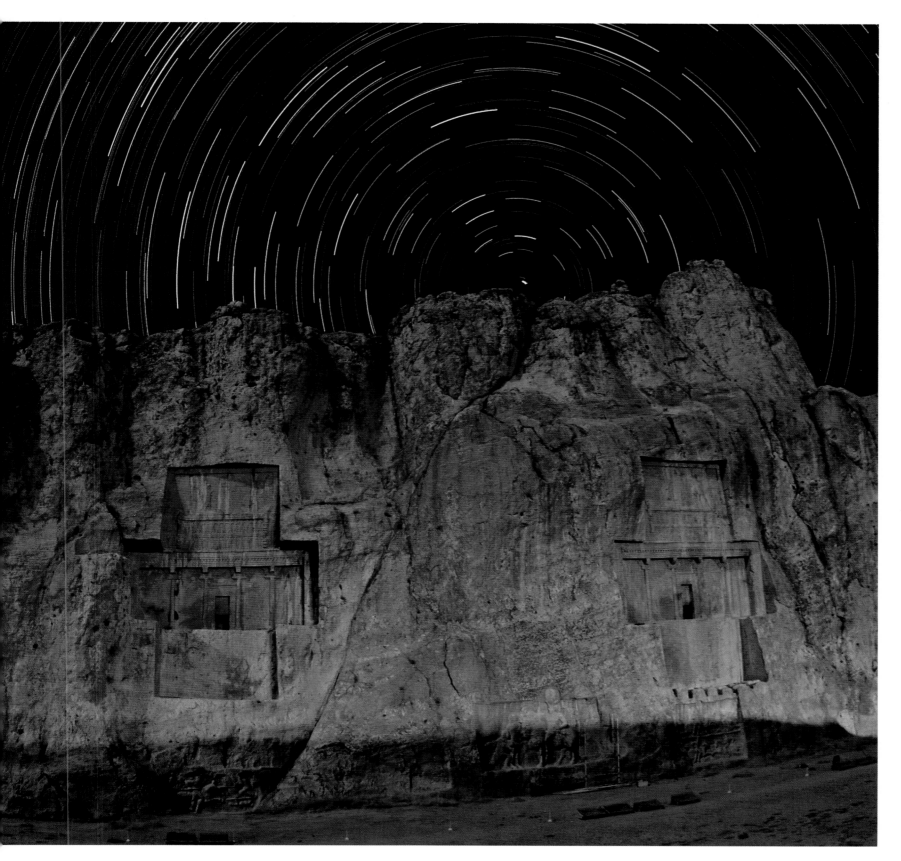

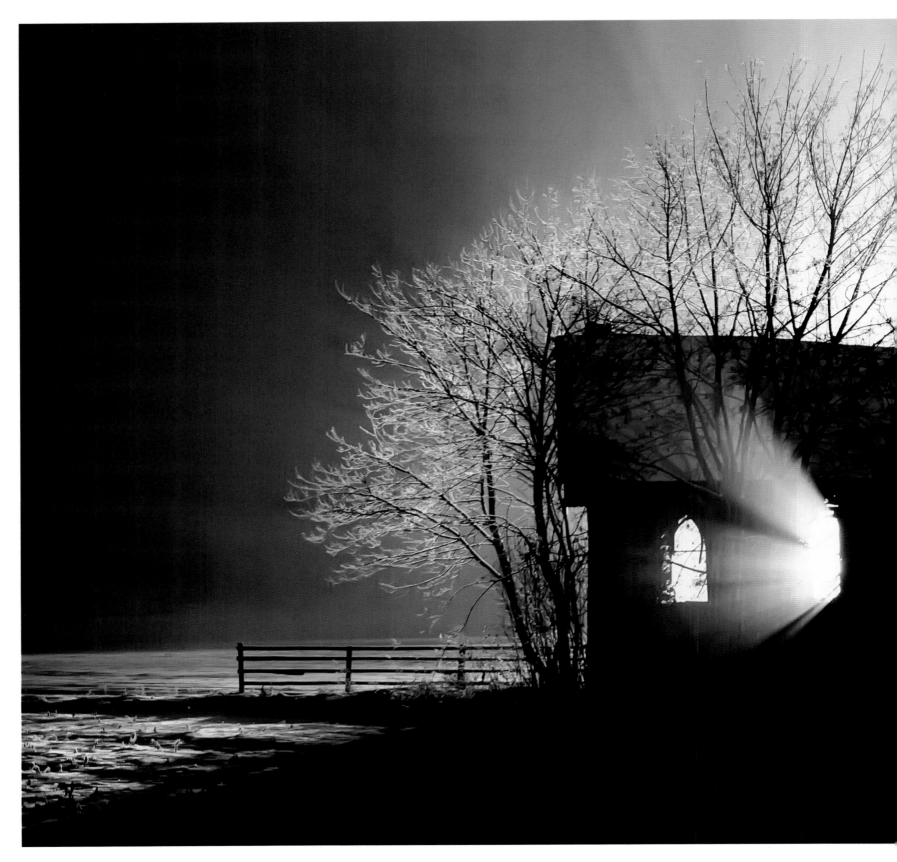

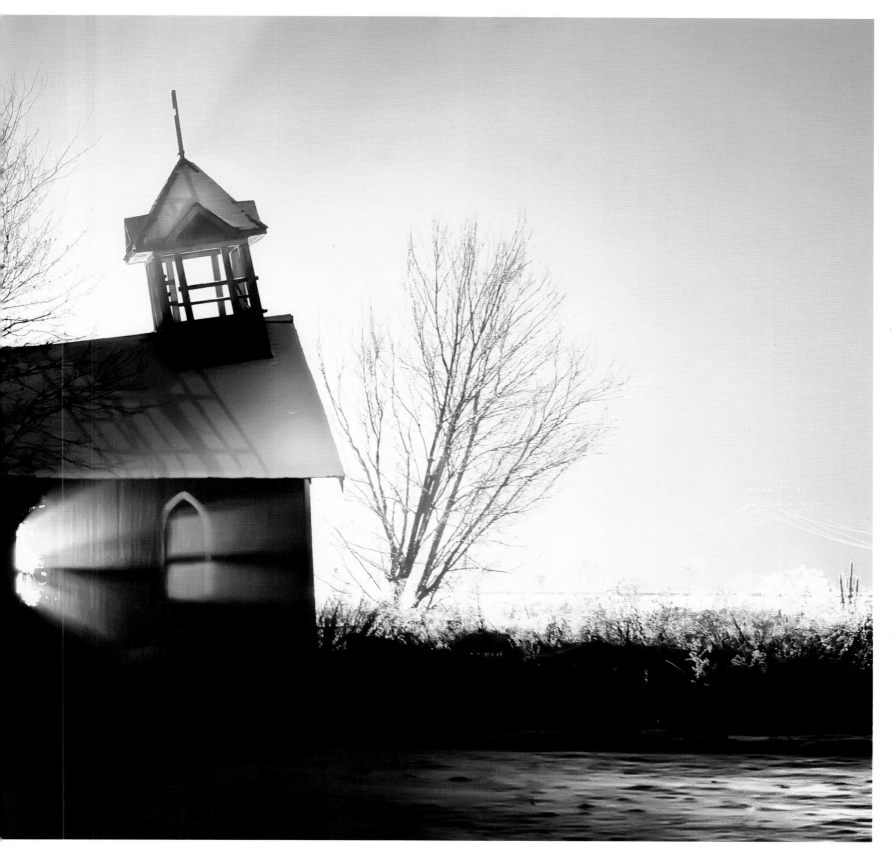

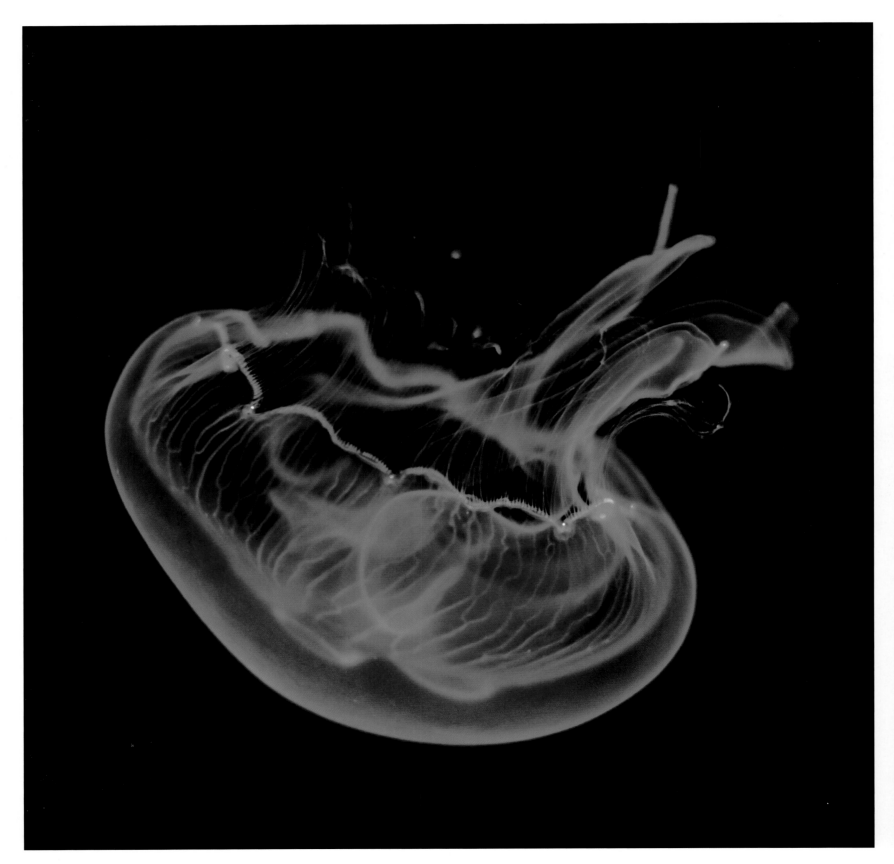

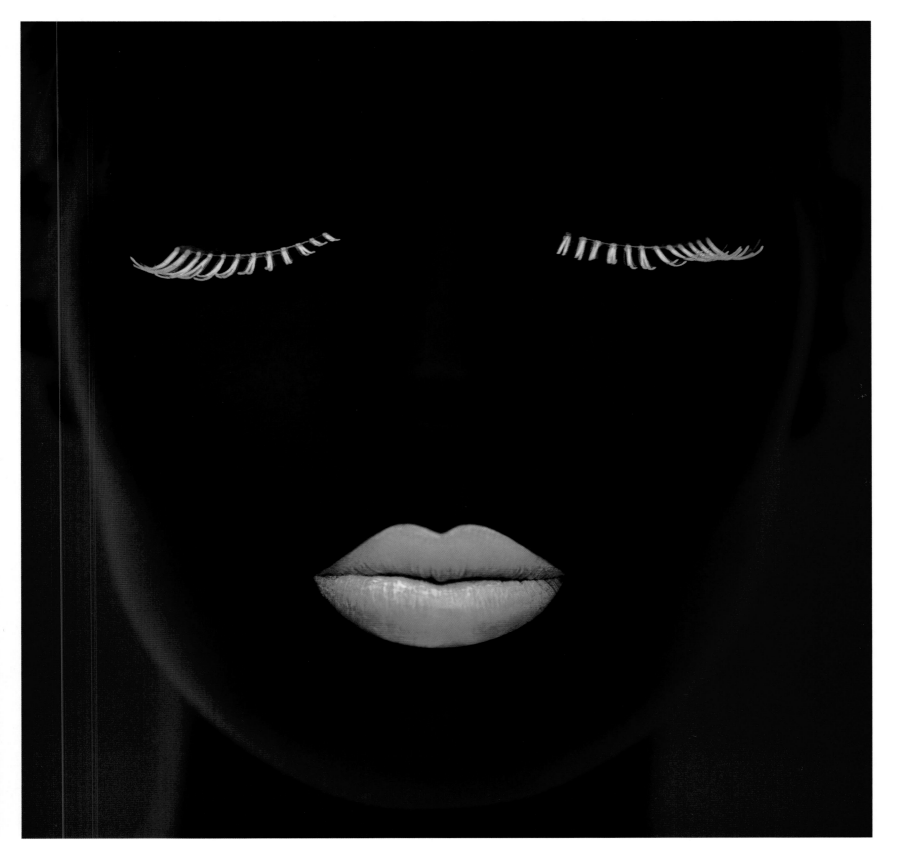

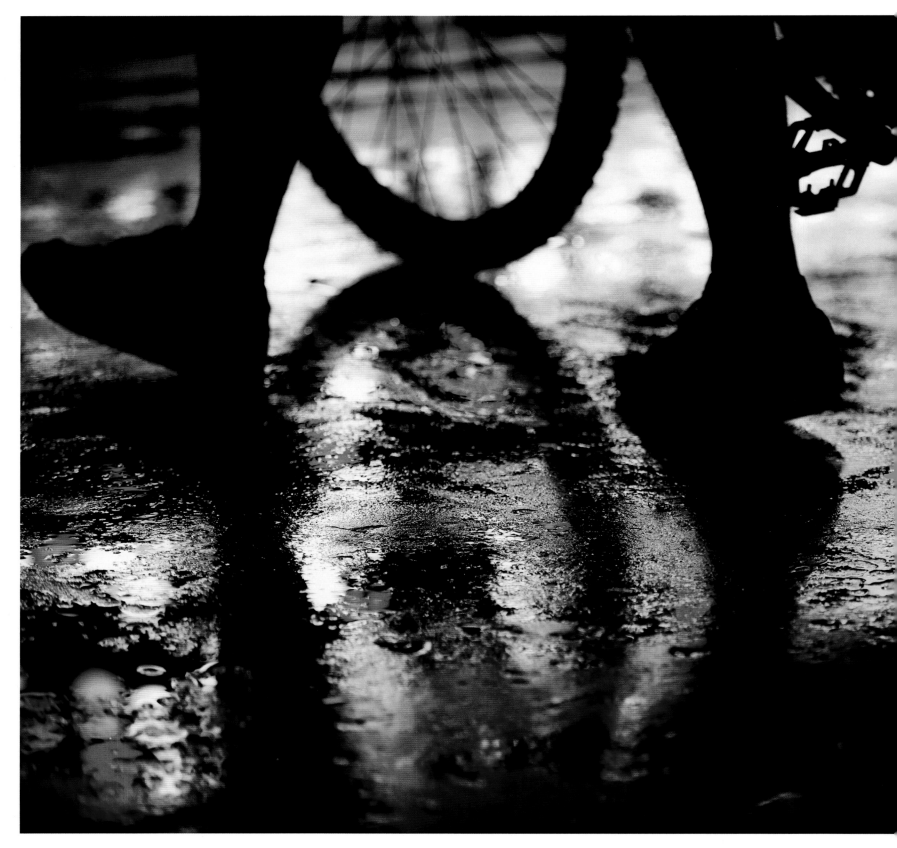

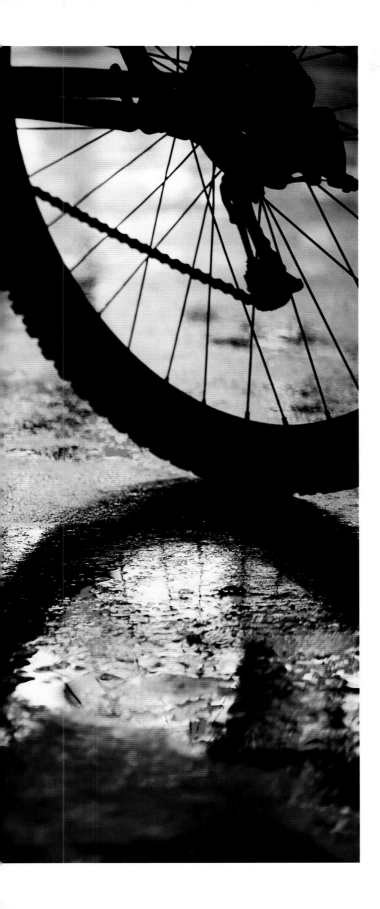

LEFT: LONDON, ENGLAND | A bicyclist casts a shadow on a rain-slick street. | *Moof*

PAGE 276: BANGKOK, THAILAND | A bioluminescent moon jellyfish shines green against dark waters in an aquarium. | *Nutthaphol Jaroongkeeratiwong*

PAGE 277: LOCATION UNKNOWN | Ultraviolet lights turn a model's eyelashes and lips green. | *Janis Litavnieks*

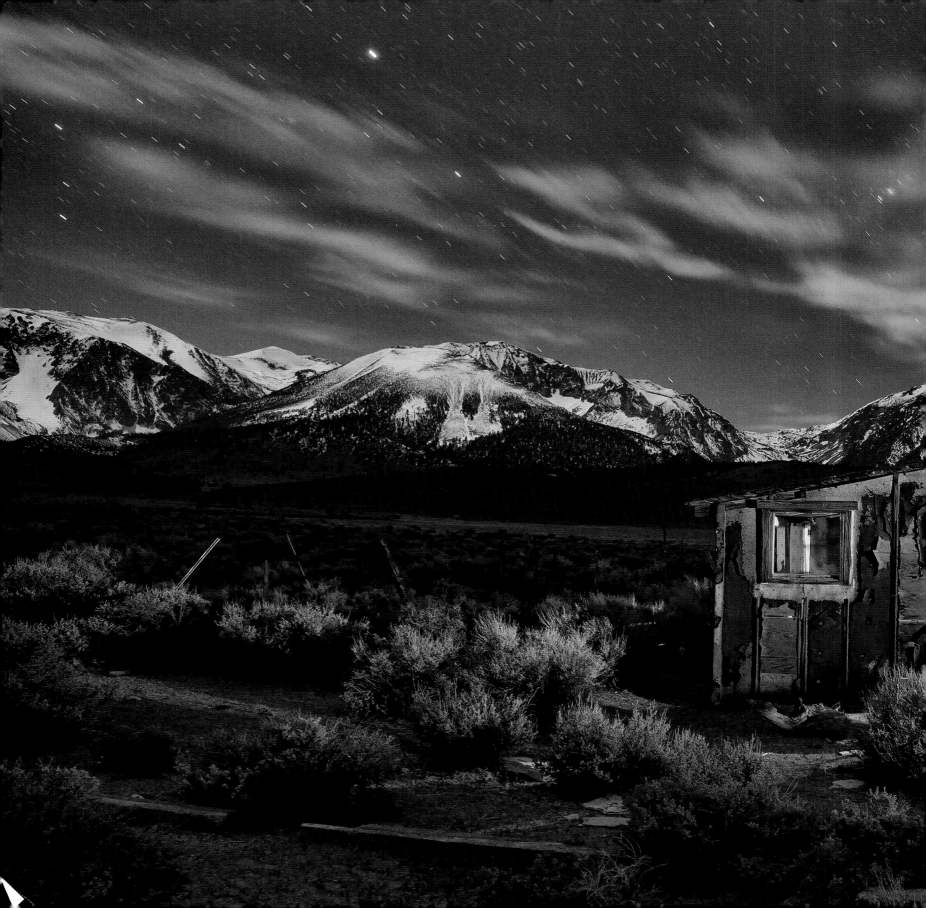

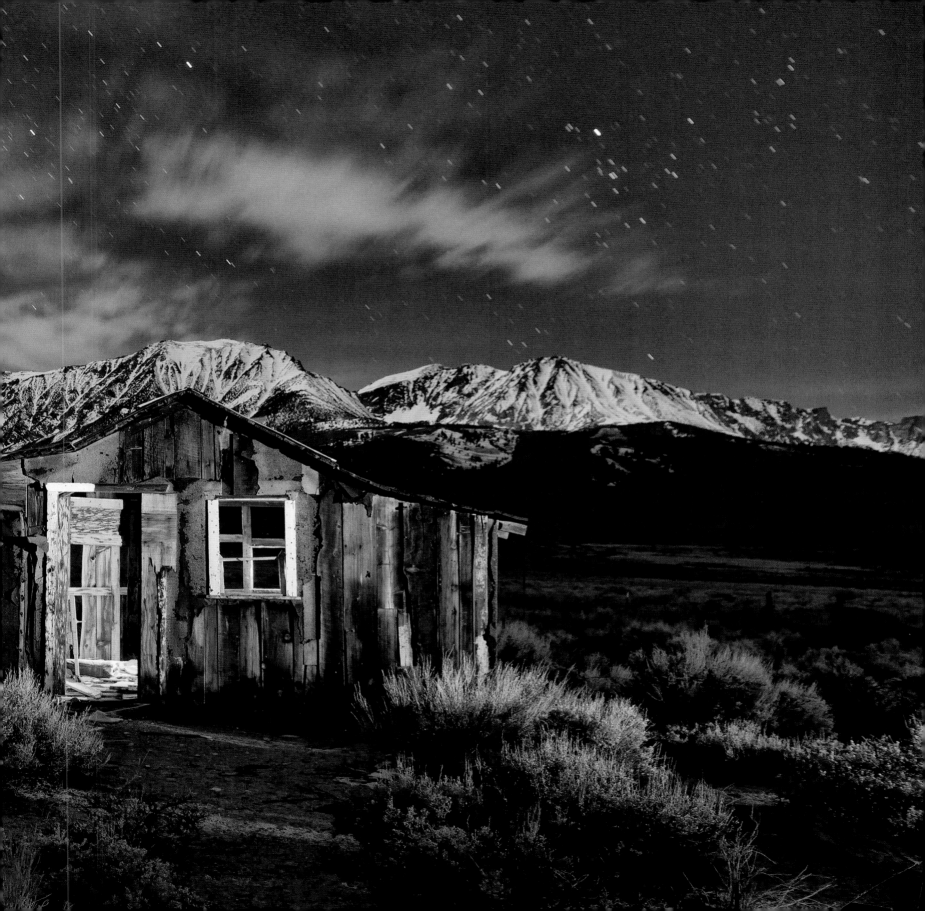

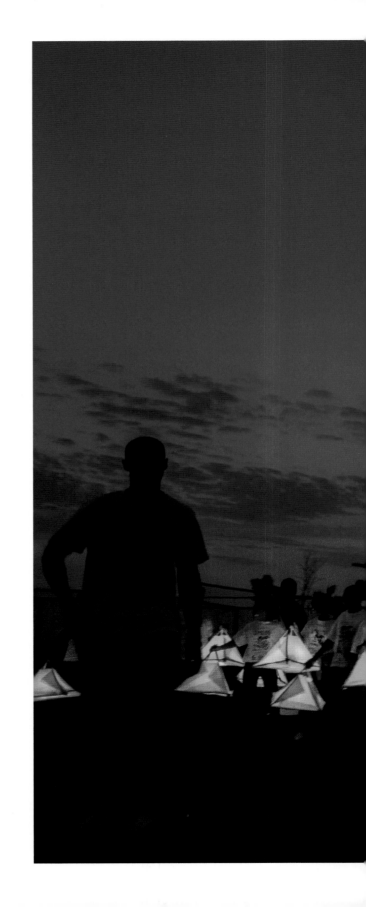

RIGHT: CLANWILLIAM, SOUTH AFRICA | Local children carry a large cat lantern figure during a festival that celebrates local culture and creativity. | *Rodger Bosch*

PREVIOUS PAGES: MONO LAKE, CALIFORNIA | The Sierra Nevada provide a stunning backdrop for an isolated cabin. | *Christian Heeb*

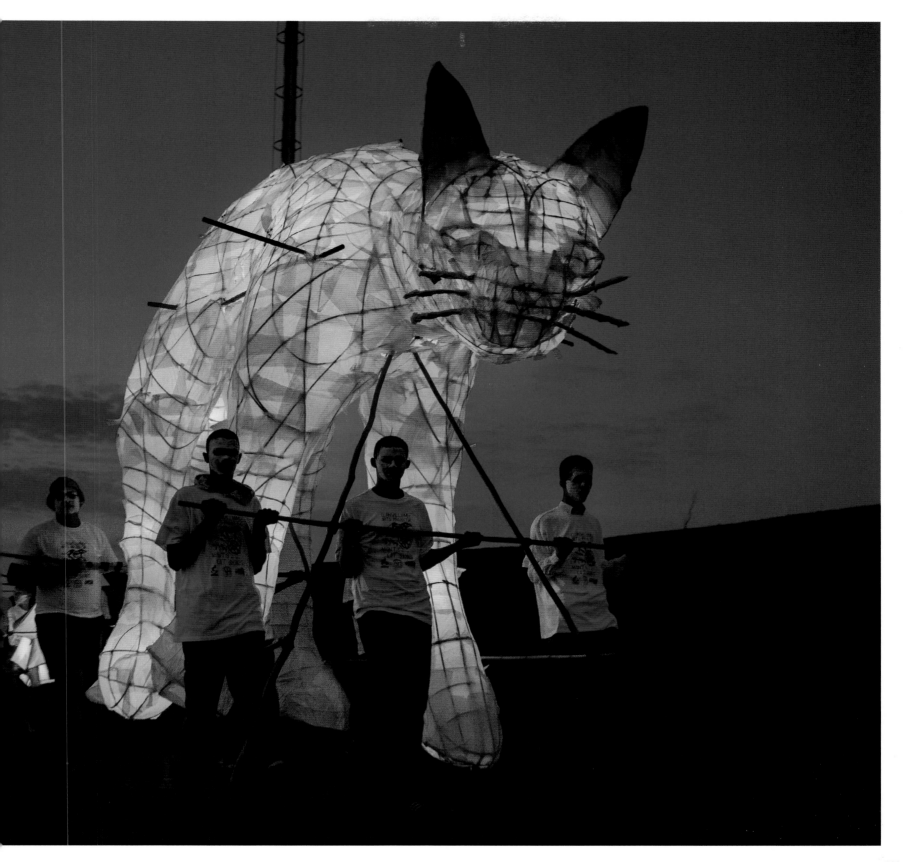

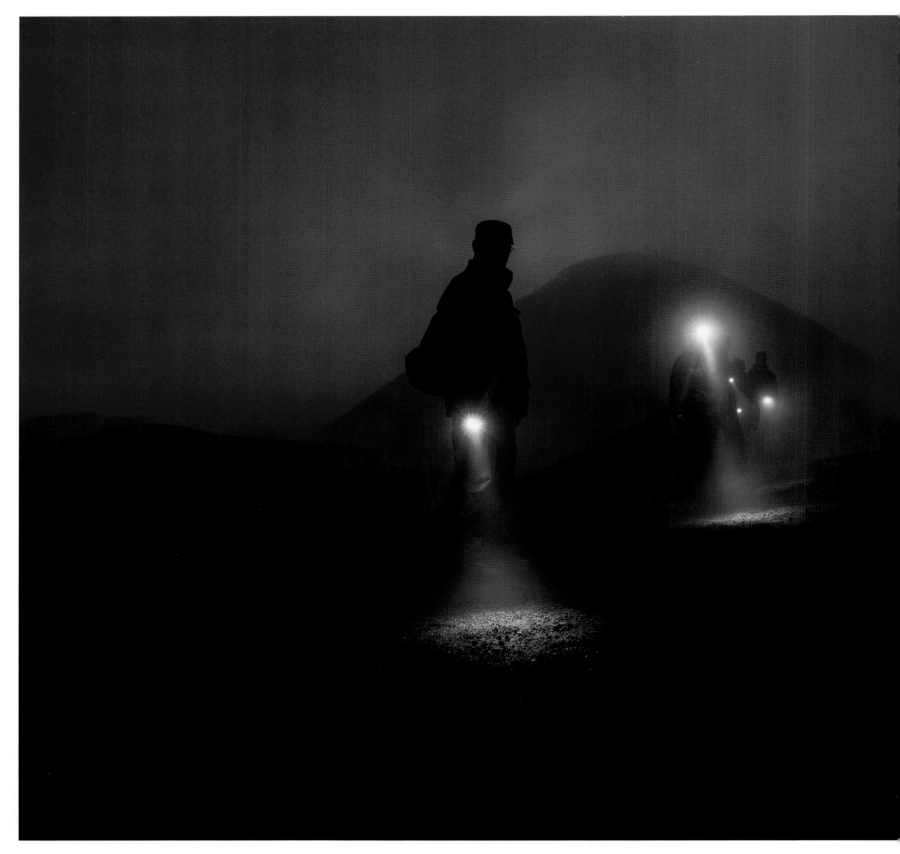

KAMCHATKA, RUSSIA | Explorers use headlamps and flashlights
to find their way in an active volcanic crater. | *Denis Budkov*

" THE GARDEN IS A MIRACULOUS PLACE, AND ANYTHING CAN HAPPEN ON A BEAUTIFUL MOONLIT NIGHT.

—WILLIAM JOYCE

OPPOSITE: **IGUAÇU FALLS, BRAZIL** | The moon lights up rivulets of water
as they pour over the falls, located on the border of Brazil and Argentina. | *Nick Garbutt*

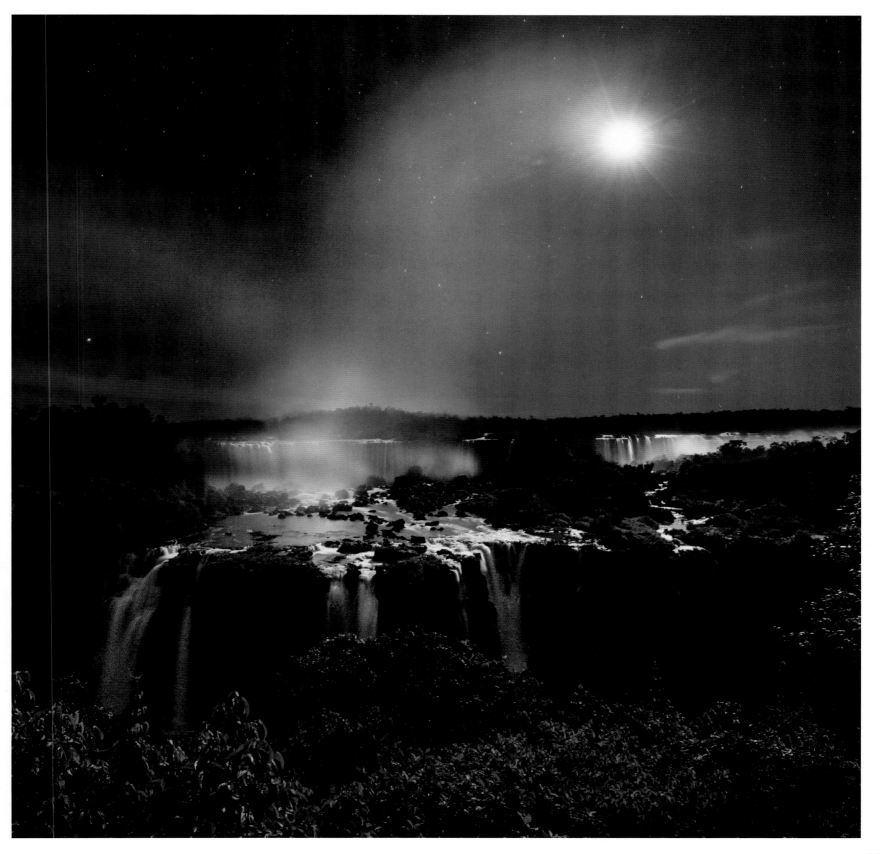

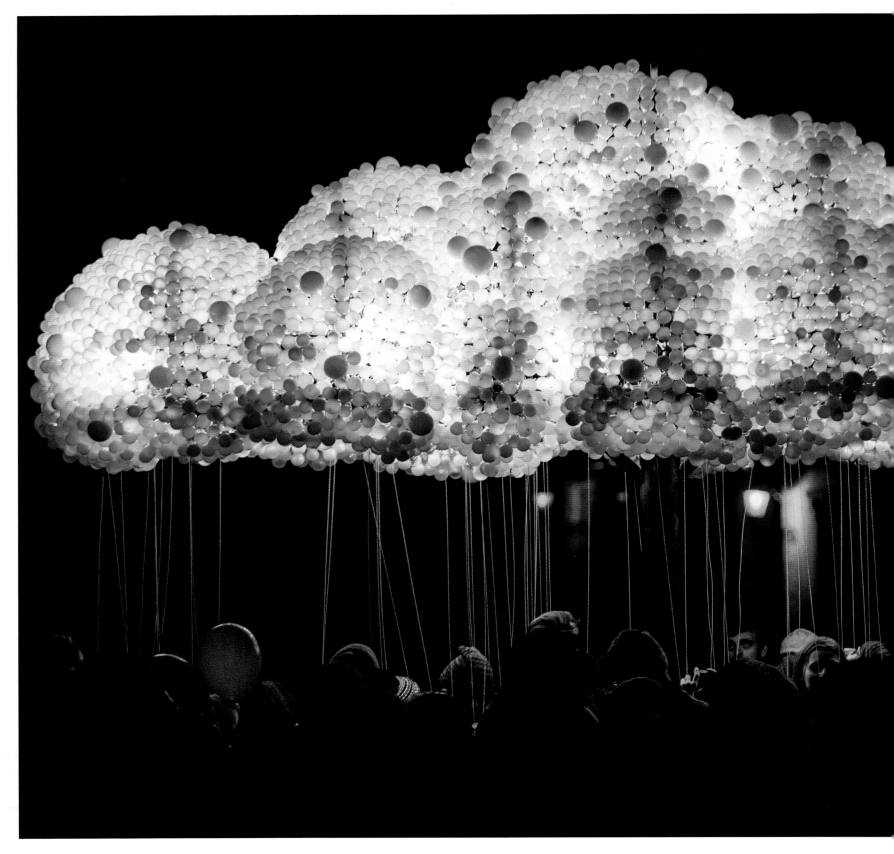

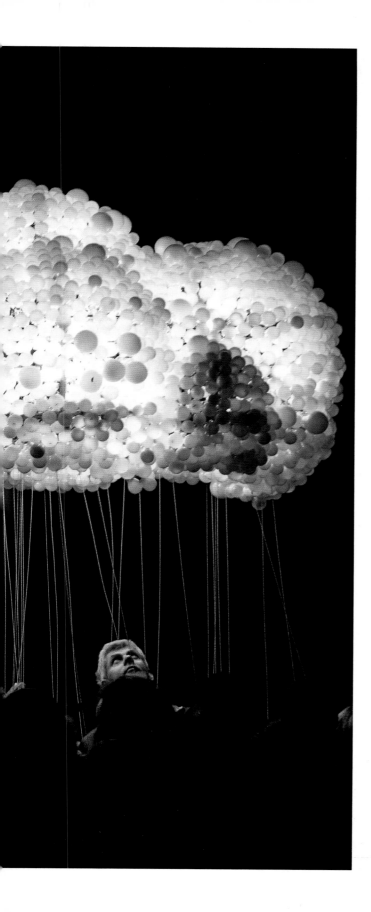

LEFT: **BRATISLAVA, SLOVAKIA** | Festivalgoers use thousands of lightbulbs to create Cloud, an interactive art piece by Caitlind r.c. Brown and Wayne Garrett. | *Vladimir Simicek*

PAGE 290: **DARWIN, CALIFORNIA** | A Joshua tree stands between the bright red windows of an abandoned miner's shack in a desert ghost town. | *Troy Paiva*

PAGE 291: **MYAKKA RIVER STATE PARK, FLORIDA** | An alligator's red eyes shine out over the water. | *Larry Lynch*

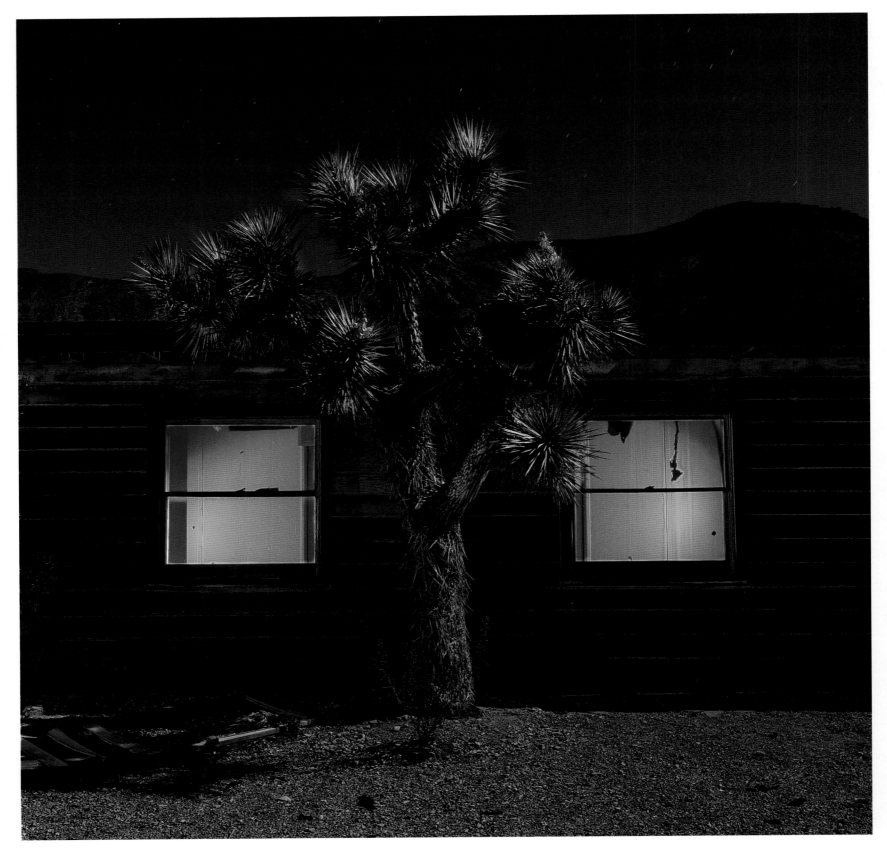

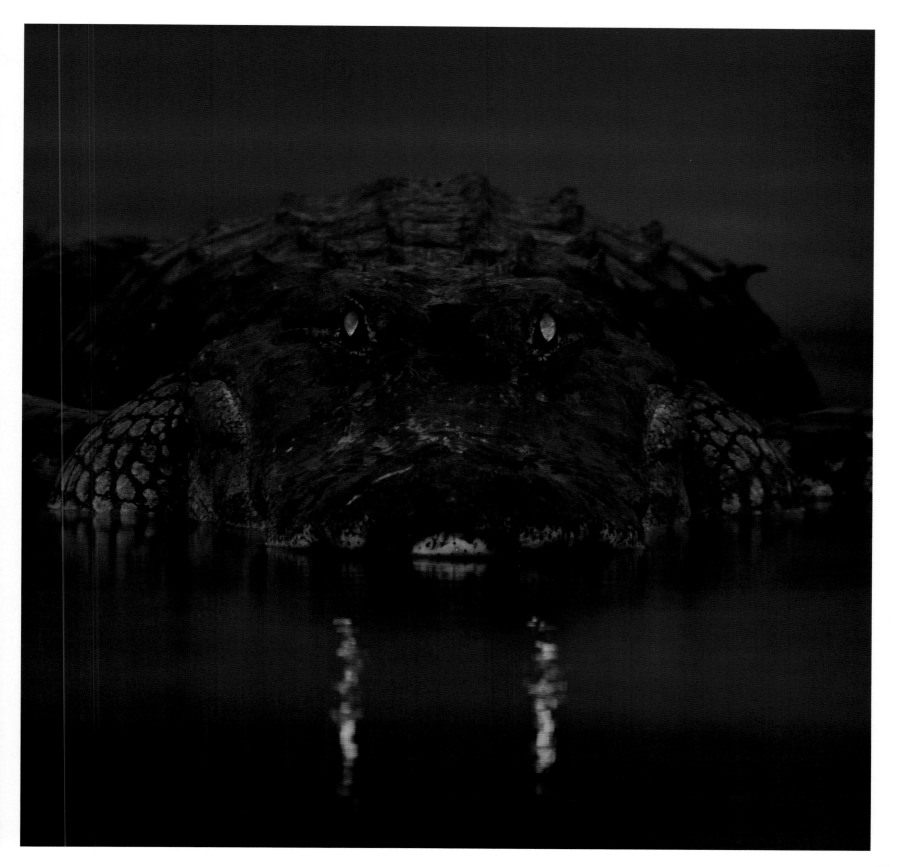

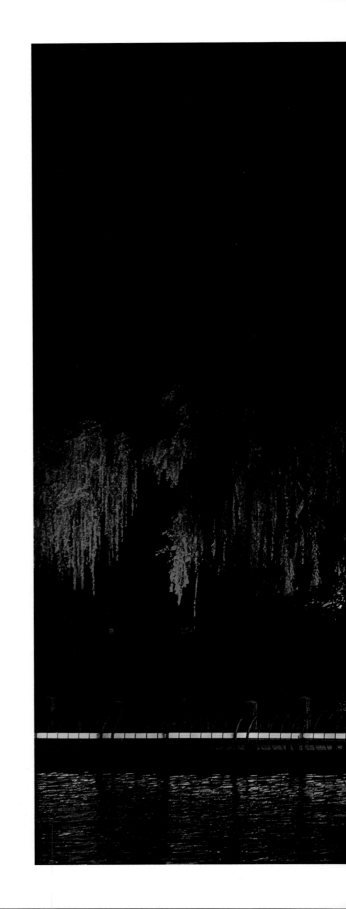

RIGHT: **NANTONG, CHINA** | Pagoda lights, a pond, and the surrounding woods create a serene evening scene. | *Svein Jarle Anglevik*

FOLLOWING PAGES: **MARIN COUNTY, CALIFORNIA** | Seen from Mount Tamalpais, moonlight and mist shroud Marin County in a gossamer tapestry. | *Lorenzo Montezemolo*

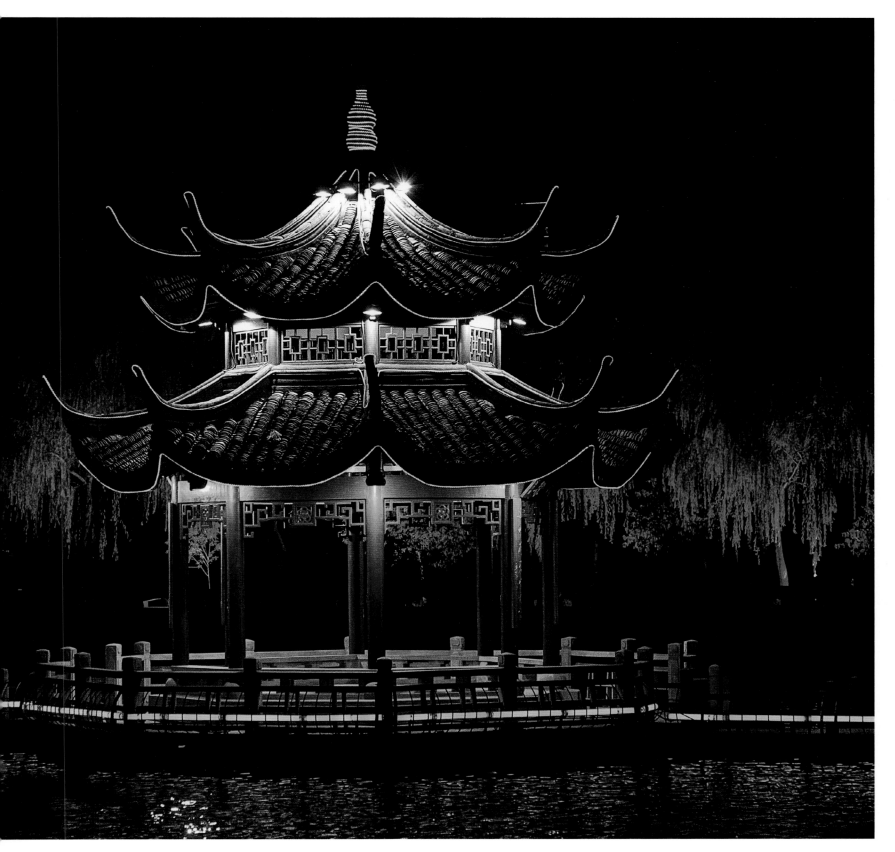

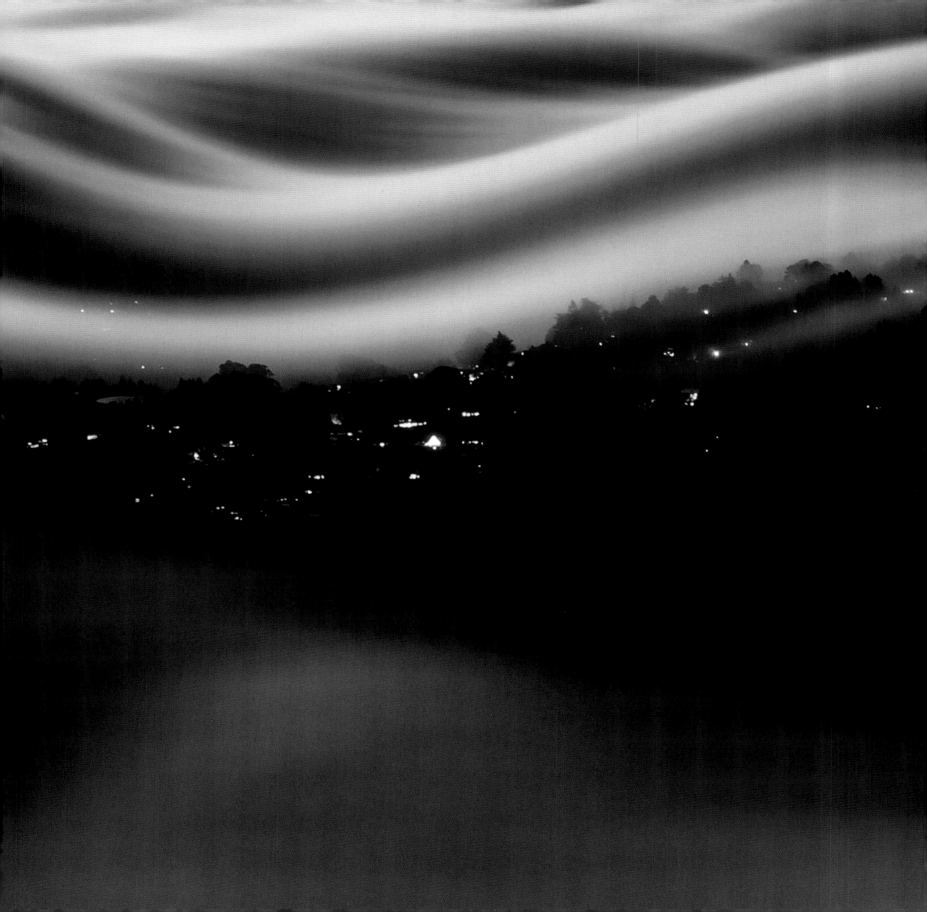

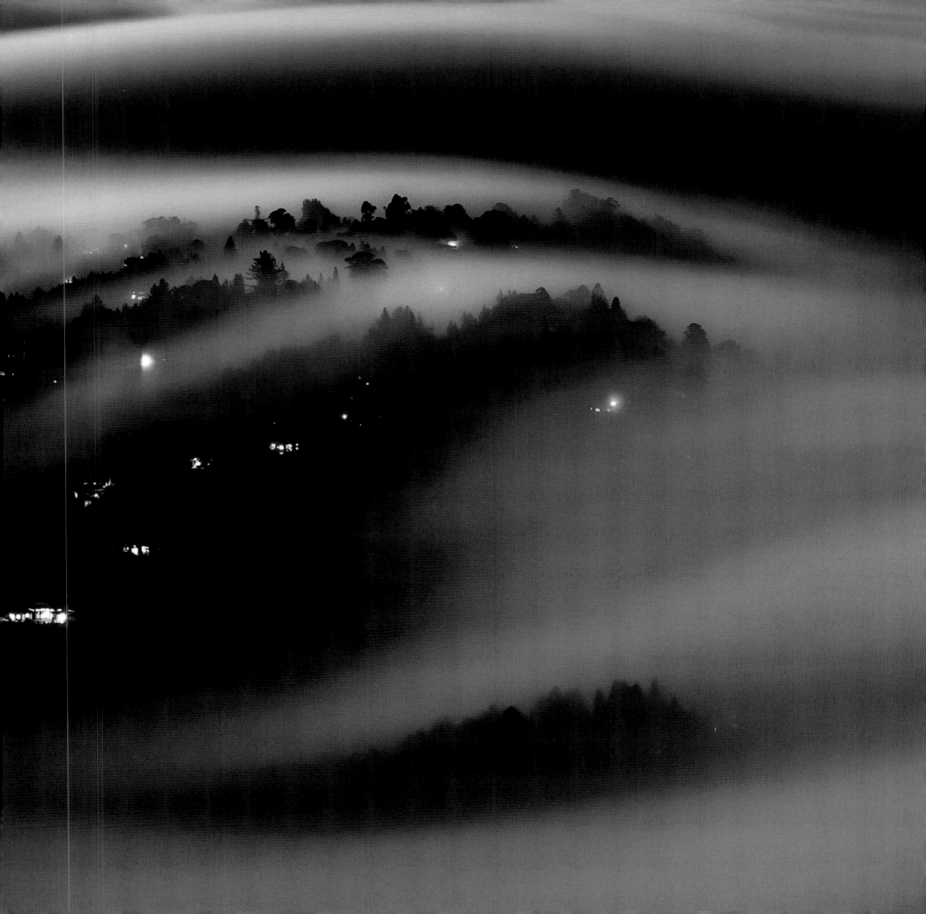

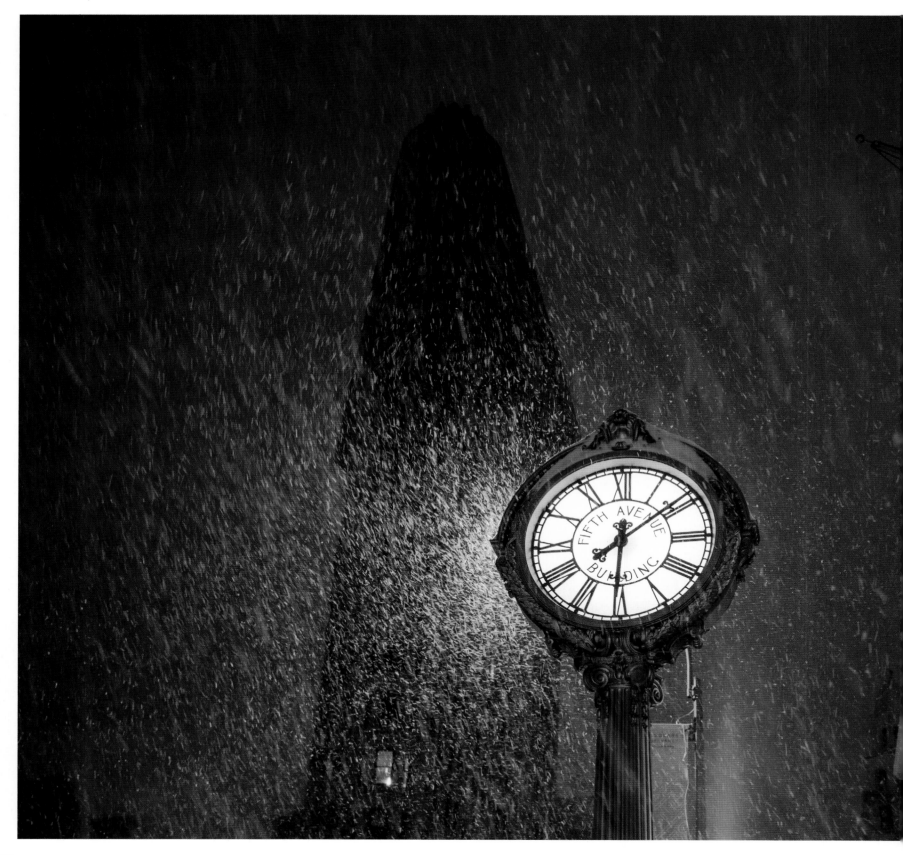

NEW YORK, NEW YORK | Snow pours down around a sidewalk clock outside the Flatiron Building on Fifth Avenue. | *Ira Block*

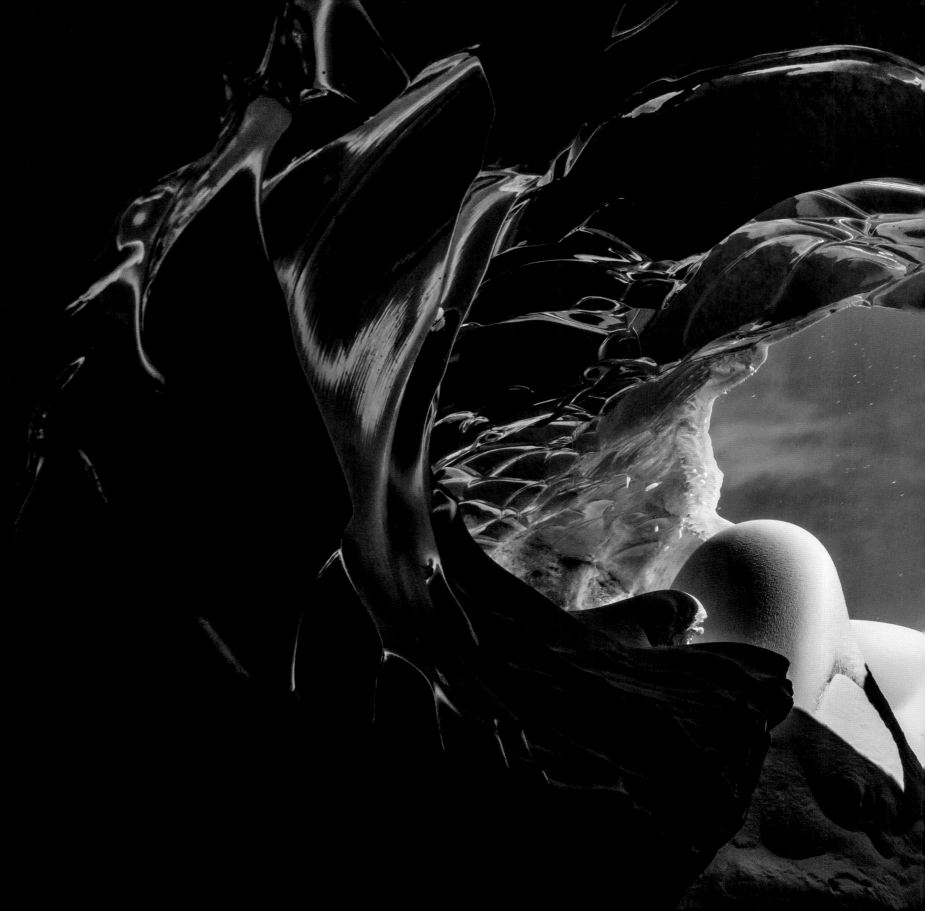

| CHAPTER FOUR |

WONDER

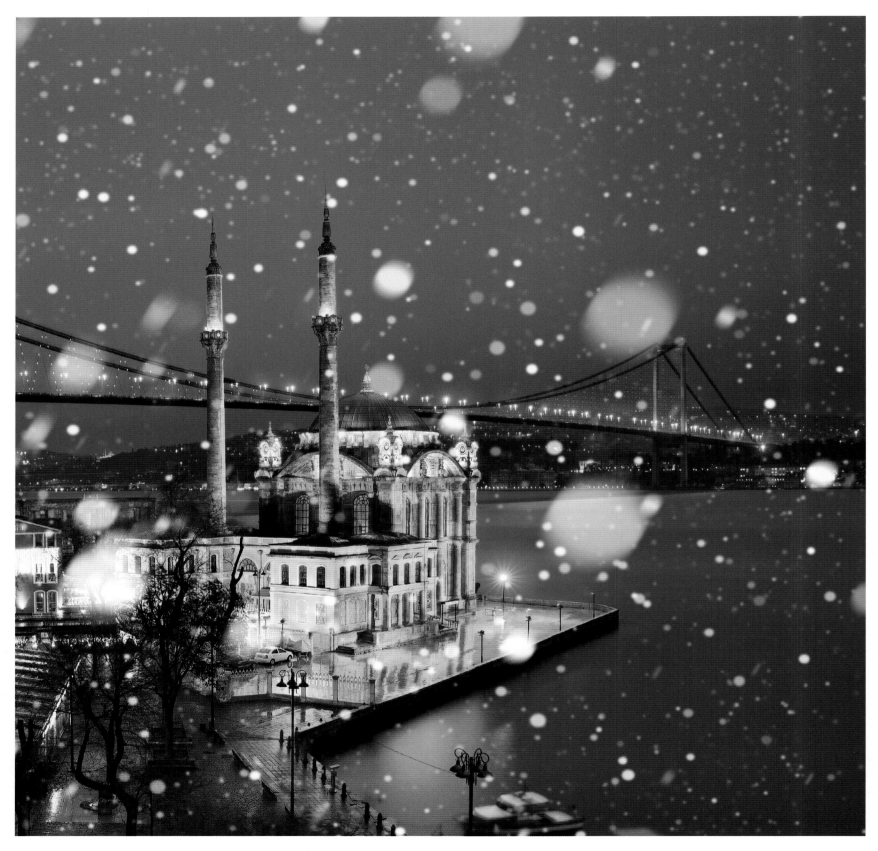

At night, you're more ready to believe in miracles. With fewer distractions, you hear the sound of water flowing, of a stealthy fox padding by. Listen and you might hear the hiss in the air that precedes a crack of lightning, or the brief inhalation of a humpback surfacing, only to dive down under again. You sense the moon rising; you're aware of every breath you take.

Daytime bustle demands action. But at night you can close your eyes and wander, letting the world wash over you. Imagination overtakes your senses and can carry you places you've never been before. Dream a little: Follow with wonder around the world. The Taj Mahal looms through the midnight mist. Red Square's colorful domes beckon. Cinque Terre patchwork mounts a cliff above a rocky shoreline.

At night the sky grows bigger, and the beliefs of the ancients come alive again. Aged ruins stand tall against the force of time. Every precipice, every peak reaches toward the stars. Our little world of what's known and what's seen shrinks smaller than ever. City lights twinkle, but they can only shine so far. Beyond, all night, the universe insists on its magnificence.

OPPOSITE: **ISTANBUL, TURKEY** | Snowflakes fall softly around the Ortaköy Mosque. | *Ilhan Eroglu*

PREVIOUS PAGES: **VATNAJÖKULL, ICELAND** | A ribbon of the aurora borealis reflects off the interior of an ice cave. | *Mika-Pekka Markkanen*

GUANGZHOU, CHINA | The horizontal Ferris wheel on top of Canton Tower
offers visitors a bird's-eye view of the busy city. | *Tuul & Bruno Morandi*

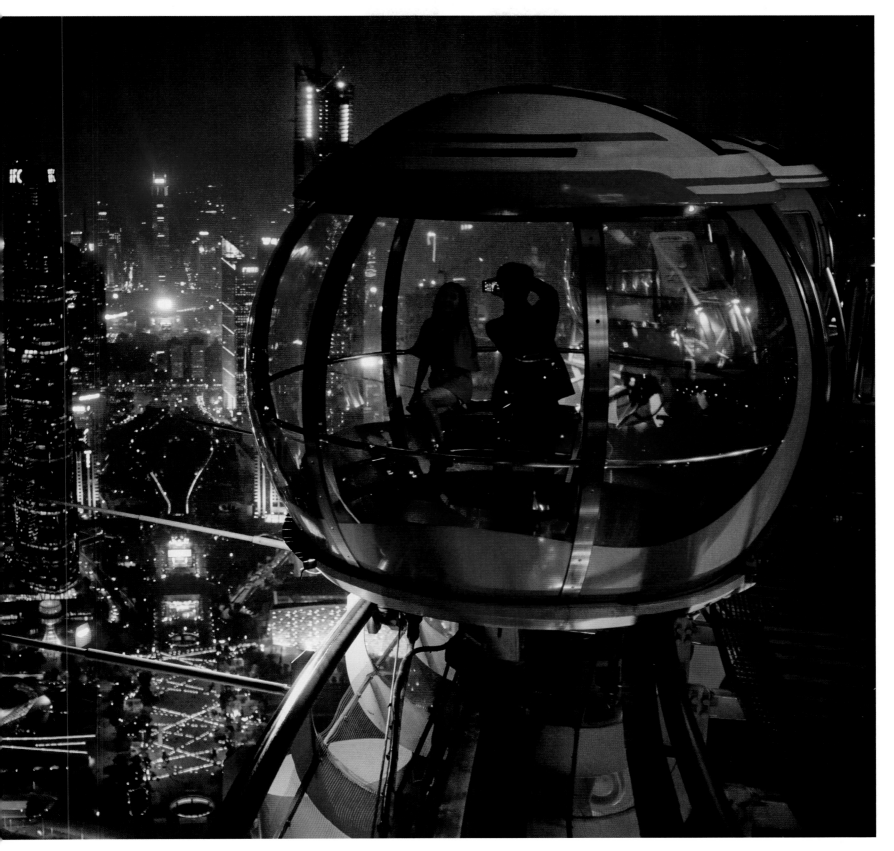

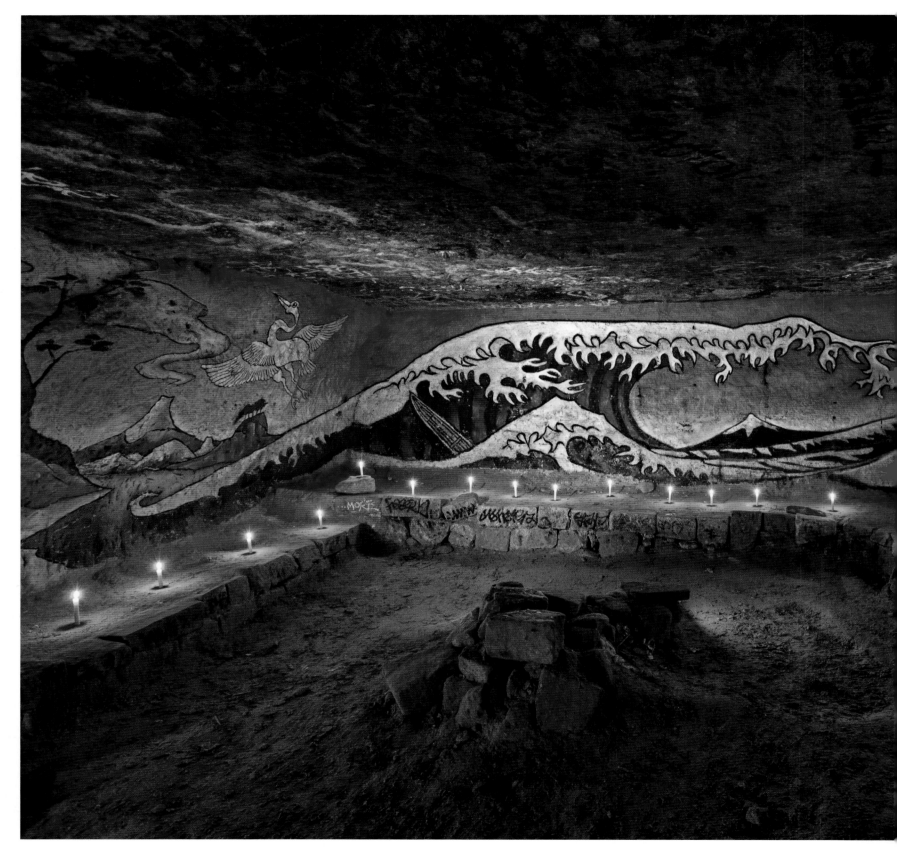

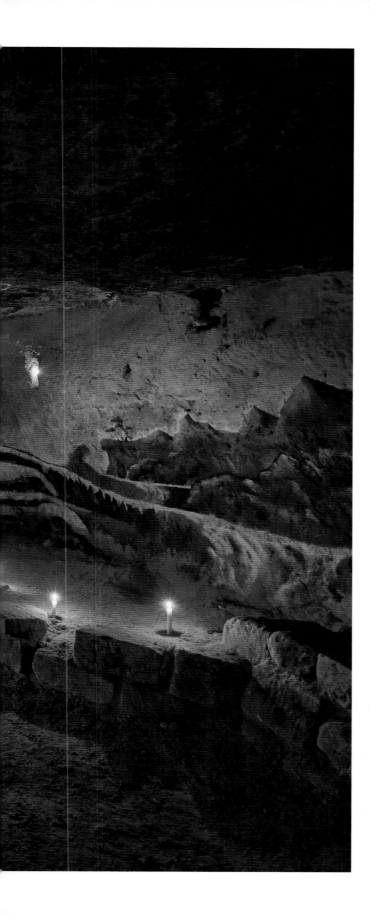

LEFT: **PARIS, FRANCE** | Artists have painted an underground tunnel in the style of Japanese artist Katsushika Hokusai. | *Stephen Alvarez*

FOLLOWING PAGES: **P'YŎNGYANG, NORTH KOREA** | North Koreans watch fireworks to celebrate the 100th birthday of the country's founder, Premier Kim Il Sung. | *David Guttenfelder*

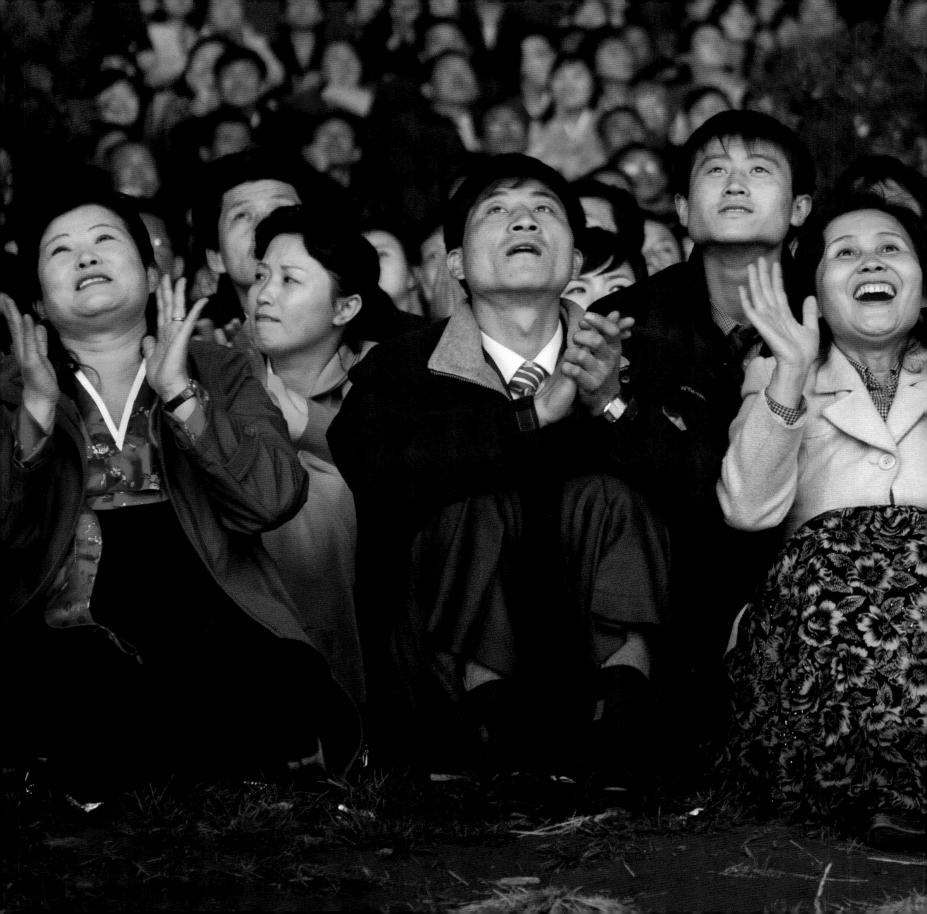

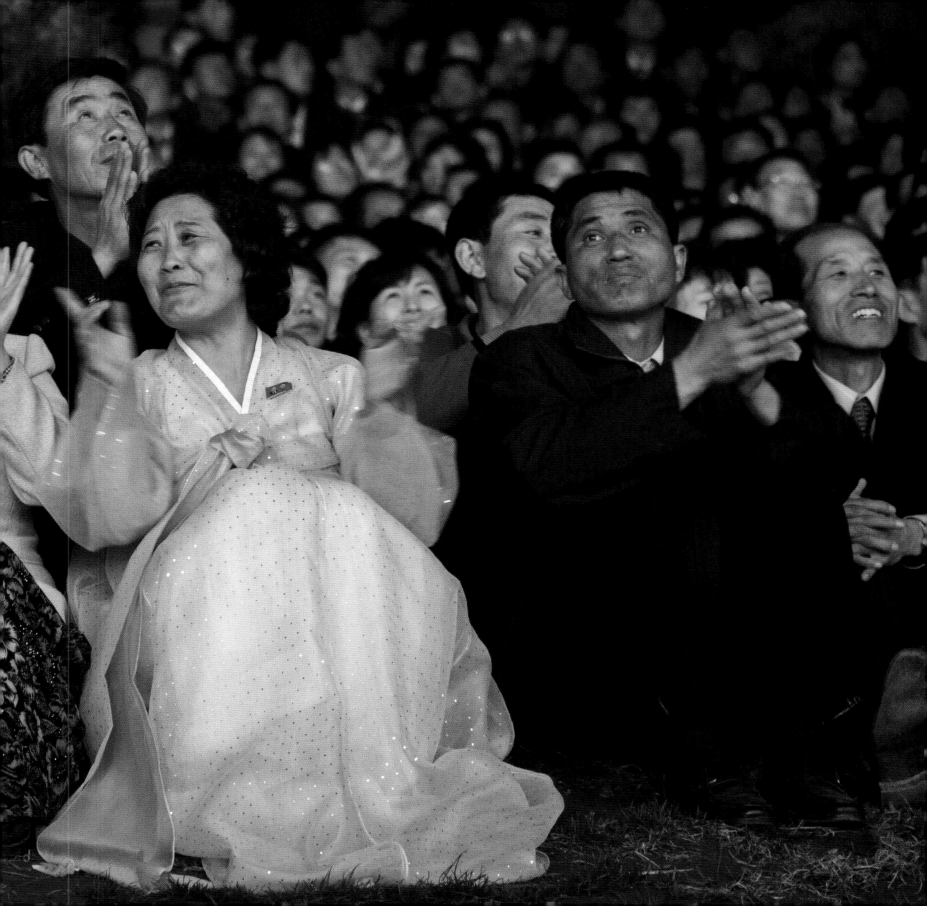

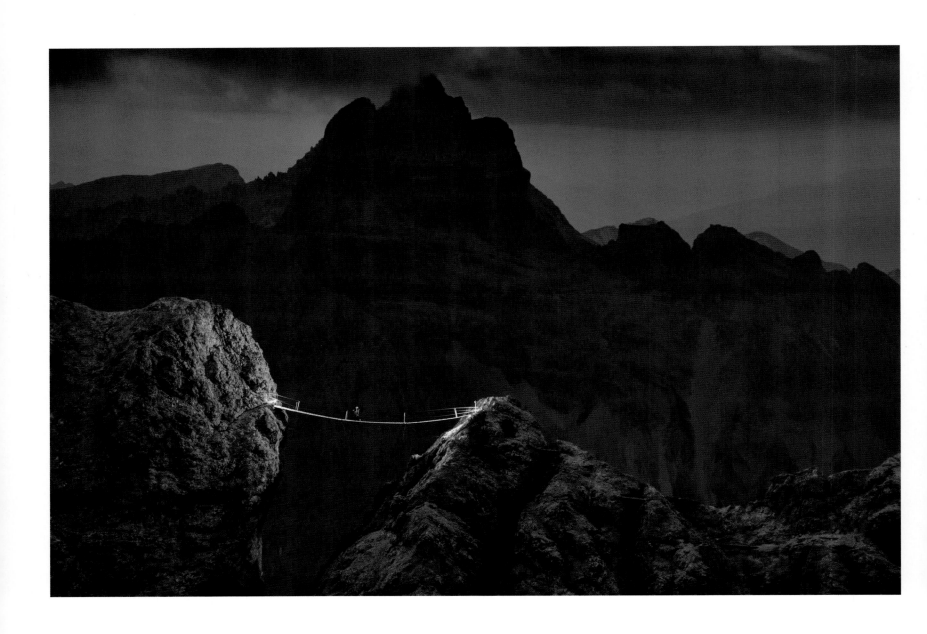

DOLOMITES, ITALY | The thin line of a suspension bridge in the
Italian Dolomites stretches out over a ravine. | *Robbie Shone*

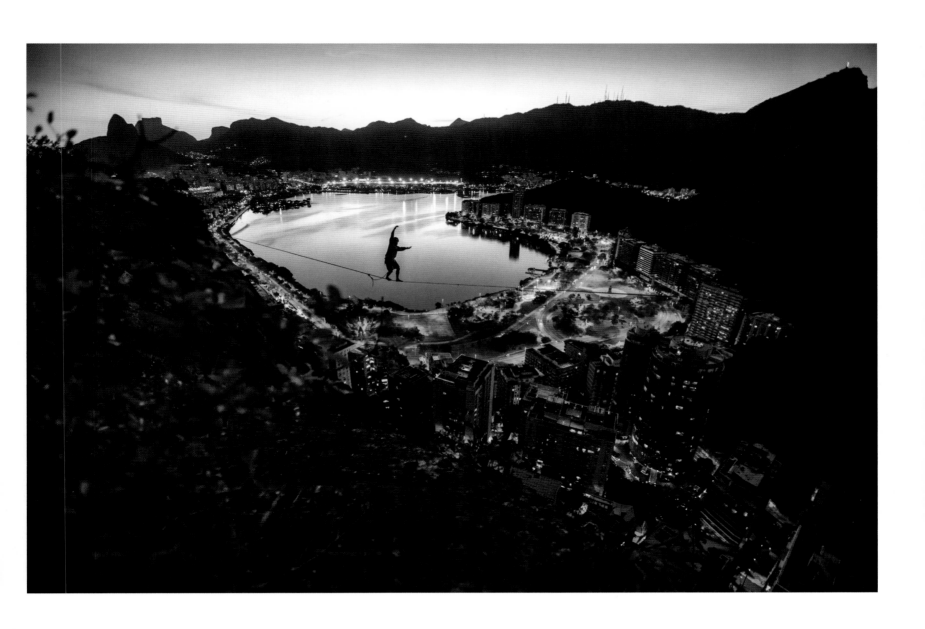

RIO DE JANEIRO, BRAZIL | A slackline walker balances high above
the beach city. | *Bruno Graciano*

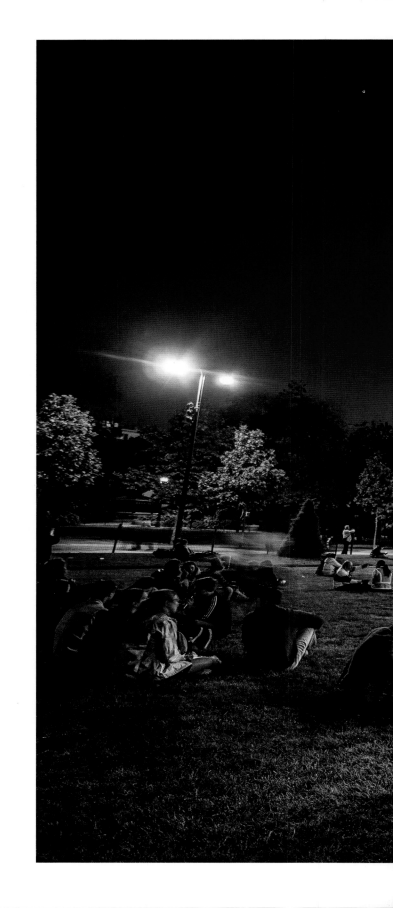

RIGHT: PARIS, FRANCE | Tourists watch from a green lawn as the Eiffel Tower lights up for its nightly show. | *Antonino Bartuccio*

FOLLOWING PAGES: JÖKULSÁRLÓN, ICELAND | Even at midnight during the Icelandic summer, beautiful colors still light up the sky above ice floes and cold waters. | *Agorastos Papatsanis*

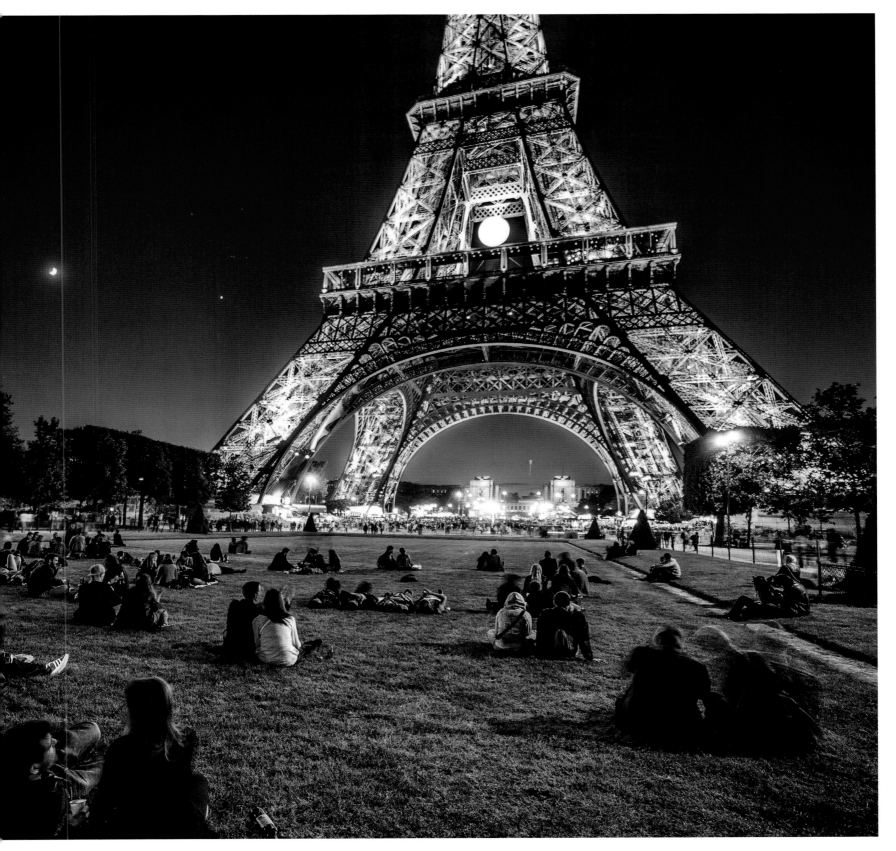

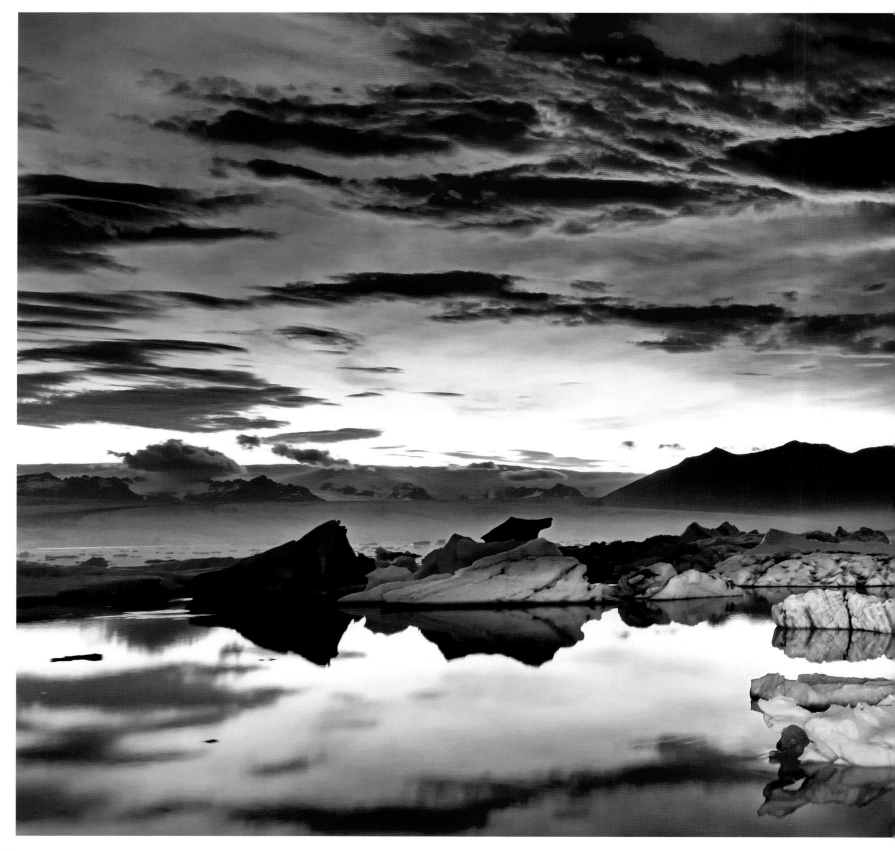

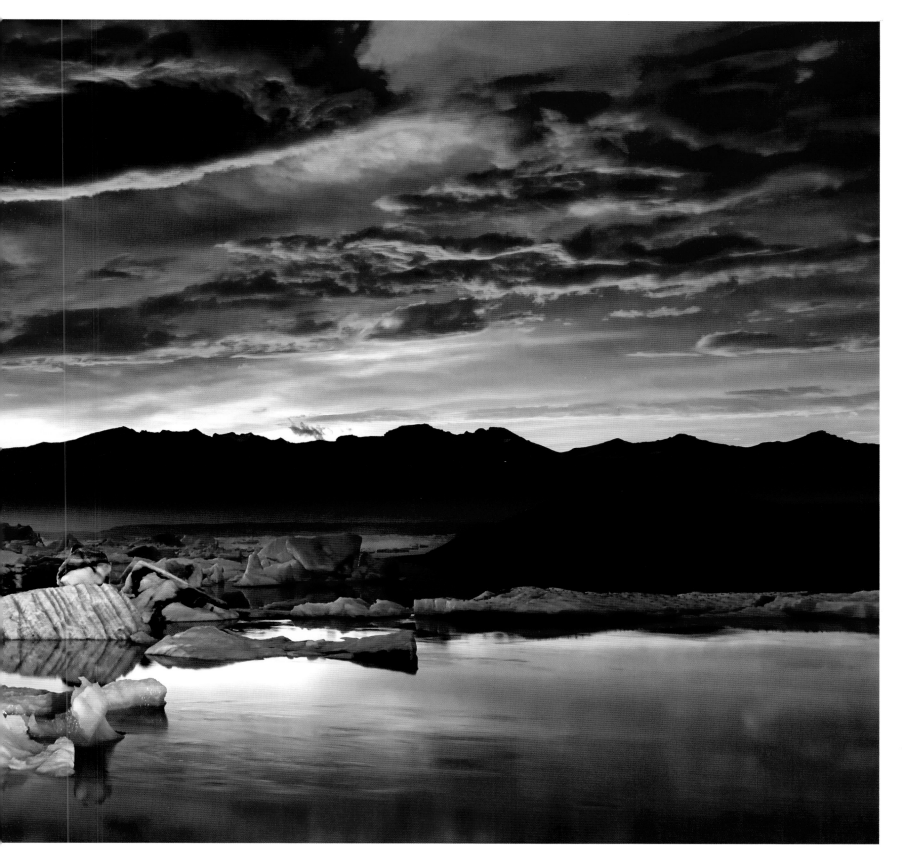

> "IN ALL THINGS OF NATURE
> THERE IS SOMETHING OF
> THE MARVELOUS.
>
> —ARISTOTLE

OPPOSITE: **MALDIVES** | Dark ocean waters look celestial
surrounding a lionfish's distinctive striped fins and body. | *Giordano Cipriani*

314

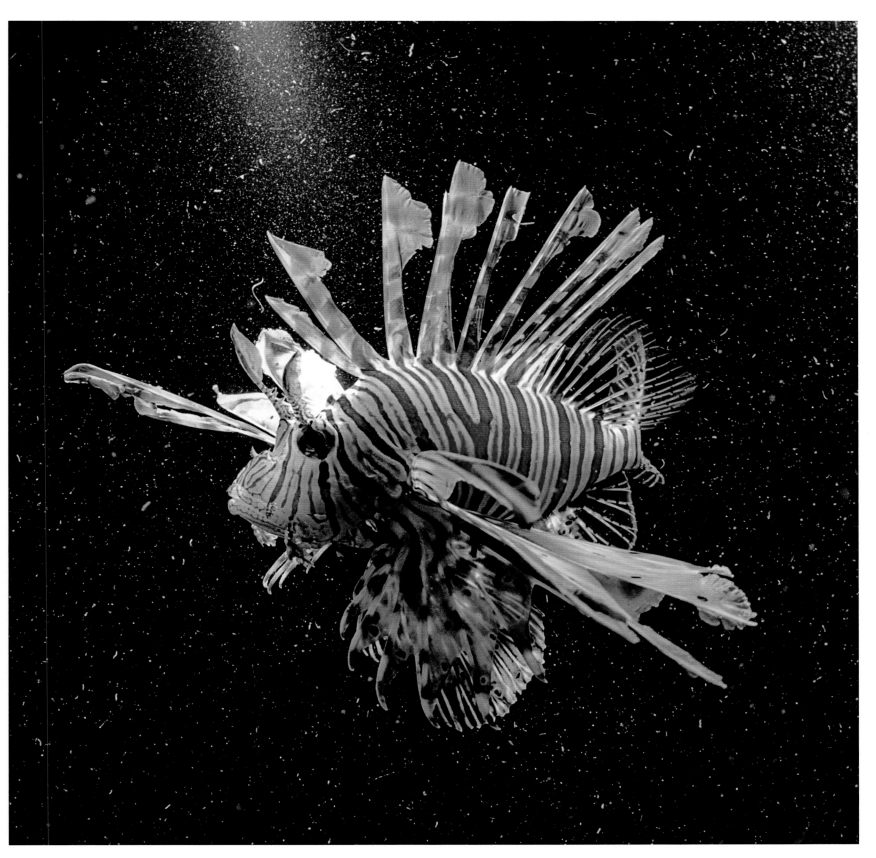

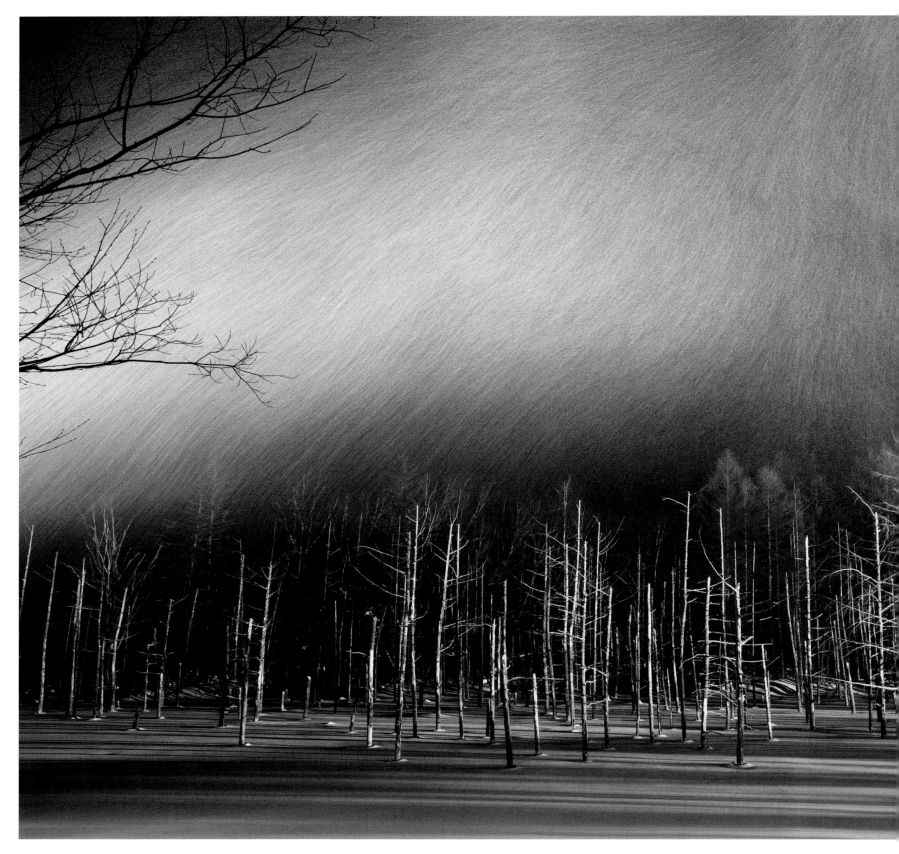

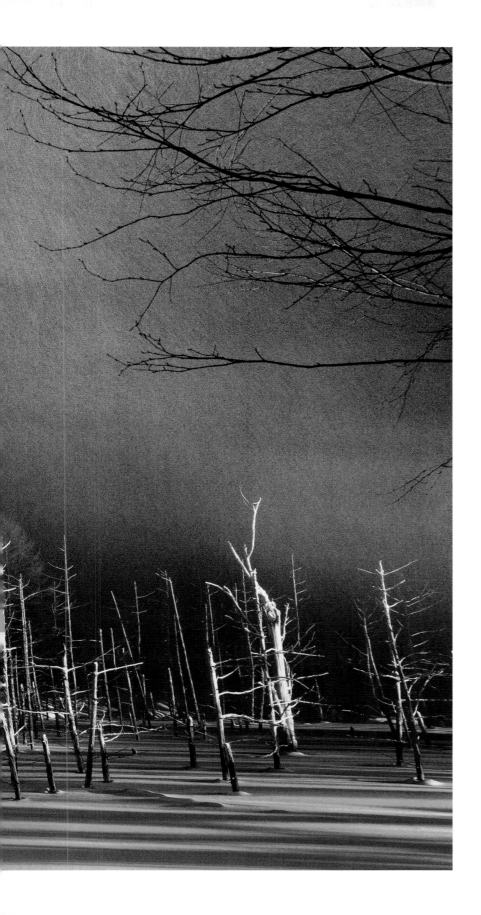

LEFT: **HOKKAIDO, JAPAN** | Spindly trees and the snowy Blue Pond
form a chilling landscape. | *Kent Shiraishi*

FOLLOWING PAGES: **HOKKAIDO, JAPAN** | An ice festival at the Lake Shikotsu
hot springs features sculptures illuminated with bursts of color. | *Kazuhiro Nogi*

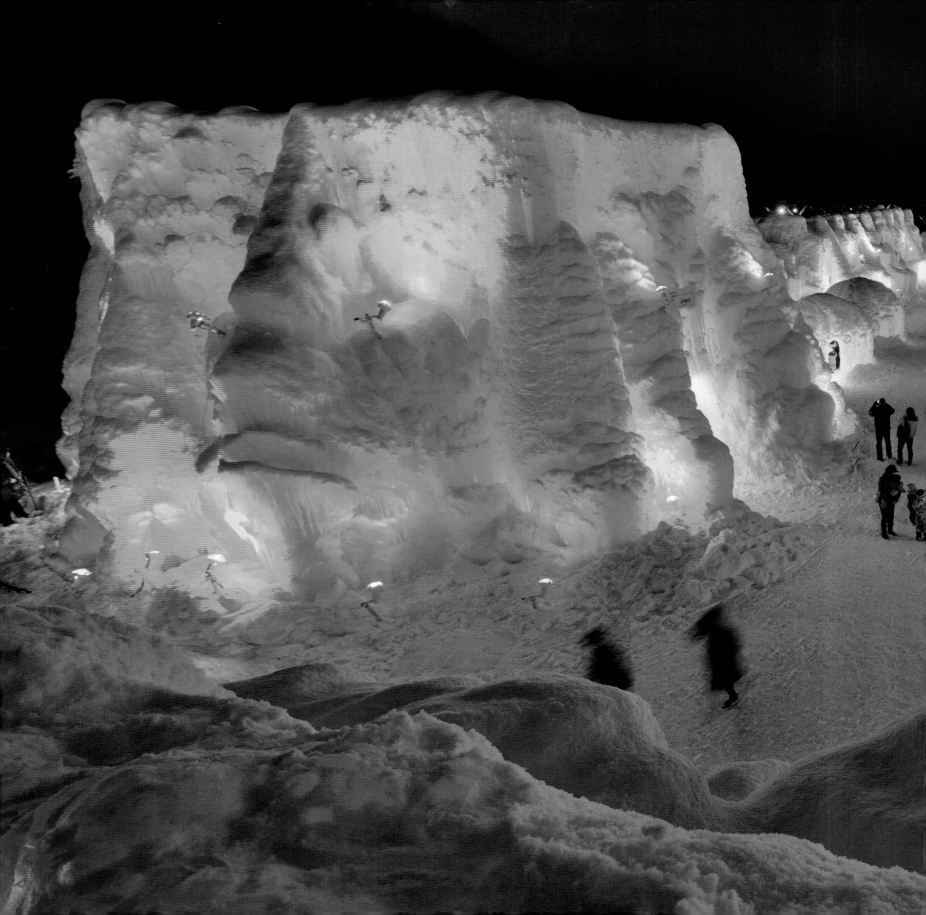

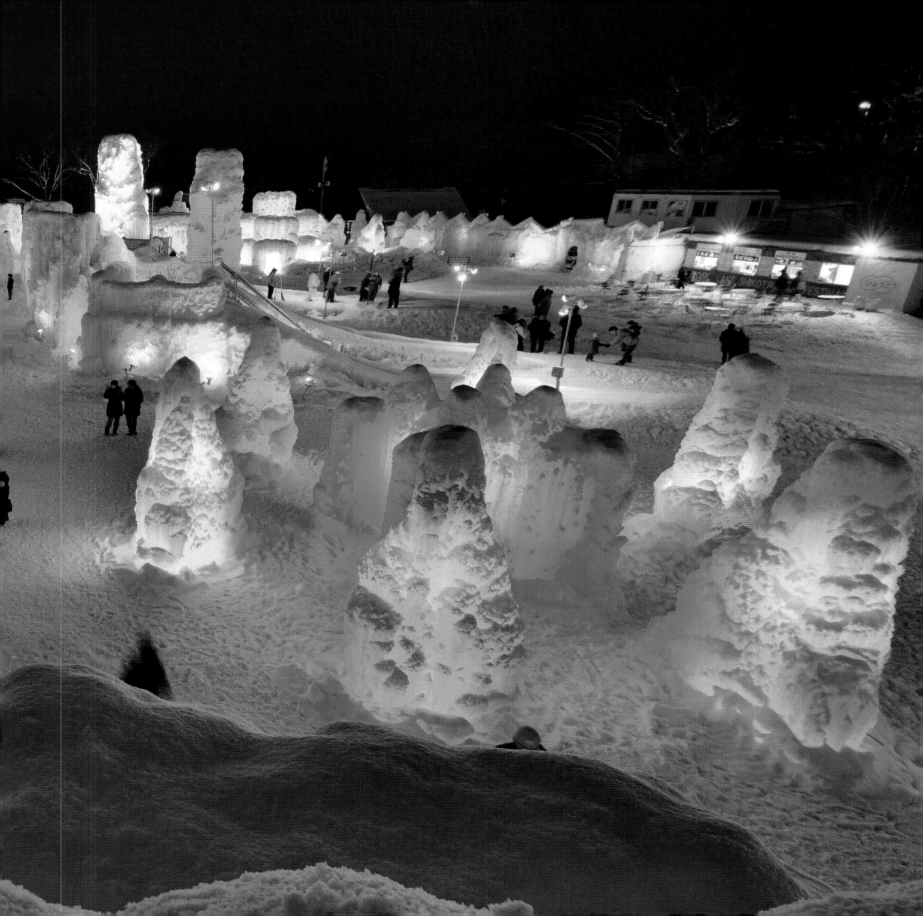

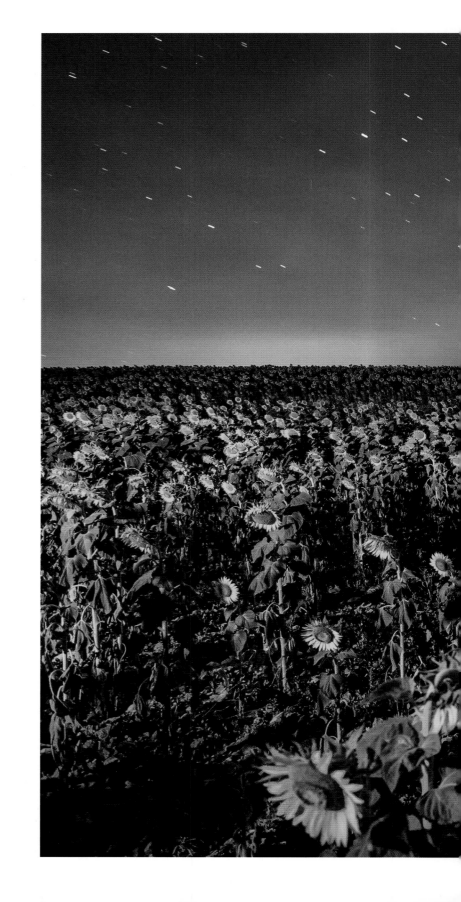

RIGHT: **BOCAIRENT, SPAIN** | A field of sunflowers shines under the light of a full moon. | *Jose A. Bernat Bacete*

PAGE 322: **TEHRAN, IRAN** | The splinter of a new moon hangs above the Milad telecommunication tower. | *Babak Tafreshi*

PAGE 323: **DUBAI, UNITED ARAB EMIRATES** | The Burj Khalifa, the tallest building in the world, rises like a slender candle in the sky. | *Koji Tajima*

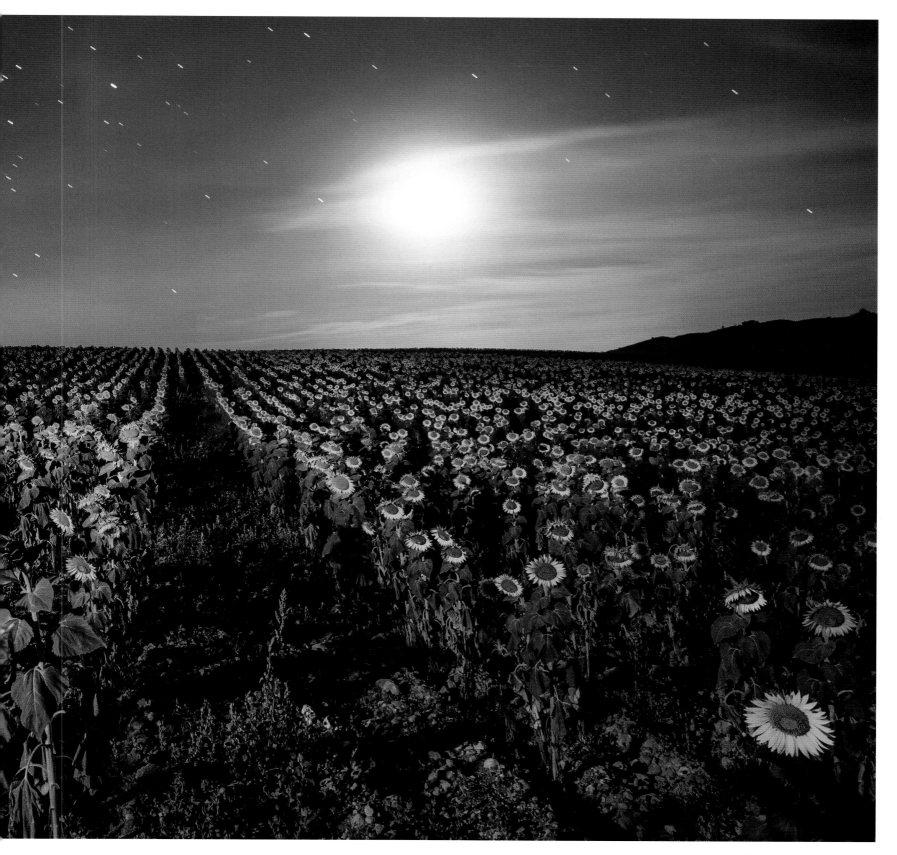

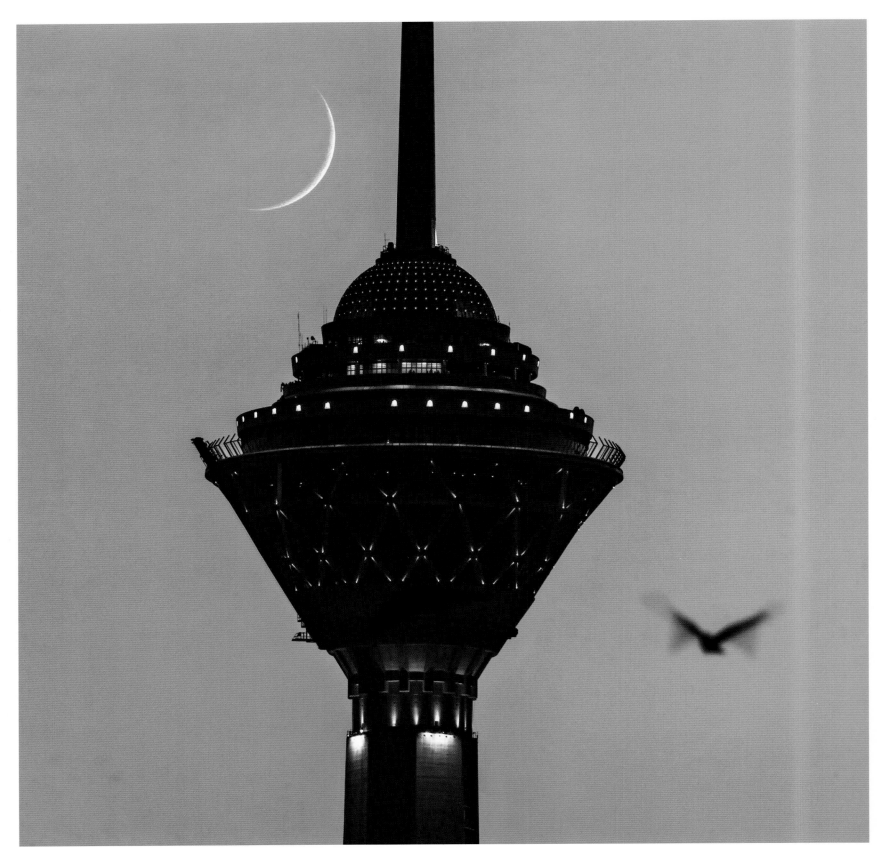

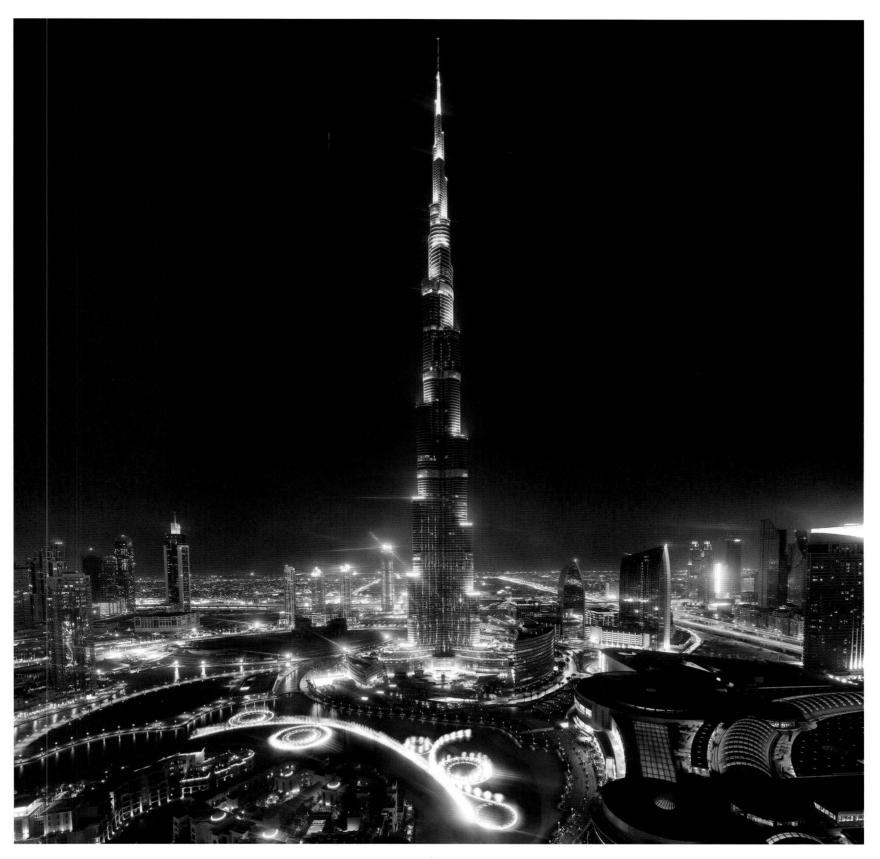

"FEEL THE STARS AND THE INFINITE HIGH AND CLEAR ABOVE YOU. THEN LIFE IS ALMOST ENCHANTED AFTER ALL.

—VINCENT VAN GOGH

OPPOSITE: **JAVA, INDONESIA** | The bright slash of the Milky Way drapes itself above Mount Bromo. | *Weerakarn Satitniramai*

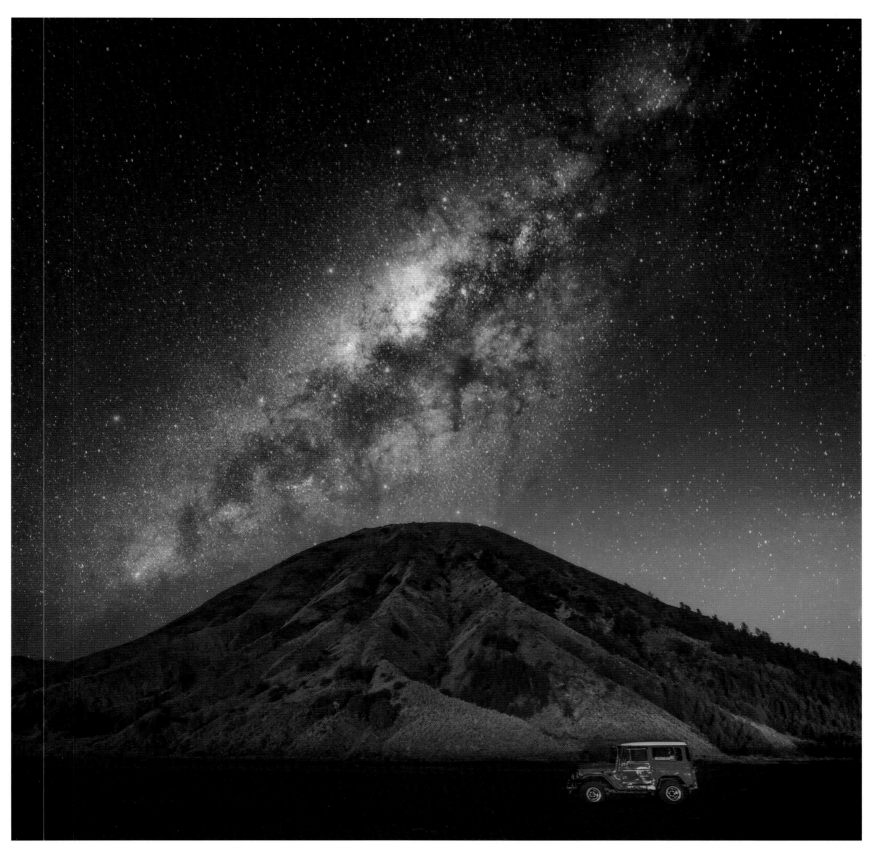

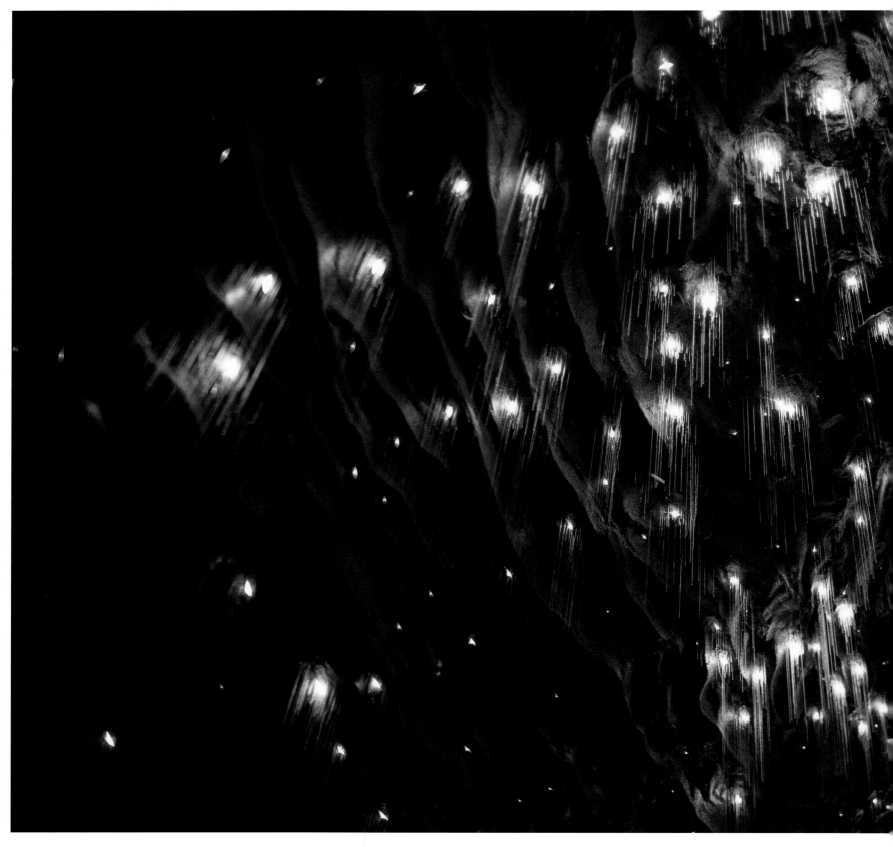

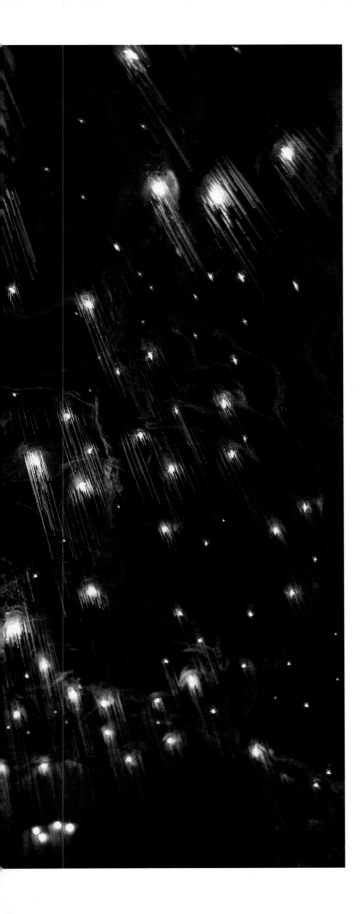

LEFT: **WAITOMO, NEW ZEALAND** | Luminescent glowworms radiate blue light in Waitomo Caves. | *Jordan Poste*

FOLLOWING PAGES: **COPENHAGEN, DENMARK** | The soft lines and reflections of Den Blå Planet, Denmark's national aquarium, cut a postmodern figure. | *Martin Schubert*

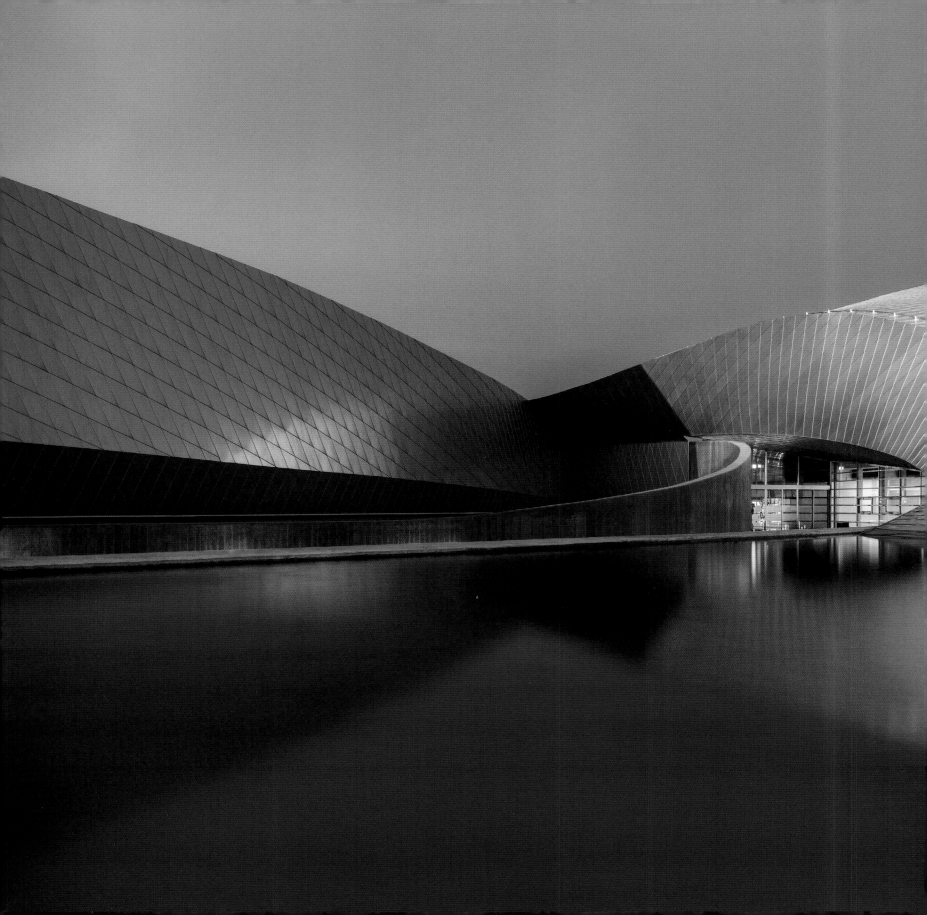

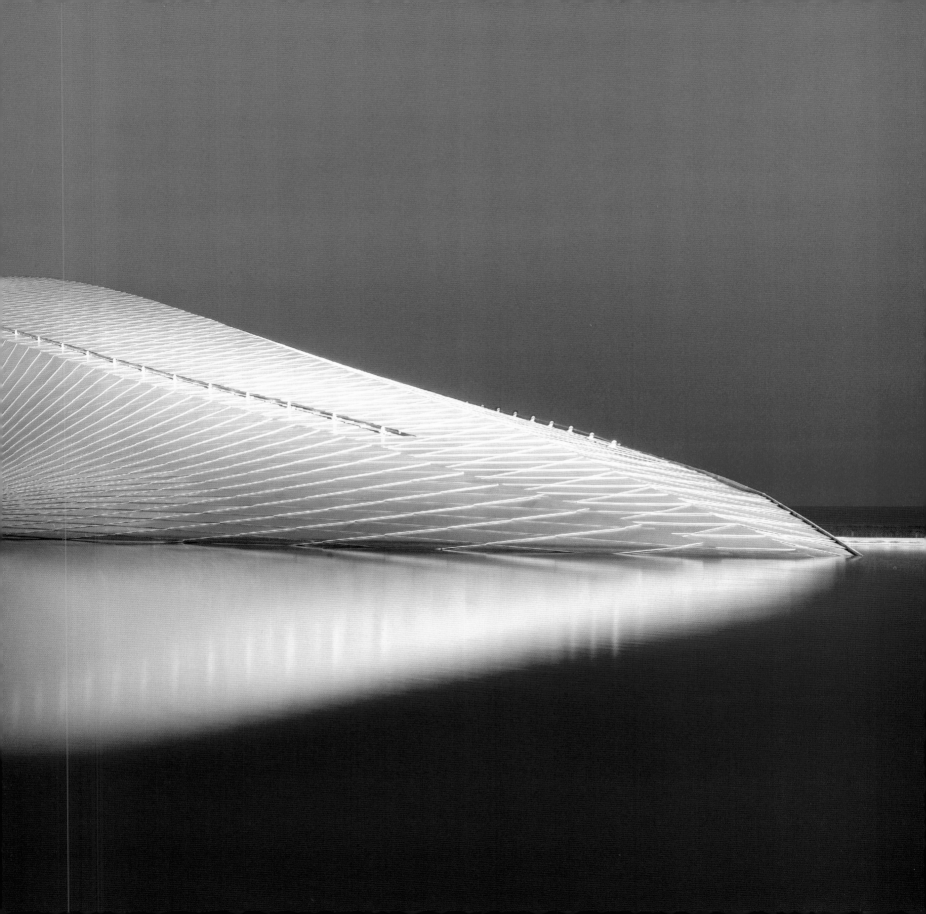

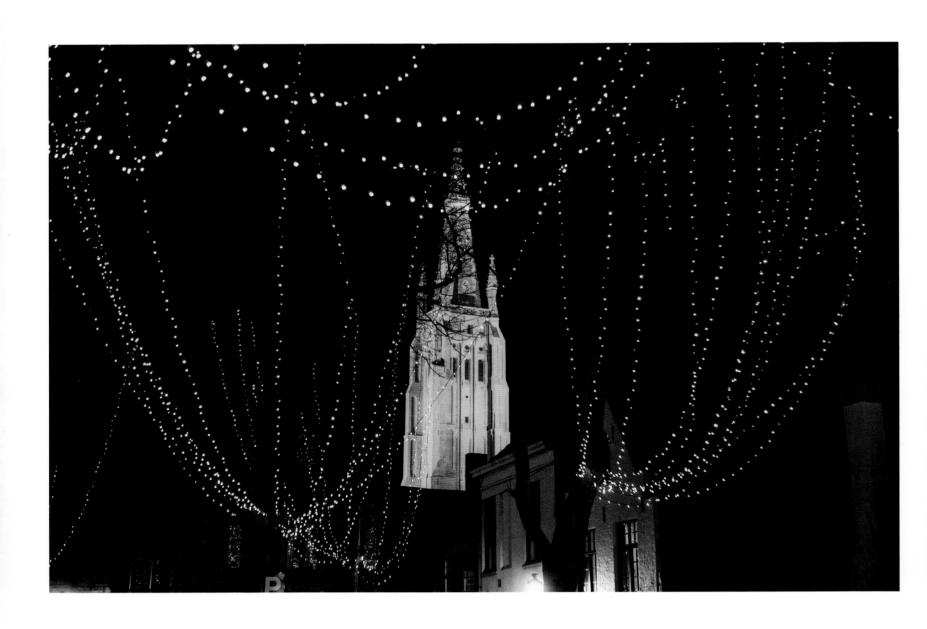

BRUGGE, BELGIUM | Lights strung between city trees lend ambience
to an old street. | *Sisse Brimberg & Cotton Coulson*

330

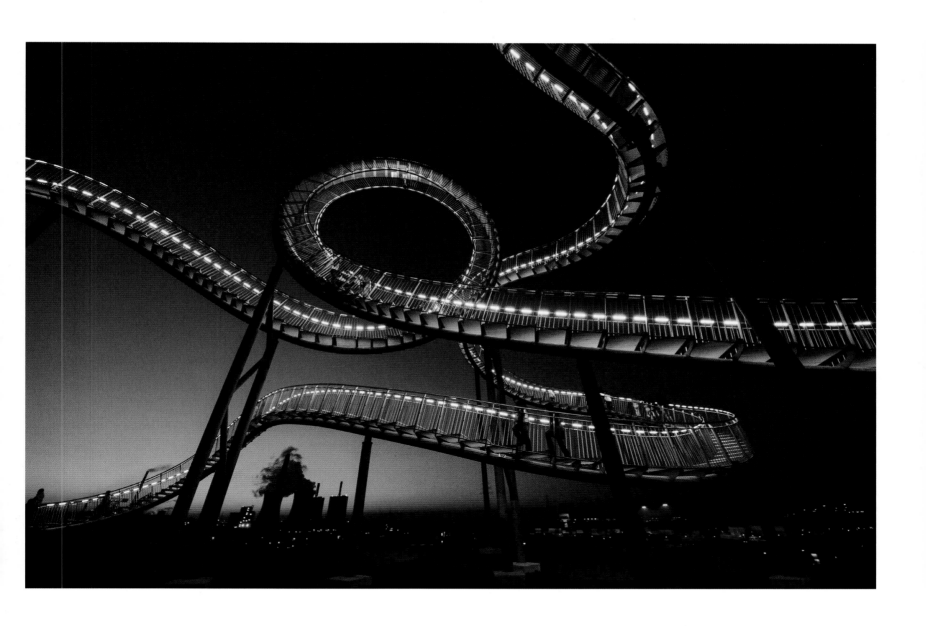

DUISBURG, GERMANY | The looping spirals of the roller coaster–like stairwell sculpture "Tiger & Turtle" gleam against the night sky. | *Uwe Niehuus*

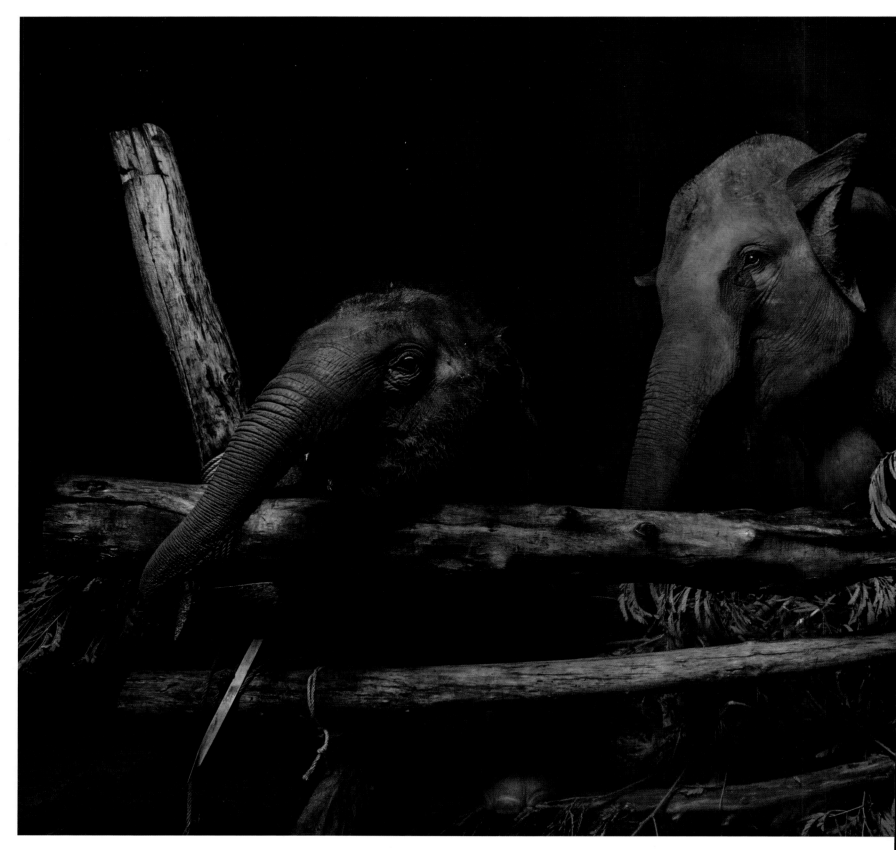

SURIN, THAILAND | An Asian elephant and her newborn calf explore tree logs. | *Arun Roisri*

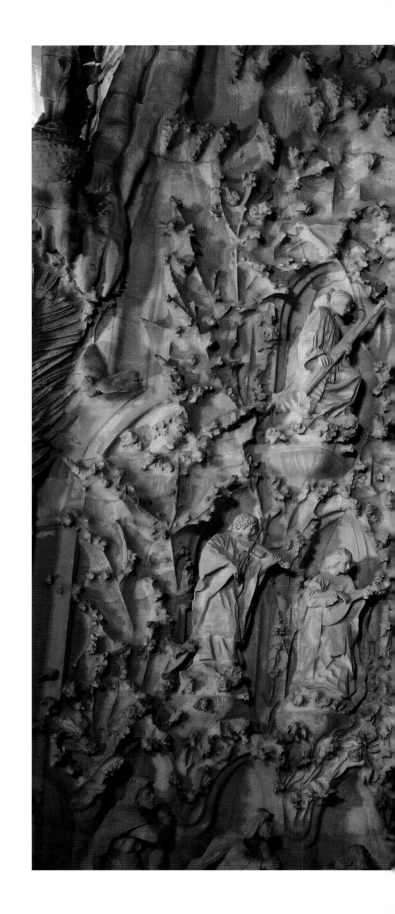

BARCELONA, SPAIN | La Sagrada Família, the uncompleted masterwork of Antoni Gaudí, includes detailed sculptures and intricate stained glass. | *Oksana Byelikova*

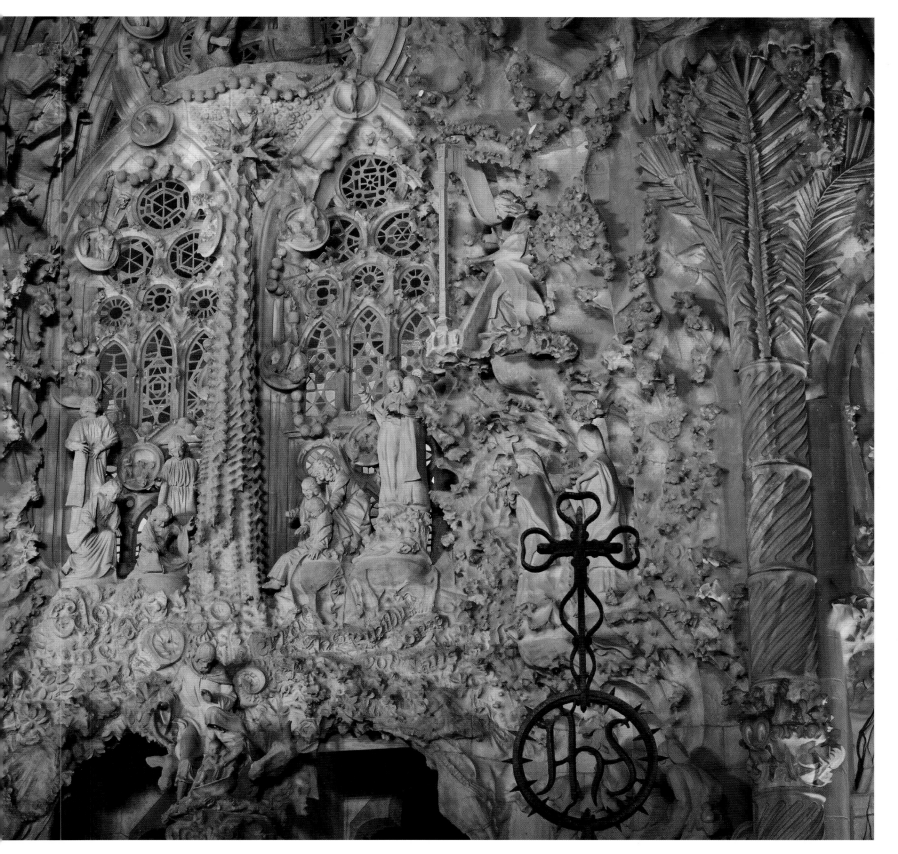

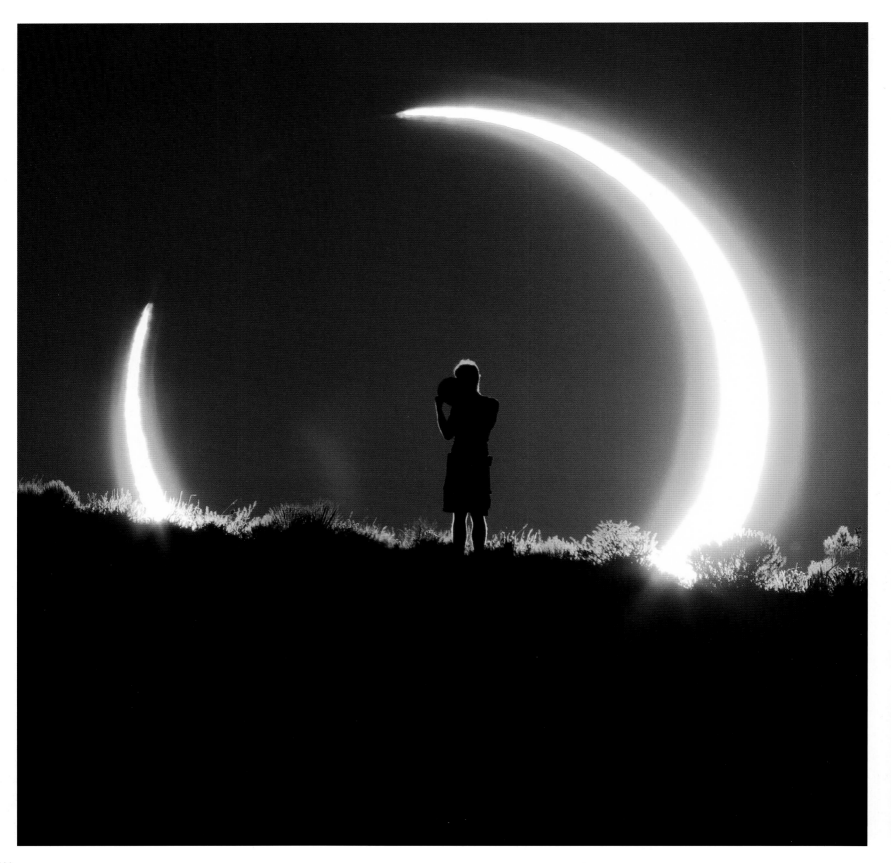

"THAT ORBED MAIDEN,
WITH WHITE FIRE LADEN,
WHOM MORTALS CALL
THE MOON.

—PERCY BYSSHE SHELLEY

OPPOSITE: ALBUQUERQUE, NEW MEXICO | An annular solar eclipse
provides quite the view for a sky-watcher. | *Colleen Pinski*

337

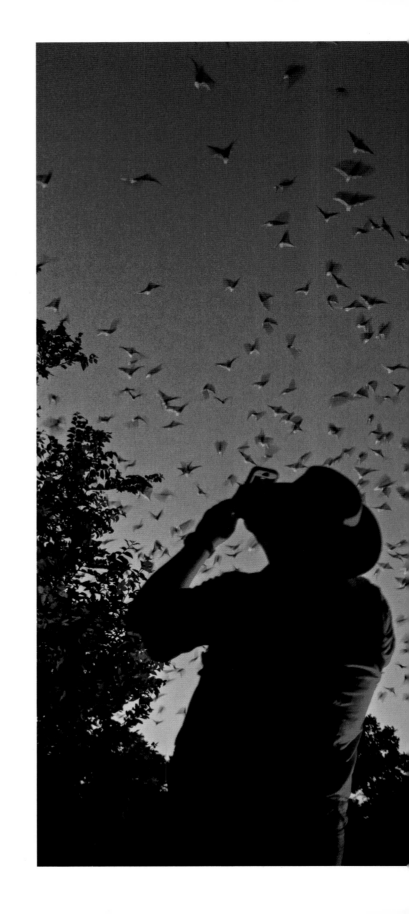

RIGHT: SAN ANTONIO, TEXAS | Onlookers capture the sky, as millions of Mexican free-tailed bats leave Bracken Cave to feed. | *Karine Aigner*

FOLLOWING PAGES: ROME, ITALY | The evening "blue hour" casts its color on the columns and ruins of the Roman Forum. | *Domingo Leiva*

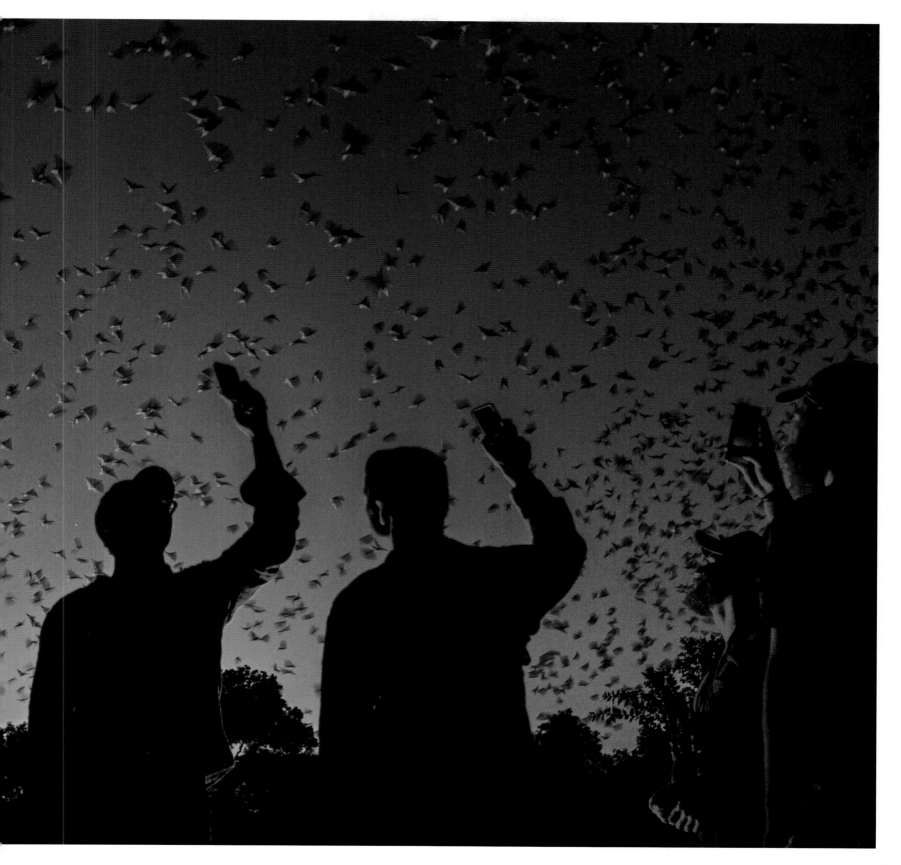

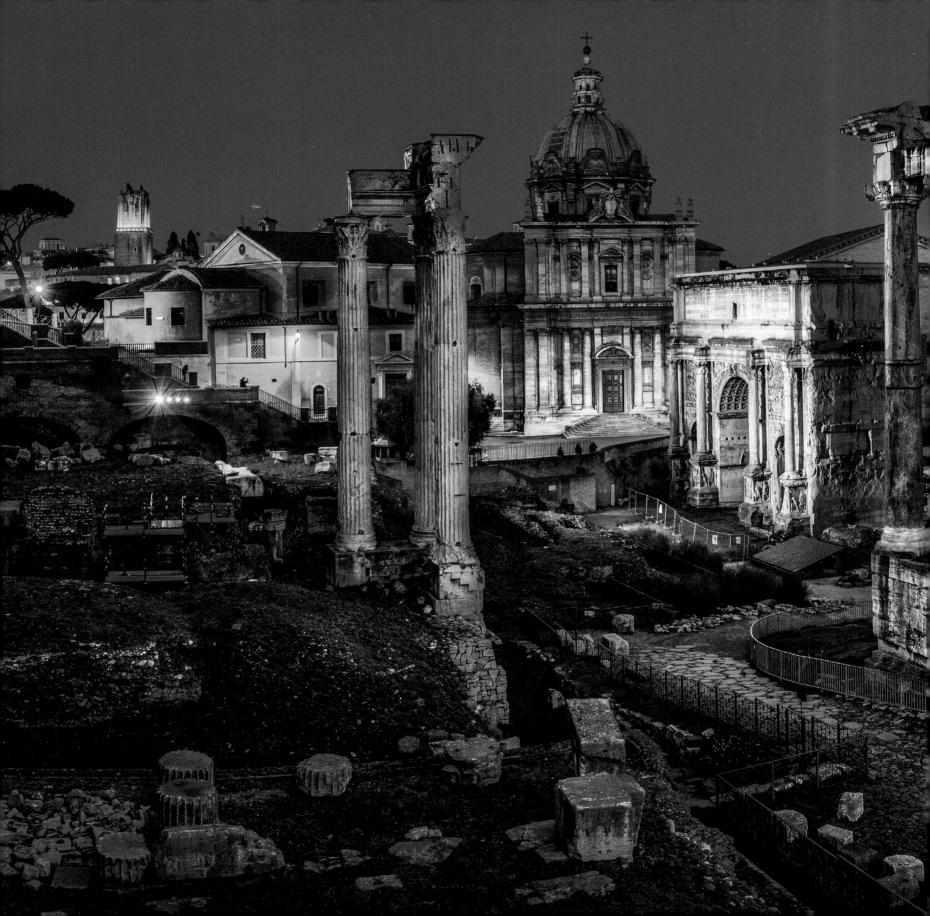

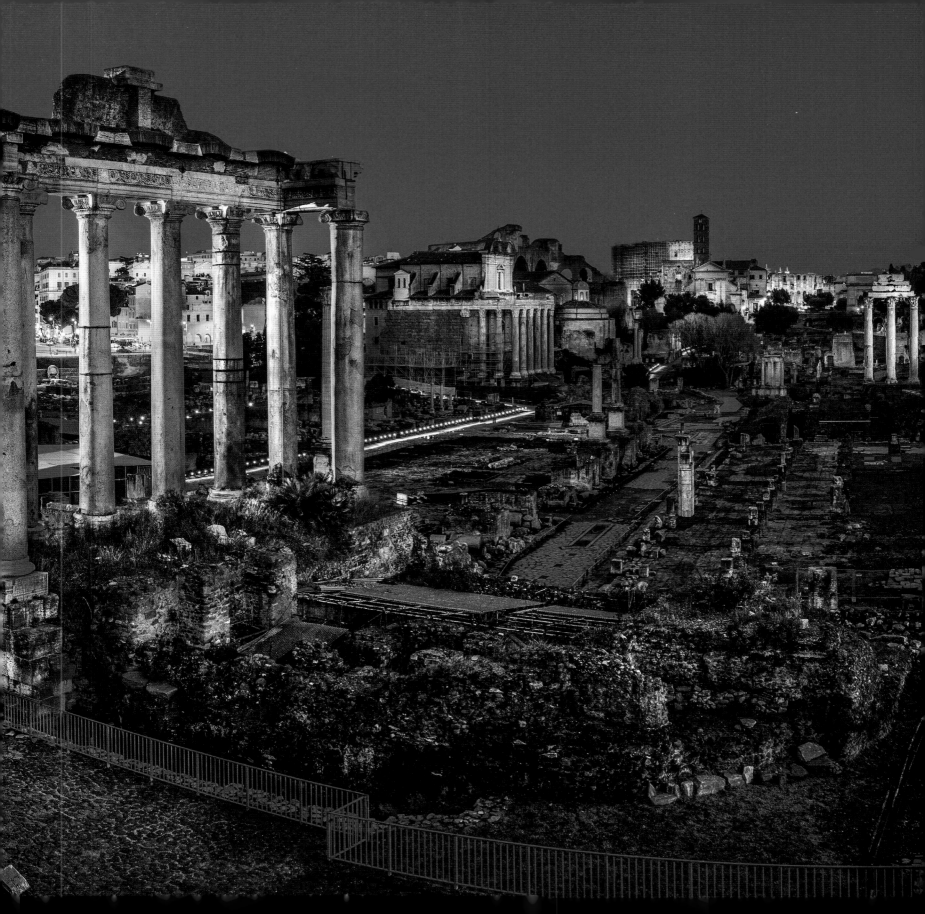

BALI, INDONESIA | Hindus at the Tirta Empul Temple bathe
and pray under the light of a full moon. | *John Stanmeyer*

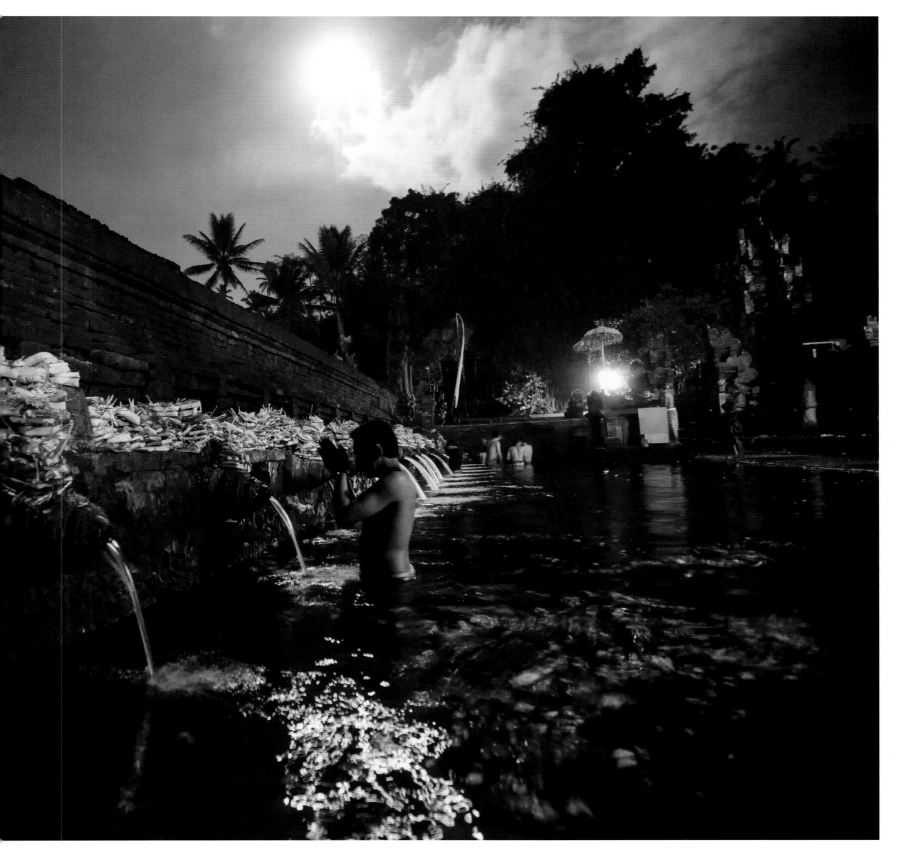

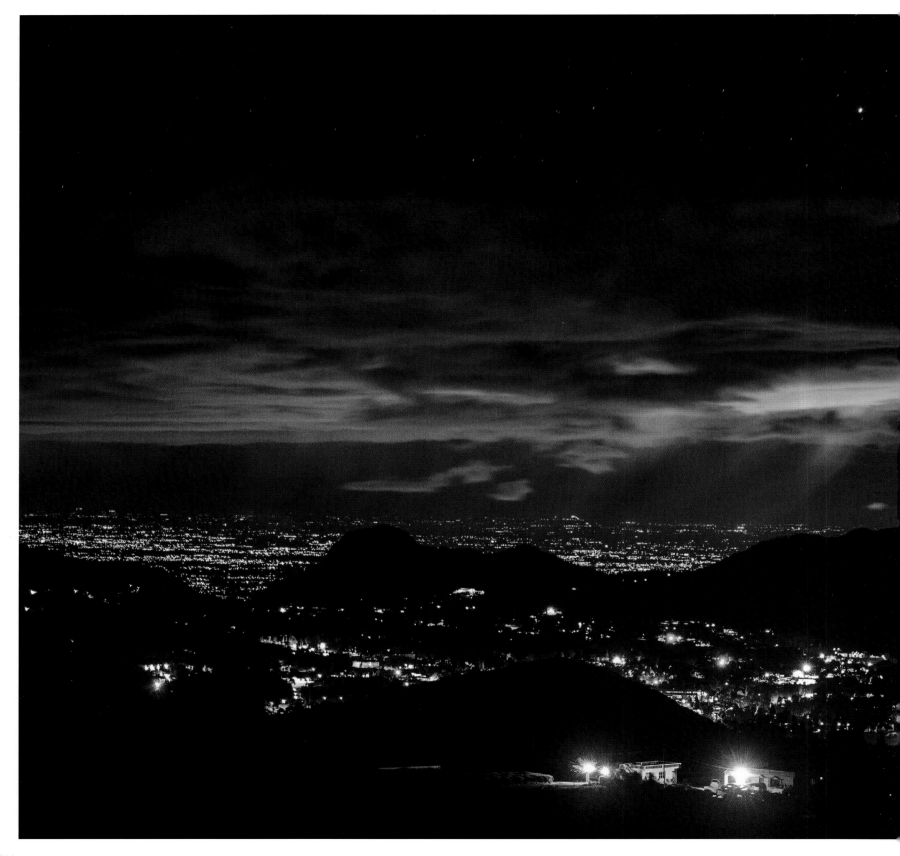

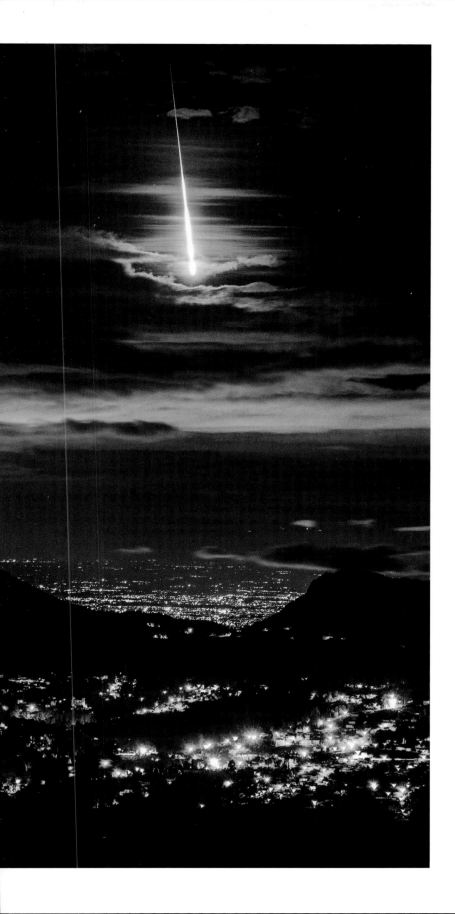

METTUPPALAIYAM, INDIA | The brilliant green tail of a meteor slashes across the sky above the expanse of evening city lights. | *Prasenjeet Yadav*

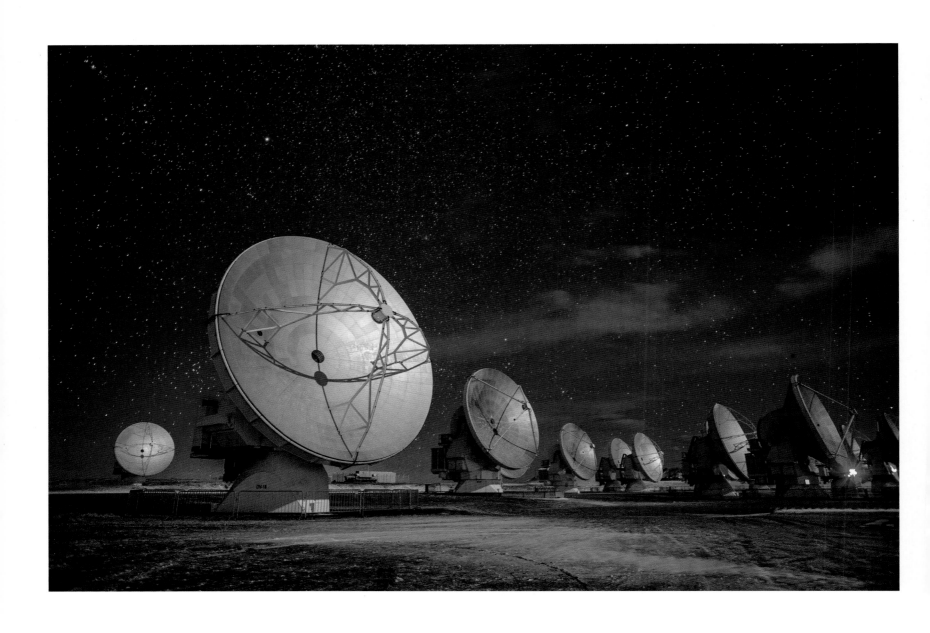

ATACAMA DESERT, CHILE | Radio telescopes from the Atacama
Large Millimeter Array (ALMA) send their signals into space. | *Dave Yoder*

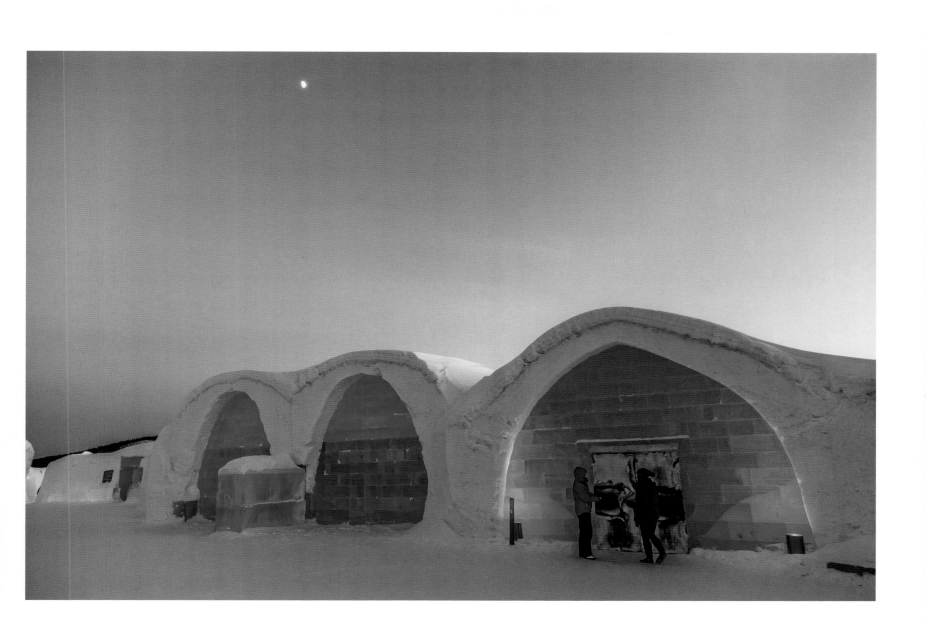

JUKKASJÄRVI, SWEDEN | Visitors arrive at an ice hotel
located just above the Arctic Circle. | *Jonathan Irish*

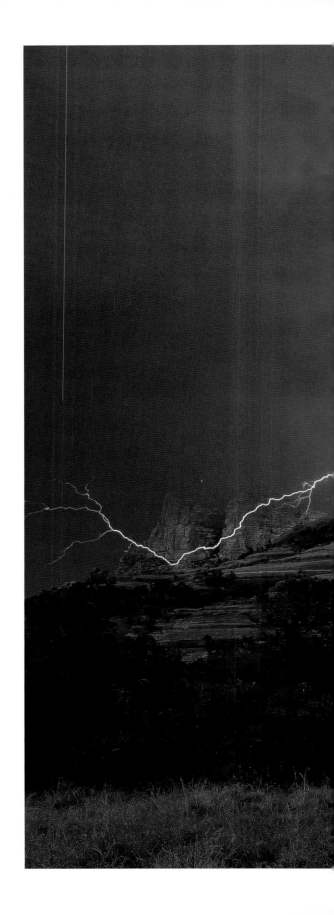

BELL ROCK, ARIZONA | Lightning dances around the red rock of the Arizona desert. | *Steven Love*

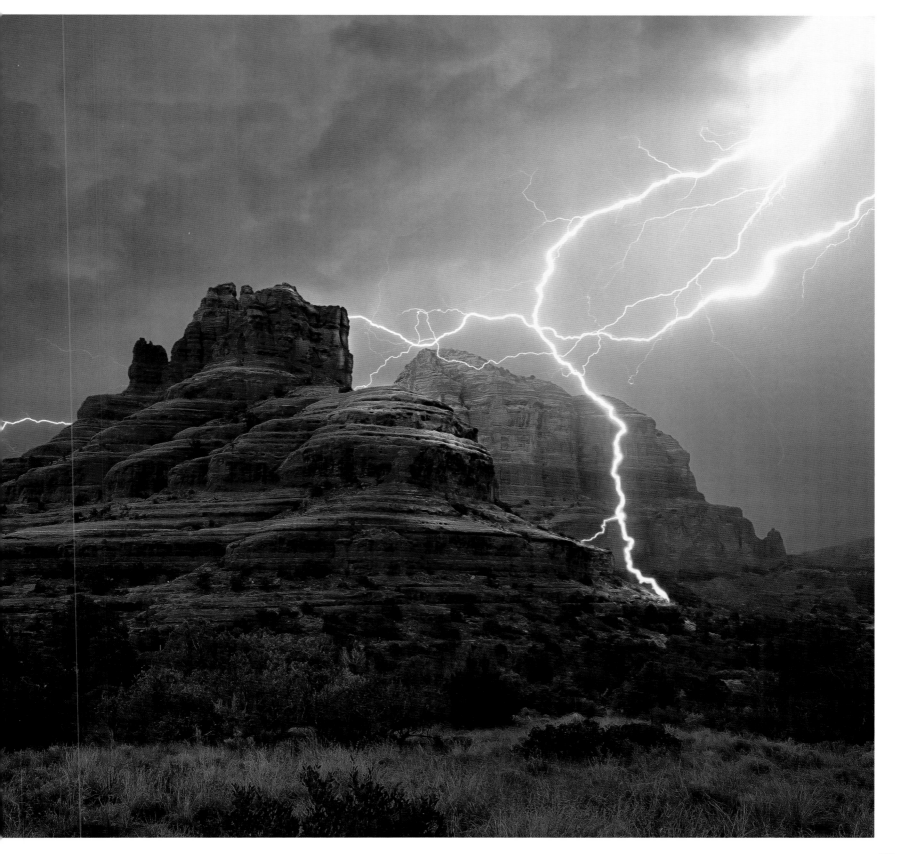

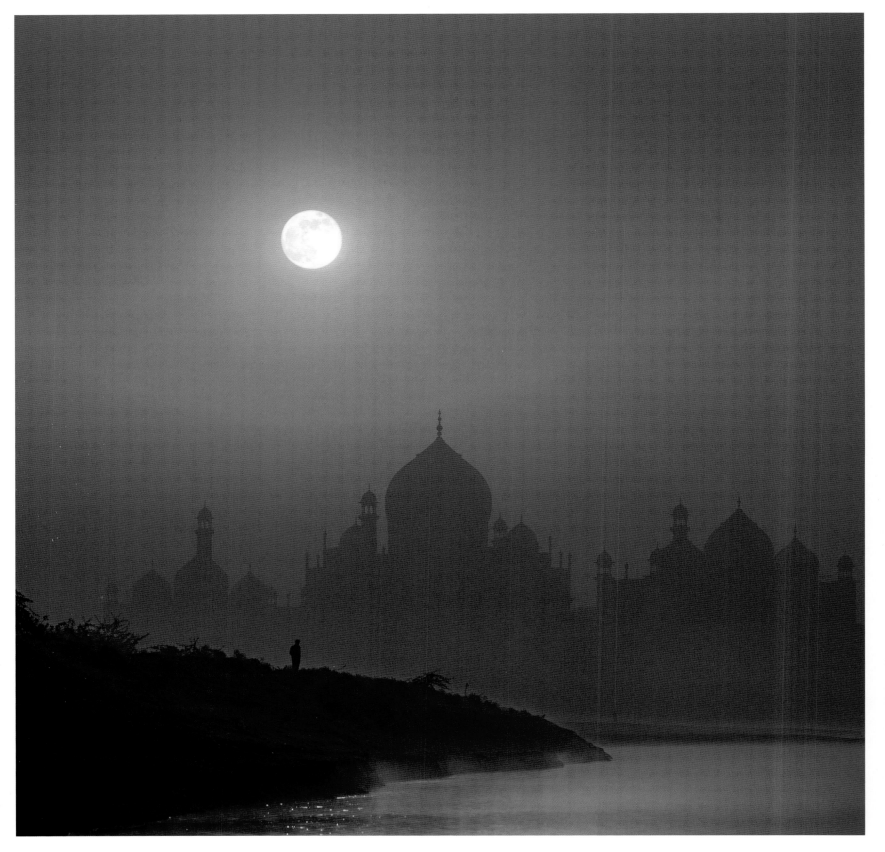

> **"THE SKY GREW DARKER,
> PAINTED BLUE ON BLUE,
> ONE STROKE AT A TIME,
> INTO DEEPER AND DEEPER
> SHADES OF NIGHT.**
>
> **—HARUKI MURAKAMI**

OPPOSITE: AGRA, INDIA | Under the light of a full moon, the Taj Mahal fades into the mist. | *Adrian Pope*

RIGHT: **EMAS NATIONAL PARK, BRAZIL** | A hungry anteater feeds on bioluminescent termites brightly glowing on their mound. | *Marcio Cabral*

FOLLOWING PAGES: **SHANGHAI, CHINA** | Illuminated fountains attract an admiring audience to their nighttime show. | *EschCollection*

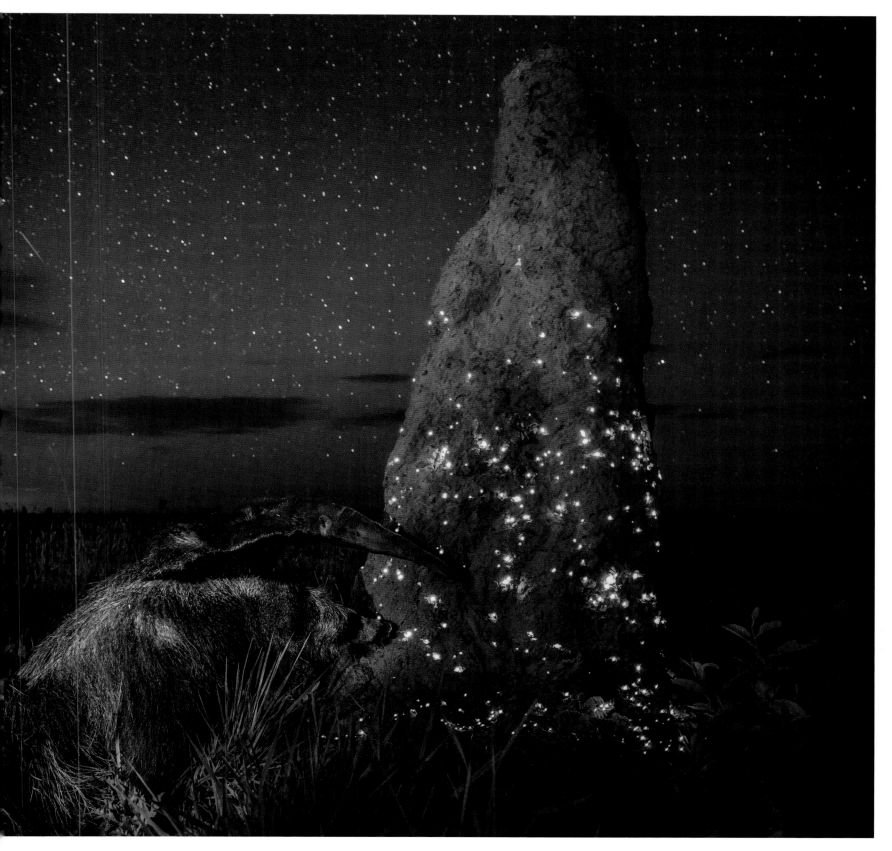

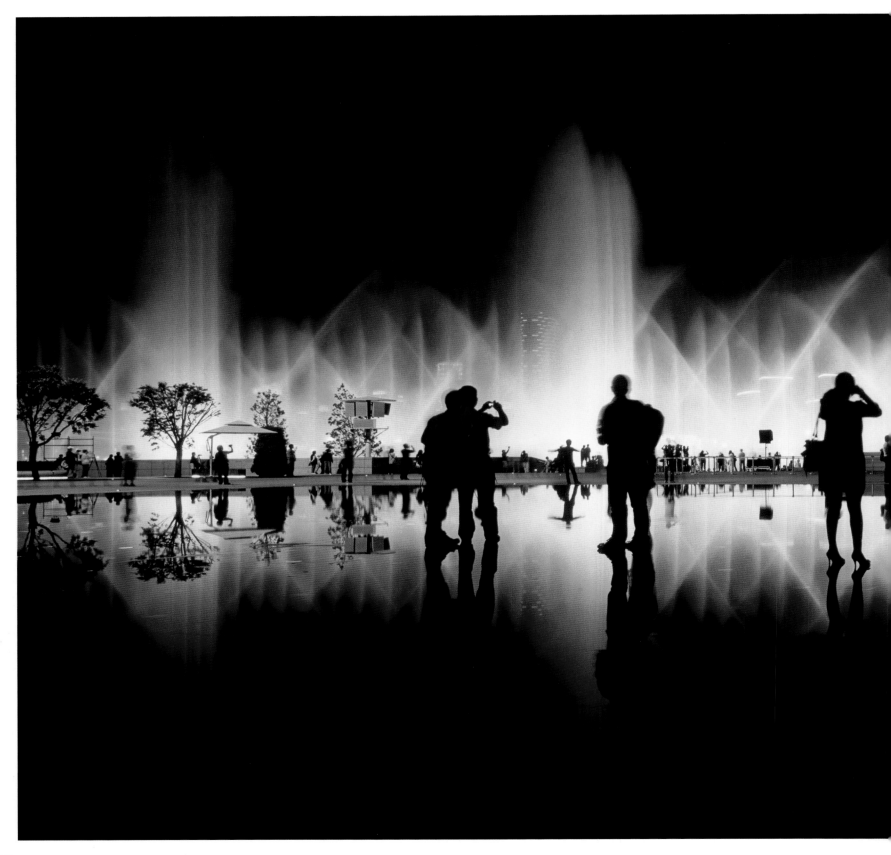

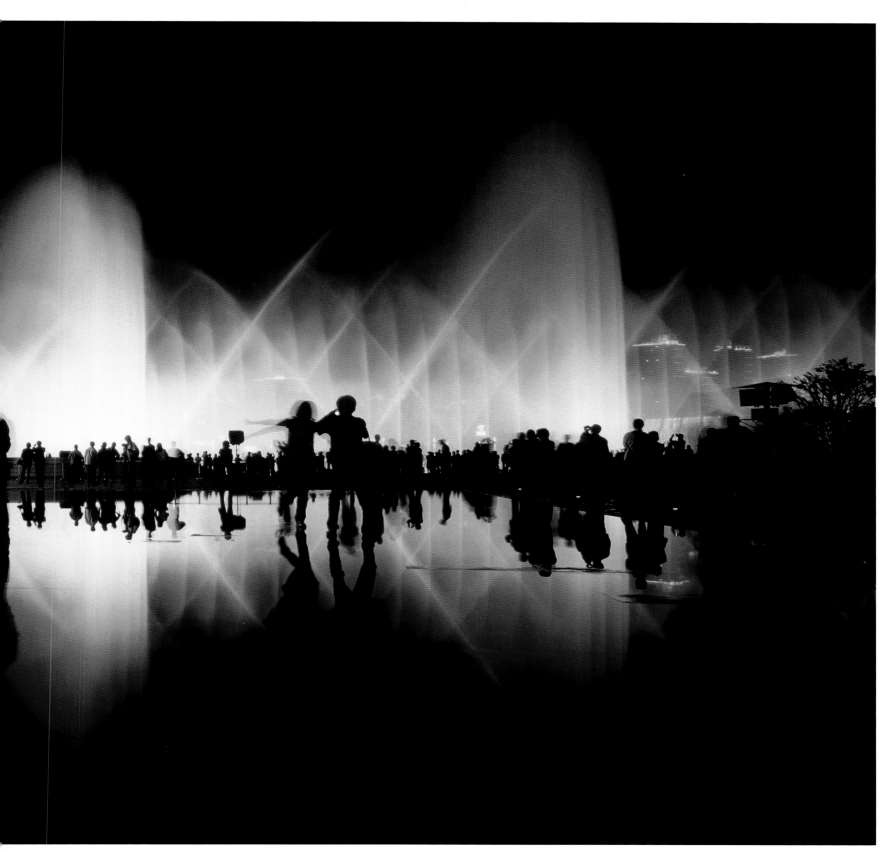

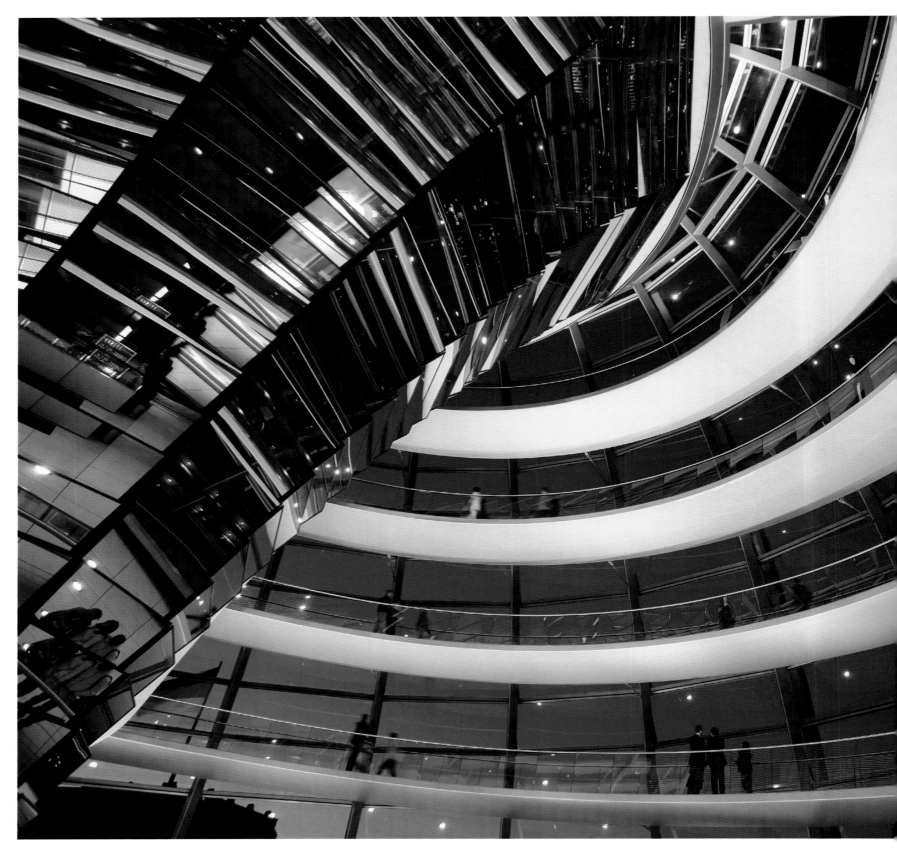

BERLIN, GERMANY | Visitors walk up the looping spiral walkways
of Germany's Parliament building. | *Gavin Hellier*

RIGHT: TIGRAY, ETHIOPIA | Two boys read a book by candlelight in the rocky cliffs of the Ethiopian Highlands. | *Asher Svidensky*

PAGE 360: COSTA RICA | A praying mantis peers out from the cup of a pink fungus. | *Juan Carlos Vindas*

PAGE 361: CHEYNE BEACH, AUSTRALIA | Looking for some nectar, a Western pygmy possum pokes its head over the spiky flowers of a red banksia. | *Martin Willis*

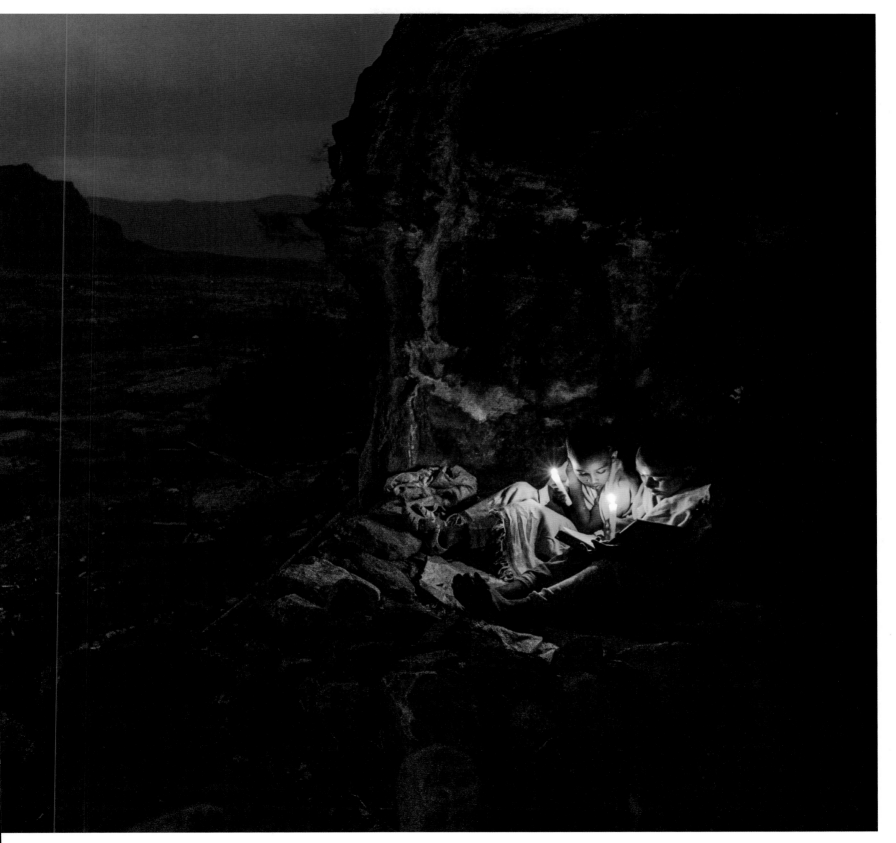

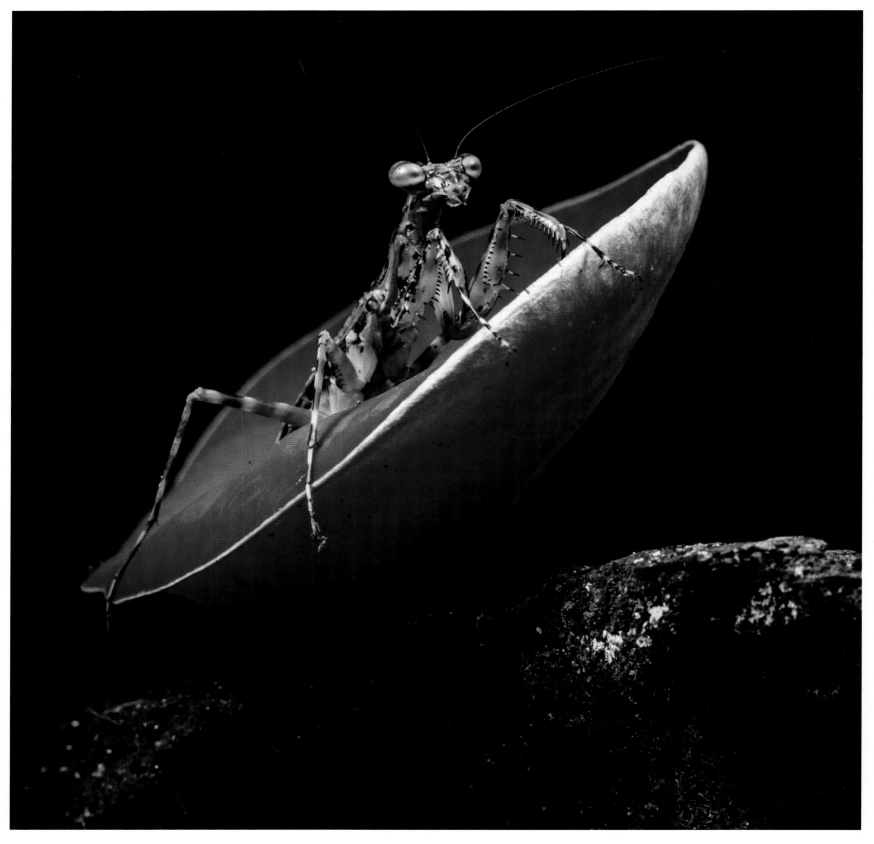

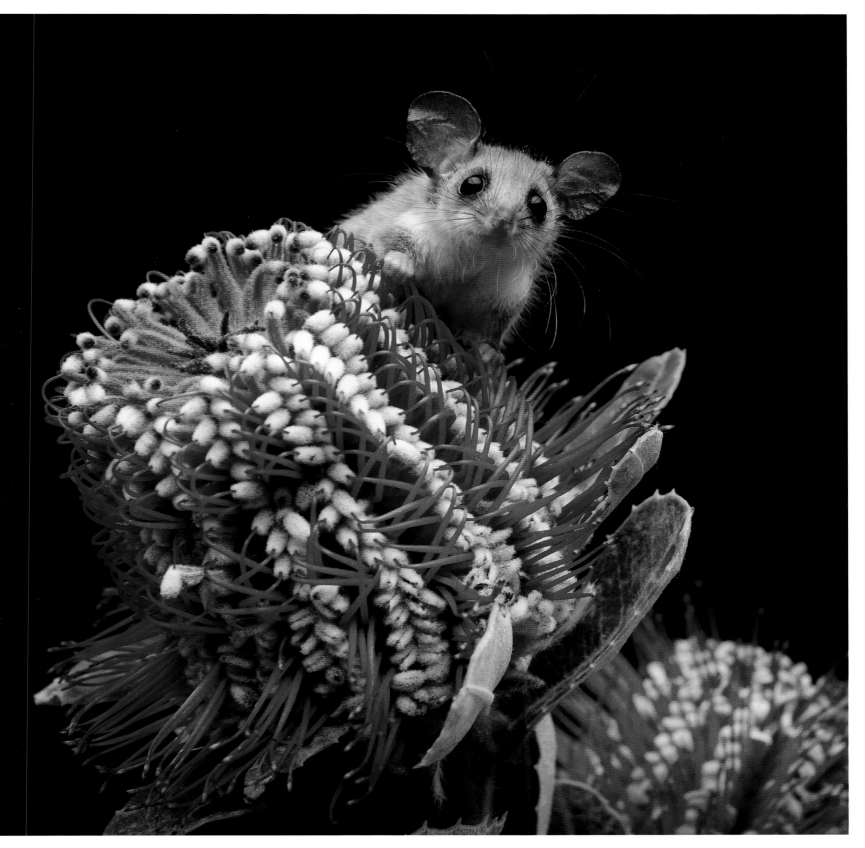

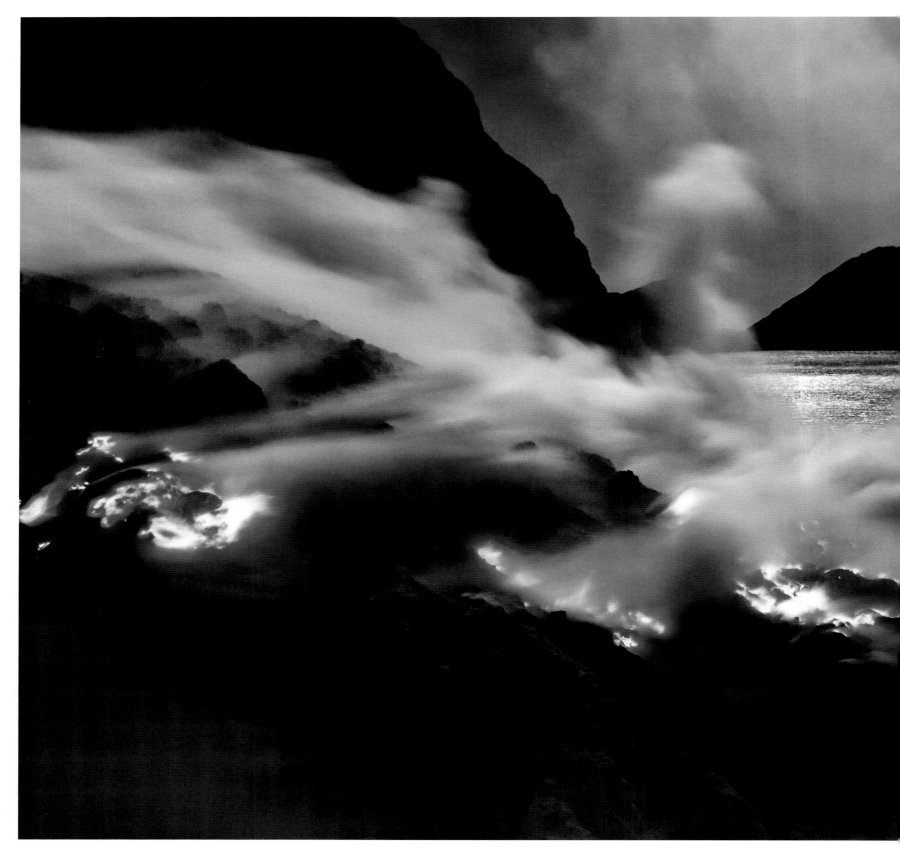

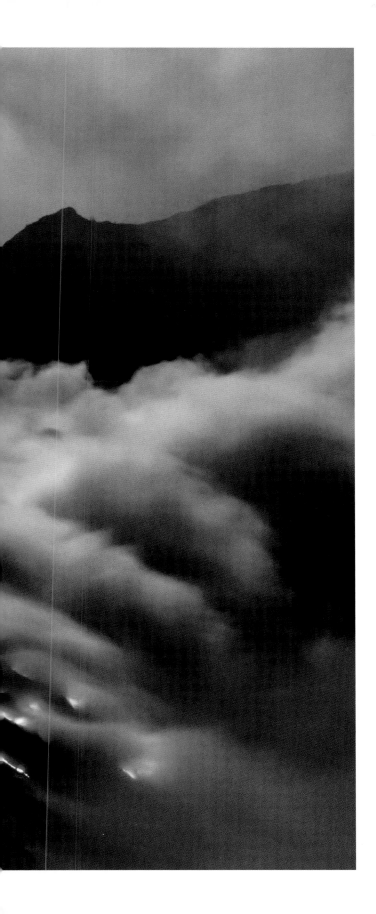

JAVA, INDONESIA | Blue burning sulfur rolls down the sides of Kawah Ijen volcano. | *Stéphane Godin*

"THE STARS ARE FORTH, THE MOON ABOVE THE TOPS OF THE SNOW-SHINING MOUNTAINS—BEAUTIFUL!

—GEORGE GORDON BYRON

OPPOSITE: TIBET | A sliver of moon sets behind the chiseled side of snow-draped Mount Lingtren. | *Art Wolfe*

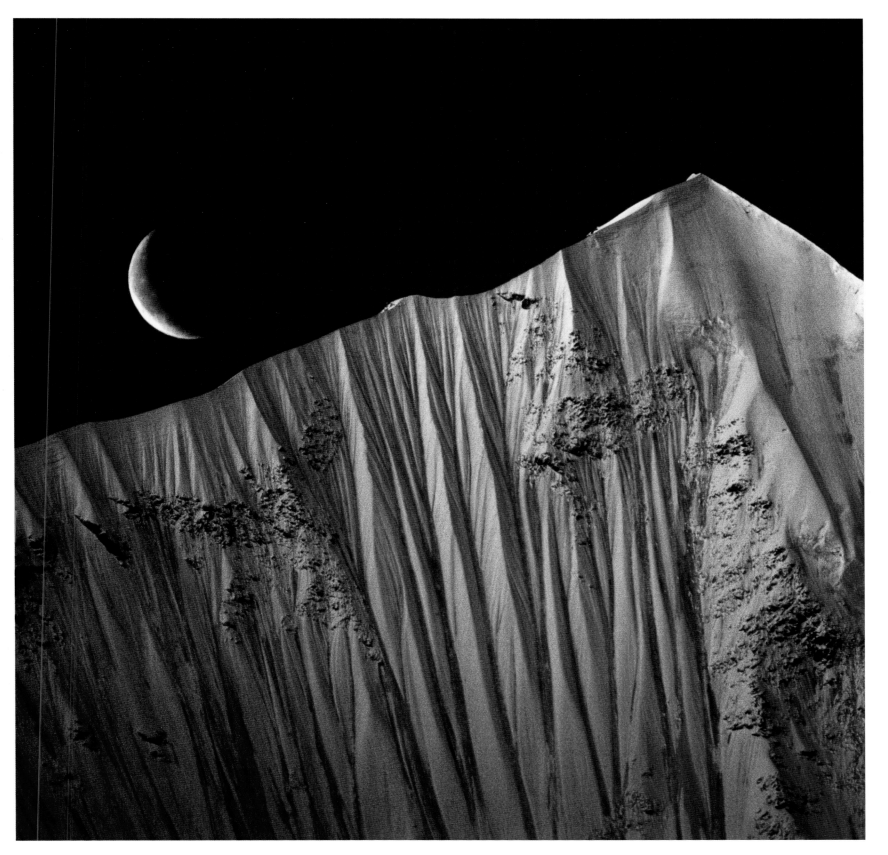

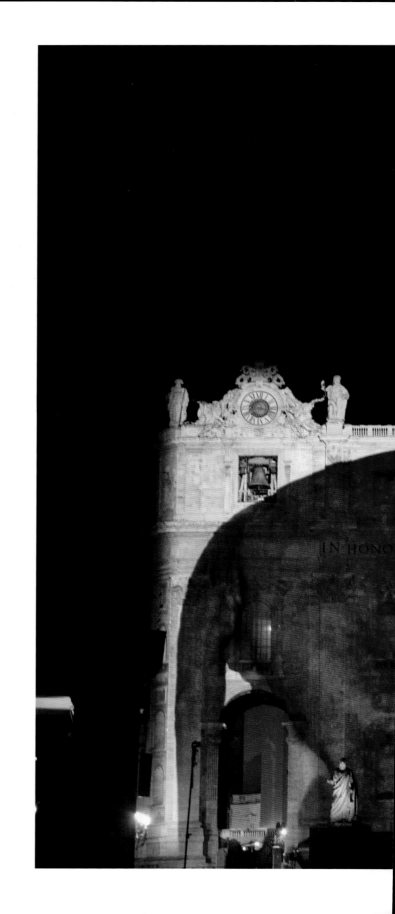

VATICAN CITY | A majestic lion is projected on the front of a Vatican building to help raise awareness about animal extinctions. | *Joel Sartore*

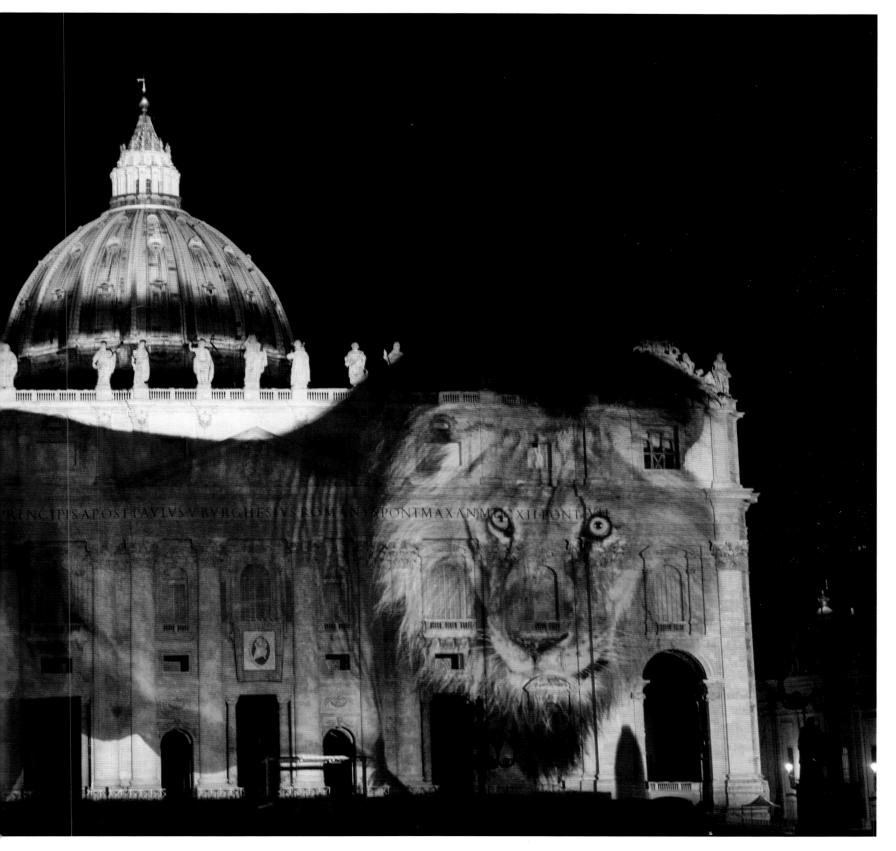

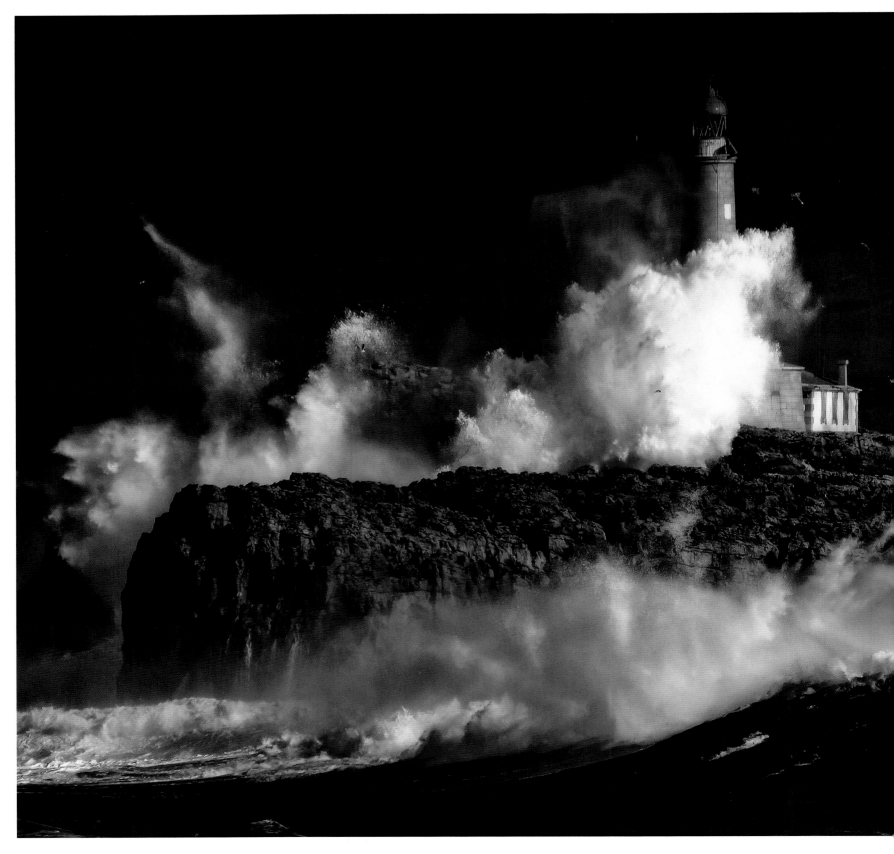

SANTANDER, SPAIN | Waves crash against the Mouro Island lighthouse
on the Bay of Biscay. | *Ana Tramont*

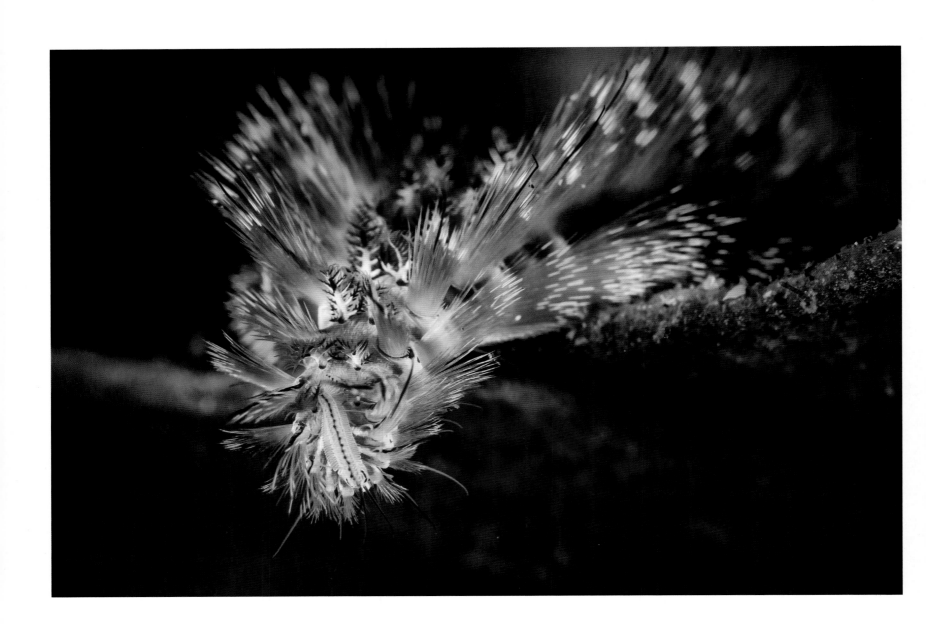

LEMBAK STRAIT, INDONESIA | The colorful bristles of a fireworm
look beautiful but pack a toxic punch. | *Michael Fung*

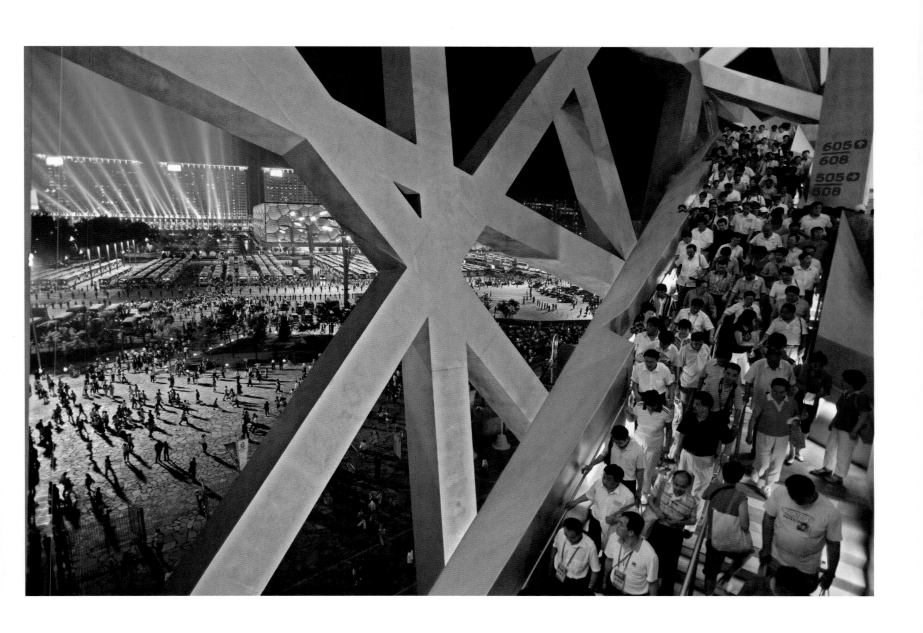

BEIJING, CHINA | Visitors to the opening ceremonies of the 2008 Summer Olympics look out from China's National Stadium, known as the Bird's Nest. | *Michael Christopher Brown*

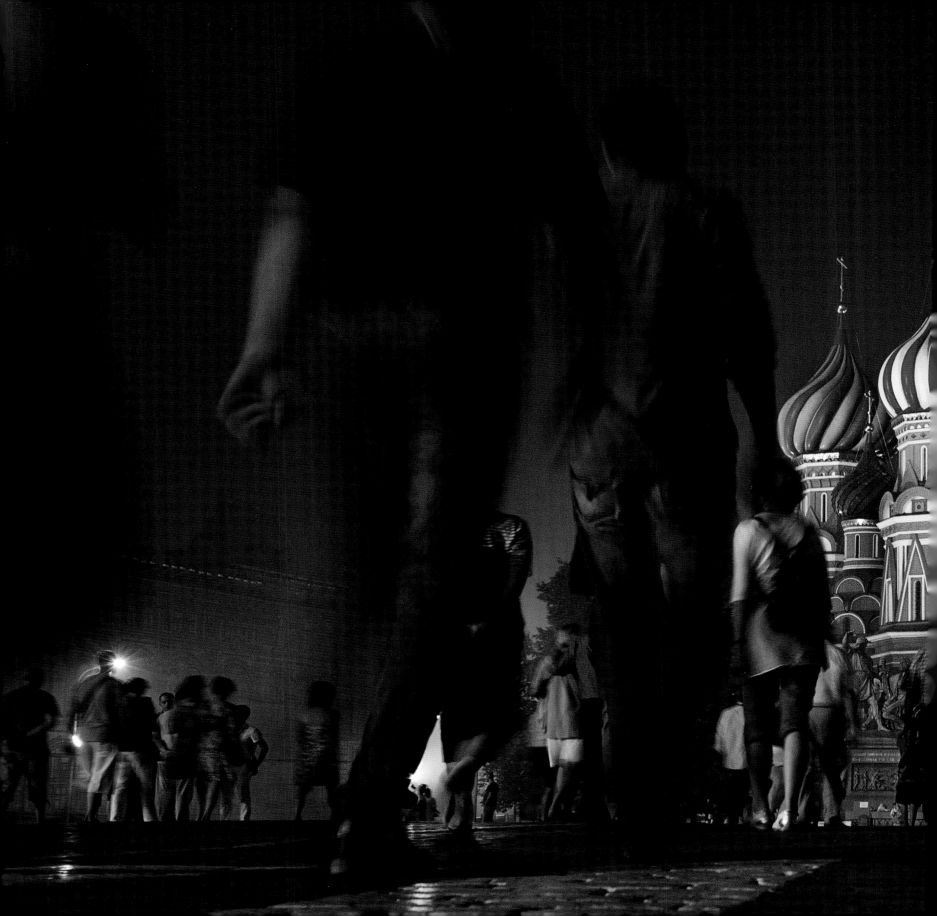

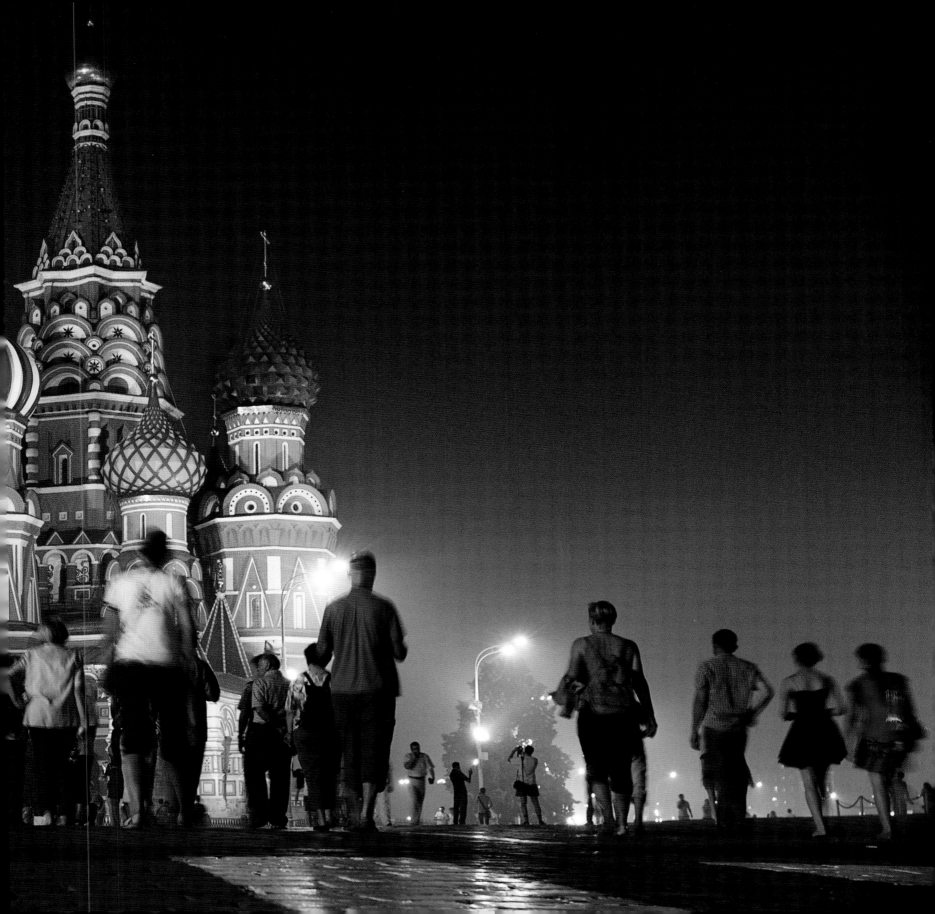

> # "ETERNAL SUNRISE, ETERNAL SUNSET, ETERNAL DAWN AND GLOAMING, ON SEA AND CONTINENTS AND ISLANDS, EACH IN ITS TURN, AS THE ROUND EARTH ROLLS.
>
> **—JOHN MUIR**

OPPOSITE: SELJALANDSFOSS, ICELAND | Midnight paints the sky hues of pink, purple, and yellow above a rushing waterfall during Iceland's long summer evenings. | *Sandro Bisaro*

PREVIOUS PAGES: MOSCOW, RUSSIA | Lit up for the night, the decorated domes of the 16th-century St. Basil's Cathedral in Red Square attract visitors. | *David Coventry*

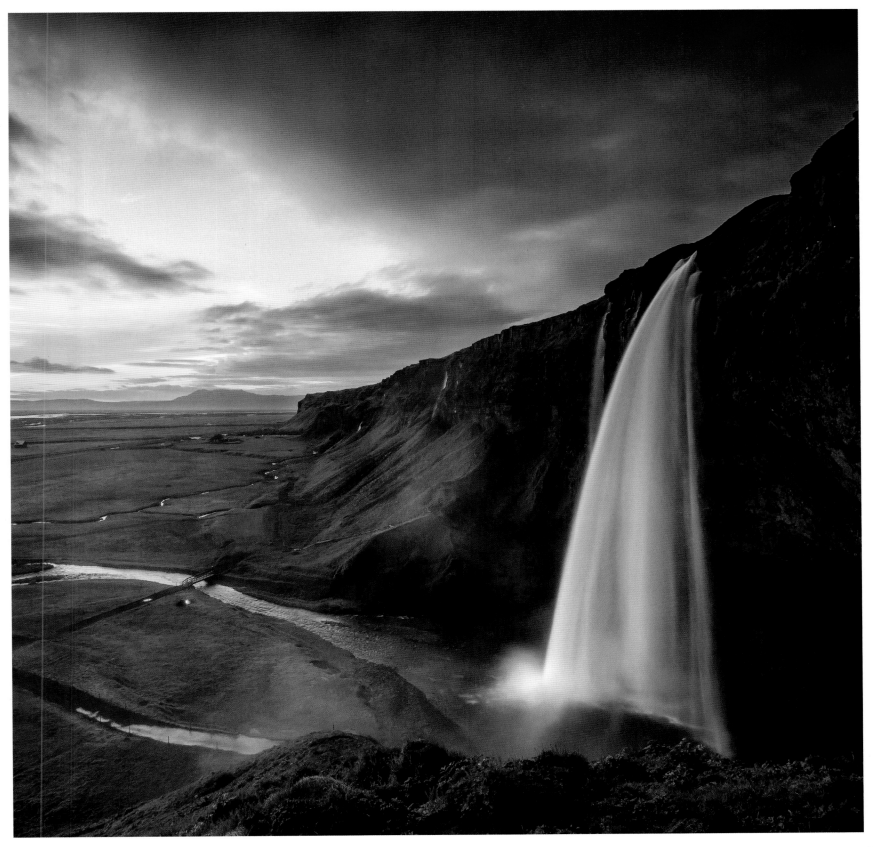

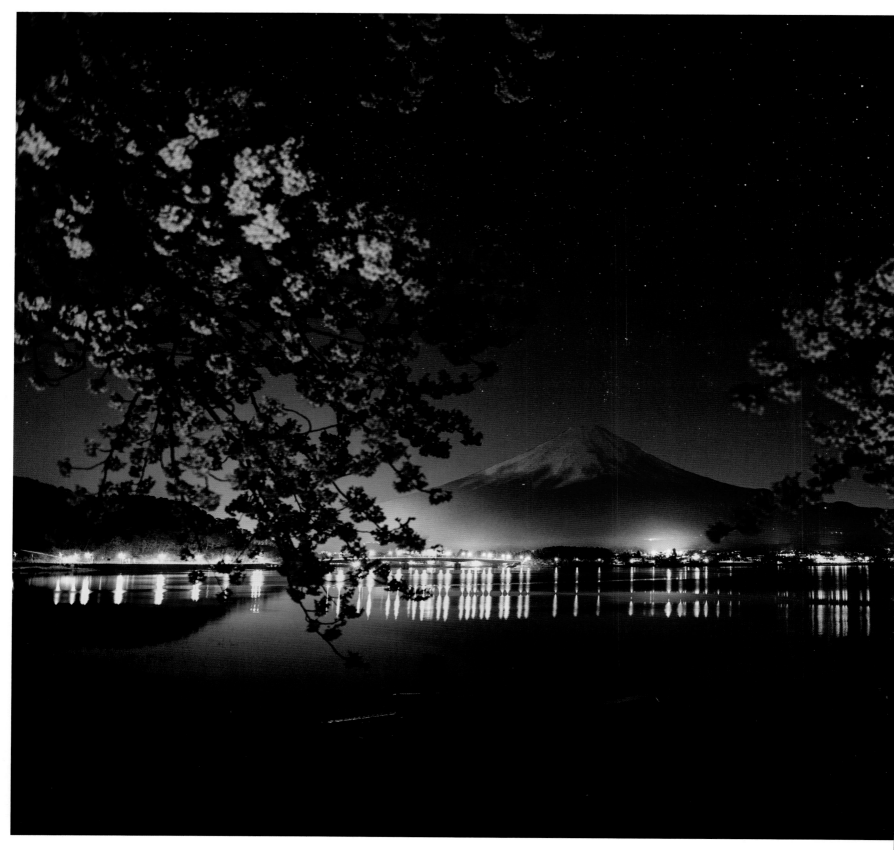

TOKYO, JAPAN | Lights dot the shoreline of Lake Kawaguchi as Mount Fuji rises in the background. | *Motoki Uemura*

RIGHT: **TROMSØ, NORWAY** | Above the Arctic Circle, humpback whales surface during the low-light hours of the polar night. | *Espen Bergersen*

PAGE 380: **NEW YORK, NEW YORK** | An arch of the Williamsburg Bridge frames the Empire State Building. | *Daniel Grill*

PAGE 381: **BARCELONA, SPAIN** | In a still scene, four columns stand watch in front of the Museu Nacional d'Art de Catalunya. | *Alex Holland*

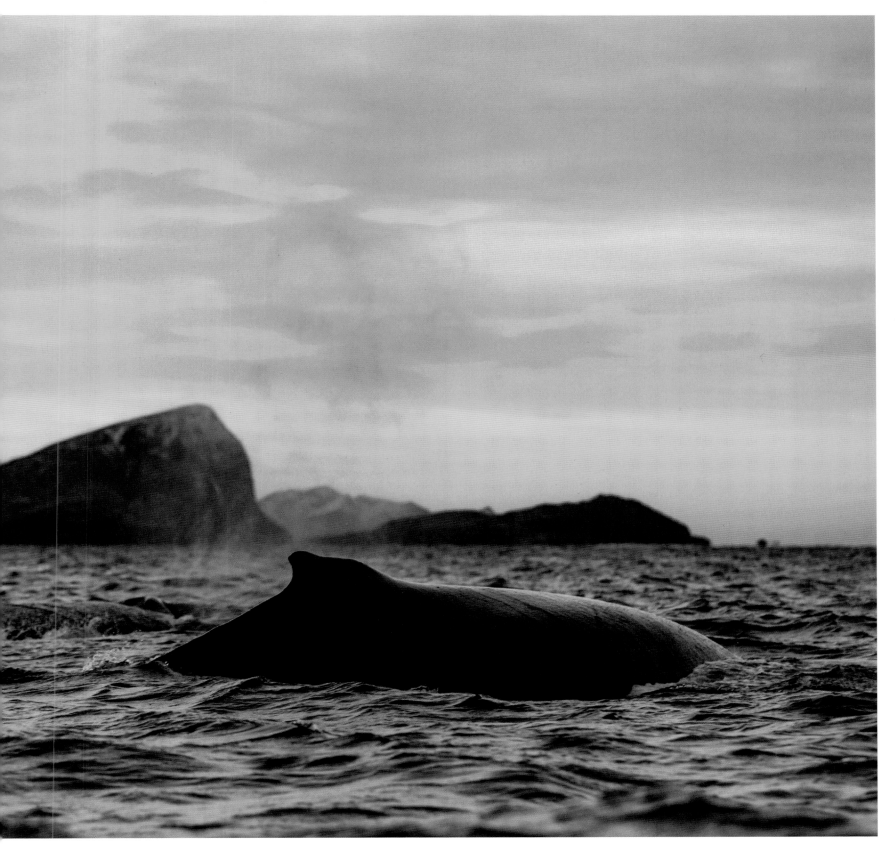

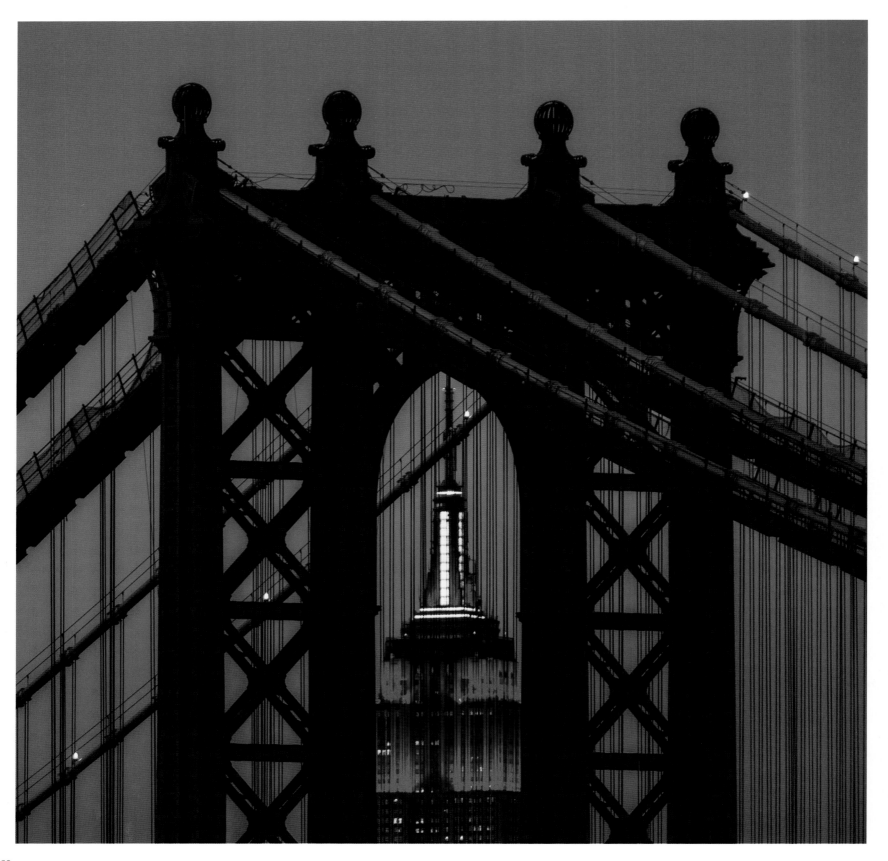

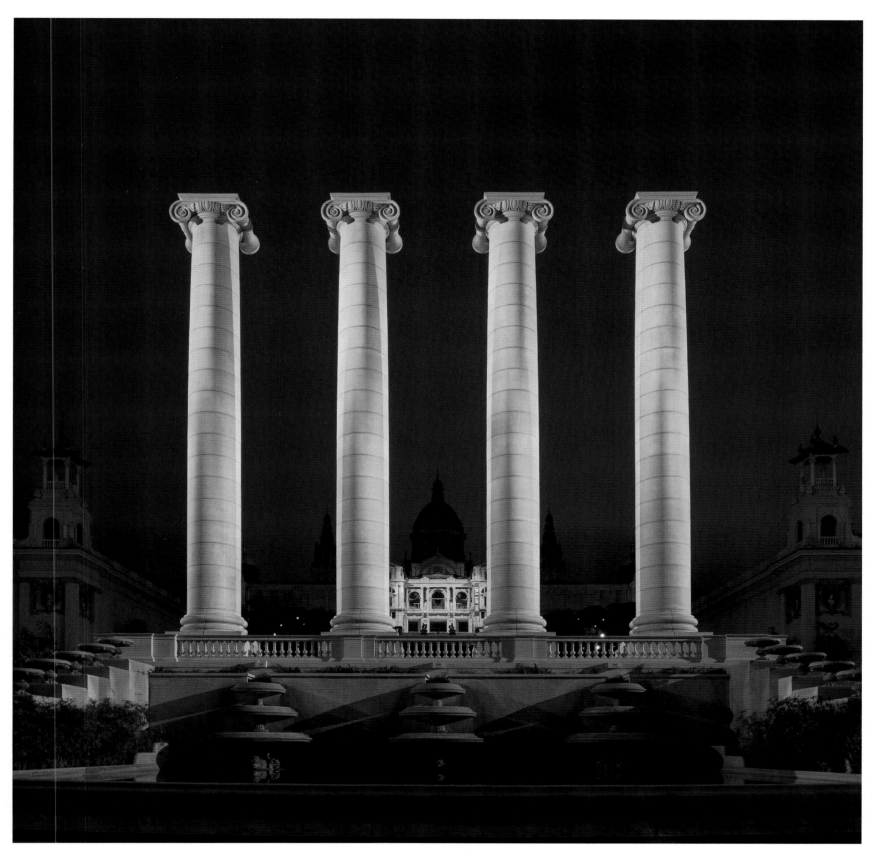

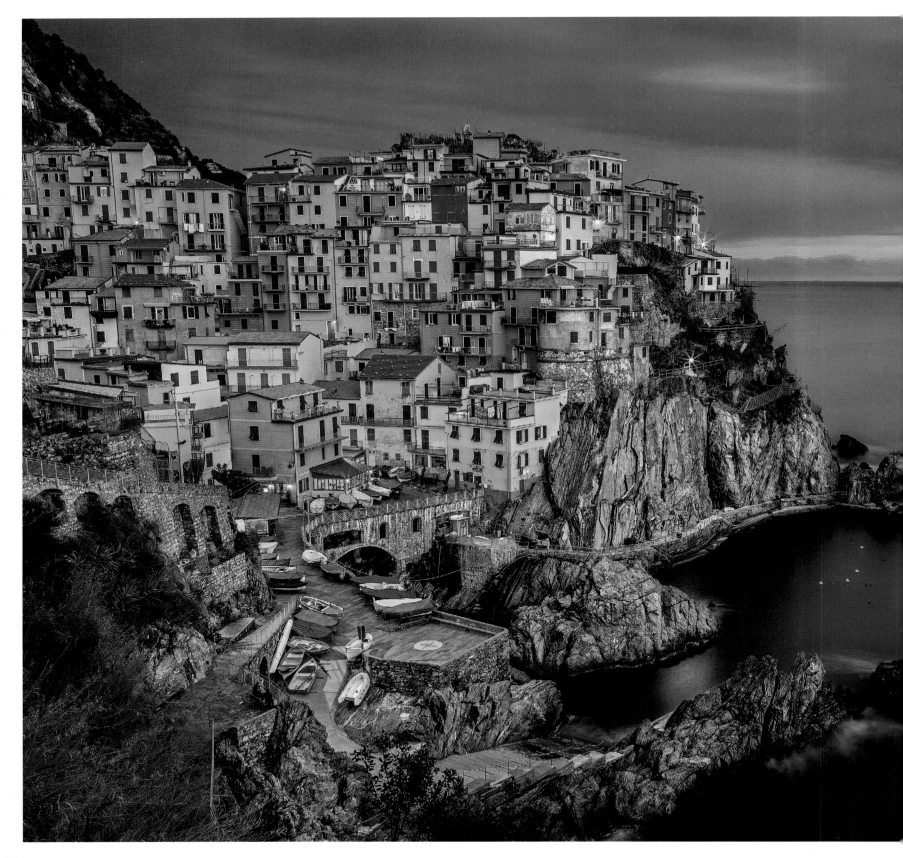

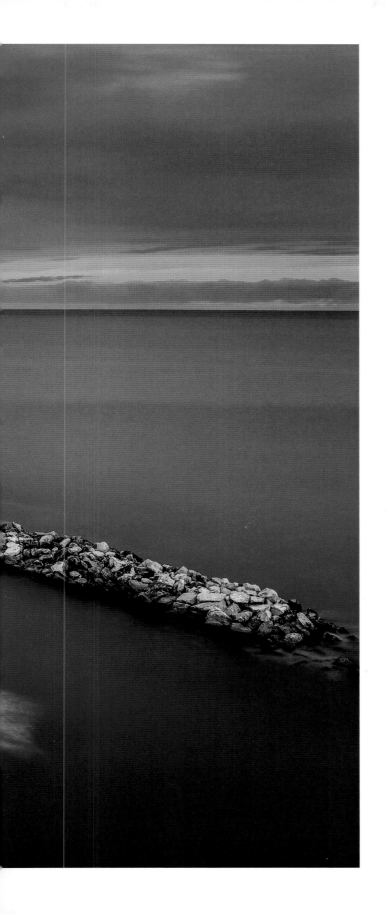

LEFT: **MANAROLA, ITALY** | Colorful buildings appear to nestle into the rugged and steep cliffs of a seaside village along the Mediterranean's Liguria coast. | *Peter Stewart*

FOLLOWING PAGES: **BANGKOK, THAILAND** | Blurred city lights come into sharp focus when seen through a pair of glasses. | *Sergey Tryapitsyn*

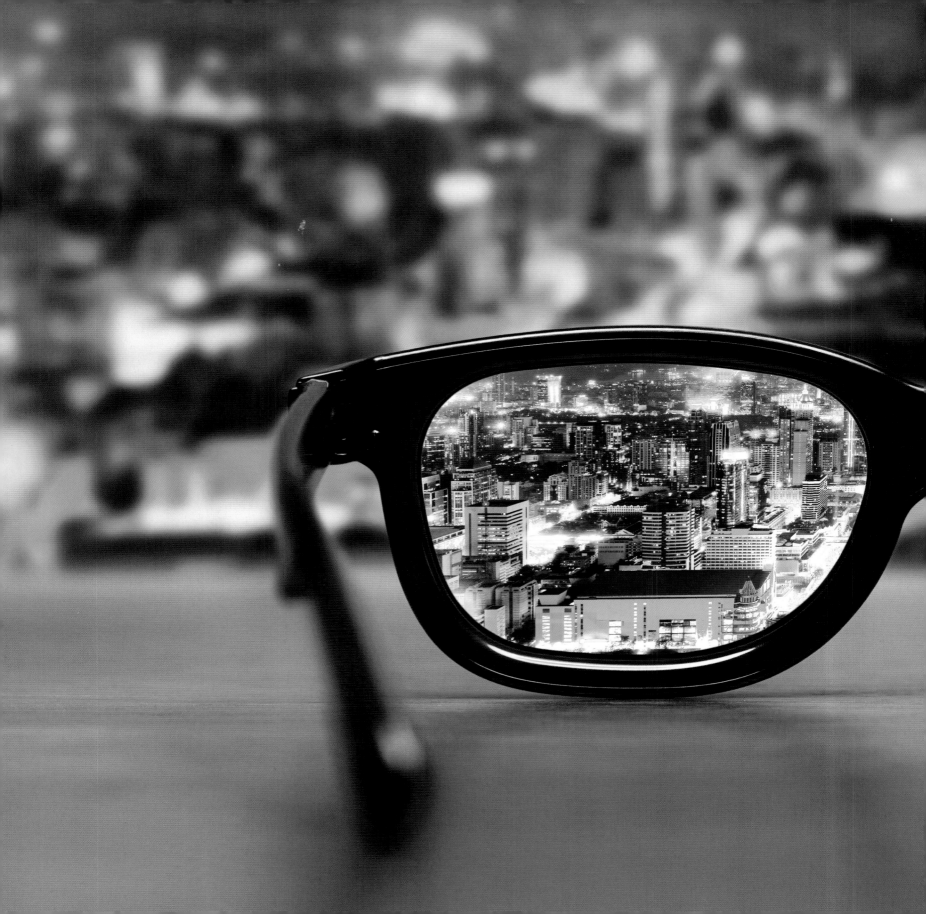

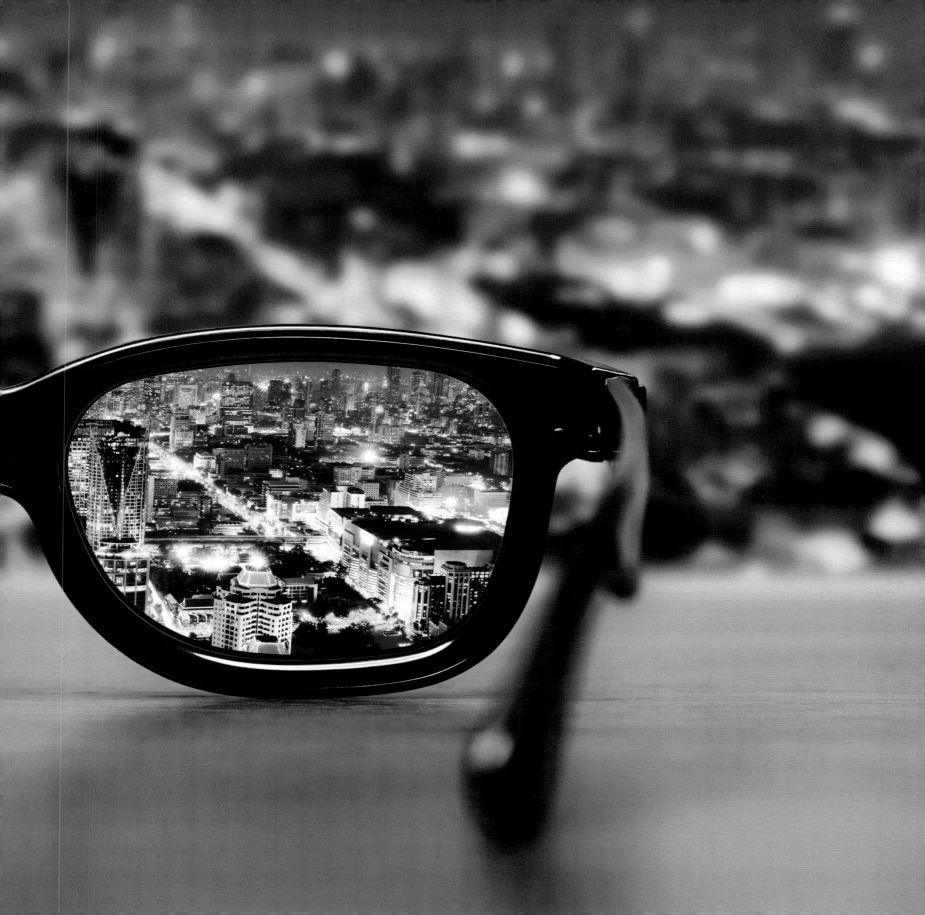

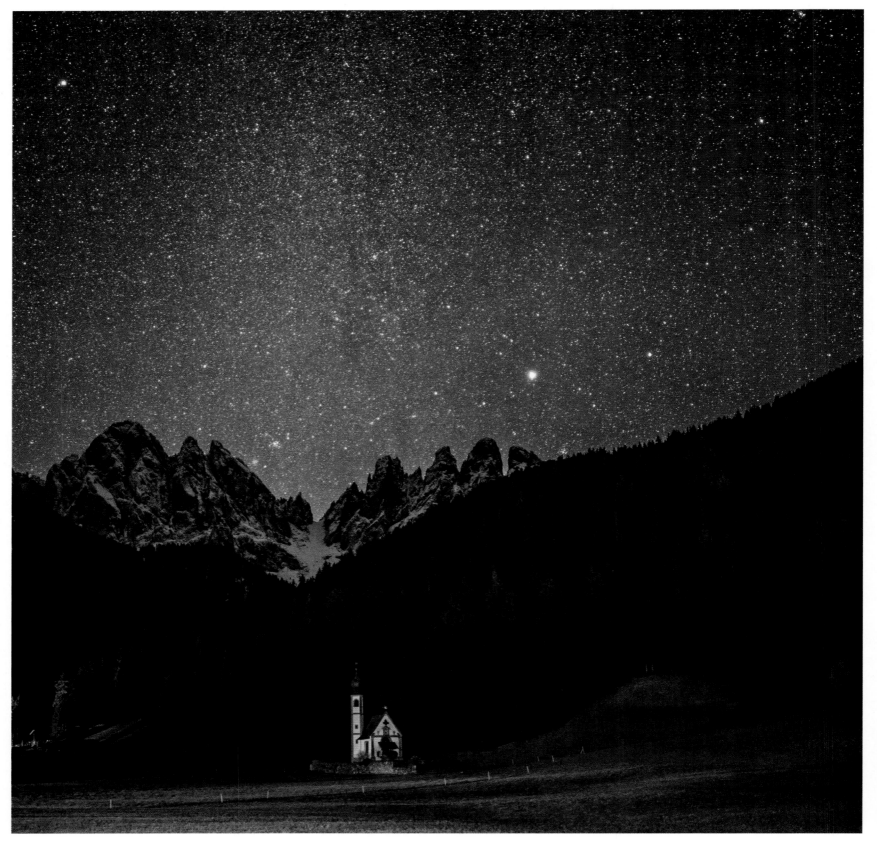

> " SILENTLY, ONE BY ONE, IN THE
> INFINITE MEADOWS OF HEAVEN,
> BLOSSOMED THE LOVELY STARS,
> THE FORGET-ME-NOTS
> OF THE ANGELS.

—HENRY WADSWORTH LONGFELLOW

OPPOSITE: **RANUI, ITALY** | The Italian Alps and a star-filled sky put the small church of
St. Johann—and our earthly endeavors—into a celestial context. | *Chris Burkard*

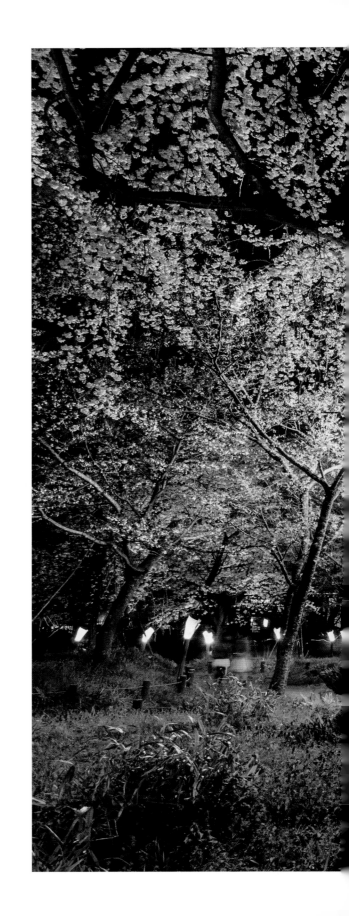

KYOTO, JAPAN | Flowering cherry tree blossoms catch the soft lights
of the Hirano Shrine. | *Diane Cook & Len Jenshel*

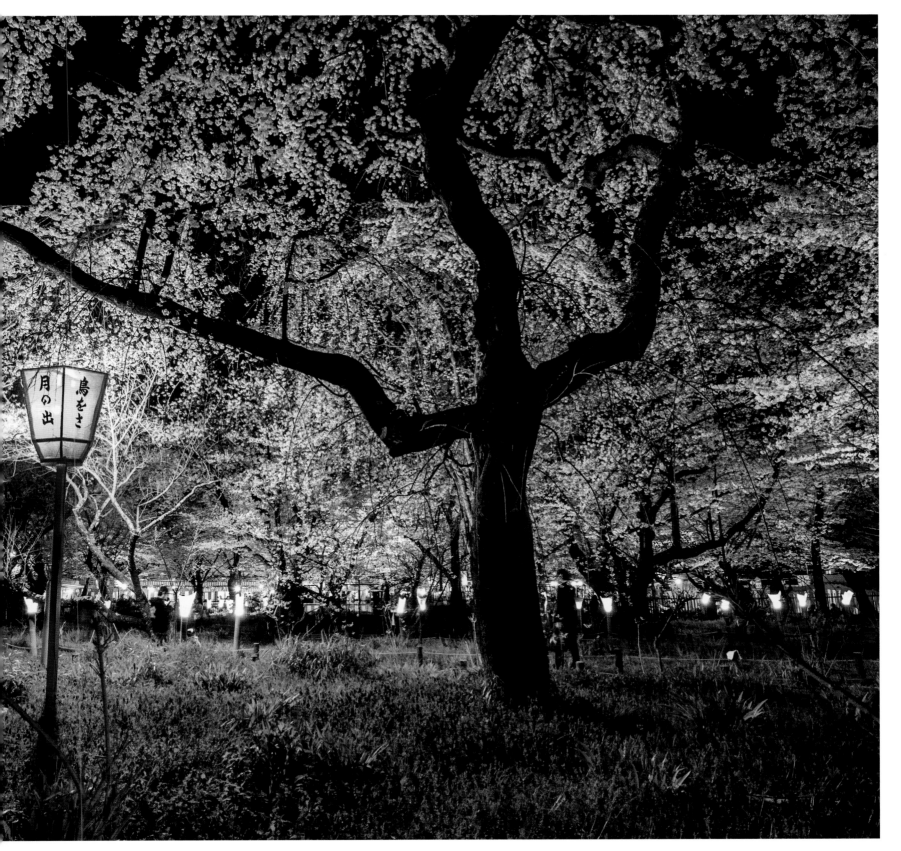

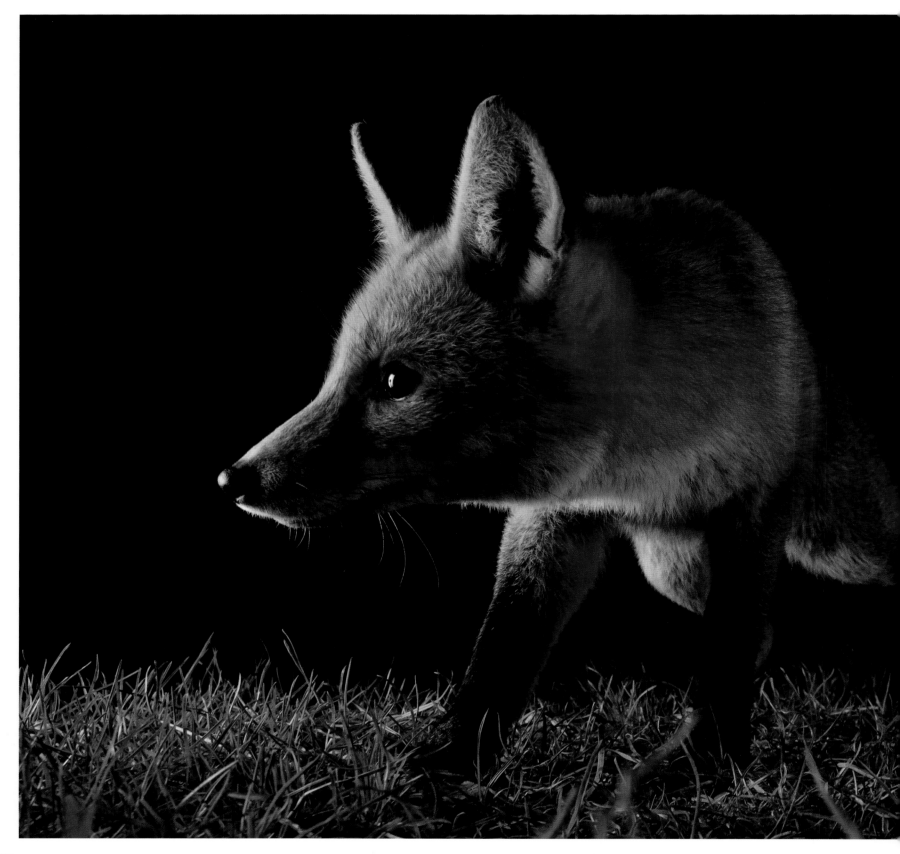

LEFT: **LONDON, ENGLAND** | With pricked ears, a fox picks up sounds of the night inside an urban garden. | *Alex Witt*

PAGE 392: **YELLOWSTONE NATIONAL PARK** | The thermal vent of Lone Star Geyser burps out steam in Yellowstone's backcountry. | *Corey Arnold*

PAGE 393: **WULONG COUNTY, CHINA** | A caver's headlamp casts a beam that slices through mist in the Cloud Ladder Hall of the Er Wang Dong cave system. | *Robbie Shone*

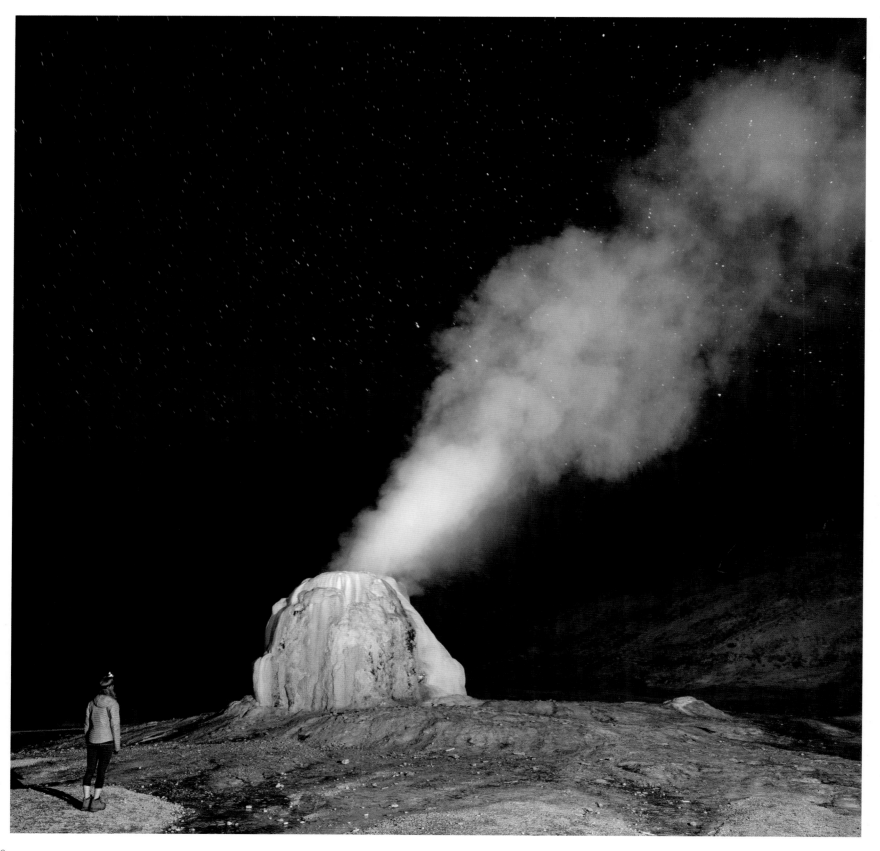

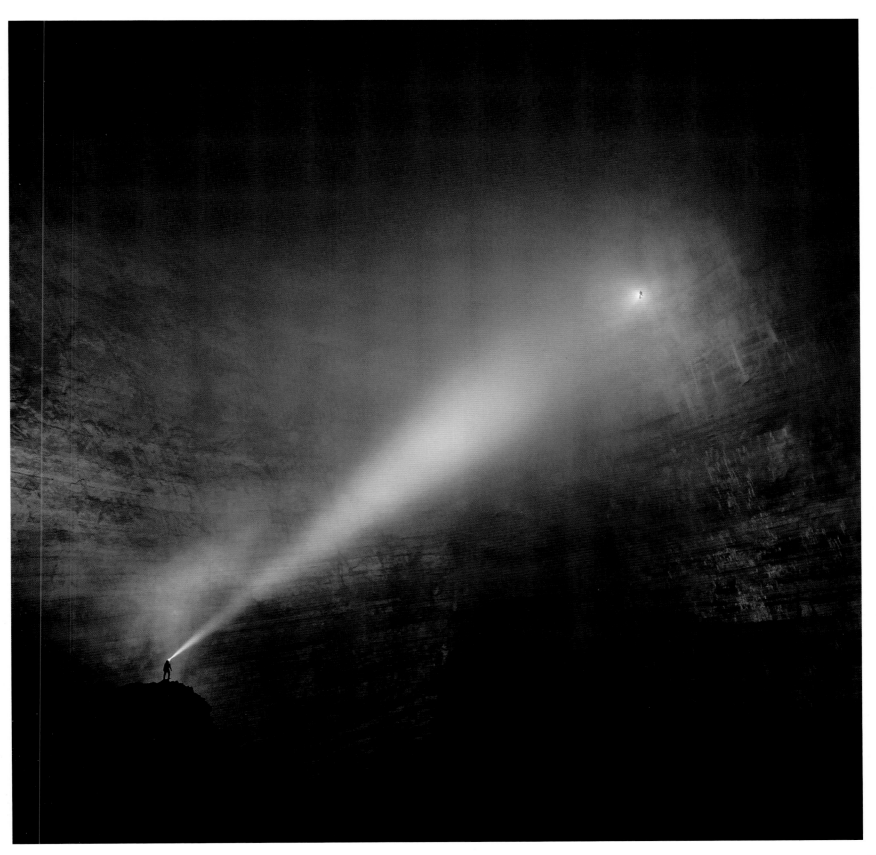

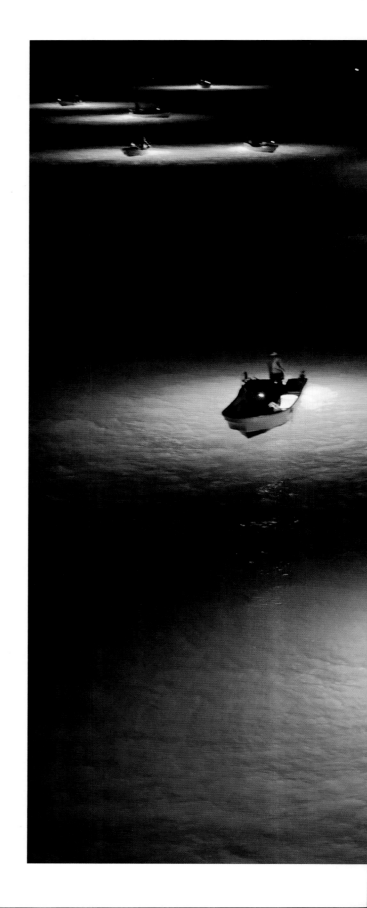

RIGHT: **TOKUSHIMA, JAPAN** | Fishermen on the Yoshino River use lamps to attract young eels, which are then transferred to facilities to be raised. | *The Asahi Shimbun*

FOLLOWING PAGES: **SPACE** | The beautiful and earthly lights of London and Paris glow below the arms of the International Space Station. | *Commander Terry Virts*

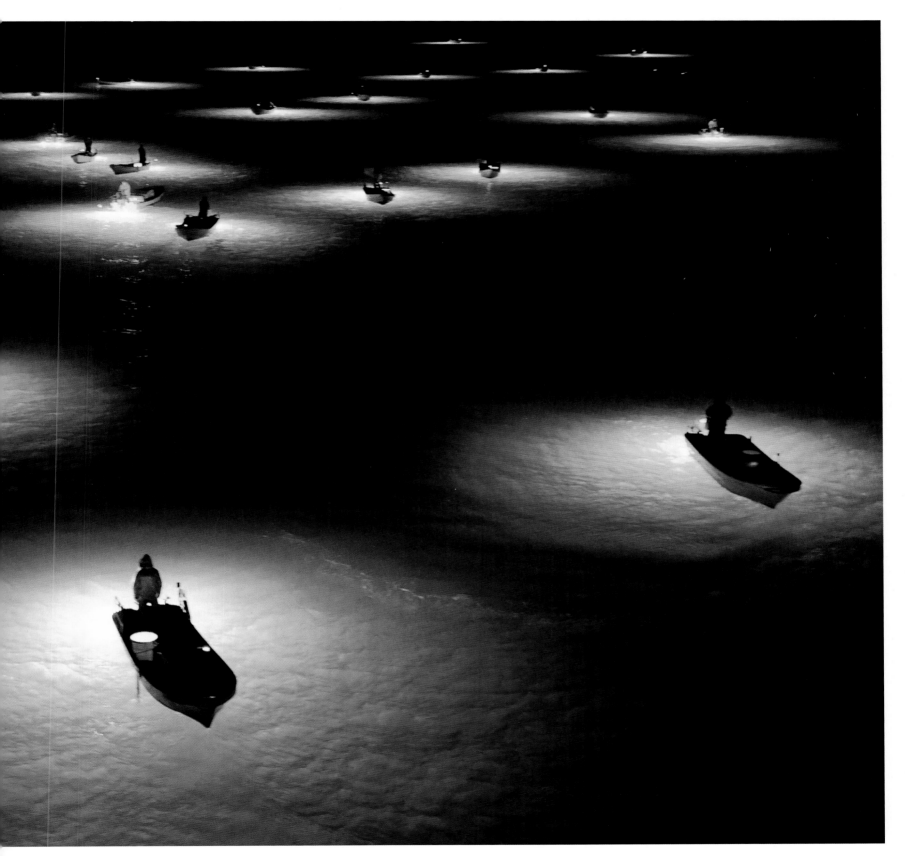

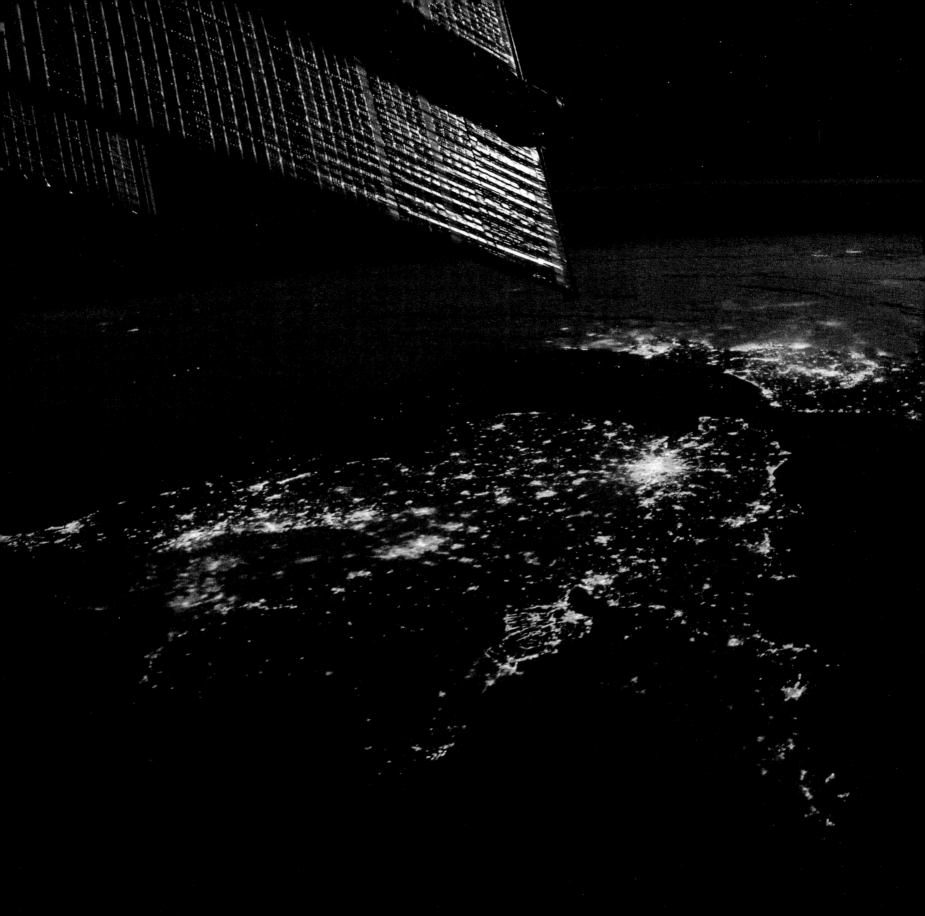

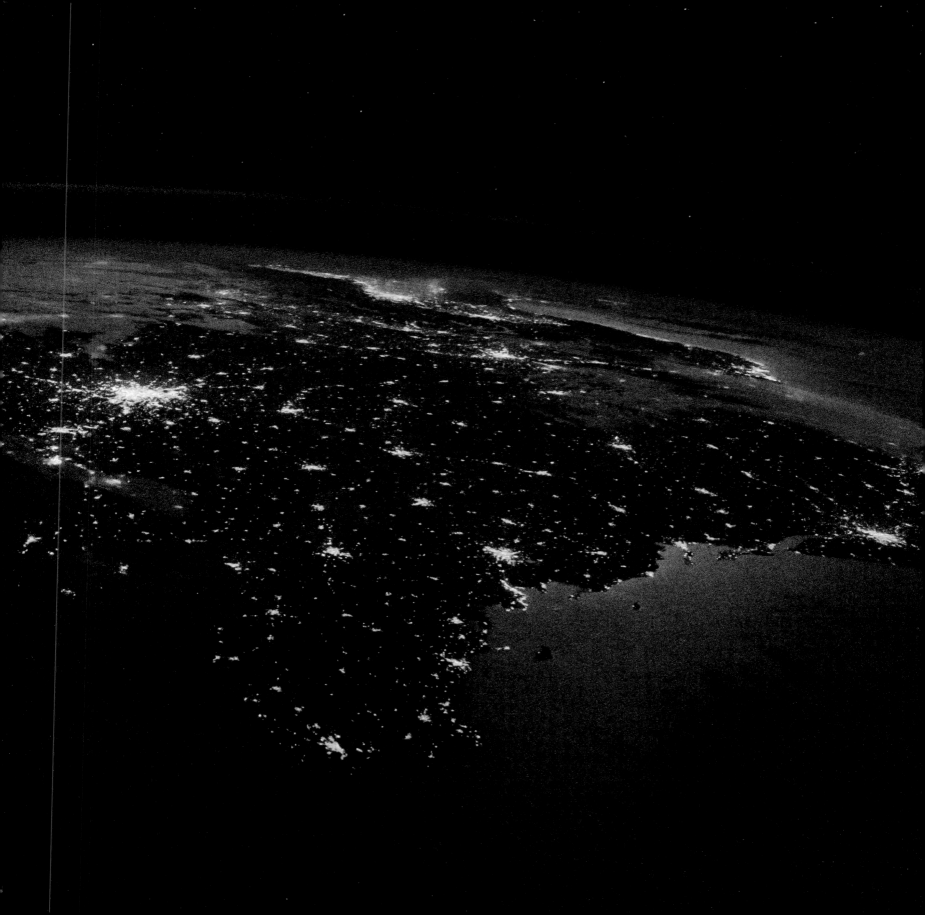

ILLUSTRATIONS CREDITS

National Geographic Creative; 309, Caters News Agency; 310-11, SIME/eStock Photo; 312-13, National Geographic Your Shot; 315, Getty Images; 316-17, National Geographic Your Shot; 318-19, AFP/Getty Images; 320-21, Getty Images; 322, National Geographic Creative; 323, spiraldelight/Getty Images; 325, Getty Images; 326-7, Stoked for Saturday; 328-9, Getty Images; 330, KEENPRESS; 331, SIME/eStock Photo; 332-3, Getty Images; 334-5, Getty Images; 336, National Geographic Your Shot; 340-41, 500px/National Geographic Creative; 342-3, National Geographic Creative; 344-5, National Geographic Your Shot; 346, National Geographic Creative; 347, National Geographic Creative; 348-9, DeepDesertPhoto/Getty Images; 350, Getty Images; 352-3, National Geographic Your Shot; 354-5, Getty Images; 356-7, RobertHarding/Getty Images; 360, Getty Images; 361, Minden Pictures; 362-3, hemis.fr/Getty Images; 366-7, National Geographic Creative; 368-9, 500px/Aurora Photos; 370, National Geographic Your Shot; 371, Magnum Photos; 375, Getty Images; 376-7, National Geographic Your Shot; 378-9, naturepl.com; 380, Tetra Images/Newscom; 381, Gallery Stock; 384-5, Nomadsoul1/Getty Images; 386, Massif; 388-9, National Geographic Creative; 390-91, Alamy Stock Photo; 394-5, Getty Images; 396-7, NASA.

ACKNOWLEDGMENTS

Night Vision would not have been possible without the hard work of the wonderful National Geographic team: senior photo editor Laura Lakeway, creative director Melissa Farris, deputy editor Hilary Black, editorial project manager Allyson Johnson, researcher Michelle Harris, senior production editor Judith Klein, design/production coordinator Nicole Miller, and countless others who gave their time and talent to this book.

Since 1888, the National Geographic Society has funded more than 12,000 research, exploration, and preservation projects around the world. National Geographic Partners distributes a portion of the funds it receives from your purchase to National Geographic Society to support programs including the conservation of animals and their habitats.

National Geographic Partners, LLC
1145 17th Street NW
Washington, DC 20036-4688 USA

Become a member of National Geographic and activate your benefits today at natgeo.com/jointoday.

For information about special discounts for bulk purchases, please contact National Geographic Books Special Sales: specialsales@natgeo.com

For rights or permissions inquiries, please contact National Geographic Books Subsidiary Rights: bookrights@natgeo.com

ISBN: 978-1-4262-1852-1
ISBN: 978-1-4262-1934-4 (special edition)

Printed in China

17/PPS/1